THE LOST FOLK

LALLY MACBETH

✳ THE ✳ LOST FOLK

From the Forgotten Past to the Emerging Future of Folk

faber

First published in 2025
by Faber & Faber Limited
The Bindery, 51 Hatton Garden
London EC1N 8HN

Typeset by Typo•glyphix, Burton-on-Trent, DE14 3HE
Printed and bound by CPI Group (UK) Ltd, Croydon, CR0 4YY

All rights reserved
© Lally MacBeth, 2025

Interior illustrations © Tabby Booth, 2025

The right of Lally MacBeth to be identified as author
of this work has been asserted in accordance with Section 77
of the Copyright, Designs and Patents Act 1988

A CIP record for this book
is available from the British Library

ISBN 978–0–571–38830–1

Printed and bound in the UK on FSC® certified paper in line with our continuing
commitment to ethical business practices, sustainability and the environment.
For further information see faber.co.uk/environmental-policy

Our authorised representative in the EU for product safety is
Easy Access System Europe, Mustamäe tee 50, 10621 Tallinn, Estonia
gpsr.requests@easproject.com

2 4 6 8 10 9 7 5 3 1

To Matthew

Cuntelleugh an brewyon ues gesys na vo kellys travyth
Gather ye the fragments that are left, that nothing be lost
Motto of the Federation of Old Cornwall Societies

✶ **Contents** ✶

Introduction ✶ 1

1 THE LOST PEOPLE ✶ 15

2 THE LOST COLLECTIONS ✶ 69

3 THE LOST OBJECTS ✶ 123

4 THE LOST CUSTOMS ✶ 189

5 THE LOST WORLDS ✶ 275

Conclusion: From Lost to Found Folk ✶ 319

Acknowledgements ✶ 329

Notes ✶ 331

Image Credits ✶ 339

⋆ **Introduction** ⋆

Folk culture is all around us: it is sitting in our churches, swinging from our pubs and dancing through our streets; it is patiently waiting to be discovered and appreciated, to be saved and cherished.

In 2020 I started The Folk Archive as a way to increase interest in folk culture. I wanted to highlight the ephemeral pieces of everyday life that often get overlooked and that I believed were in danger of getting lost, such as pub signs, church kneelers and corn dollies. I set out on a journey to record these objects, as well as folk customs, rituals and tales, with the hope that through saving them we might collectively learn from our past and to help inform our future. This vision of the past and future coalescing formed the basis of my motto for The Folk Archive: folk from the past, folk from the present and folk for the future.

For years I have scoured charity shops, car boot sales and junk shops for photographs, horse brasses, books, costumes: anything that I felt belonged to the category of 'folk'. From these items a collection formed, but perhaps more importantly, so too did a methodology – one in which, both academically and practically, folk takes centre stage.

As a practice, it can be hard to define. For me, there are a few helpful pointers to establish if something is folk:

1. Has it been touched or made by the human hand?
2. Is it being made/performed with a particular locality in mind?
3. Is it for and of the people?

THE LOST FOLK

There are, of course, a multitude of other questions you can ask yourself, but I find these are pretty helpful starting points, and they cover most objects, customs or places I'll be discussing in *The Lost Folk*. At its core, folk does not belong to anyone; it is everybody's – this is perhaps its most important and defining feature, and something it is key to remember in any consideration of a 'folk' object, custom or costume.

What is folk?

Before we look at what I believe 'folk' to be, I thought it might be useful to briefly define what has traditionally been considered as 'folk'. Mostly, the term is used in relation to the traditional practices or customs of a place. This can be related to the music, art, dance or customs of a particular town or village, or of a particular country. Folk as a term involves both people who make 'folk' – those who perform it or create it – and those who 'collect' it.

The people who 'collect' it are often talked about as 'folklorists'. These people work to collect folk practices, including folk dances and folk tales. In many cases, these collectors of folk have been from the middle or upper class, while the people 'performing' or 'enacting' the folk practices have been working class.* Collectors have traditionally had very particular ideas about what or who should enter the canon of folk. This has meant that many people, customs and objects have been left out.

As a whole, the canon of folk, as with that of other disciplines, has become one in which a select number of people have had an outsized

* Although this is the case in most folk collection, in the instance of folk music working-class people have often been instrumental in the collecting of songs. I refer particularly to the period in the 1950s and 1960s when people such as Norma and Lal Waterson, Martin Carthy and Shirley Collins were collecting.

INTRODUCTION

voice in how it is collected and preserved for the future. Given that folk is of and for the people, it should not be so exclusionary, but instead for all of us to decide who and what is important.

In 1907 the folk song and dance collector Cecil Sharp, whom we will consider in more depth later, described folk music as 'the song created by the common people'.[1] This gives a sense, I think, of the pejorative way in which folk practice has been spoken about and recorded in the past: the 'people' were rendered as a generic group of nameless individuals from a particular class. So much of the way in which folk has been written about or discussed has implied an *us* and a *them* – 'we are the ones who *collect* it, they are the ones who *participate* in it'. As a collector of folk myself, I aim to begin to redress this balance by actively engaging in folk practices local to me, and I can happily say this is a growing trend. I explore traditions that previously have been excluded because they haven't met folklorists' criteria for what constitutes folk, and I encourage everyone with an interest to do the same.

My vision of folk

It is important to note at this point that I don't claim to be an expert on folk; it is such an expansive topic that it would be nearly impossible ever to truly understand it all. It is also constantly evolving and changing: just as you think you have a grip on it, it slips and morphs into something new. 'Expert' is generally an unhelpful term when talking about folk because both the making of folk and the collecting of folk should be an exchange of ideas, a coming together of community and a sharing of knowledge.

Although I would of course count folk songs, dances and customs among my definition of what folk is, nostalgia also plays a large part in my vision of folk culture. Including nostalgic recollections within

3

a definition of 'folk' could be seen as being at odds with more traditional folk collection practices, where the emphasis has tended towards factual accounts based on information recorded by a perceived 'expert'. However, for me, nostalgia is often at the heart of why things become perceived as 'folk' by people and communities.

Literally, 'nostalgia' means the yearning for a lost home. In the context of folk, this feeling can be applied more broadly to a lost place or object – somewhere or something mythic and unknowable, or belonging to a bygone time – that is held in the highest reverence by the people who remember it. A great number of folk customs encompass this nostalgia, but it can also be used in the context of much newer folk practices and objects, such as school plays, model villages and craft projects made from tinsel and crêpe paper, toilet rolls and bits of string. This is most readily seen in online Facebook groups and internet forums, where people gather together communally to reminisce about customs, traditions and places from a particular town or village – creating together an environment that feels like home.

While nostalgia is sometimes perceived as being rose-tinted – and it certainly can be – in my own folk landscape, I do not wish to do away with the gritty or more frightening aspects of folk culture: they matter, too, and are important in moving our folk practices forward into the future so they can be truly inclusive. I believe folk should be about the full breadth of human experience, from childhood to death, and that scope must include everyone and all experiences of the world.

Identifying new customs

The youth jazz bands of Newcastle might not be considered a 'folk custom' in a conventional sense, but they perform many of the same

functions that other, more traditionally accepted folk customs do: they bring people together into a community and mark particular points in the calendar through parades that feature music and costume. Likewise, in Toxteth – an inner-city area of Liverpool – since 2017, each 23 November, people have gathered together to celebrate their recently and long-since departed friends and relatives at the Toxteth Day of the Dead. It parallels older traditions in the use of DIY materials to create costumes and props for a procession through the streets. But here, people are building a new tradition: they are building the folk memory.

The development of customs and the terminology associated with them are important aspects of the way folk culture evolves through history. The identification of new customs happens frequently, as communities evolve and build their own traditions. It is, I think, an extremely positive and exciting idea that folk can constantly move forward and that rather than being scared of the 'new', we can actively embrace it, alongside celebrating the past.

Many folklorists have served a vital function in evolving folk via the invention of new terminology, for instance the folklorist Ellen Ettlinger's use of the term 'religious folklore', which she came up with at a point in history when many religious customs were in danger of being lost in an increasingly secular post-war world. Her use of the term threw new light on customs and traditions associated with the Church.

In my own work collecting and preserving folk culture, I have identified a series of customs and practices that falls under the banner of 'municipal folklore'. These are all customs that, until this point, might not have fallen under the heading of folk because they have generally been associated with councils or institutions. Municipal folklore, like Ellen's term, encapsulates a world of folk that has been largely ignored.

Customs, traditions and objects that fall under the category of municipal folk are varied, but their overarching and unifying factor is that, unlike many folk customs that are perceived as traditional, they sit not in the rural landscape but instead in the town- or cityscape. That is to say, they are all related to urban living in some way. This can, and does, include flowerbeds, fairs and charter days, pageants and processions. Municipal folklore is also often, but not always, instigated and organised by town councils or governing bodies.

'Let nothing perish'

For a long time, I have drawn inspiration from the collector and architect Charles Paget Wade's Latin motto, *Nequid pereat*, which translates to 'Let nothing perish'; it resonates with a sense of love and respect for all things.[2] By its very nature, folk is often ephemeral: it can be tricky to catch, hard to preserve and even more difficult to resurrect. Folk customs are often 'blink and you'll miss them' in their lifespans: costumes get worn and used and disintegrate, pub signs get painted over as new landlords arrive, and local tales are lost as people move away.

An interest in saving folk objects is so often the preserve of a few dedicated individuals who help keep a custom going or save items from a skip. These characters have very often, during their lifetimes, been ridiculed or considered eccentric for their passions; they have often had to go above and beyond to save objects or buildings. Take Isabel F. Grant, who opened the first ever open-air folk museum in Britain (although we will come later to an even earlier example). It was founded on the island of Iona in Scotland, where Isabel had collected agricultural tools, costumes and ephemera from the Highlands over a number of years and purchased a chapel to house them. Before long, this building was far too small, so she put on an

INTRODUCTION

exhibition in Inverness in the hope that someone would see the collection and deem it important enough to provide a larger and more permanent home. Alas, this was not the case, and Isabel moved the collection several times before finding a site in Kingussie in 1944.[3] Isabel had to work extremely hard to keep the collection together, fighting against the odds and the turbulent times of the Second World War. Preservation of folk takes dedication and more than a little determination.

In the summer of 2015, I was faced with the task of saving an archive myself. I come from a family of collectors: collectors of dolls, postcards, textiles, troll dolls and songs. My grandparents' home had shelves filled with books, drawers filled with photographs and cupboards overflowing with magazines. My grandma even had a collection of gingerbread men in her kitchen.

My great-aunt Barbara, a librarian by qualification, took it upon herself to become the family archivist. She carefully labelled and classified each photograph, birth certificate and piece of ephemera connected to many generations of the family. When she died, the family home was sold, and all her things were left in the care of my grandfather, who duly put them in the shed at the bottom of his garden. My grandfather was not a sentimental man, and for him this 'archive' was an encumbrance, taking up space, so into the shed the carefully labelled archive went and there it stayed until one summer's day, when my mum, aunt and I decided to tidy it. At this point, we were unaware how thorough a job my great-aunt had done, but as we pulled out boxes it became apparent: she had researched each member of the family, saving everything she had collected.

Within the boxes I discovered photographs of long-lost relatives, their lives and loves contained in curated boxes. A shed is not the friendliest environment for paper, so many of the photographs had become stuck together; the negatives had taken on strange blurry

splodges and the letters were littered with rat droppings. However, in among it were some items that had survived: out of one box came a tinted A4 photograph of a woman in mock Tudor garb, dated 1934. Contained within the same box was a programme for a pageant that took place in Ludlow the same year. The pageant was a rendition of John Milton's masque 'Comus', and the programme contained a list of characters and a fold-out map of Ludlow Castle and seating plan. This lady in Tudor dress was my great-great auntie Enid, dressed as the 'Merchant's Daughter'.

A little more research and I discovered this pageant, directed by Edward Baring, was one of the largest to take place in the whole of Britain in the 1930s.[4] It was held to commemorate the first ever presentation of 'Comus' at Ludlow Castle on Michaelmas (29 September) 1634, and over a period of six days, 28,000 people watched it. The journalist Evelyn Lloyd states: 'At every performance the seats were fully booked.'[5]

This was pageantry on an enormous scale; without this foray into my grandfather's shed, and the scramble to save the family archive, I might never have discovered either the Ludlow pageant or the fact that my family played a small role in this huge moment of folk history in Shropshire. The experience of discovery, of saving and researching this archive, of fighting for its right to remain in the world, brought to mind so many other collectors and researchers whose archives have been disbanded and broken up.

The family archive is, of course, a uniquely personal treasure; quite often the photographs and papers collected in such a hoard are of no, or limited, interest to the outside eye. However, when I discovered the collection of pageant photographs, it set me thinking about all the folk customs, parties, fancy dress and revelry contained within any family archive, and the importance of saving these items of 'lost folk'.

INTRODUCTION

Folk is for everyone

There is a danger that we forget the importance of our own place in the collection and preservation of history, that we can view the items of our own histories as irrelevant or uninteresting to the wider historical picture. Yet I would argue that they are possibly the most important fragments in building the bigger picture. Without the small moments – the photographs of pageants and churches, and the Christmas decorations – we would be without any sense of what real 'folk' culture is, and what a seasonal year actually entails for people in the modern world.

From first visits to Stonehenge to maypole dances, family archives quite often contain within them entirely lost places or customs – pieces of our folk culture and history that would otherwise be lost; sites such as model villages, which are often deemed the preserve of rainy days and fulfil the need to occupy long summer holidays with an 'activity'. They do, however, crop up frequently in family photo albums across the world, with children posed next to miniature replicas of country pubs, town halls and watermills. Sometimes it is impossible to date them or even to find their location, but over time pieces can often be put together, and the jigsaw can be solved; sometimes it will never be. I hope to encourage people to discover these snippets of folk culture that would otherwise get lost and to appreciate them, even if their history and provenance are a mystery.

Model villages are always handmade, usually with meticulous detail, and always rendered in miniature.* They almost always commemorate buildings within their locality, and are generally a mixture of traditional buildings and more modern structures. They are perfectly formed encapsulations of a village or town and its

* Generally at between 1:9 to 1:20 scale.

9

history and ways of life. Even so, the model village is not something that has typically been recorded by traditional collectors of folk. It is, perhaps, too modern – the earliest-known example dates from 1907 – and seen to be without merit. For me, however, these sites perform two roles that mean they deserve a place in any modern discussion of folk: they record buildings and places, and they are handmade. They have also, in recent years, begun to decline in number, for reasons ranging from landslides to low visitor figures. With upkeep being problematic – repairs cost time and money that is not covered by the generally cheap admission fees – the model village is fast becoming a feature of the past.

This is a story that is repeated across the British folk world: customs and objects take labour and financial backing, which is not easily found for maverick creations such as shell grottoes and miniature worlds, or elaborate occasions like pageants and parades.

In the following pages, I attempt to set out this landscape of the lost folk of the twentieth and twenty-first century – the forgotten fragments of our shared folk history: stories of lost folklorists, forgotten model villages and sandcastles turned to dust; of carnivals faded into the distant horizon and fires that once burnt brightly on St John's Eve but have ebbed away into embers.

I have also attempted to search out and build the puzzle of our current folk landscape, and why certain people or communities have been left out. When I started writing, I had a firm idea of the places and people I might follow in the pages of this book, and while that idea hasn't changed, it has evolved. I was lucky, in the early stages of writing, to spend several weeks living in a tower in Northern Ireland. I had never visited the country before, and my eyes were opened up to a rich and dynamic folk environment that would be impossible to begin to know without having visited it. It became quickly apparent to me that folk in Northern Ireland is still a living, breathing tradition

INTRODUCTION

– even more so than in the depths of England: folk tales slip off the tongue with ease and the sense of place and community is second to none. The fallacy of folk is that it belongs solely in history books, but deep in the Glens of Antrim I found something very much alive, and people who really understood the need to keep it moving forward into the future.

Although I touch on aspects of what I discovered in Northern Ireland in the coming pages, it is my hope to return and explore its folk culture in even more depth. It is rich, diverse and has both incredible overlap with and a remarkable disparity from the rest of the United Kingdom. In short, the true nature and character of such a fertile and full land – one I have come to love and admire for its strength of spirit and folklore – needs more time and attention to explore than I have so far been able to spend.

As exemplified by my experiences in Northern Ireland, my approach to collection has always been an intensely personal one, and you will find in this book that my homeland of Cornwall has more than its fair share of space. I have always believed in focusing on where you are in the moment and discovering what you live among: naturally this has led me to explore what the rich and dynamic folk landscape of Cornwall has to offer. This, for me, is true folk collection: immersing yourself in the place you live and discovering its folk practice. I have, of course, sought to explore in this book the diverse folk landscapes across the United Kingdom, including those of Lancashire, Worcestershire, Lincolnshire, and beyond – it just feels salient to note here that the balance of the book does weigh in favour of the places I have spent more time in and therefore have greatest knowledge of.

There are a few notable gaps; with a surname like MacBeth, it will perhaps come as no surprise that I am half Scottish, and it is with sadness I acknowledge that there is so little of Scotland contained

within this book. I have a long-held ambition to take some time to explore the folk culture of Scotland, and although there are a few examples of Scottish folk within the book, it is by no means a comprehensive overview of the incredible wealth of material to be discovered there. Regrettably, I have not been able to spend the time on the ground exploring Scotland and its customs that I would have liked to. Likewise, I have a deep personal connection to South Wales, where my maternal grandfather grew up and many of his family still live. While I have delved into some folk collections and museums in Wales, the customs are sorely underrepresented, the reason being that, as with Northern Ireland and Scotland, they are so vast and varied from those of England that they could each fill a whole book all of their own. My hope is that I will be able to return to Scotland, Northern Ireland and Wales in future works and properly investigate each of their unique folk landscapes separately.

How, then, did I go about selecting the customs, collections, objects, buildings and people that you will find among the pages of this book? I would be lying if I made the process out to be anything other than organic. Sometimes I came across a pamphlet on a long-forgotten museum or custom, which led me down a tangled path of many other strange and wonderful folk-related items. Sometimes I wandered down the street in a town I was visiting and stumbled, quite literally, on a building or a fragment of a sign. Other times a chance conversation with a person in a shop or an overheard snippet on a train led me to a new discovery. I think of it like a Victorian crazy patchwork quilt, a slow process of finding and selecting all the odd pieces that fit together and then stitching them into a story.

Perhaps some of the connections are more obvious than others, but all of them hopefully go some way to telling the story of folk in Britain as I see it. Many of these stories are lost, some of them are forgotten and lots have simply been ignored or left out of previous

INTRODUCTION

explorations. Some of them are traditions that could be considered as still active and not lost at all, but without these intact aspects of folk, the lost fragments would be largely meaningless.

It is also important to mention that some of the histories I write about contain problematic and offensive historic language. It is quoted verbatim because I feel it is vital that we unpick and understand the ways in which people have previously been written out of folk, and in order to do this we cannot, as folk collectors, shy away from the pejorative language and stereotypes that have made up some folk practices in this country.

I make no claims to this being a comprehensive history. The folk traditions of Britain are so vast that it would be a lifetime's work to weave them together: an impossible and wonderful task, and one we all need to unite in if we are to preserve and properly record the multitude of folk histories on our islands.

My hope is that this book will act as a call to arms. Take it and go forth. You, too, can become a collector of our folk traditions, customs and buildings. Is there a pub in your village with a magnificent sign? Photograph it! Does your town host a summer carnival? Record it! Folk is constantly evolving and it is up to us all to document it, to participate in it and to create our shared folk future.

1
✱ THE LOST PEOPLE ✱

Folk, above all else, is about people: people who make the objects, people who enact the customs, people who watch those customs happening and people who 'collect' the folk culture and practices so they are preserved for the future. Although the people who make folk objects and enact customs are of the utmost importance in telling the story of lost folk in Britain, they are largely anonymous. The power of folk is that it is a collective experience, and one in which ego is largely absent. It is not about who made what but rather the experience of the community in using the object or enjoying the custom. Due to this, it is often very difficult to credit the creators of objects, and tricky to track down the instigators of customs. There are, of course, exceptions to this rule, as we will see later in the 'Lost Worlds' chapter, but for the most part, folk is nameless.

What we do have is a wealth of information about the people who have sought out and recorded folk customs, whom we shall call *the collectors*. Historically, these people were often upper middle-class, and therefore had the means to go about recording in a way that would not have been afforded to the people enacting customs or making folk objects. Chiefly this meant time and money to travel the length and breadth of the country collecting folk practices and making notes along the way. This class divide has meant that folk collectors have, in the past, approached the collection of folk in a judgemental and subjective way, with people and traditions being

THE LOST FOLK

'written up' in a way that is palatable to middle-class tastes – that is, without any of the dirty, difficult or tasteless bits.

Sometimes these collectors refer to themselves as 'folklorists', and this is a term we will encounter from time to time in this chapter. In the most general sense, the word refers to someone who is actively, and knowingly, engaged in the collecting or recording of folk practices. I have mostly (with a few exceptions) chosen to use the term *collector* over 'folklorist' because I believe it better represents the activities of the people I am going to spend time exploring; very few of them would have referred to themselves as 'folklorists' and very few of them actively considered themselves to be collecting. They were driven by other motives than the collection of 'folk' alone.

Folklorists have largely decided what gets saved and what gets remembered; what gets left out and who gets forgotten. They have held a monopoly over the history of folk, and therefore could, if we let them, hold one over the future of folk. In order to move through the lost collections, objects, customs and worlds of folk, we must first explore who the collectors were, what they were collecting and why certain people have been left out of the narrative. Even within the history of the collectors themselves there are collectors who have been marginalised. It will come, perhaps, as no surprise that these people are often women, people of colour or disabled people, or people who have tried to tell a different story, a story that is more inclusive and open.

So what constitutes collecting and how might a collector go about it? Collecting can, and does, encompass both objects and activities, so it can include objects such as church kneelers or folk costumes, or activities such as morris dancing or rapper dancing*, or traditions

* A form of folk dance from Northumberland and County Durham that uses swords.

THE LOST PEOPLE

such as spreading salt outside houses for jubilee days or wassailing.*
The variety of what can be collected is enormous, and it is constantly
evolving and growing as new traditions emerge or customs are
reinvented. The practicalities of how folk collection happens are
also varied: collectors sometimes work with a notepad and pencil,
sometimes with a camera, sometimes with sound recordings, some-
times just with memory, only making notes when they have returned
home or many years later.

There is one key figure who has framed what has been deemed
'folk' more than any other: Cecil Sharp, collector of folk song and
reinventor of morris dancing. Sharp is a contentious figure for
many, but nevertheless an important one in the history of collecting
and remembering folk cultures. While I am not going to write the
biography of Cecil Sharp in the pages of this book – plenty of space
has been given to him elsewhere – I would like to take a moment
to consider his agenda. In Cecil's tireless and 'encyclopedic' (I put
this in inverted commas for a reason) efforts to document folk music
in Britain during the late nineteenth and early twentieth centuries,
he managed almost entirely to write women and people of colour
out of his work, and to record incredibly racist dance practices. Cecil
created a folk world that suited him: sanitised, classist, racist and
very, very male.

What is interesting is that this agenda is quite at odds with the
history of morris dancing and the history of folk music. Neither has
ever been performed by just one gender, and in fact at the time Cecil
was collecting morris dances from across Britain there was a woman
reintroducing the traditional dances of Britain to young women:

* There are two forms of wassail: one that moves from house to house and one that
takes place in an orchard. They both take place in the winter and are both used as
a form of blessing the town or the apple trees in hope of a plentiful harvest for the
following year.

19

Mary Neal. Mary began a group called the Espérance Club to offer folk dance classes (in particular Cotswold morris) to working-class girls employed in factories. Initially Cecil and Mary worked in collaboration, with Cecil offering much support to Mary by way of excursions to collect songs and dances, but it didn't take long before he decided she was too outspoken, and stealing his limelight as 'the folk collector', and that she was incapable of passing the dances on to her students in the way he saw fit. Cecil wrote in a note to the composer and collector Ralph Vaughan Williams that 'I began teaching Chelsea girls . . . up at Stratford. They had been taught villainously badly by Esperance girls. So I had Kimber* up and tried to put matters right. Miss Neal got wind and I wrote to her that it was impossible to allow the Esp. girls any longer to rule the roost.'[1]

It is clear that he was unimpressed by Mary and the Espérance Club girls' teaching style; he was insistent that morris dances should appear only in the particular style that he deemed acceptable. In a letter to Mary from 1909 Cecil states that: 'My great desire is that at the outset these songs and dances should be introduced to the present generation in the purest form possible.'[2] The use of the word 'pure' sums up neatly their difference in style: Mary believed that morris should be drawn from a variety of sources, to get a true flavour of the full breadth of how morris could be danced. She stated in an Espérance programme of 1909: 'In all the Espérance morris dancers have had instruction from ten different traditional dancers from different parts of England . . . The danger of relying too much on one form of the tradition is that it becomes fixed and therefore lifeless.'[3]

Mary Neal was a suffragette, a social worker and a member of the burgeoning Kindred of the Kibbo Kift movement (a pacifist group

* William Kimber was a concertina player and morris dancer with whom Cecil Sharp worked.

focusing on craft and outdoor pursuits). She was political and vocal, and – much to Cecil's dismay – she was not going away. Her version of morris was modern, and most importantly it was for all classes. Her emphasis was on the ordinary woman or man, and she argued that everybody had the ability to learn folk dances because folk is for everyone . . . right? Well, yes and no.

Cecil Sharp very much believed that folk was enacted by the people or 'folk', but that it was for the *enjoyment* of the middle and upper middle classes. He took the music and dances of the people and repackaged them into a neatly formed and palatable parcel of folk ready to be consumed across Britain. On the opposite side was Mary, who was more concerned that the revival should be for all and that revivalists, such as Cecil, would do well to remember that at its core folk dance should be full of vitality and, most importantly, fun.

Although Mary Neal continued to have a lifelong interest in folk song and dance, the First World War saw an end to Espérance morris, due in part to the redistribution of working men and women to the battlefield and war work. As a consequence, Cecil's vision of folk gained increasing dominance over Neal's more inclusive one and ultimately prevailed. In 1911, the English Folk Dance Society was formed and subsequently merged with the Folk-Song Society to become the English Folk Dance and Song Society (EFDSS) in 1932. In 1930, six years after Cecil's death, Cecil Sharp House was opened, which would also become the home of EFDSS and the Vaughan Williams Memorial Library.

While it would be easy to finish the story of British folk song and dance collection here, there is a figure who is even less well known than Mary Neal, who had a vital and transformative role to play in its history: Lois Blake. Born in London in 1890, Lois was a nurse during the First World War and travelled abroad widely before settling in Llangwm in Wales. In London she had been a keen member of the

EFDSS and had on her relocation to Wales been enthusiastic about learning some Welsh folk dances. However, during this inter-war period, Wales was experiencing a severe ebb in the interest and preservation of traditional folk culture. Dancing, in particular, was seen as sinful and to be discouraged rather than taken up in a puritanical and deeply religious cultural climate. As a result, Welsh folk dances were almost impossible to learn, because there was almost nobody dancing them. Lois was deeply disappointed by this and set to work to restore and reintroduce Welsh folk dance. Using records in archives and speaking to older members of the community, she managed to piece together dances from across Wales. Like Mary, Lois was passionate about teaching the dances she had learned to young people in schools throughout Wales. She was adamant that Welsh folk dance would not disappear. Her most lasting contribution to the folk map of Britain, however, is that in 1949 she formally began the Welsh Folk Dance Society, which has worked to elevate and promote the practice of Welsh folk dancing ever since.

Both Mary and Lois bear witness to the fact that although Cecil had a tight grip over folk culture in Britain, there are many other people who have made incredible contributions to the culture and preservation of it; they just didn't have the same establishment backing, and thus they haven't been canonised in the same way. Unsurprisingly, many of them are women, whose stories are seldom told. Although their work and collecting habits vary, they do share one defining characteristic: they all fought against the odds (which were stacked against them) to compile their research and produce their findings.

'Lemonade appetites'

Around the same time that Cecil Sharp House was opening its doors, there was a woman in Worcester determinedly trying to

THE LOST PEOPLE

record the stained glass of the churches, abbeys and cathedrals of Worcestershire and Gloucestershire. Her name was Florence Elsie Matley Moore, and she was known to everyone as Elsie. She had trained at Birmingham School of Art during the First World War, and was an active member of the Worcester Archaeological Society alongside her mother, Florence, and brother, Matley. It wasn't until the 1930s, however, that Elsie began to find her stride. She began work in 1930 on a reredos* for the St John Chapel of Worcester Cathedral and initiated, and completed, the restoration of fifteen of the tombs in both Worcester Cathedral and nearby churches.[4] Even more notable is a project that she began at the beginning of the Second World War.

Owing to her years of restoration and interest in heritage, Elsie had spent many years exploring the nooks and crannies of churches, and on the outbreak of war she became increasingly distressed that the stained glass of these buildings would be destroyed and there would be no record of their existence. So she set out on a mission to record it. Taking with her just watercolour paints, paper and brushes, she made pilgrimages to a number of churches in the surrounding area, recording the stained glass in painstaking and beautiful detail. She copied all the windows at Tewkesbury Abbey and Malvern Priory, among a great many others, and in a number of instances these are now the only existing records of the windows. Of her epic undertaking she wrote:

> Now, after being Commandant of my Ambulance for a year, with no work to do luckily, I have felt that whereas there are many women in Worcester who can be Commandant there are very few who can make accurate records and I have taken it upon myself to start off with stained glass in some of the village churches nearby.[5]

* An ornamental screen that sits behind the altar of a church or cathedral.

Her drawings are luminous. The intensity of the colour, the thick black lines to denote the lead between the panes of glass and the softness of her marks combine to create a feeling of transcendence. To her mind nothing, not even photography, could record the stained glass in the same way that an artist with brush and paint could.[6] There is something about her decision to use watercolour that amplifies this effect. It gives the paintings a translucent, glass-like quality, which would be entirely absent if gouache or oil paint had been used. It is, then, very distressing to find out that on writing to Walter Godfrey, then director of the National Building Record, to plead for some money for petrol in order to continue making her drawings, she was turned down.[7] The reason? It was too expensive to employ someone to record the drawings as meticulously as Elsie wished to. This was the era of modernity and speed, and only a photograph would do. Thankfully, despite the rebuff, she continued regardless: there are fifty-five of her stained-glass watercolour drawings in the Historic England Archive and a further eight in the Victoria and Albert Museum.

Elsie also managed to record a great number of other important architectural features, such as wall paintings (which were a particular specialism of hers), tiles and tombs, all of them carefully labelled in her instantly recognisable calligraphic hand, and she managed to save and restore a number of buildings alongside her brother Matley Matley Moore, including a tumbledown half-timber Tudor building on Friar Street in Worcester called Greyfriars. Elsie and Matley, alongside the Worcester Archaeological Society, secured the purchase of Greyfriars in 1949 after a long campaign to save it. Their main inspiration in the restoration of the house was Clough Williams-Ellis, who in his bright yellow socks and plus fours had recently begun his folly village of Portmeirion in North Wales. It was his celebration of British eccentricity fused with Italianate architectural excess that captured Elsie and Matley's attention: pastel-coloured houses, palm

trees, turrets and scrolls, cobbled streets and elaborate metal signs. The siblings forged ahead with their renovation of Greyfriars, buying up objects at auction to restore, blending them with their own reconstructions of period pieces. Seemingly Elsie could turn her hand to most things, from screen-printing fabrics to use as drapes to elaborate Jacobean embroidery for bedcovers to painting ironwork lamps to light the passageways, and Greyfriars is a wonderfully unconventional experiment in renovation. It is truly a folk environment created by two people who were fanatical about history and, in particular, Tudor buildings. The colourways and zest they brought to the interior were, I think, deeply inspired by Portmeirion, and the entrance to the garden at Greyfriars is in fact guarded by two enormous bronze fish at the head of the steps, reportedly given by none other than Clough Williams-Ellis himself. Elsie and Matley spent the rest of their lives dedicated to Greyfriars and both remained there until they died. It is now in the care of the National Trust.

In 2019, I had my own brush with Elsie. My grandparents lived in Worcester, and I spent many hours in the garden of Greyfriars as a child, so have always held it fondly in my memory. Although Elsie had long since died by the time I was visiting, my grandma had been friendly with her. They shared a love of gardening and needlework, and both my mum and grandma recounted often being invited to the annual garden party at the house – an occasion not to be missed.

In an idle moment in 2019, I decided to Google Elsie's name. I had never known much about her history and was intrigued. Up popped an article in the *Worcester Evening News* from November 2010 entitled 'I've got two special photos of Elsie.'[8] I read on. It transpired that in 2001, someone had taken over a bookshop in Wolverhampton and in the back room had been a box full of items relating to Elsie Matley Moore. At the end of the article was an email to contact for more information. I was fairly certain that the

items would be long gone given that this article was now nearly ten years old. In the spirit of Elsie, however, I decided to send an email to check. Remarkably, I received a response: the items were still in this person's possession. I felt consumed with a need to save them, and to tell Elsie's story. We struck a deal and happily I now own the box.

On opening the box to explore the items, I found that Elsie not only recorded in her own hand, but she was also fanatical about taking photographs. Reams and reams of images of sixteenth-century painted cloths at Owlpen Manor, wall paintings at the Commandery in Worcester and stained glass at Malvern poured out. Interesting, for the woman who had spent so much time fighting for her right to draw: photography clearly suited her as a method for documenting the stages of renovation. I also discovered that she wrote and illustrated a number of articles for *Country Life*, including a long article in August 1944 about Owlpen Manor and the aforementioned painted cloths. Most excitingly, it led me to the magnificent discovery that in April 1930, Elsie had produced a screen print for the EFDSS and was a keen advocate for folk dance (she was a regular at folk clubs in Worcester and Malvern).

In a palette of yellow ochre, black, mint green and white, Elsie captured the dances recorded by Cecil Sharp in *The Country Dance Book: II* (1911). The print takes the form of a map featuring titles of Playford dances, which Cecil had reinterpreted, including Christchurch, London and the Nowhill Hills. In the far distance of the map, across a vast ocean, an island is pictured with the label 'Jamaica', another of the Playford dances. The writer and music scholar William Chappell suggests in his book *Popular Music of the Olden Time* from 1859 that the title 'Jamaica', comes from the British invasion of Jamaica, when it 'was taken from the Spaniards in 1655, and the tune probably took the name from some song on that event'.[9] This seems to line up with

THE LOST PEOPLE

the fact that all earlier iterations of the tune were known under different and unrelated titles; its renaming became a way of glorifying British rule. It could perhaps be seen as an odd choice for Elsie to have included on her map, but it is useful to remember that Jamaica remained under British rule until 1962, and the conversation around the history and colonialism of the Playford dances and their titles has only started relatively recently.

Elsie's map was intended to be sold at folk dance clubs across Britain. At the bottom, she printed something of a rallying call:

> To those frivolous souls whose feet are so nimble, whose brains are so active, whose ears are so musical and whose lemonade appetites are so monstrous: this map is cheerfully and laughably dedicated, in the sure hope that though they may grow old in years and eventually become lookers-on in the dance, yet will life never cease to be for them a time set to a pleasant tune & a merry rhythm.

For me, this is indicative of Elsie's ability to see the positive in the gravest of times and circumstances. She never gave up, either on herself or on the numerous projects to save and promote what she felt needed to be preserved of folk history. She had a 'lemonade appetite', always striving for the next project. Interestingly, the EFDSS now has no record of the print within its archives. This suggests to me that perhaps, again, this is an example of Elsie taking the reins and deciding to get on with a project she felt needed doing, regardless of whether anyone 'official' wanted her to. There is just one original print of Elsie's map that I know of in a museum collection, held at Brentwood Museum in Essex.

Although Elsie sought the approval of the establishment, she rarely got it, but this did not faze her: she was obsessive about recording, and continued resolutely. Sadly, Elsie died in relative obscurity,

27

and remains fairly unknown, despite her important contribution to recording the history of Britain.

Lost worlds

Around the same time Elsie was getting started on her stained-glass project, there was a woman on a bicycle travelling the British Isles in search of lost crafts and recipes, another woman with a 'lemonade appetite': Dorothy Hartley. Born in Skipton, North Yorkshire, in 1893, Dorothy, like Elsie, was an illustrator and a prolific photographer. In 1932 she was employed by the *Daily Sketch* to write a series of articles on rural life in Britain. These pieces offer a funny and poignant portal to another world – one in which sheep are shorn by hand, cherries are plucked from trees and made into wine and cream is heated in great vats in farmhouse kitchens to make clotted cream. The research from these articles went on to form the basis of her books: *Here's England* (1934), *The Countryman's England* (1935) and *Made in England* (1939). A year after she began her work for the *Daily Sketch*. she moved to Froncysyllte in North Wales, where she remained for the rest of her life. It became an important focus for her work, and the lost worlds that she found in this remote part of Wales spurred her on to seek out others across England and beyond.*

Dorothy shone a light on the need to record and collect the daily lives of real people, in particular those from travelling and farming communities. She was a huge advocate for oral history and spent many hours interviewing people on her travels around the British Isles. Traditional agricultural life was at this point fading fast. Increased mechanisation and a general move towards industrialisation meant

* In 1938 her book *Irish Holiday* was published, detailing her time in Southern Ireland.

that many traditional crafts and practices were gradually vanishing from daily life. Fighting against the mass production of this new era, Dorothy set out to document it. Through pen illustrations and essays, she conjured up vivid and expansive vistas of a forgotten landscape. In *Made in England* she covers everything from how to thatch a haystack to charcoal burning in Kent. The opening paragraph offers something up by way of explanation of what she was trying to achieve with her documentation:

> All Countrymen are not farmers or land workers. They have many other skilled occupations of which the average townspeople know little or nothing, such as thatching, weaving, making saddlery, work in the smithies, in the woods and quarries ... This book describes some of these age-old country jobs and tries to explain the skill put into them.[10]

Dorothy certainly managed to achieve what she set out to do, not only in her articles and first three books but also in what is probably her best-known book, *Food in England* (1954), in which she offers an encyclopedic look at English folk cookery. Dorothy explores everything from how to bake bread in a traditional brick oven to how to cook over an open fire and what weeds are good to eat. What is readily apparent from her writing is that she researched widely and spoke to a great number of people to gather her recipes.

Folklorists and collectors often speak of 'discovering' lost worlds or forgotten folk practices, and this was the case with Margaret Fay Shaw, a collector and folk music enthusiast who travelled from Pennsylvania to the island of South Uist in the Outer Hebrides, in pursuit of a lost world, in 1929. As Dorothy found in the small villages of the English and Welsh countryside, Margaret discovered a way of life that had largely begun to fade on this remote Hebridean island.

THE LOST FOLK

She had initially found herself there after giving up her profession as a concert pianist in New York due to rheumatism in her hands, which left her unable to play, and thus was in search of a new career. She had travelled hoping to find a new home, exploring various islands. South Uist captured her heart, and on this isolated island she embarked on her new way of life: discovering and collecting the old ways of island living. Two sisters, Mairi and Peigi MacRae, whom she had met on her first trip to the island, took her under their wing and taught her Gaelic – an essential at this time, given that most people on the islands did not speak English. Having helped her get to grips with the language, Mairi and Peigi then went on to teach Margaret many of the folk songs of the islands, and a number of the old folk tales. Margaret used a camera to document her experiences and the fast-disappearing customs and folk practices of South Uist in a series of beautiful black-and-white photographs depicting everything from villagers thatching barns to women spinning wool from the Hebridean sheep.

In 1955, Margaret put together her first, and only formally published, collection of Hebridean song: *Folksongs and Folklore of South Uist*. She was, given her close relationship with the island and its inhabitants, worried about its reception, stating in her autobiography that she had told Mairi that she'd 'be terribly upset if indeed I had hurt anybody's feelings'.[11] Thankfully Margaret needn't have worried: Mairi and the wider community of South Uist were delighted by the book, and by the fact that someone had taken the time to collect the songs and write them down. Mairi told her, 'There's not a wrong word in the four corners of that book.'[12] The worry about getting it right and representing the community and its culture shows how invested she was in the island and its people.

Her photographs, film footage, diaries and the many sound recordings of the sisters and other island dwellers now sit in an

30

archive that she set up with her husband, the historian and folklorist John Lorne Campbell, at Canna House on the island of Canna in the Inner Hebrides.*

Both Dorothy and Margaret discovered lost worlds that were on the cusp of vanishing. They managed to capture aspects of folk that were fading after the war with the increase in mechanisation in farming and the redistribution of rural populations to cities, driven by economic causes. They observed, listened and recorded. They saw what many took for granted, and as a result we have them to thank for these glimpses into the lost worlds of inter-war England, Wales and Scotland.

Storytellers

Oral history is a resource that is particularly important in collecting and preserving folk history, but it is not without contention. For a long time, there has been an emphasis on recording history in a linear and academic fashion. Sources are king, and woe betide you if you haven't recorded them properly or, worse still, don't have a source at all. The folklorist Ruth Tongue found herself on the receiving end of just what can happen when the establishment decides to reject you because your methodology doesn't conform and your sources don't line up.

Ruth was born in Somerset in 1898. She was the daughter of a Methodist preacher and spent much of her childhood roaming the streets of Taunton with her brothers, talking to people and gathering tales. She was a natural storyteller and went on to study drama. Aged eighteen, she wrote and illustrated a handbound book entitled *The*

* The Campbells bought the island in 1938. Although Margaret continued to live there until her death aged 101 in 2004, the island was given to the National Trust in 1981.

Castle of Twelve Towers. It now sits in the archives of Somerset Heritage Centre and is a marvellous piece of myth-making, featuring mermaids, medieval maidens and creatures from the deep. In her twenties she founded the Harrow Children's Theatre, and subsequently went on to give a series of talks for the Women's Institute on storytelling and theatre. In 1969 she wrote a small pamphlet entitled *Travelling Folk Theatre* about a travelling theatre that was, presumably, an offshoot of her work in Harrow. There was no doubt that Ruth enjoyed both crafting a story and the theatrics of telling it, and it is clear that she was considered a gifted storyteller. The folklorist, Theo Brown, wrote in Ruth's obituary:

> Memories of the tales she had heard in early childhood came flooding back and she was in great demand; her audiences poured out further material. The fact is she was of that rare breed of story tellers – a 'spell-binder'. She came to Exeter in 1967 and electrified one of my groups. She was a creative artist and worked hard to give a dramatic performance.[13]

In the 1950s, the folklorist Katherine Briggs became aware of Ruth's work. They quickly became friends and were soon collaborating. Katherine seemed to admire Ruth's innate ability to tell a story in an unpretentious and 'real' way. It must have felt refreshing to meet someone who seemed entirely of the land and of the people. Around this period Ruth also had her first books published: *Somerset Folklore* (1965), followed shortly by *The Chime Child, or Somerset Singers* (1968). At this point she could do no wrong in the eyes of the folklore establishment. She was authentic and fresh, with seemingly endless stories and accounts of lost or entirely forgotten folk tales. The problems only began to arise when she had not one but two house fires, the first in 1966 and the second in the early 1970s.

THE LOST PEOPLE

People began to question her vague and ambiguous sources – often they are recorded as just a single name; sometimes no name is given at all. Gradually she was discredited. Ruth maintained until her death that her fieldnotes were consumed in the fires. The flames had licked away all and any evidence (this isn't strictly correct: Halsway Manor has many of her papers and research), and this is backed up again by her friend Theo Brown, who recounted that 'some critics suspected she had invented them all. But this would be quite untrue: her tales were certainly hers to a major extent, but the actual material on which they were based was perfectly genuine.'[14]

What is interesting to consider is that Ruth always said her tales came from her childhood spent in Somerset. All her stories were recalled from memory, and the memory of a small child (she lived there only until she was ten) at that. There is an emphasis in field recording on collecting in an orderly fashion, with dates, names, places and corresponding notes attached to the event or tale. As a small child, Ruth obviously recorded none of these details, so does this make her later revisitation to these stories in adulthood false or inaccurate?

At this point I should probably mention that Ruth believed herself to be a 'Chime Child' – that is, someone who is born after the last chime of Friday and before dawn on Saturday – despite having been born on a Monday. People born between these hours are believed to have special powers in seeing 'through the veil' – a term that generally implies that someone has a gift at communicating with the supernatural world, the veil referring to the curtain or barrier that lies between reality and the supernatural world. According to Ruth, this included the ability to see fairies, commune with the dead and talk to animals. She also, crucially, believed Chime Children to have 'immunity from ill-wishing.'[15] The notion of Chime Children was, in

33

THE LOST FOLK

fact, introduced by her, in her book of the same title, with a rhyme she is said to have recorded in childhood:

> *They that be born of a Friday's chime*
> *Be masters of musick and finders of rhyme,*
> *And every beast will do what they say,*
> *And every herb that do grow in the clay.*[16]

Perhaps Ruth did truly believe herself to have been born on a Friday: after all, it was not as easy to research details such as this at the time in which she was writing. Perhaps also, and more likely, she really wanted to believe she was – the power of mythmaking being so important to her. A good tale was what she was after, above and beyond anything else, and being a Chime Child fitted incredibly well with her narrative as storyteller and folklorist of the old ways. Certainly, because she believed Chime Children had 'immunity from ill-wishing', it did not seem to faze her that people didn't believe that she was.

Ruth lent power to the idea that people can speak their truth. By stating her wish to become a Chime Child, she did in some ways morph into one. Her natural ability to tell the tales of country folk, fairies, boggarts* and spriggan† far exceeded many of her contemporaries in skill and imagination. She was clearly able to communicate in a way that many folklorists have struggled with. There is a clarity and lucidity to her writing, which feels intensely real and well considered. Whatever she was trying to achieve with her tales, she definitely

* A boggart is a folkloric creature often associated with the stealing of household or farmyard items, or the spoiling of food such as milk. The term is typically found in the North-East of England but also in Southern Ireland and Cornwall.
† A spriggan is a folkloric creature typically associated with mines, ruined buildings and megalithic structures, and is a term mostly used in Cornwall.

understood how to craft them. Of course, to say everything she wrote was truthful would be inaccurate, but there is certainly merit in her work, and it shouldn't have been discarded quite so readily. Truth, after all, is often made up of fiction. Folk tales are, at their heart, invented by someone, be it fifty, a hundred or four hundred years ago. Ruth managed to weave tales and folklore from childhood experience into beautiful stories that are both evocative and memorable, so for that alone she should be remembered and celebrated.

Likewise, Pamela Colman Smith, known as 'Pixie' to her friends, also struggled to forge a career as a folklorist and storyteller. Born in London in 1878 to American parents, Pamela spent her formative years in Jamaica and New York before landing back in England. Her early life saw her train at the Pratt Institute in New York before attempting to start a career as an illustrator. In 1899 she had some success when she illustrated and wrote her first book, *Ammancy Stories*, which brought together her favourite Jamaican folk tales. It was widely acclaimed and put her on the map as a storyteller. From a very young age she was interested in the theatre, as well as story-telling, and as a teenager in New York she created a miniature paper travelling theatre, which she used as a tool to aid her writing. On her return to England, she struck up a friendship with the actress Ellen Terry, and later Ellen's daughter, Edith Craig, and as a result became immersed in the mainstream theatrical world – although only as an observer, often illustrating actors and actresses in costume.

As time went on, Pamela became a known figure of the London scene: she was friendly with members of the Hermetic Order of the Golden Dawn,* and generally was deeply absorbed in the occult world that was burgeoning at the tail end of the nineteenth century.

* A magical order founded by William Robert Woodman, William Wynn Westcott and Samuel Liddell MacGregor Mathers.

THE LOST FOLK

Her flat in Chelsea became a hotspot for this community, with people coming to hear her distinct style of storytelling and ogle at her mysterious collection of objects collected from her travels. The writer Arthur Ransome vividly describes visiting Pamela in her Chelsea flat in his book *Bohemia in London*: 'We left our hats and followed her into a mad room out of a fairytale. As soon as I saw it I knew she could live in no other.'[17] He goes on to paint an evocative picture of her home, but also of her storytelling style:

> There I heard poetry read as if the ghost of some old minstrel had descended on the reader, and shown how the words should be chanted aloud. There I heard stories told that were yet unwritten, and talk that was so good that it seemed a pity that it never would be.[18]

Pamela was, like Ruth, known for creating a fully immersive story-telling experience with costume and props, and – as Ransome suggests – often using patois to tell the stories of her childhood in their true voice. Her folk-telling style was drawn both from theatre and from an innate sense of what an oral history should be – from the people who told the stories originally. She could also see sounds, a condition we now know to be synaesthesia,* and this perhaps made her storytelling capabilities even more intense; she is certainly known to have put her synaesthetic ability to use when painting.

All of this suggests that Pamela's legacy should have been well cemented into history, and yet she has lain almost completely forgotten until very recently. This is particularly surprising given that she illustrated one of the most famous and widely used Tarot decks in the world: the Rider Waite Tarot deck. Pamela was paid meagrely for her

* Sometimes referred to as chromesthesia when it is related to the visual representation of sound.

work on the pack and it took more than fifty years after her death in 1951 for her to be fully credited for her illustrations, let alone for her influence on the symbolism and colour theory of Tarot to be recognised.

Perhaps some understanding of why she was forgotten comes from the fact that Pamela, like Ruth, was often ridiculed or made fun of for her work. She was considered too wild, too free and too 'other' – she did not conform to the establishment standards of what a folklorist should look like or how they should behave. The question of why Pamela was excluded from the history of folk collection can also perhaps be answered by the fact that in 1911 she converted to Roman Catholicism and moved to the far depths of Lizard Point in Cornwall to set up a small Catholic church in a tin shack. Here she lived with her 'companion' Nora Lake in relative obscurity before relocating to Bude in north Cornwall during the Second World War. During these years in Cornwall, she almost entirely stopped illustrating and worked only on her missionary work. She died lonely and in debt. Her possessions were mostly sent to a skip or given away, and she is buried in an unmarked grave. A sad end for such an important storyteller and illustrator.

Although in recent years Pamela has happily been somewhat rediscovered, there are still many, mostly female, folk storytellers whose work has almost entirely vanished from public consciousness. There is one figure who has been mostly written out of the history of Cornish folk collection: Nellie Sloggett, a name that rarely gets uttered. Born in Padstow in 1851, Nellie was struck down by an illness as a teenager that left her permanently paralysed from the waist down. Confined to her top-floor bedroom, she wrote upwards of fifteen books under the name Nellie Cornwall. Her stories were filled with folklore. There were devils and piskies* and changelings,

* Piskie is a Cornish-dialect word for pixie.

but they were all resolutely fictional stories, until in her fifties she changed tack and began writing under the name Enys Tregarthen. Under this new alias, she started to explore the folklore of this forgotten part of north-west Cornwall and the tales of the caves, beaches and moorlands that surrounded her.

She begins her book *The Pisky Purse* (1905) with the sentence 'The tales given in this small volume, with one exception, are from North Cornwall, where I have always lived.'[9] It is clear she had decided to move away from writing purely fictional stories and become a folklorist; the question is, how did she find and collate her material? She had very limited mobility, so was unable to gather research in the same way that many of her contemporaries would have, by visiting places and people. Instead, it seems people came to her, up the stairs to her little kingdom at the top of the house. She had a near-constant trail of visitors who came to share their folk tales and encounters with fairy folk.

Letters played an important role. Nellie maintained correspondence with numerous people across her lifetime who shared stories with her. Letters offered her access to an outside world she had barely seen since childhood, one that must have felt very distant from the confinement of her bedroom but which through her writing and memories she managed to keep close. Like Ruth Tongue, she wrote up many stories from her childhood memories, stories that she had heard during her adventures through the streets of Padstow: tales of piskies stealing bowls of junket and witches guarding wells. Through these tales collected from conversations, letters and overheard snippets, Nellie created a rich and dynamic realm from her bedroom, one that had been completely overlooked by her contemporaries.

On rare occasions, Nellie was 'taken outdoors in her cot on wheels', and she would feverishly record everything she could see and hear – the wind in her hair, the sound of the birds, the wildflowers on the

cliffs – before being wheeled back home and carried to her bed.[20] Nellie's use of a combination of sources, both real and imaginary, means her tales are deeply unusual and full of life. While many of her contemporaries relied on more Linnaean* methods of collection, Nellie's world was one of lore, not of empirical evidence.

It is perhaps unsurprising that Nellie was not recognised as a folklorist during her lifetime. She was entirely focused on storytelling, the act of crafting the tale, beyond anything else. Publicity did not interest her. She wrote infinitely more stories than were ever published in her lifetime, and on her death she left behind a trunk filled with many more unpublished manuscripts of her tales, as well as her extensive correspondence, and scrapbooks and diaries filled with pictures and notes.

In 1923, an American playwright and storyteller, Harriet S. Wright, visited Cornwall in search of Enys. Harriet had discovered Nellie's work in America, while reading stories to children in Greenwich Village. The children had been captivated, and Harriet had come to hunt down this elusive folklorist about whom so little was known. She hunted high and low, finally finding the answer to Enys's identity in Padstow's post office, where someone happened to overhear her conversation and proclaim, 'That is not her real name. She is Miss Sloggett.'[21] The eavesdropper's wife turned out to be a good friend of 'Miss Sloggett', and arrangements were made for Harriet to visit her. She soon found herself inside Nellie's room, with Nellie and 'her frail body . . . made as comfortable as possible in a reclining position on her bed.'[22] They discussed her stories and how popular they were with American children, and Nellie seemed interested by this, but true to form was even more interested in what tales this American visitor might have brought with her. Nellie died only a few months

* A method of organised classification invented by the botanist Carolus Linnaeus.

THE LOST FOLK

after this visit. The path does not end there, however. In 1939, nearly fifteen years after Nellie's death, another American came on the trail of Enys, the writer Elizabeth Yates. Elizabeth and her husband had been sent in search of Enys/Nellie by Bertha Miller, the founder of the children's literature periodical the *Horn Book Magazine*. Bertha had written to Elizabeth in the summer of 1947 with the words 'Do you know the legends of Enys Tregarthen?' and was hopeful that Elizabeth might be able to track down Enys, since she was eager to republish her stories.[23] Elizabeth asked around Padstow to no avail; no one seemed to have any recollection of a writer named Enys, but finally someone recalled that Enys was, in fact, Nellie Sloggett, who had been dead since 1923. Elizabeth found Nellie's gravestone in the churchyard and tracked down Alice Maude Rawle, Nellie's cousin, who had cared for her in her remaining years and who was now in possession of the trunk of papers. Over tea, 'saffron buns and "thunder and lightning",* Alice shared the contents of the trunk with Elizabeth.[24] Having known that they were important enough to keep, but not what to do with them, Alice seized the opportunity to interest the illustrious American author in her cousin's legacy, and they became fast friends, with Elizabeth visiting on a number of further occasions. On her final visit before returning home, Alice gave her the trunk of papers.

Nellie's archive had found a loving home, and Elizabeth used it well, collecting together *Pisky Folk: A Book of Cornish Legends* (1940) with a foreword that explained her enthusiasm for Nellie's work, in which she recounts her experience of being taken into Nellie's room for the first time, with its expansive views over the River Camel and the tors of Bodmin Moor. As Elizabeth eloquently puts it, 'Nellie's world was her room; but its walls were not to be her boundaries.'[25]

* A Cornish delicacy of clotted cream spread on bread and drizzled with treacle.

THE LOST PEOPLE

Elizabeth would go on to publish a further two longer-form stories, *The Doll Who Came Alive* (1942) and *The White Ring* (1949).

In her own lifetime, Nellie was largely disregarded by other folklorists, with Charlotte Burne, the then-president of the Folklore Society, stating in a review of two of Nellie's books that 'she has chosen to put her material into the shape of fiction, dressing it out with characters, dialogues, descriptions, and bits of word-painting, so that it is absolutely valueless as evidence'.[26] 'Valueless as evidence' is a terribly damning accusation. This spurn by such an influential figure in the world of folklore was no doubt extremely damaging to her work being considered anything more than as stories for children. Nellie's last book to be published in her lifetime came out in 1911, but the lack of commercial interest clearly didn't seem to deter her: she kept writing right up until her death in 1923.

That her appeal as a writer and collector seems to have been truly understood only in America is corroborated by her obituary in a local Cornish newspaper, which refers to her great fame in the States.[27] We can largely credit Elizabeth Yates with widening Nellie's appeal and presenting her for the first time as a proper folklorist. I cannot help but think that Elizabeth – a prolific writer and diarist – saw in Nellie something of herself, someone who was also entranced by tales of enchantment and Arthurian landscapes, or, as Ruth Tongue might put it, a Chime Child, touched by the fairies.

Piskie stories are now seen as an incredibly important thread in Cornish folklore, and Nellie, under her alias Enys, was one of the first people to write these stories from north-west Cornwall down. For generations they had been passed down orally, and she had the foresight to put pen to paper and record them. Yes, like Ruth, perhaps there was some artistic licence taken in their telling, but given that she lived a life marked by pain and illness, it is all the more remarkable that she continued in her pursuit of giving voice to the piskies and the

41

THE LOST FOLK

folk who had seen them. Nellie recognised that her stories needed to be enjoyable and readable, and this is what sets her apart from many other folklorists of the period. Rather than being bogged down by facts or a need for correct sources, she opted for romanticism, for telling a story and for painting a picture of a world. Her writing is not always the most factual, but it is often the most evocative of its period, and of Cornwall's otherworldly atmosphere. She recognised that for her writing to have the widest possible appeal, it must be entertaining. She chose characters and places to pin the folk stories to, in order to create a level of recognition and understanding in the reader, to allow them to be able to place themselves into the stories and for them to imagine that perhaps they might encounter a piskie too. In many ways she made the folk story egalitarian. She brought it away from the recesses of academia and gave it back to the people. Nellie gave folk tales a contemporary form for a mass Edwardian audience, and even in her retellings, she managed to preserve a sense of true folklore: ultimately, she should be much more appreciated for her contribution to folk collection in the early twentieth century.

Tools for recording

Another figure who has largely disappeared into the annals of history is Ellen Ettlinger. Ellen was born in Germany at the beginning of the twentieth century, and from a very young age she was fascinated by folklore and folk customs. However, as a Jewish woman, she was forced to flee Germany at the advent of the Second World War and found herself displaced and living in Oxford from 1938. Extraordinarily, despite having to give up her home to live in a strange place, she dusted off her pencils and got straight to work recording and exploring folk culture in Britain. She joined the Folklore Society in 1939 and was soon publishing articles on a vast array of subjects

THE LOST PEOPLE

from wells to amulets. She also offers us an example of one of the most interesting tools within folk collection that I have encountered: a folk index card system.*

Ellen's index card system consists of a series of cards, each with several images and a label stating what it is, and where and when it was taken. The cards were then sub-categorised under labels such as 'church weathervane', 'festivals' (such as May morning), 'folklorists': although the index is by no means comprehensive, there are more than six hundred cards. Ellen included both images taken by herself and images sent to her by others – notably a collection of photos of well dressing at Tissinghurst in Derbyshire taken by the folklorist and curator Ingegärd Vallin, who was visiting from Sweden and sent Ellen the photographs after Ellen had lent her several books on the subject. Ellen also included clippings from newspapers and magazines on the cards, and anything she deemed to be of interest in relation to the particular heading of each card. It is a remarkable archive of her own research interests and gives a real insight into the way she went about collating information for her essays.

It might seem a rudimentary technique to modern eyes, but Ellen was, in her own way, exploring an idea that the German art historian Aby Warburg pioneered: the Bilderatlas Mnemosyne, or mind atlas, a place in which images coalesce side by side. In Aby's version there were no captions, prompts or cues; the viewer was left entirely to their own imagination and thought process. Each person would bring something unique to the mnemosyne, informed by their life experiences, politics, emotional state and sense of place in the world. In many ways the mnemosyne can be considered as the earliest form of Pinterest, an enormous collage of things that interlink and talk to

* Ellen Ettlinger donated the index card system to the Pitt Rivers Museum in 1965, where it is still housed today.

THE LOST FOLK

one another visually. Ellen Ettlinger's index has many similarities, particularly the way she forged together seemingly disparate elements to create a folk map, a tool to read the world and the ways in which people live in it, from signs to sheela-na-gigs.*

Ellen's archive offers a wonderful insight into a passion and obsession for folk collection translated from a homeland to a strange place – one in which the customs and associated traditions would have had some overlap, but would have also have felt puzzling at times, I imagine. Why make an index system? Was it perhaps a way of understanding and finding the links between folk practices? After all, her archive contains not just British but also French, German, Flemish and Swiss customs and lore, among others. Within it, Ellen offered up the opportunity to create connections to gain a better understanding not only of the new place she found herself in but also the place she came from.

In a similar vein, the Suffolk-based Welsh historian George Ewart Evans realised there was a need for a tool to record the fading folk histories of the countryside and country people. He, like Ellen, found himself living in a new place having relocated from Cardiff to Blaxhall in Suffolk, and later to Brooke in Norfolk. His childhood had been spent in a small Welsh village called Abercynon, and in Suffolk he found overlap with the life that he remembered but that had faded in the wake of the post-Second World War industrialisation of South Wales's traditional agriculture. In his new home in the East Anglian landscape, George found a place that evoked an old way of living for him.

He believed it was necessary to document the lives of farm workers and the equipment and tasks with which they were engaged before

* Medieval carvings of naked women exposing themselves found on churches across the UK.

THE LOST PEOPLE

they vanished from East Anglia entirely. George set about interviewing them and recording the interviews on cassette tapes. When he began his interviews in the 1940s, sound had not yet been truly utilised as a means of recording history. George used a method that has now become a mainstay in how folklorists, collectors and historians formulate histories: oral history. Although this is now mainstream, it was, at the time George was using it, an unusual way of collecting information, and although in many parts of the world oral histories have formed part of a tradition in which folk stories or songs have been passed down from generation to generation, George was one of the first collectors to make use of this tool as a formal way of making notes or recording his research.

The interviews George collected went on to form a number of books, including *Ask the Fellows Who Cut the Hay* (1956) and *The Pattern under the Plough: Aspects of the Folk-Life of East Anglia* (1966), and the cassette-tape interviews now sit in collections across the UK – most notably in the British Library.

Listening to George's interviews is fascinating: there are clunks and bangs when he or the subject knocks the table; there's the crackle of the recording equipment; and the accents of his subjects are, even more than the topics they speak of, a portal to another time. These voices from deep within the countryside, weathered by storms, hardened by work but with a softness that only comes from time outside on the land, offer, alongside the words in George's books, a fully rounded picture of the characters he wrote of – which would not be afforded to us by just a written record.

Tools for recording often get neglected, but they are hugely important aspects of why and how certain aspects of history are remembered or forgotten. In the instance of George, thanks to his foresight, we have an incredibly rich depiction of a very small pocket of time in rural Suffolk. Without George's cassettes, the voices of the

45

sheep shearers, hay dealers and blacksmiths would have been lost forever to time and the grave, because so often ordinary people's voices were not audible other than in a transitory and intangible way. In typical oral traditions, once the family line dies out there is no continued record: it fades with the last person who learnt the song or story. Through George's recordings, by contrast, people's lives were archived in a physical way.

Ellen used her archive to build a better understanding of her new home, and it seems George also used his to try to comprehend the places he found himself in. By interviewing the people of the villages in which he lived, such as Charles Hancy, Mr Ablett, Mrs Netherway and Ida Sadler, George created a sense of place and of belonging. This was a vibrant landscape in which people read the land and seasons of their home like they might make a cup of tea or eat a slice of bread and jam: that is to say, with great ease. Inspecting the minutiae of people's existence and working life, their daily patterns, allowed him to show us ordinary people's lives in a manner that is rarely offered.

Using oral histories to construct written histories is one method of utilising this important tool for collection, but it can also be employed in the curation of museum collections and archives. This was done by another largely forgotten collector, Enid Porter. Even though she was the curator of the Cambridge & County Folk Museum for over twenty years and was instrumental in collecting both objects and stories from across the Fens, her contribution is seldom mentioned. Like George Ewart Evans, she was an early advocate for the use of oral histories, believing that talking to people was the best way of finding out the true history of a place. The area in and around Cambridge, known as the Fenlands, was – by virtue of its remote position in England – home to many folk traditions and agricultural practices that lasted well beyond those of other areas. It was teeming with folk stories waiting to be discovered and preserved,

and Enid was the person who through her position at the museum took it upon herself to gather them.

'Enid was the museum, the museum was Enid.'[28] She was well known locally, and very well liked, so she didn't find it difficult to earn people's trust: they felt she was performing a service in collecting their history and their families' histories, and saving them for future generations. Alongside her work collecting oral histories, she was also perhaps one of the first curators in Britain to begin formal outreach work into the local community. Enid understood the importance of making sure the people of Cambridge and its surrounding villages and towns felt like they had a voice within what was effectively their museum. She spent time writing articles that were published in the local magazine, gave talks about her research and worked with local children to encourage them to visit the museum. Above all, she cared that the people of Cambridgeshire were still able to access their own histories, even when they had entered the walls of the museum. In many ways Enid's ethos of collection and communication was completely in line with the origins of the folk museum. It had started with an exhibition of folk objects put on by the Women's Institute in 1936. These items were subsequently gathered together to make the beginnings of the museum. Enid truly believed that it was the people who made the museum. Of course the objects were important, but without the stories, and the context of the place, they were ultimately meaningless.

By and for the people

It might sound odd to think about 'collecting' places, but this forms another vitally important aspect of folk history and collection; buildings and places are critical to folk histories, and often get left out of considerations of folk collection because they can easily fade

THE LOST FOLK

into the backdrop of our lives. Places are eminently connected to folk culture, be that through the villages where folk customs take place, patches of coastline where we walk our dogs every day, buildings where we register births and deaths or megalithic monuments that hint at our more ancient past. They all serve as locations that feed into our everyday lives and experience of the world, and therefore into our collective folk memory.

In many ways it would be perhaps more helpful to think of 'saving' places rather than 'collecting' them: so often collectors of place will fundraise to save a building or piece of the landscape as a way of ensuring it is 'saved for the nation', i.e. the people. In this way the role of collectors of place is more about lobbying than recording.

There is a group of women who made it their lives' mission to preserve and conserve coastlines and buildings across Britain. In 1927, headed up by Peggy Pollard, five other women – Rachel Pinney, Ruth Sherwood, Mabel Joyce Maw (known as Joy), Brynhild Catherine Granger (known as Brynnie) and Eileen Bertram Moffat* – came together to form Ferguson's Gang,† working under the pseudonyms: Bill Stickers, Red Biddy, Lord Beershop of Gladstone Islands, Kate O'Brien the Nark, Sister Agatha and Shot Biddy respectively. They initially established the group to draw attention to a campaign to save the landscape surrounding Stonehenge. The First World War had caused much damage around the monument, and there was a sense that, although the stones themselves had already been scheduled‡ and saved for the nation, the terrain around Stonehenge should also

* She joined slightly later, when Rachel left.
† The origin of their chosen name is something of a mystery: the gang members never revealed who or what Ferguson was.
‡ Although the scheduling of monuments didn't formally begin until 1913, Stonehenge was given scheduled monument status on 18 August 1882 under the Ancient Monuments Protection Act. Scheduling is only issued to monuments considered in need of state protection.

48

be maintained and saved, given that it included a number of other important sites. Luckily the campaign was successful, and the money was raised to purchase the land in July 1927.

Ferguson's Gang, however, did not stop there. Inspired and buoyed by the success of this widespread campaign, they set out to save other places of importance across Britain. In 1928 the architect Clough Williams-Ellis wrote a book entitled *England and the Octopus*, which became the gang's bible. Within its pages, Clough makes the analogy that urbanisation is like an octopus with its tentacles invading all areas of Britain and destroying the rural landscape. Peggy Pollard was particularly inspired by this and felt that the octopus must be stopped in its tracks and the ancient landscape saved for people to enjoy in the future.

On 26 March 1932, the gang held its very first formal meeting at its headquarters in the attic room of Shalford Old Mill in Surrey; Red Biddy swore their oath, 'England is Stonehenge not Whitehall,' and the gang was ceremoniously brought into being.[29] The women's belief, like Clough's, was that Britain's true soul lay in the ancient landscape; it was in the stones, and the very earth beneath our feet, not in the mechanisation and industrialisation of the land. Although their focus was slightly different, their motivation was much the same as that of George Ewart Evans, Dorothy Hartley and Elsie Matley Moore – the conviction that the places, people and customs of Britain were what mattered, and they needed saving from the grip of post-First World War redevelopment. This could all sound a bit regressive, but it's important to stress that the group was not against progress, but rather opposed to the wilful destruction of places and buildings. During this inter-war period, Britain was at a turning point where buildings, fields and pathways that had survived for hundreds of years were being knocked down or ploughed up to make way for the government-run, country-wide Rebuild Britain

THE LOST FOLK

scheme, and while this had its plus points, the sprawl of the octopus saw the tentacles of modernity, such as modern prefabricated homes and transport networks, replace the places the gang felt needed saving – places that had a connection to the land and to the people of Britain. Stonehenge was the perfect focus for their activities, being the quintessential emblem of ancient Britain, and throughout the group's fight against the spread of modernity in the 1930s, it would remain a central point that they would return to time and time again for meetings and excursions.

After their first meeting, they quickly began raising money to save sites that were at risk of falling into disrepair. They delivered this money or 'loot', as they described it, to the then-burgeoning National Trust with instructions about which sites the money was to be allocated to. The 'loot' was delivered in numerous bizarre ways, including inside a silver pineapple, attached to a goat, rolled up in a cigar and contained within a faux purple bomb: masterful publicity stunts that captured the press and the National Trust's attention. These women were not to be ignored. Through their exploits, they managed to save large swathes of the Cornish coastline, such as Frenchman's Creek* and plots of land from Derbyshire to Wiltshire, as well as a number of properties now under the National Trust's ownership, including their headquarters of Shalford Mill in Surrey, and Newtown Old Town Hall on the Isle of Wight.

The Second World War saw the disbanding of the gang. Many of its members were engaged in war work, and by the end of the 1930s they had mostly relocated or gone to ground. However, that is not quite the end of the story. By the end of the 1930s, Peggy Pollard, already a Sanskrit scholar, had found herself living in

* An area which would later become popularised by Daphne du Maurier's novel of the same name.

50

THE LOST PEOPLE

Cornwall, where she immersed herself in learning Kernewek* and keeping goats. In 1941, she wrote *Beunans Alysaryn*, a play entirely in Kernewek, based on sixteenth-century Cornish mystery play texts. She was also well known for her musical abilities, and had often entertained the gang on excursions with tunes she had written. It seems this passion continued into life in Cornwall, since she is recorded in the *West Briton* newspaper as having treated the Madron branch of the Women's Institute to tunes sung in Cornish, Hungarian, Spanish and Gaelic, and was the harpist for the Cornish Gorsedh†.[30] She lectured frequently for the WI and the Old Cornwall Society on subjects as varied as Cornish saints and regional witchcraft, and in 1947 some of her research from these lectures made up the pages of a book entitled *Cornwall*, which was published as part of the series 'Vision of England', edited by Clough and Annabel Williams-Ellis. A full circle.

On reading through contemporaneous newspaper articles from Cornwall, it is curious to find that Peggy is named throughout as the sole saviour of large stretches of coastline. The gang is mentioned nowhere. In most accounts of its histories and activities, it is stated that members' identities were kept a veiled secret until their deaths, and only Peggy was ever formally outed as a member, in her obituary in *The Times*. However, on reading through articles from the 1930s right through to the early 1970s, it would appear that the National Trust and wider public were probably aware that it was Peggy raising and donating vast sums of money while also drumming up public support for protection of the landscape, as she is the only member

* The word for the Cornish language in Cornish.

† An organisation, still in existence today, that works to maintain the Celtic spirit of Cornwall. They hold a ceremony each year that recognises people for their unique contribution to the furtherment of Cornish culture in which people are selected and made bards.

THE LOST FOLK

known to have spoken about the gang publicly. In May 1937, she is mentioned in the *West Briton* as having given a rousing talk on 'Vanishing England' to the Truro WI, in which she spoke about Ferguson's Gang and their 'original and daring methods of raising money'.[31] There is no doubt that Peggy was the driving force behind the work of the gang – it's possible that by discussing it, and in doing so risking revealing her identity as a member, she was trying to recruit new comrades and further the cause. After all, for her, the most important aspect of their work was raising money to protect the landscape and buildings of Britain. The rest was just good for publicity.

In 1937, Peggy was made a bard of the Cornish Gorsedh, not for her vast skills in the Cornish language but for her contributions to the preservation of Cornwall – offering more evidence that her exploits as a collector and saver of place were known widely. Her bardic name was Arlodhes Ywerdhon, which translates as 'Irish Lady', a rocky outcrop off the coast of Land's End that the gang had saved for the nation in 1937.[32] At Peggy's barding ceremony, held at the Trippet stones on Bodmin Moor, the Gorsedh banner bearer, Henry Trefusis,* is recorded as saying 'We love Cornwall . . . We love her high cliffs and broad downs. How beautiful they are . . . How beautiful is the green grass, the purple heath, the yellow gorse!'[33] It is clear that Peggy had found another group of people through which she could promote and further her cause.

It is apparent that Peggy, above any of the other members of the gang, remained an active force for change in saving the British landscape. For fourteen years she was the secretary for the Cornish branch of the Council for the Protection of Rural England, fighting

* Henry Trefusis was a morris dancer and a friend of Cecil Sharp's. He was married to Lady Mary Trefusis, who was the first president of EFDSS, and was herself a collector of a number of folk dances.

fiercely for the protection of nature. The role gave her a position that was accepted by the establishment, and thus she was able to further the work of the gang in a much more concerted and official way.

In 1957, she converted to Roman Catholicism, and this is the last time the gang crops up in records. She called on them for help, enlisting them to raise money to build the first ever Catholic church in Truro. The money was raised and it was opened in 1973, complete with wall hangings and church kneelers embroidered by Peggy. She was tireless in her energy and enthusiasm for the land, in particular Cornwall, and she should be far better remembered than she is; without her efforts, we would not still be able to enjoy the views from Land's End or marvel at the bubbling waters of St Mawes Well.

There is a connecting thread between Ferguson's Gang and many of the other collectors I have discovered: they were unfaltering in their absolute commitment to the collection of folk tales, customs or practices, be it cycling the corners of Britain, trailing after people hoping to catch a folk song or faithfully copying the lines and radiant colours of stained glass. Each of them played an extraordinary part in the collection of Britain's folk history, each of them helped to shine light on people and places that would have otherwise been entirely left out of history, and each of them helped form the way in which we look at and record history.

Without their contributions and explorations of how history is assembled, we would have a much more linear view of who and what has constituted our collective histories. Britain is a wonderful patchwork of folk customs, stories and traditions, and it is formed of a myriad of people who have collected and preserved these. What we must continue to ask ourselves is: how can we continue to collect the histories of today's folk? How can we move forward and expand how we collect, and what and who make up Britain's folk histories now?

Reimagining folk collection

There is no doubt that the way in which folk customs and histories have been collected in Britain was problematic in times past. In 1975, the Folklore Society published an article in its journal *Folklore* by the folklorist Venetia Newall called 'Black Britain'. In it, Venetia talks about the entrenched racism that prevails in folk collection, and explains how often inaccuracies in recording can be because of ingrained prejudices held by the collector. She gives examples of the following stories having been collected by various folklorists: 'immigrant workers eating . . . pet-food sandwiches, . . . a poodle roasted and served up for dinner in a Chinese café, two rats and half an Alsatian allegedly discovered in a restaurant refrigerator'.[34]

Venetia concludes that these stories cannot be true because, in her experience of interviewing and spending time with immigrant communities, they are, in fact, 'exceptionally meticulous in the preparation of food'. What can be taken from this is the importance of spending time with people in order to gain cultural understanding. Recording from afar or speculation without on-the-ground research mean that often-pejorative preconceptions can creep into the findings. This example illustrates that folk collecting has, even in relatively recent times, been prone to racial stereotyping and as a result inaccurate and, frankly, racist stories have been recorded as fact.

Gender and sexuality 'norms' have also provided difficulties in folk collection, as folk customs generally uphold certain archetypal images as 'traditional'. Venetia Newall asserts in an article called 'Folklore and Male Homosexuality' that anyone considered 'other' within these spaces is typically cast in a role that either turns them into the enemy or objectifies or pokes fun at them in some capacity: 'Do you have red hair? Then you must be related to the devil. Do your eyebrows meet on your nose? Then you must be a werewolf.'[35]

THE LOST PEOPLE

This can present challenges: a culture of perceived 'normality' can lead to a narrative that creates an exclusionary folk practice, meaning that people who are queer, disabled or in some way different from the self-imposed 'norm' of society feel unable to participate, and, in some cases, have been actively discouraged or made to feel unwelcome.

Further back in history, practices such as rough music, which we will discuss in more depth later, encouraged deep-seated homophobic prejudices, with people actively making fun of homosexual relationships by dressing up and performing mocking folk plays. In the Gloucestershire Council Archives, there are records of a form of folk play in the town of Westonbirt constructed by the townspeople specifically to publicly shame a farmer who had been accused of sodomy.[36] The practice of this form of very targeted mockery has, thankfully, long since died out.

There are, however, other forms of folk practice, sadly continuing today, that perpetuate exclusionary or mocking stereotypes. The Britannia Coconut Dancers of Bacup are a group of clog dancers from Lancashire whose dances were first collected by Cecil Sharp's friend and collaborator Maud Karpeles for the English Folk Dance and Song Society in 1929. Their costume is made up of red-and-white-striped skirts with black turtleneck jumpers. On their heads they wear white turbans with a blue feather, and their faces are painted black. They have two accessories that they dance with: either a floral hoop in the style of female clog dancers from the region, or two halves of a wooden coconut that they clack together as they dance. In July 2020, the Joint Morris Organisation issued a statement on the usage of blackface in Morris, stating that 'the Joint Morris Organisations (the Morris Federation, the Morris Ring, and Open Morris) have ... agreed that each of them will take action to eliminate this practice from their membership.'[37] At the annual general meeting later in the year, a vote saw the act of blackface completely banned from morris,

and the three organisations elected to stop offering public liability insurance to sides that continue the practice in any way. It was a monumental moment in the history of morris dancing.

Of course, many teams had already evolved their kit by the time the statement was issued, but the Britannia Coconut Dancers – despite the ruling, and the enormous pressure from the JMO – have continued to paint their faces black, maintaining that it represents the coal on the faces of Lancashire miners, and is not racist. However, history tells a different story. The area around Bacup has a deep connection to a nineteenth-century custom that suggests an alternative and very sinister narrative. Children were known to black up during the period of Eastertide and make loud music around their villages in a custom known as 'N*****ing'.[38] The historical accounts make for terrifying reading. The children mocked and cajoled onlookers as they walked the streets, adopting clothing that was seen as being taken from Black culture but was in fact informed by the costuming of then-popular black-and-white minstrel stage shows. There are accounts of the practice also taking place in Aston on Clun in Shropshire: 'The lads of the village dressed in old clothes, blacked their faces, and toured the inns at Christmas, up to 1938, with bones, tambourines, tin whistle and such like, but there was practically no dance.'[39]

At the same time that this custom was arriving on the streets of Lancashire, black-and-white minstrel shows were rising in popularity on stages across Britain. At one point there were more than three hundred shows a night. The actor David Harewood makes the point in his BBC television programme on blackface that the abolition of slavery had led people to feel that the Other was going to take over, and that out of this fear arose a custom of horrific racist mockery as a way of keeping true Black culture suppressed.[40] It is almost certain that these Lancashire children were informed by what they were seeing in the theatres, streets and newspapers at the time.

THE LOST PEOPLE

So what do these children and black-and-white minstrel shows have to do with the Bacup dancers? Well, although the Britannia Coconut Dancers are the only remaining group to engage in this form of dance and costuming, there were once many other sides in the area that did so, including the Tunstead Mill Nutters, from whom the Bacup dancers are said to have learnt their dances, and the Cloughfold Cokernut Dancers. These seem to have appeared in line with the rise of black-and-white minstrelsy. They all conformed to the same style of costuming, with blackened faces, striped skirts and turbans. Folk practice is often informed by popular culture, and frequently uses archetypes or figures in the public consciousness that are in some way the enemy: take, for example, the effigies of politicians burnt each year in Lewes, or the use of Napoleon or the Turkish Knight in mumming playscripts. It is perhaps not surprising that this folk-dance practice was influenced by the pejorative and racist images that were being encouraged by entertainment during this period.

In her essay 'Black Faces, Garlands, and Coconuts: Exotic Dances on Street and Stage', the dance historian Theresa Jill Buckland makes the point that until the early 1950s, the Bacup dancers, alongside their faces, also blackened their hands, suggesting that they were trying to engage in a similar practice as the children of Lancashire once had.[41] Theresa goes on to say that due to the lack of any other dance groups to compare their practice to, in the late twentieth century it had become easier for the Bacup dancers' routine to be considered purely as some strange antiquated dance of the past, rather than as racist. This is certainly corroborated by the way in which the Bacup dancers were viewed in twentieth-century recordings and literature, with the focus always on them being something ancient, the meaning of which has been lost to time. In 1983, a programme was broadcast on national television called *The Human Jigsaw*, exploring 'remote tribes'

THE LOST FOLK

across the world.[42] It included the Bacup dancers alongside ceremonial rituals from the Mehinacu people of Brazil, further enhancing the narrative that these dancers from the North-West of England were, in fact, enacting some ancient forgotten rite, and not something that had its origins in a hugely racist Victorian form of stage show. That it has taken such a long time for folk collectors to recognise the true origins of coconut dancers would seem largely down to the fact that black-and-white minstrelsy was still being broadcast until as late at 1978. And, as I discovered one day via a poster of a black-and-white minstrel show in a charity shop in Dorset, it was still gracing seaside piers around Britain until at least 1981 (the year of the poster), if not into the 1990s. This is not to mention the enormous quantity of black-and-white minstrel LPs I regularly come across in charity shops. We also must not forget that it was not until 2015 that compensation payments to former slave-owning families ceased, despite the fact that the Abolition of Slavery Act was passed in 1833. There is no doubt that blackface was still considered as an acceptable and non-racist practice within the popular vernacular, and as a result the Bacup dancers were until very recently backed by the folk establishment. Folk dance organisations such as the EFDSS, which had the Bacup dancers at their annual Festival of Dance throughout the 1960s and 1970s, actively encouraged and promoted them – in 1963 they even graced the festival programme's front cover with a short description inside referring to them as 'black-a-moors', going on to state that the music they dance to is 'derived from folk songs of the remote past, others from popular songs of the last century', further enhancing the connection between black-and-white minstrelsy and coconut dancing, and implying that the dismissal of a connection between minstrelsy and folk is only a very recent phenomenon.[43]

Although the Bacup dancers doggedly continue to wear blackface, support for them has ebbed considerably in recent years.

Nevertheless, uncomfortable folk practice still exists, and in order to truly move forward in a properly inclusive spirit, we must unpick the problematic histories connected to some folk traditions.

There is a whole host of people doing important work in the re-evaluation of folk histories to make them more inclusive, and to push the discipline of folk collecting forward into the future. The folk singer Angeline Morrison has recently curated a resource for the EFDSS that explores the lost and forgotten histories of Black British people in relation to four traditional folk songs. The resource is available to schools across Britain and marks a very important moment in the history of folk-song collection in Britain. The redressing of previously white perspectives on our folk histories to include new research that is inclusive and encompassing of all people feels like a significant and long-overdue point to have reached.

Gender narratives in folk song are also being confronted; the musician and illustrator Amy Hollinrake recently founded 'Loathly Lady', a project looking at the way in which folk song is catalogued and presented in archives. Alongside this, Amy has produced a magazine under the same heading, which investigates a series of folk songs, and the ways in which women have been portrayed in them. Likewise, the Armagh Rhymers have for generations been bringing the folk songs and stories of Ireland to children in Northern Ireland and beyond. They have crafted them into a form that makes them accessible and participatory, allowing children to learn about every-thing from traditional masking customs of Armagh to the tale of Bríd Uí Chléirigh being burned to death by her husband for witchcraft. They do not hide away from the more terrifying aspects of folk his-tories, instead placing them in a context that is understandable for children today, and exploring what this meant in the context of the time. Like Amy Hollinrake, they are rewriting folk histories in a way that puts minority figures into a place of empowerment.

Alongside the re-evaluation of folk song, there has also come a new era of morris dancing, one in which new perspectives on gender are leading the way. Groups such as Boss Morris and the WAD* have cast a fresh eye on traditional morris dancing, with kits that play on identity and dances that are representative of the members' place as women of the modern world. The WAD are based in Falmouth, close to my home, and so I took up the role of the Fool for them, a position normally held by a man in male-only morris. The character typically engages with the audience in a loud and often teasing fashion – they usually carried a pig's bladder on a stick, which was used to bop members of the public and dancers on the head or bottom. I wanted to re-embody the position and recreate it for the present, so I became Hector Nit, a strange fictitious character who allowed me to transform from my shy persona into the rambunctious fool. As Hector Nit I have a series of costumes, each in some way playing with gender, from elaborate lace-laden frocks to a straw bear-inspired suit, and I have two hand-stitched and -painted stuffed fish for bopping people with. While in character, I aim never to make anyone feel uncomfortable or singled out but rather to enhance their enjoyment of the dancing – acting, if you will, as a hype girl for my morris companions.

In a similar vein, Bristol is home to Molly No-Mates, a side that describes itself as a 'queer drag molly dancing team'. Historically, molly dancing has been a form of morris that involved men dressing up as women, generally in a pejorative way, that has been used as a way of making fun of both women and queer men. Molly No-Mates have reclaimed this narrative and formed it into a new and positive

* The WAD's name is inspired by a character from Cornish folklore known as Joan the Wad, the queen of the piskies. She carries a lantern and represents both good and evil in that she will use her lantern to light you either to safety or to your death.

message of gender inclusivity, representative of the time we live in now. The London-based group Shovel Dance Collective produces music and performances that also explore the queering of folk, and the ways in which folk tales can be re-examined.

In 2017, a group of female morris dancers came together to produce a series of zines called *Dance Like a Girl*. The content was focused on morris dancing, with articles exploring how to stay safe when dancing out in public as a woman, forgotten female collectors of folk dance and music, and morris-inspired memes. They produced thirteen issues, and not one of them names the people behind the endeavour. Although I do now know the creators, I enjoy the spirit the zines were created in, not driven by ego but by a sense of wanting to get more women into morris, of wanting to build a community and to make it a truly inclusive one.

The message that everyone is welcome is being extended into folk customs, too. In 2021, the artist Lucy Wright produced a manifesto for better representation in folk, entitled 'Folk Is a Feminist Issue'. In it, Lucy argues for more inclusivity and progression within the world of folk customs and traditions. All of Lucy's work aims to bring awareness to lesser-known customs and to empower people to engage in folk practice. A later project entitled 'Hedge Morris' was formed as a way of further enabling everybody to get involved in morris dancing regardless of location, mobility, gender or race. Lucy introduced the concept through a series of Instagram posts teaching people what morris dancing is, the different forms of it and how they might go about it in their locality. The project has opened up a world in which everybody is welcome to morris dance, no matter who they are, where they are or how they identify.

Although folk is meant to represent the ordinary person, it has, in the recent folk revival, had a tendency to be painted as something extraordinary or fashionable. Folk has always come from necessity:

a necessity to bring joy to working life, a necessity to let our hair down, a necessity to celebrate a particular point in the year. There are, of course, fabulous costumes and strange dances, but there are also very practical reasons for many of the songs, objects or customs from our collective folk past. We often overlook what is straight in front of us, and so more modern folk customs can find themselves ignored because they make use of costumes that have not been entirely handmade, or are in some way distasteful to our rosy lens of nostalgia. They are, however, legitimate as customs in the folk year; they are using what people have to hand in the present day and they are enacted at points in the modern calendar such as Boxing Day, when people have time off from working life.

The Wigan-based artist Anna F. C. Smith creates work that looks at regional customs and community. She often collaborates with other practitioners, and in 2017 she worked with the photographer Bryony Bainbridge and the printmaker and poet Natalie Reid on a project informed by the living archive of the folklorist Doc Rowe. The work produced included a life-size purple 'obby 'oss* made by Anna, who reimagined Doc as a central part of folk customs. Doc is so often on the sidelines, documenting, but here each of the customs that he visited was painted onto the skirt and the documenter became the documented.

Anna, like Lucy, has often used research into lesser-known folk practices to produce work. In 2020, during the COVID-19 pandemic, she created a piece called 'The Thingumbob – Mystery Machine': a luminous green carnival float complete with huge bulbous eyeballs and tinsel streaming from its roof. It was made as part of a project to

* 'Obby 'oss is a term that refers to a horse costume generally worn over the head by the performer. At Padstow in Cornwall it takes the form of a black costume formed of a hooped skirt and a mask that pulls over the performer's head. There is also a tradition of hooden horses across Kent, where the costume has clapping jaws.

THE LOST PEOPLE

continue an unbroken tradition that started in Wigan in 1978, where on Boxing Day, people take to the streets in fancy dress and make floats. Due to the 2020 lockdown, the event could not physically take place, so Anna, in collaboration with artists Al and Al, and Wiggle Dance CIC, created a film entitled '42' for which makers from Wigan were invited to create socially distanced costumes. The film was streamed online on Boxing Day 2020. The work came out of a wider project that Anna had been working on for several years investigating this modern-day folk custom. Anna was the first person to properly record and research the Boxing Day tradition and suggest that it was in fact a folk custom. Until Anna's work, it had just been an oddity in the year, something fun that people from Wigan *just do*.

Part of the problem around the neglect of regional folk customs relates to the issue of classism within folk collection. As I discussed at the beginning of this chapter, folk collectors have historically been from wealthy middle- to upper-class backgrounds, with little understanding of the day-to-day life of most people in Britain. This issue of class is a large part of why some customs are actively written out of or disregarded from traditional folk histories. It is easy to frown on objects that come from, for instance, the supermarket, but it must be remembered that where people collect together of their own volition, there is folk, and it is not for collectors to judge the ways in which this happens or how the objects are made.

As Lucy Wright powerfully asserts in her 'Folk Is a Feminist Issue' manifesto: 'Reclaim folk for women. Reclaim folk for the poor/ benefit class. Reclaim folk for the queer and Other. Reclaim folk for radical politics, community-making and care. Reclaim folk for the environment. Reclaim folk for art.'[44]

What is deeply encouraging is that the work of Angeline, Amy, Anna and Lucy offers opportunities to discuss access points into folk – in particular music, customs and traditional dances. It also

63

highlights how and why certain groups or people have found themselves written out of history, and how difficult it can still be to engage in folk customs because certain biases still prevail. There is, thankfully, a sea change in the way in which modern folk collectors are looking, how they are considering what enters the canon of history and how it can make for a better and broader future of folk.

It should be the responsibility of anyone who considers themselves to be in any way collecting or working with folk practices today to be inclusive, progressive and all-encompassing in their approach. We have a collective responsibility to make sure everybody is included in the collection of contemporary folk histories.

Although, as I have discussed, collecting has in recent years become much more inclusive, there is work to be done in evolving it. One particular issue we are still faced with is the question 'What is important enough to save?' The act of making collections can often produce hierarchies, meaning that some items get saved over others; this can lead to items that are not visually enticing being discarded. Frequently this happens in relation to research notebooks and papers. In the 1980s, a shudder went through the world of folklore studies when the archive of the late Barbara Spooner was said to have been put into a skip. Barbara had died in 1983 in a council house in Wadebridge, Cornwall. Since the late nineteenth century, she had been recording Cornish folk tales and customs. On her death, the council threw away her possessions, with no family or friends to save them. Among them were hundreds of pages of handwritten notes. Her contribution to folk studies was vast. Like Peggy Pollard, she was made a bard of the Gorsedh in 1930, in recognition of her work; her bardic name, Myrgh An Hallow*, reflected her deep-rooted understanding of Cornish folklore. She published many papers for

* Meaning 'Daughter of the Moors'.

THE LOST PEOPLE

the *Folklore* journal, as well as giving lectures for the Folklore Society and various branches of the Old Cornwall Society, and her research included work into stone circles, giants and Cornish hurling. Her papers deserved more than to have been casually discarded. Luckily, some of them appear to have been retrieved and saved, including her pamphlets, bound and illustrated by hand, which are now kept, alongside four boxes of papers, at Kresen Kernow library in Redruth.

Although social media often gets a bad reputation, it can be used to great effect in saving archives. In 2020, the archive of historian and folklorist Chris Jenkins was in danger of meeting the same fate as Barbara's. Someone put an appeal up online and the folklorist and writer Mark Norman saw it. The next day he drove to Totnes to save it. Mark runs the Folklore Library and Archive, currently housed at Crediton Library in Devon. He has been instrumental in saving a number of archives in recent years, including fundraising to save the research papers of Venetia Newell. Mark's work is incredibly important: he recognises and preserves the voices of many collectors who in years past would have been lost. Handwritten papers and photocopied notes and notebooks are generally at the bottom rung of the ladder when it comes to preservation, and yet they often contain hidden information that has not made it into the finished article or book, as in the case of Ellen Ettlinger. They are of vital importance when building a wider picture of a collector's research and outlook, and providing a sense of the drive and purpose behind the act of collecting. Cecil Sharp's notes from his travels around Britain collecting folk songs and dances, before his revision and editing of them, reveal quite how much he had left out or changed in the final versions that he published. For this reason, keeping records becomes hugely important, as it offers us the opportunity to revisit and understand what has been left out in the final edit. Yet it can be easy to overlook paper archives in light of more visually alluring ones.

65

THE LOST FOLK

In the summer of 2023, I took a trip to visit the Folklore Library and Archive. In a small corner of the library, Mark has carefully transformed a space into a working folklore study centre. In my mind, it is the perfect space for such papers to exist. Many are on open display, making them truly accessible to anyone who wishes to delve into the world of folk studies. I spent an enjoyable afternoon consulting old copies of the *Folklore* journal, chatting with Mark and ogling the shelves of papers. It felt like a truly egalitarian space for folk to exist in, with people popping in and out with their book returns, checking their emails or just coming in for a chinwag. Libraries are, after all, spaces for people, so what better place for a folk archive to live?

A fundraising page was set up in autumn 2023 to help digitise and properly archive the work of Doc Rowe, who since the early 1960s has been photographing and filming folk customs across Britain from Padstow May Day* to the Burryman Day† in South Queensferry. Over £50,000 was raised in a month: an extraordinary achievement, and one that shows quite how far we have come from Barbara Spooner's papers being dumped into a skip. Nevertheless, when we are confronted with intensely visual clips of 'obby 'osses dancing or floral-garlanded figures sitting atop horses, scrappy pieces of paper with pencil scribbled notes can, in comparison, seem vastly

* Padstow May Day sees two 'obby 'osses – the red 'oss and the blue 'oss – take to the town of Padstow and dance through the streets. The 'oss is a large black horse costume consisting of a hooped skirt and hat that is placed over a dancer. Each 'oss has a band of musicians and dancers, as well as a teaser who teases the 'oss as it dances about the street.

† The Burryman Day involves a man dressed from head to foot in a costume made from burrs moving through the streets of South Queensferry on the second Friday in August. He has two attendants who guide him along his way (his vision is very obscured!). They shout 'Hip hip hooray, it's the Burryman's Day' as they go. Townsfolk offer him a dram of whisky, as it is believed to be good luck to give him refreshment. It is also considered lucky to take and save one of his burrs.

66

THE LOST PEOPLE

uninteresting. The truth is that both are integral in telling the folk histories of our many counties, and we cannot save one without saving the other. We must use all means of recording in order to build a full picture of the customs, traditions, people and places of Britain, and we must work to preserve all methods of documentation. If we save one but not the other, we are left with a hierarchy, and to be true folk collectors we must be anti-hierarchal: folk, as I keep coming back to, is of and for the people.

2
★ THE LOST COLLECTIONS ★

Having explored the collectors of folk, I want to now delve into their collections and the museums that were opened to house them. These are varied and, at times, strange. There are what might be considered more traditional collections of objects – things such as ships' figureheads or agricultural tools – and then there are the less traditional collections, including those so ephemeral they have almost disappeared by the time they have been gathered together, like one of regional cakes (which we will come to later).

Other unusual collection types include the gathering together of buildings or building structures from their original locations and erecting them somewhere new: in the twentieth century this became an increasingly popular way of saving or preserving buildings of historic importance that were going to get knocked down or be left to ruin. These structures were collected in the same way that other, more typical objects were gathered and placed into 'open-air museums', where people could come and visit them. Generally, the people collecting these – pieces ranging from farm buildings to shopfronts and other architectural details such as weathervanes or gates – would go from village to village in search of buildings that needed to be moved to preserve them for the future. This was not always an easy process and was often opposed by people who believed that the building, gate or door should stay in its original location. Collectors face this issue across the whole spectrum of folk collection: objects being collected have generally come from

a community that, rightfully, feels strongly about how and where these artefacts end up.

In order to better understand the ways in which collections are amassed, it is helpful to explore the great many ways in which collectors have attempted to bring their collections to the public, whether through ambitious museum projects, exhibitions or blink-and-you'll-miss-them displays. There are more than a few collections that have not even made it out from the pages of a collector's notebook, and some that have barely opened to the public.

As viewers, we often come to collections because of singular objects, being attracted by a particularly pretty vase, a delightful bonnet or a handy-looking bucket – or a specific item we are searching for. We often do not think of the collection as a whole and curated thing, or of the act of collecting as an art form, and yet many of the collections I discuss in the coming pages are more like artworks than anything else. Singular, impassioned people creating folk collections which in turn become folk art. The key thing to remember, with all the collectors and collections considered within this book, is that more often than not, people are doing it for the love of the objects and of folk culture, rather than any wish to make enormous amounts of money or to gain huge visitor numbers.

The folklorist Mary MacLeod Banks wrote an article in 1945 for *Folklore* magazine, detailing a list of the folk museums and collections across Britain. She explained that it would be impossible to be comprehensive, due to the fact that many of the collections sat in people's homes. She also stated that 'smaller collections have been broken up at the death of the owner, whose family and friends have felt little sympathy with a preservation of "old rubbish".' This list seems to have instigated a wider national drive to help preserve folk museums, and a desire to imagine new ones.

There is no doubt that folk was firmly on the agenda during the

72

THE LOST COLLECTIONS

immediate aftermath of the Second World War. The First and Second World Wars had left people with a sense of needing to preserve intangible heritage: oral histories must be forged, buildings must be saved and objects must be preserved. In the wake of so much destruction came an invigorated drive to set up folk collections, to preserve what remained for the future – a sense that if it wasn't saved now, it would be lost forever.

Building folk collections

In 1947, the Royal Anthropological Institute (RAI) had a vision of a folk museum dedicated to 'English Life and Traditions'.[2] It gathered together a committee of like-minded people and set to work formulating what such a museum might look like. The summer 1949 issue of *Folklore* magazine has an article by the deputy chairman of the committee, T. W. Bagshawe, exploring the idea. Within the article, Bagshawe makes a compelling case for the need for a national museum dedicated to the old ways. He argues that due to the war – and the associated displacement of people and increased road building and development across Britain – there was a danger that farm equipment and agricultural vehicles and buildings would be thrown away or destroyed.

The notion of a folk museum or folk collection was not new at this point. The belief in the need for a place to collect together objects associated with dying crafts or farming practices – agricultural and rural tools that would otherwise have rusted away in barns or been thrown on compost heaps, for example – had been gathering strength since the industrial revolution. This collecting was mainly done by individuals on a shoestring budget. Some of these people formed collections that far outgrew their homes, and thus small museums were started. The RAI's argument was that these collections should all sit under one unified roof where they could be properly cared for and maintained,

73

THE LOST FOLK

and in some cases restored. All sorts of names were proposed by the committee, from the very simple 'Folk Museum' to the slightly more exciting 'Museum of Popular Art and Traditions', but these were all rejected in favour of 'Museum of English Life and Traditions'.

You may find yourself thinking at this point that you've never heard of such a museum; that would be because it never, in fact, came into existence. The plans fell flat, and despite a number of meetings and a comprehensive proposal for how and what the museum would collect, who would look after it and where it would be sited, it never came to fruition. What did emerge in the same period was the Museum of English Rural Life in Reading and St Fagans National Museum of History in Wales. Both have done an incredible job of actively collecting and saving objects associated with rural life and customs, in a way that is both far-reaching and inclusive.

This ambitious project for a national museum of folk was largely inspired by the people: since the First World War began, people had started opening their own small museums, gathering objects from farms, saving textiles from skips and generally scouring their local villages and towns for items relating to more distant times. From the Isle of Man to Gloucester, folk museums popped up, with collections ranging from smocks to horse-drawn carriages, and everything in between. However, as efforts to rebuild following the Second World War began, so too did the demise of the small museum. As build-ings were demolished to make way for new apartment blocks and shopping centres, many of these makeshift museums were lost along the way or merged into much larger council collections and almost entirely detroyed.

During the Festival of Britain in 1951, there was a drive to try to cement some of these collections, and an array of exhibitions was put together that celebrated the rich agricultural and folk histo-ries of Britain. 'The Cotswolds Tradition' was one of the largest,

THE LOST COLLECTIONS

bringing together traditional craft tools and machinery from across the Cotswolds. It was designed to tell the history of the region through three main themes: stone, wool and agriculture. Included within the displays were smocks, cheese stands and butter churns, gingerbread moulds and Valentine's cards, hand looms and wicker work. It was an ode to the continuation of folk crafts, and the people who produced them. There were also, alongside the static exhibits, talks and performances, including a talk by the folklorist Violet Alford on the subject of Cotswold dances, with members of EFDSS demonstrating the dances as she spoke.

The Welsh Folk Museum* similarly staged a series of exhibitions and events in 1951 celebrating the rich cultural and craft heritage of Wales. There was 'Welsh Rural Crafts', an exhibition that, like 'The Cotswolds Tradition', took a look at all aspects of folk crafts and their production in Wales. There was also a comprehensive exhibition on Welsh quilting – including more than sixty-five examples collected from across Wales – displays of folk dancing and a pageant. Scotland also explored its folk heritage with an exhibition in Edinburgh called 'Living Traditions of Scotland', with displays of straw work, peat baskets from Shetland and the famous twelfth-century chessmen that were carved from bone from the isle of Lewis.

Although most of the Festival of Britain exhibitions had only a limited lifespan, the committee of 'The Cotswolds Tradition' did try to find a permanent home for some of their displays, with a call placed in *The Citizen* newspaper in November 1951 for a suitable hall to take and exhibit the collections that had been amassed. None was forthcoming, but they did manage to have the exhibition memorialised in the form of a short pamphlet, with captions written by the poet and broadcaster John Betjeman.

* Now the aforementioned St Fagans National Museum of History in Wales.

In Northern Ireland, folklorists were a little more successful, managing to preserve collections from the 'Ulster Farm and Factory' festival exhibition, which took place in Belfast in the summer of 1951. The displays went on to form the basis of the magnificent Ulster Folk Museum, which opened ten years later in 1961, and is still in operation today, with its plethora of cottages, farmsteads, shops and oddities gathered from across rural Northern Ireland.

Looking through Mary MacLeod Banks's list of small folk collections, there are some familiar places – including York Castle Museum and the Pitt Rivers Museum, both of which still exist – and many that have been renamed, such as Somerset County Museum, which is now the Somerset Rural Life Museum, and the Salisbury, South Wilts and Blackmore Museum, now the Salisbury Museum. What is most encouraging is that every single one of the collections or museums she lists is either still open or sits in the archives of a larger museum. This is, perhaps, because Mary only listed the already well-established collections, or ones that had already been subsumed into larger museums. There are very many much smaller collections that Mary doesn't mention.

Domestic collections

In the depths of Cornwall, Freddie Hurst opened up the Wayside Folk Museum in the tiny village of Zennor in 1937. The collection comprised everything from a working water wheel to ploughs, horseshoes and mill stones. The idea behind the museum was that the collection of objects told a full history of a working life in Zennor. There was also a shop, in which you could purchase flour ground on-site using the water wheel. The Wayside Museum remained open until 2015, when it finally closed its doors for good. On a visit to Zennor, it's still possible to see the Zennor Plague Stone, which once

sat outside the museum, with its label stating that it was placed there to ward off the plague – villagers would fill the dip in its centre with vinegar, and all money that changed hands would be rinsed in it. The yard behind the building is still home to many of the exhibits – presumably those too heavy to remove when it closed, including a large cider press. Of the rest, some ended up at Poldark Mine, where they remained until its recent closure; many of the others were bought by local antique dealers. As a whole, the collection was disbanded, and barring the traces mentioned above, there is almost no record of it ever having been housed there.

A more hopeful story is that of the Angus Folk Museum in Forfar, Scotland, a collection put together by Lady Jean Maitland, inspired by Isabel Grant's Museum at Kingussie in the Highlands. Jean, like Isabel, was fascinated by the ways of life in the region and was worried that they were rapidly being lost to time, so she gathered together as many objects as she could and found her collection a home in a row of empty cottages in Glamis. The interiors housed her vast array of agricultural and rural implements, including a working hand loom and a working smiddy.* In 1957 the landowner, the Earl of Strathmore, presented the buildings to the National Trust for Scotland, and in 1974 the Trust also took over the guardianship of Jean's collection. The museum closed its doors in 2017, owing to the cottages being structurally unsafe. It remained closed until 2022, when it reopened in a new location at the House of Dun, another site managed by the National Trust for Scotland.

This tale of closures is repeated across Britain. Sadly, most collections' fates are more akin to the Wayside Museum than the Angus Folk Museum. For over twenty years, in Newent, Gloucestershire, there was a curious place called the Shambles Museum of Victorian

* A Scottish colloquial term for a blacksmith.

Life. It was begun by Jim and Holly Chapman. Their collection of objects associated with Victorian life began to outgrow their home, and so, in 1988, they found premises nearby in which to display it. The collection centred specifically around Victorian life; within it were a great number of folk items all laid out in shop-style scenes that made up a town. There was a blacksmith, a wheelwright, a basket weaver and a pub, as well as a full-size tin tabernacle – all within 16–24 Church Street. The museum gained its name from the Old English word 'shambles', which refers to the chopping block of a butcher – the museum began in number 20, which had previously been a butcher's shop.

In 2010, the entire collection went up for auction, when Jim and Holly decided to retire. Over the course of four days, four thousand lots were sold off, and every last scrap was sold. In the space of a few short days, over forty years' worth of collecting was broken up in the clap of a hammer. Of course, this was the collectors' decision, but it is discouraging to think that no larger museum swooped in and saved at least a proportion of the collection.

Although I never had the opportunity to visit the Shambles Museum, what is readily apparent is that it was laboured over; every object was loved, and as a collection it was loved even more – each item was appreciated in relation to all the others. One empty beer bottle or tankard would not have made an interesting display, but a whole shelf of bottles and tankards in a variety of shapes, sizes and colours did. The power of the collection is what made the Shambles a place that people knew and loved.

Nautical collections

For many years, Sydney 'Long John Silver' Cumbers housed his enormous collection of ships' figureheads in a building in Gravesend,

Kent, called the Look Out. It was fitted out like a ship's interior, with elaborate scrolls and portholes hung on the walls, and more than eighty figureheads on its two floors. Sydney lived in London but was obsessed with all things nautical and in 1931 took his vast collection to Kent, where he had found the annexe of an old hotel to display it in. He travelled down to the seaside at weekends to open up for day-trippers and seafaring enthusiasts. His collection had been put together over many years from junk shops and rubbish tips; it comprised objects that otherwise would have been lost.

Each area of the collection was arranged and named as if part of a ship. There was the helm, the bridge and the forecastle, as well as a galley, and at the entrance was a sign made from a ship's wheel. Except for the lack of any water, the collection was ready to set sail on the high seas. Clearly a man who understood the theatrics of showing off his collections, Sydney donned an eyepatch,* a cigarette holder and a yachter's cap, and took on the role of a piratical captain when showing people around his museum. A short British Pathé film from 1951 follows Sydney taking a news reporter around the rooms and objects: from bells to a model of a lighthouse made from papier-mâché, the film shows quite how large Sydney's collection was, and like Jim, Holly and Freddie, how much he cared about the way in which the objects were displayed and related to one another. Nothing about this nautical experience was an accident.

In 1951, some of Sydney's extensive figurehead collection was selected for display at the Festival of Britain, again highlighting the importance of the objects he had saved. Sydney was elderly by the time he opened the collection at Gravesend, and in 1953 he decided to downsize, donating the full collection to the *Cutty Sark* in Greenwich.

* As a child Sydney had an accident that caused him to lose an eye, so he usually wore a glass prosthesis.

THE LOST FOLK

Sydney's figureheads are now on permanent display in a space below the ship, and are shown in a way that feels appropriate to his vision: a jumbled crowd of figures, it is as if they are in conversation with one another. The art of the collection has been preserved in a way that allows the objects collectively to sing. Sydney's collection has fared well compared to other collections, and I am sure this is in no small part to do with its emphasis on nautical and military histories, as well as his standing as a white male.

For an experience even more reminiscent of Sydney's original museum, you must travel to the Scilly Isles, disembark at St Mary's and take a small boat to the island of Tresco, where, in the world-famous Tresco Abbey Garden, you will find Valhalla, an open-air museum situated among the palms, echium and red squirrels. The museum is housed in a shed made to look like a shell-encrusted grotto and is covered from roof to floor with figureheads and signs from boats wrecked on the shores of the Scilly Isles. It is, as I imagine a trip to the Look Out would have been, immersive and deeply emotive. The figureheads are placed side by side, each accompanied by a plaque naming the boat they were once attached to. Sometimes these give the name of the person and who made it; sometimes they tell the tale of where and how it was wrecked and saved. Some have had arms knocked off, or parts of their faces smashed: a harrowing reminder of the tumultuous lives they have endured. The collection was begun in 1840 by Augustus Smith, a former Lord Proprietor of the islands, and is now maintained by the National Maritime Museum. Thankfully it is kept exactly as it always had been, outside in the salty air, and offers a rare chance to experience a nautical collection as near to the sea as it is possible to be.

Like Gravesend, Chapel Street in Penzance was once home to its own buccaneer, Roland Morris. Roland was something of a local character, known throughout the town for his diving expeditions

THE LOST COLLECTIONS

and his total obsession with anything and everything nautical. He started working life as a mechanic, went on to train as an engineer and then became a fisherman and diver. Throughout his various careers, he always maintained a collecting habit, gradually gathering together bells, wheels, carvings and lamps, all from shipwrecks. In 1950 he bought two cottages on Chapel Street and began converting them into what has become a Penzance institution: the Admiral Benbow pub. In the nineteenth century, the houses had been an inn, known first as the Admiral and later as Benbow House. Roland combined the two names. His vision for them was a restaurant, not that he knew much about catering. He did, however, know a lot about making a memorable interior and used his diving expeditions to gather material for the conversion – many of the interior beams came from wrecks, including a schooner named Hetty that had lain derelict on Mount's Bay for many years before being reused.

Alongside this conversion, he also set to work on opening up Cornwall's first Museum of Nautical Art at his home further along the street at Captain Cutter's House. The museum is much mythologised, but from the little evidence that remains, it seems to have been stuffed to the brim with objects from the deep – so much so that Roland's collection expanded outwards into the Admiral Benbow. Although the museum disappeared into the annals of history many years ago, the pub remains, and still has much of Roland's incredible collection of seafaring finds on its walls and floors. On stepping through its mermaid-adorned doors, you will still find a treasure trove of nautical objects. There are ships' figureheads towering over tables, as well as a full ship's interior in the back restaurant (complete with a steering wheel) and upstairs there are 3-D murals made by Roland from Bondo, a type of hard-wearing polyester filler that is generally used in car maintenance but was used by Roland to create

81

THE LOST FOLK

mouldings. There is a lion and a unicorn holding a heraldic crest, and at the back, in the Wreck Bar, there is a scene that fills the whole wall, featuring interlocked hands, a pint of beer and creatures from the ocean's deepest recesses. Sitting in the Benbow, sipping a pint, is like diving beneath the waves into a watery realm ruled by mermaids and sea monsters, and the occasional pirate wielding a cutlass.

It might seem like a museum and a pub would have been enough to keep Roland busy, but seemingly not, as he also authored a number of books on diving and shipwrecks, most notably *Island Treasure*, which is nominally about the search for the wreck of Sir Cloudesley Shovell's flagship, the *Association*, but actually covers all manner of other wrecks and dives in its pages. Alongside his career as a writer and diver, he also found time to redevelop an old bus into a library and getaway on Abbey Slip, just down the road from the pub.

It's hard to ascertain when the museum opened and closed its doors, but it appears to have faded away at some point in the 1980s. Roland mentions planning to open it in *Island Treasure*, which was published in 1969, so it seems to have opened that year or shortly after. The objects themselves appear to have ended up in both the Admiral Benbow and the Shipwreck Treasure Museum in Charlestown, which has amalgamated them into its brilliantly packed displays.* The museum is an ode to the likes of Sydney and Roland, and the environment is very much one of excess: it is full of piles of ingots, portholes, hundreds of bottles, china and all sorts of other strange items discovered in the murky depths. The museum was begun by Richard and Bridget Larn in 1978: as a diver, Richard had much overlap with Roland, and there is no doubt that Roland would have approved of the way in which his collections are now presented.

* During the writing of this book, it was announced that the Shipwreck Treasure Museum would close, so once again the objects Roland collected are left with an uncertain future.

THE LOST COLLECTIONS

The only clue to the Captain Cutter's past as a museum is a gigantic anchor on the side of the house, saved by Roland from a wreck.

Travelling collections

Another story of a long-forgotten collection fell into my lap while I was reading *Voyage into England* by John Seymour. In one of the closing chapters he makes reference to a collection at Stoke Bruerne in Northamptonshire. There, by the canalside, was the National Waterways Museum. It was opened by the British Waterways Board, but it was in fact the lockkeeper of Stoke Bruerne, Jack James, who had worked on the canals his entire life as a boatman, that had amassed the collection. Over a lifetime he had collected and saved painted barge ware, horse brasses, maps and hundreds of other items pertaining to life on the water. The museum opened on 4 May 1963, and is still available to visit today under the new name of the Canal Museum. The collection was the first of its kind to be opened to the public in England, and a number of others followed in its wake, including collections at Ellesmere Port in Cheshire, Gloucester and King's Cross in London.

Collections exploring liminal spaces or communities such as waterways, canals or travelling people have traditionally been established by people from those worlds, and so have often fallen through the cracks of the wider museums network, or – even worse – been thwarted before they have even come into being.

In particular, traceability can be difficult when it comes to the collections amassed by Gypsy, Irish Traveller and Roma communities. Their very existence is nomadic, so it should come as no surprise that discovering whether collections still exist, or even whether they are in the same location, can be complicated. Transience is their essence and without it the collections would make much less

83

contextual sense. The fact that you might pull up to a place one day and find a museum stuffed to the brim with painted wagons, yet the next week the same site might have no trace at all of any activity could at first seem intensely frustrating, but it is in a way a much more honest presentation of stopping culture than if you were to encounter it in a national museum. The spaces chosen to house collections are often in industrial estates, barns and wayside buildings, near waterways, roads and trackways, which lend themselves to a liminality absent in major institutions. However, all these spaces on the periphery, as much as the objects themselves, add to the experience and understanding of the exhibits. By way of example, the South East Romany Museum at Marden in Kent, begun in a shed by members of the Brazil family in the mid-2000s, is almost untraceable bar a vague Google listing and an article on the BBC website detailing its location as of 2014.[3] It could still be there, but it equally might have moved.

For decades, Peter Ingram collected Romany wagons, signs, posters, clothes and carvings while working as a wagon restorer. Born in Worcestershire, he became interested in Romany culture as a young teenager and gradually trained to become a wagon painter. He relocated to Selborne in Hampshire, and this is where he began the Romany Folklore Museum in 1976. Here he mounted displays on Romany lore, language and costumes, and ran demonstrations on wagon-painting techniques. It was a cultural hub for all things Romany.

It was by no means plain sailing for the museum, however. In an interview in the *Observer* from 1993, Peter was already suggesting that there was a growing lack of respect towards travelling people, and that he was thinking of selling up and moving on.[4] Interestingly, seemingly quite by chance, beneath this article is a piece about the 1968 Caravan Sites Act, which obliged local authorities to offer Romany, Gypsy and Irish Travellers sites on which they could stay. In

the early 1990s, after the terrible events of the Battle of the Beanfield*
in the summer of 1985, the government was trying to reform the Act
in order to stop New Age and hippy communities from setting up
encampments. There was a general sense that Irish Travellers, Gypsy
and Romany people were being conflated into one bracket, that
their traditions were in danger of being entirely crushed and that
the amended Act would be used to stop, in particular, Romany and
Gypsy people from settling at sites, diminishing their ability to live as
they had for thousands of years and creating 'a sinister type of ethnic
cleansing'.[5] Sadly, it seems the determent from the government and
councils did eventually have an impact on Peter, because although
he has remained with his collection in Selborne† and still actively
collects and restores wagons, he made the decision in 1995 to close
his museum for good.

In 1989, there was an attempt to establish a national museum of
Romany culture at the Lea Valley Nursery at Waltham Abbey, Essex,
by the Romany Guild Charity Association. It was to be a centre for
people to celebrate and learn about Romany crafts, language and
heritage, with facilities for educational visits and demonstrations
of crafts. The proposed site, however, was found by the council to
be on Green Belt land and therefore deemed inappropriate, and the
project never came to fruition.[6] Although the site was unquestion-
ably on Green Belt land, it is hard not to imagine the response to
such a museum from the establishment in the first place. Romany
people have often been driven to the side-lines of society and had

* The Battle of the Beanfield took place on 1 June 1985 and involved the police
 brutally cracking down on the Peace Convoy and the associated New Age
 Travellers, who had travelled to Stonehenge to celebrate the summer solstice.
 The events that unfolded were hugely violent, and a large number of people were
 injured and arrested.
† Peter sadly passed away during the writing of this book on 7th January 2025.

their voices and culture supressed. The suggestion of a museum would certainly not have been popular, and it seems an incredibly convenient excuse.

A parallel story can be told of Adeline Lee-Toombs when she tried, in vain, to begin a Romany museum in Skegness in 1999. The planning committee refused the application to convert her home into a museum. Beyond the refusal by the planning committee printed in a local newspaper, there is no record of whether Adeline's museum got off the ground. I suspect, having scoured for more references, that Adeline never got the opportunity to open it.

Similarly, in the 1980s, John Martyn, of Hulme in Manchester, fundraised to try and begin a Romany museum and craft centre in the heart of the city. Having himself lived on the road for many years, he saw it as 'a chance to give respectability back to the travelling people'.[7] Although John ran a number of events and markets, the museum that he envisaged, with workshops and exhibits exploring the rich history and heritage of Romany culture, never came into being.

At Webbington in Loxton, Somerset, Ted and Pat Atkinson, and their daughter Katrina, opened the Wheelwrights Working Museum and Gypsy Folklore Collection in the summer of 1990. Katrina had, like her father before her, trained to become a wheelwright, and was then the only female wheelwright in the country. Alongside demonstrations of their craft, they also had a number of traditional painted wagons and information about Gypsy lore as static displays. It is again difficult to ascertain what happened to the museum, but it seems that the site is now a luxury hotel and spa, so I can only guess that the Atkinsons decided to sell up and move on.

In order to find a Gypsy and Romany collection that *did* get off the ground, I needed to search a little closer to home. When scanning the shelves of a charity shop one Saturday afternoon, I came across a book by Michael Williams. This in itself was not an unusual

occurrence; for much of the 1980s and 1990s, Williams was publishing books through his small press, Bossiney Books. His short and informative books all centre on the West Country, and cover everything from paranormal activities to folk tales. I have many of them on my bookshelves, and on this particular afternoon, my interest was piqued by the title *Curious Cornwall*. I flicked through its pages to find a chapter titled 'Recalling a Romany Way of Life'. It turned out that the chapter told the story of a truly curious and very short-lived museum at Trereife House just outside Penzance: the National Museum of Gypsy Caravans. It was opened in March 1991 by the owner of Trereife House, Tim Le Grice, and featured a collection of wagons purchased from Pembrokeshire, as well as displays on lore, language, wagon-making and cookery. The clip-clop of horses' hooves and the creaking of wagon wheels filled the air through the soundscape that played through speakers, and there were corn dollies, artificial flowers and wooden pegs showing off the history of Romany craft.

In the book Michael states enthusiastically, 'You not only step back in time, but into a vanished Romany way of life.'[8] Sadly, the museum did not last very long: by 1994 it had closed, and the contents were sold off at auction, scattered across the country. There is no explanation given for its closure. I can only guess, given Michael Williams's brief explanation, that it was too expensive to run, and that ultimately it was more cost-effective to sell the contents than continue to pay the electricity to keep the hooves clopping and the wagons creaking.

Collections investigating the history of Gypsy and Roma people have certainly struggled more than most folk museums to get off the ground and to maintain a presence. There are, of course, some exceptions. The Worcestershire County Museum at Hartlebury Castle, for instance, has a series of vardos on display, including a bow top,

THE LOST FOLK

a square bow, an open lot, a ledge and a Gypsy queen, and at Bristol Museum & Art Gallery there is a wagon on permanent display that was originally bought by the Blaise Museum in 1953 when they had a folk museum sited there; it moved to its current home in 1957. Dover Transport Museum has an open lot wagon, built in 1930, and the Weald and Downland Museum has a nineteenth-century Reading-style wagon. Then there are a great number of museums that have items relating to Romany culture that are currently not on display: York Castle Museum has in its archive a wagon from 1897 bought by the museum in the late 1950s, and in the old Coach House at Kenwood House on the edge of Hampstead Heath, London, is the Buckland caravan, a resplendent red-and-gold wagon built in 1905 by Dunton and Sons of Reading.* At Milestones Museum outside Basingstoke there is a wagon bearing the signature of Peter Ingram, having been restored by him in the early 2000s.† In terms of writings and ephemera connected with Gypsy and Roma people, the largest collections in Britain can be found at the University of Leeds, and the Ahmed Iqbal Ullah Race Relations Resource Centre in Manchester.

In recent years a number of projects have looked to re-evaluate how museums interpret Romany culture, so stories can be told in a more meaningful and respectful way; most notably there was the Feasability Study: Romanies and Travellers Project conducted by the Victoria and Albert Museum in 1999, the *Private Past, Public Future* report written by the Roma journalist Jake Bowers for South East Museum, Library and Archive Council‡ in the early 2000s and the 2023 EFDSS project Gypsy and Traveller Voices in UK Music Archives, all of which are concerned with the interpretation of archival

* It can be viewed once a year on Open House Weekend in late September.
† It is interesting to note that all these objects are contained within non-Romany or -Gypsy collections.
‡ Now called MLA South East.

material but also accessibility for the communities it belongs to. The Record Office for Leicester, Leicestershire and Rutland developed an exhibition called 'Stopping Places' in 2008 from a series of oral histories they had collected in the previous year, and in 2023 York Castle Museum mounted an exhibition, 'Celebrating York's Gypsy and Traveller Heritage', in conjunction with the York Travellers Trust. There is no doubt that the tides have begun to turn, and there is a greater willingness to begin to understand how more itinerant and transient cultures' heritage might be recorded and archived.

The Gordon Boswell Romany Museum in Spalding, Lincolnshire, which was established by Gordon and Margaret Boswell in 1995, is home to one of the largest collections of Romany vardos in the country, and is easier to find, having remained in the same place for several decades. The collection has the feeling of what I imagine the Romany Folklore Museum, or John Martyn's imagined Romany museum and workshop, would have been like: full to the brim with objects, wagons and carvings, and an incredibly knowledgeable and insightful guide in Gordon Boswell. Although it is, of course, gratifying to see larger museums decide to display and reinterpret their collections, it feels to me that a true understanding of the culture can only come from people who fully immerse themselves in the culture of Gypsy, Irish Traveller and Roma people. There is a lightness of touch and artfulness to how the objects are displayed – a sense, once again, of the collection as whole rather than of objects taken out of context with labels attached to try and retain meaning.

Living collections

Storytelling is of central importance to most instigators of folk museums. There is a need to create a sense of magic, or at least wonder, when dealing with objects that are associated with often

fairly mundane activities. They must be presented in a way that makes them meaningful beyond being a spoon or jar, or indeed a wagon or a cart. Although in the next few pages we will explore people who have pushed these boundaries further than most, there is an awareness among many collectors that their objects must be placed in a setting that makes them transcend their day-to-day existence. The hazy lens of nostalgia is one way of doing this: they can be placed among other objects contemporary to the environment where they would have been used. Another technique is the repetition of objects that all have some property in common, such as material or type, but have no correlation in other ways, such as time periods – Sydney Cumbers offered a brilliant expression of this in his displays of figureheads. Then there is the living archive or collection, a form that can, and often does, have aspects of both nostalgia and repetition but maintains as its core principle a keen eye on constantly being added to, even after it has become a museum or collection. Charles Paget Wade, whom we will meet again later, created a collection that did just this at his home at Snowshill Manor. He lived among his objects, showing visitors around on elaborate tours while dressed in costumes from his extensive collection of eighteenth-century outfits, and he continued to add to the collection even after he had retired and donated Snowshill Manor and its contents to the National Trust in 1951. Similarly, the Bissock Manor Folk Museum, based in Ladock, Cornwall, was also home to its curators, Mr and Mrs Stephens. The collection was opened in 1961 to great fanfare in the local press, being lauded as the only folk museum of its sort in the area. It collected together objects from across the parish to be displayed, inside the Stephenses' home. They opened up the exhibits on Saturdays and Sundays, with Mr Stephens, like Charles Paget Wade, giving tours. It has long since closed: the collection was sold off bit by bit.

Sadly, when collectors die, collections often get dispersed, and the

original curation of them is entirely changed; the sympathetic retelling or rehousing of a collection is rare. In County Antrim in Northern Ireland is a small town called Ballycastle, and at the beginning of the nineteenth century it was home to a shop called An Tùirne Beag.* It was initially set up by a Mrs Frances Riddell, with the help of the folklorist F. J. Bigger, and although it described itself as a shop, it was much more than a commercial enterprise. Mrs Riddell was keen to promote the crafts of Ireland as a way of reinvigorating the local economy and came up with an ingenious way of doing it; alongside handmade objects, she also brought people in to teach folk crafts. Often described as the Irish Peasant Home Industries, the shop was home, over its years, to a great many illustrious craftspeople. At the suggestion of local woodcarver Stephen Clarke, Frances bought over the German toymaker Anton Lang from Bavaria, and also employed a number of local people to teach everything from lace-making to painting, the aim being to teach the children of Ballycastle skillsets that would last them for life.

They were by no means alone. In the even smaller village of Cushendall, just along the coast, Barbara McDonnell had also set to work, offering classes in drawing and woodcarving to local children, and setting up a toymaking firm that specialised in handmade toys. Both the Irish Home Industries and the Cushendall Toy Making Industries were seen to be having a beneficial effect on the local economy and population, and as a result, in 1904, both Frances and Barbara were asked to attend the first ever Feis na nGleann, a festival that was devised as a way of promoting Gaelic language, craft and tradition. The Glens was one of the last areas in Ulster to retain a deep connection to its traditions. Owing in part to its mountainous position and difficult boggy terrain, the old customs and traditions

* A name that translates to 'the little spinning wheel'.

THE LOST FOLK

had been retained in the Glens for much longer than in other areas, but they were in danger of fading out, and the Feis na nGleann was considered a very important way of raising awareness and elevating the importance of these dying arts. It was the first and largest festival of its kind to be devised in Ireland, and a particular emphasis was placed on the Art & Industrial Exhibition, which acted as a showcase for crafts local to the area. Barbara and Frances were both now engaged in making toys within their shops and the exhibition offered an opportunity to promote both the crafts and the old ways of life they were interested in preserving. The toys became tiny adverts for Gaelic culture; from the Cushendall shop there were tiny Irish thatched cottages, miniature spinning wheels and minuscule ploughs, all of them carved in wood and made to exacting standards. The wheels spun, and the ploughs moved. The Home Industries shop specialised in cottages that also contained all the traditional contents in miniature form: butter pats, turf spades, potato washers and dressers with plates and cups.

In 1912 the woodcarver Stephen Clarke took over the management of the Irish Home Industries shop. He took the experiment even further and turned the front room of the shop into a full-size model Irish cottage, complete with an open fire and a pot hanging over it, a mantelpiece and a kitchen table. He wanted to display the toys in a way that was in keeping with how they would originally have been kept, while helping the customer to understand the place that had inspired the toys. He also added a great number of display cases with historical objects from the surrounding area, which included banners and items from the first Feis na nGleann. It gradually evolved into a fully immersive but very small folk museum. Although Stephen Clarke died in 1931, his family continued to manage the shop, until in 1982 they closed the doors for the final time. They donated the museum's contents to the local council in the hope that they would

be able to use it to start a larger folk museum in Ballycastle: this did not happen, but the objects did end up in other collections. There are items from Stephen's museum in both Ballycastle Museum and the Ulster Folk Museum, and items from the Cushendall Toy Industry can be found in Dublin and Downpatrick museums. Stephen, even more than Frances and Barbara, was interested in the museum experience: how could you transport someone into a space that emulated the experience of standing by the fireside in a traditional Irish cottage? How could you make someone visiting Ireland for the first time understand the smells and sounds? And how could you use their experience of visiting to amplify and promote Irish folk culture? Like Jim and Holly, Stephen understood the power of collection, and how it could be used to captivate and engage visitors, transporting them to another time and place. Although it is heartening that many of his objects were saved, what has been lost is the sensation and impression of stepping through the doorway of An Tùirne Beag and seeing the collection en masse; the objects in isolation don't hold quite the same history or context.

At Haslemere in Surrey, in the early 1910s, around the same period that Barbara and Frances were setting up shop in Northern Ireland, there was a community of makers and collectors forming under the leadership of Godfrey and Ethel Blount, Joseph and Maude King, and Greville MacDonald. Driven by a wish to 'restore true country life, its faith and its craft', they began the Peasant Art Society, which aimed to encourage and train the people of Haslemere and its surrounding villages in everything from how to weave cloth to the carving of wooden toys.[9] It was to be an immersive exploration of the creation of a folk industry. Their main objective was to 'produce pleasure in the making and in the use, but not to produce direct gain of money'.[10] This represented a total rejection of mass industry and, as the group saw it, the perils of modernity and mass-produced goods.

93

A monthly magazine, *Vineyard*, was set up to further this message and report on 'peasant life'.

Alongside these educational endeavours, they opened up the Peasant Handicraft Museum, which showcased 'peasant arts' from across Europe. The collection was purchased from the Reverend Gerald S. Davies, a friend and supporter of the society's activities, who had amassed an assortment of textiles, pottery and treen* while travelling across Europe. The society bought the collection because its members felt there was a need to back up their teaching with objects that students could study and learn from, and it was opened up to the wider public as a museum in 1910. The collection moved twice before being given a permanent home at Haslemere Educational Museum in 1926. On the occasion of its rehoming, Joseph King gave a rousing speech in which he exhorted that the museum must not become 'a mere treasury for the mummified beauty of the past, but rather insist on it as an inspiring reminder ... of creative power'.[11] He was adamant that it must remain a living collection: the objects were to be held, studied and used.

In the 1950s, disaster struck, and some of the carefully handwritten labels next to the pottery exhibits were swapped around by children on a school visit. This, alongside a number of other incidents of displacement, led to the collection and its accompanying information becoming less and less factually correct. The collection was reinterpreted in the 1990s, with researchers working to reinstate the correct information alongside the corresponding objects.

Although the Blounts and Kings had the best interests of the community at heart when they began their project, it is hard to look back on their endeavours with a contemporary gaze and not feel perturbed

* A term for small, wooden household objects. Can encompass objects such as boxes, bowls and tools. Their purpose is always functional.

THE LOST COLLECTIONS

by a group of upper middle-class people moving to a place in order to 'educate the peasants'. Although it has overlap with the Northern Irish Peasant Industries in terms of ambition and outlook, it seems to have failed to engage properly in the saving of the actual folk arts present in Britian during this period. Whereas in Cushendall and Ballycastle there was a long history of the production of linen, the weaving workshops at Haslemere were entirely a fabrication, dreamt up as something the group thought people *should* do. In Haslemere, they turned to Europe for inspiration, because they believed it was capable of more beautiful and more authentic forms of folk art, while neglecting to see the folk arts that already existed and surrounded them in Surrey, the crafts and industries that were going to die out if they were not taught: wheelwrights and blacksmiths, farriers and thatchers. In looking outwards for inspiration, they failed to see what was living around them.

In November 2023, I was invited to spend some time in Northern Ireland in an old curfew tower without central heating or internet. Although I was born in Southern Ireland, I'd never been to the North and was intrigued, so readily accepted. Two weeks in and looking for some respite from the driving cold in the tower, I took a trip to Belfast. I had been knee-deep in journal articles about the toymakers of Cushendall and Ballycastle, and was on the hunt for more information, or indeed hints about where to go next on my hunt for lost collections. I found my way to a second-hand bookshop, and as I surveyed the shelves I spotted an intriguing pamphlet with an ochre-yellow cover patterned with tiny silhouettes of long-forgotten tools. Contained within its pages were clues to another forgotten museum in Middlesex, England. I snapped it up and returned to the tower to read more.

The pamphlet described a museum packed with roomfuls of objects described as 'wooden bygones'.* It was stuffed with butter

* Also sometimes referred to as 'treen'.

THE LOST FOLK

pats, clothes mangles, handmade boxes and toy animals: hundreds of useful objects that, if it weren't for the museum's founders, Edward and Eva Pinto, would have been discarded. Initially, the wooden bygones were displayed in their home, but the collection soon began to expand out from the couple's living room. They also began to receive requests to 'visit' the objects and so they converted an outbuilding in their garden into a museum entitled the Pinto Collection. They decided to organise the various objects by use and so they created shop spaces in which to display them. There was a carpenter's shop, a shoemaker's shop, a laundry and an apothecary, their thought being that in order to truly understand these objects, they had to be seen in a context in which they might have been used. Many of the objects were implements that had fallen out of use, such as skippets – basin-shaped boxes used for holding folded parchment – and so visitors would potentially, without the context of other, more recognisable objects, have no way of placing or imagining how these oddities functioned. The pamphlet also contained reference to some objects directly related to folk customs; in the 'fun and games' room there was a full-size eighteenth-century mummers' hobby horse and a jester's bauble.* There was also a case dedicated to Celtic objects, which included items such as lámhógs, a form of Irish drinking vessel made from willow, and Scottish quaichs, a two-handled drinking cup offering an intriguing overlap with Irish Home Industries; in fact I would not be surprised if the Pintos had objects within their collection from Ballycastle and Cushendall.

* Mumming is a custom that generally takes place in the winter season of the folk year. There are two forms of mumming: one which involves the performers, known as mummers, going from door to door singing for the prize of money or food, and the other, where mummers perform folk plays in the centre of towns or at pubs. Both forms involve the performers dressing up in old or rag-like costumes, and they are often accompanied by creatures such as hobby horses.

THE LOST COLLECTIONS

In 1955, the Pintos built a number of chalets in their garden to house even more of the collection, and a small wooden playhouse called Noddy's Nook for children who wanted 'some peace from their elders'.[12] The themes were at times nebulous and were constantly evolving – in 1960 several of the shops were reformed into new displays – but the sense from their writing and film footage of the collection is that the Pintos cared deeply about the visitors to the museum understanding the collection and the objects' use and value. They wanted people to appreciate why they had felt the need to carve their house in two and save these strange bygones.

By the 1960s, Edward and Eva were beginning to think about how they could wind down their collecting, and the museum, in its entirety, eventually found a permanent home in Birmingham City Museum, where in April 1969 a long-term exhibition was opened of seven thousand items from the Pinto collection, including a late sixteenth-century wassail bowl and a ship's figurehead. Although the exhibition is no longer on display, many of the objects are available to look at via the Museum's website, and on Friday afternoons it is possible to visit the Museum Collection Centre, where the bygones are now housed.

Nicholas Thomas, Keeper of the Archaeology Department at Birmingham City Museum in the 1960s, is quoted as saying 'They are dead honest, not pretentious objects,'[13] and it is true the Pinto's collection encompasses both the magical and the mundane. Emphasis was not placed on singular objects abstracted from their context, and therefore lacking meaning, but on how they could be celebrated in conjunction with related items: love spoons from Wales next to love spoons from Switzerland, a wassail bowl and double-handled loving cups, a pork-pie stamp and a mould for hammering dents out of pewter spoons. Eva and Edward were not just collectors: they were curators, on a huge scale.

THE LOST FOLK

The Pintos and the Blounts were influenced largely by the size of their growing collections in opening them as museums. There are, however, instances in which the saving of a building becomes the primary force behind bringing a folk collection together and putting it on display. Master shoemaker Jack Anderson did just this in Marske-by-the-Sea in North Yorkshire when he saved a cottage from demolition in 1968. The cottage he saved is the only remaining example of a half-cruck building in the area – an early building technique that had almost entirely disappeared by the eighteenth century. On receiving the keys, Jack set to work renovating it and filling it to the gunnels with bygone objects that he had been gathering for years from across the county. The displays that Jack created were a hotchpotch of images and objects telling the story of Marske and the long-lost figures who had once inhabited the rooms of the cottage (and possibly still haunt it). Gradually, over the space of seven years, Winkies Castle Folk Museum was brought into being, named after Jack's cat, Winkie, who liked to pad around the cottage as if it were his palace. In 1975 it welcomed its first visitors; Jack famously manned the museum himself, with Winkie always in tow, spending hours chatting to visitors with his encyclopedic knowledge of the area around Redcar, where he had lived and worked for his entire life. He continued to add to the collection, which formed a living archive of the area and its people. You may be wondering, 'Can I visit?' On Jack's death in 2001, he bequeathed the cottage and its contents to the local council. It was renovated, the displays were updated slightly and it reopened to the public in 2005. It continues to welcome visitors today, although many of Jack's objects have been moved to the stores at Kirkleatham Museum in Redcar.

The objects Jack collected were important, but his true impetus for opening a museum was definitely the building. Before he saved the cottage his objects lived in his house, and they would probably

never have been brought together into any form of story or collection without the motivation of having a building to fill. An information board in the cottage today quotes him as saying: 'I couldn't bear to see this old cottage come down. I am interested in local history so I decided to buy the place. There is little written about the history of Marske so when a chance comes up to keep a place like this, I think something should be done about it.' In this instance, the collection would be nothing without the building. It would just be some old objects collected from junk shops, attics and skips, but with the backdrop of a creaky old cottage with lime walls and exposed beams, they become a way to tell the story of a place. Hundreds of years of history are woven through both the fabric of building and the objects that were used in it by ordinary working folk, from baskets to corn dollies. The objects without the building, or the building without the objects, would be something entirely different.

Winkies Folk Castle Museum offers just one example of the way in which buildings can become the beating heart of a collection, and I have already mentioned the wonderful worlds that Kingussie, St Fagans and the Ulster Folk Museum have created by using buildings to tell stories. There is, however, another lost world that paved the way for these museums of folk life – one I discovered by chance while trawling the internet for postcards of 'old folk museums' (as you do). One evening I came across a sepia postcard with the label 'Neolithic Pit Dwelling *c.* 5000 BC, Abbey Folk Park, Park Road, New Barnet'. The image was of a mound of earth with a pit and a broomstick propped against it. I was immediately intrigued. I searched on and found images of wattle and daub huts, stained glass saved from Winchester Cathedral, hand-painted carriages, a smithy and a 'witches' house' from Herefordshire.

The Abbey Folk Park was the work of the Christian mystic, priest, writer and Freemason John Sebastian Marlowe Ward. He had begun

THE LOST FOLK

amassing a collection of interesting artefacts in the early twentieth century, and at the end of the 1920s this collection began to encompass buildings too. He bought, dismantled and re-erected, in a new location, a sixteenth-century tithe barn. Inspired by the open-air folk parks that were beginning to pop up across Europe, John had a dream to create his own. He filled the barn with the antiques and ecclesiastical art that he'd gradually been gathering and set it up as a church with an active community of members. This community would become instrumental in the further development of the park, living on site and following a strict monastic lifestyle. Having established a group of willing hands, John then set to work on sourcing other buildings in danger: barns and cottages were found and added to the site. Alongside these, he started to create a series of constructed environments, such as a Neolithic pit dwelling – which I stumbled on during my late night eBay session – and opened the whole thing up to the public in June 1934. He did not stop there, however, and continued to add new buildings and displays, with his live-in community helping with demonstrations of crafts such as Neolithic pot throwing and thatching. It was to become what could be considered Britain's first outdoor folk park, a living, breathing timeline of Britain. In an article for the *Sunday Observer*, he gave a detailed description of how he envisaged the museum: 'The objects are displayed in buildings which are furnished with their appropriate furnishings, thus enabling visitors to envisage the life and surroundings of the people who made them. Furthermore, it enables old buildings which are about to be destroyed on their old sites to be saved and rebuilt.'[14]

Much like the scenes created by Eva and Edward Pinto inside their home, John set about creating tableaux that visitors could step inside: an apothecary with jars of strange and fantastical archaic cures lined up on shelves, an arcade of shops featuring everything from a sixteenth-century armoury to an early nineteenth-century

100

THE LOST COLLECTIONS

dressmaker, a prehistoric section filled with Neolithic huts and funerary barrows. Sadly, however, this transportive dream was not to last. The outbreak of war in 1940 saw the museum close its doors, and it was never to reopen. John also ended up embroiled in a difficult court case involving a young member of his church, Dorothy Lough, whose parents believed she had been lured away from civilisation under duress. The court case was ultimately very damaging: John was found guilty and fined £500. Subsequently, John and his followers – including Dorothy, on a forged passport – decided to emigrate to Cyprus. He sold off much of the contents of the museum and all of the buildings, taking only a few thousand of the ninety thousand artefacts that he had accrued with him.

He touted around for a suitable buyer and soon landed on his friend Gerald Gardner, the founder of Wicca and an avid collector of mysterious things, but Gerald was only really interested in one thing: the sixteenth-century cottage that John had found in Ledbury. They agreed that it would be swapped for a patch of land in Cyprus that Gerald owned, where the community subsequently moved and re-established its church. Gerald resurrected the cottage in the grounds of Five Acres nudist club, where he had established his Bricket Wood Coven,* and used it for ritual magic. It is known as the witches' cottage because of the magical sigils and marks that were painted on the walls, but they were almost certainly not there when John originally purchased the building: given his interest in reconstructive archaeology, it is probable that he added them and enchanted the cottage himself.

The park and most of its historic buildings were purchased by William Ohly, a Jewish art collector who had fled Germany. William

* A coven of witches established in 1940 by Gerald Gardner at Bricket Wood in Hertfordshire. Gerald's work with the coven is considered the foundation for the neo-pagan religion Wicca.

used the houses to set up the Abbey Arts Centre, which was initially used as refuge for artists who, like William, had fled persecution during the war but it gradually grew to offer safe and affordable workshops and accommodation for artists from all over the world looking to relocate to Britain. The tithe barn was used to display a collection of ethnographic art from around the world. The centre still provides workshops and flats to artists today. The prehistoric buildings that John had built with his volunteers were mostly dismantled or left to ruin. Perhaps, in thousands of years to come, they will be excavated and thought of as a reimagined Stone Age. John died in 1949, and shortly afterwards his loyal community of followers relocated again to Australia where they re-established a small museum, displaying a number of artefacts that he had taken from the original Abbey Folk Park Museum, and which is still open today. However, the true vision of a world in which people could step back in time was lost. His objects and buildings were dismantled, and thus the core of his ambitious project was diluted to the point of complete dissolution.

Next door to the post office in Great Bedwyn, Wiltshire, there is an astonishing patchwork display of tablets and signs hung across the breadth of the wall, all made from varying forms of stone: another living collection, but one in which the curators are working rather than living among their objects. There are granite gravestones, memorials made from Portland stone and a frieze of the Last Supper which has been painted in white and powder blue. They hint at a collection, and indeed they were once all part of Bedwyn's Stone Museum, which was housed in the same spot. It was the very definition of a living museum, with a family of monumental stonemasons at its helm. They first made their way to the area when the Kennet and Avon Canal was being built in the late eighteenth century, and after helping to build the tunnel, they laid down roots and established their firm Lloyd of Bedwyn in 1790. Seven generations of

THE LOST COLLECTIONS

sons have worked the stone since. In the sixth generation, Ben Lloyd (there were quite a few Bens) was, alongside his incredible work as a mason, also a passionate collector of anything and everything to do with stone. Over time he amassed a collection of carved pieces and started to display them, alongside works by his apprentices, on the front and sides of his workshop. People started visiting, and he would talk to them about what it was like to work as a stonemason and show them the many examples of stonemasons' work that he had collected from across history, and so the museum was formed.

In 1983 he was interviewed for a segment on the BBC.[15] The film opens with Ben painting a headstone in a wild array of colours, prompting the confused interviewer to ask him, 'Aren't they meant to be sombre?', to which Ben replies, 'They are meant to attract attention' – therefore why shouldn't they be painted? He goes on to explain how painting the carved symbols elevates their meaning. In Ben's view, a basket of flowers, when painted in white and black with flowers in red and yellow, becomes a clear metaphor for purgatory: 'There's nothing unhappy about death, you've got to think you're going to a happy place!'

Through the use of bright colours, the gravestones are completely changed in their tone: they take on a cheerful appearance and their symbolism becomes far more readable. There are hidden codes in these slabs, according to Ben, with tales of multiple lovers or illicit affairs and children born out of wedlock. It is a code, he argues, that was depicted visually so that illiterate people could understand it: an angelic head with three lines in its hair to suggest a life spent with two men, for example. Rich people who could read would, he says, have been none the wiser, because the text on the gravestones makes use of language that suggests a life of purity while the images on the same stones suggest, as in the case of the angelic face, an alternative, and potentially immoral, life story.

THE LOST FOLK

The interview is illuminating, throwing light on the stones that remain on the walls at Great Bedwyn, many of them still bearing the mark of Ben's paintbrush. Ben died in 2008, and his son, John, has been the master mason since the early 2000s. The museum collection is much diminished due to various pieces having been sold off over the years, but even now a few can be observed from the pavement; as a whole they certainly still give the sense of what the museum once looked like. Ben was not only a collector but also a folk artist, transforming his collection into a canvas that he could raise to new heights through both the jam-packed display and the picking out of the cherubs, skulls and flowers in exuberant colour. Through making each object worthy of attention individually, he made the collection as a whole vibrate with life and wonder. His museum was very much alive, constantly being changed, rehung, re-carved and repainted. It evolved like an artist's painting. It was collection as an organic process. There were no preconceived displays nor endpoints in view. It was purely an articulation of one man's craft and a way of showing his apprentices how they could evolve theirs.

On the pebbled shores of Hastings beach, Ernie 'Oxo' Leslie Richardson entertained children and adults with a very peculiar museum. It was 'living' in more ways than one. On a painted cart, Ernie would arrange a selection of freshly caught fish each morning: lemon sole, mullet and his prize exhibit, a skate. The cart had a beautiful handwritten sign with the words 'Ernie Oxo's Wonders of the Deep' painted in mauve, and the skate was tied to a pole with a cigarette poking from its mouth. Ernie would wheel the cart to a spot along the seafront and spend his day telling elaborate tales and facts using his living displays.

In his earlier years Ernie was a fisherman and had been known locally for his proficiency in catching herring, so was well equipped to give his talks. He had come up with the idea of the Wonders of the

THE LOST COLLECTIONS

Deep Museum at the end of the war and set up in the summer of 1945. It became exceedingly popular, with tourists and local children putting their money into the 'Oxo' donation boxes, enthralled by Ernie's unusual style of storytelling. The fishy exhibits constantly evolved, giving the museum a unique selling point: every day was different. Perhaps it was the most ephemeral museum of all. But was it folk? Here was a man talking about something he had spent his life learning about in his work, bringing that knowledge to people enjoying a day off at the seaside. It dances on the line between museum, performance, folk art and labour. Ernie retired from his museum exploits in the late 1990s and died in 2017. His cart now lives, alongside his donation boxes and Wonders of the Deep sign, in the Fishermen's Museum at Hastings: a place that feels both fittingly connected to Ernie and, as museums go, very alive. At the centre of the Fishermen's Museum is a huge ship that was driven into the space that now houses the 1950s museum created by Ernie and his fisherman friends; a whole wall was removed to get it into the building. At the time the museum building was a church known as the Fisherman's Church, a place that, although never consecrated, was dedicated to St Nicholas of Myra, patron saint of seafarers, and used to venerate the sea and give thanks to the people who sailed it in hunt of the next catch.

At the beginning of the Second World War, the church was closed and used to house military goods. During this time it sustained much damage, and it wasn't until 1956 when the Hastings Old Preservation Society took on the lease that it was restored and converted to a museum, with the ship becoming the star exhibit and case after case of strange and wonderful artefacts connected with the history of Hastings's fishing industry and the sea that laps the shore behind the chapel. When I say converted, I mean this in the loosest sense, given that it retains many of its original fittings from its life as a place of worship, and to this day the museum still serves as a working church.

105

THE LOST FOLK

It is a deeply idiosyncratic and fascinating place, filled with objects that feel like they could grow legs and wander out of the museum at any moment: a living, breathing archive of the community that still surrounds the museum. Outside, net huts, boats and sheds selling crab and cockles line the pebbled shoreline; the largest beach-launched fleet of fishing boats still glides into the ocean from behind the museum, and a miniature railway brings day trippers trundling along the tracks, dropping them just by the entrance. It is a collection of the community, for the community, and one that is constantly evolving with exhibits being added or moved about, everything jostling for space just like the boats parked up outside.

In the depths of Carmarthenshire in Wales, on the outskirts of the hamlet of Glyn Aur, which sits on the road that weaves its way into the village of Abergwili, there was once another extraordinary living collection. The exhibits in this collection literally grew. The collection was known locally as the Garden of Eden and consisted of a series of topiary sculptures cut into tableaux. The scenes were mostly taken from the Bible: there were bushes cut into the shape of angels, trees pruned into the form of birds soaring through the sky and a hedge shaped to look like Jesus and his disciples at the Last Supper. There were also many smaller shrubs cut into a variety of animals including chickens, dogs and foxes. It was a feast for the eyes and mind, requiring an astounding level of skill and upkeep. Its creator was David Davies. Having spent his life working at separate points as a farm labourer, a lead miner and a plate layer* for the railway company LMS, on his retirement in 1932, David set to work on creating a mystical paradise in the garden of his cottage. He was a man of many talents, also turning his hand to coracle fishing, beekeeping and poultry keeping – winning many prizes at the local country show. He also dabbled in writing a

* A plate layer was responsible for tightening the bolts on the railway tracks.

THE LOST COLLECTIONS

number of poems for local newspapers and for the Eisteddfod,* and was a bard of the Gorsedd Cymru.† It seems his true calling, however, was the art of topiary: shaping plants into magnificent scenes.

You may be wondering, 'Can I visit?' Sadly, the answer is no; the topiary has long since become formless. David died in 1948 at the age of eighty, and subsequently the garden was left seemingly untended. In a 1956 cartoon-strip-style advert for tourists to visit the village of Abergwili, there is a speech bubble with the following text inside: 'At one time a famous topiary in a garden here attracted many visitors – only a few examples now remain,' suggesting the garden was still partially there in the mid-1950s.[16] When I first read this, I was intrigued by the mention of the many visitors. When I first discovered David's topiary garden through a series of tinted postcards on eBay, I had little to no information about who the creator was or why they had felt compelled to turn their garden into a mythical landscape. I subsequently discovered some scant information via the Welsh Historic Gardens Trust: they have some of David's postcards within their archive, and had also tried to discover the garden's origins in the mid-1990s. However, it seemed that evidence of the garden and David had faded almost entirely from history. After much intensive digging, I discovered a small reference in a newspaper article that featured an image of a tourist coach with visitors spilling out of it to view David's topiary. Alongside this photograph was a mention of photographs taken by the *Picture Post* magazine. After some unravelling, it seems that in 1938, an American photographer from the magazine came to take photos of David and his collection, which were later reprinted in 1949 after David's death, sparking another few years of enthusiastic

* The annual celebration of Welsh culture and where the annual barding ceremony of the Gorsedd Cymru takes place.
† A society instigated to celebrate Welsh culture and promote the Welsh language.

visitors to this small town. In its day it was clearly famous across the world, with visitors travelling from far and wide to witness the miraculous spectacle of these astonishingly crafted bushes and shrubs. There is even mention that the BBC came at one point to record David speaking on the art of topiary, although I haven't been able to track down this footage.

Living collections are transient because they are so often part of someone's home or workplace. The deep connection with a place and person means that when they are no longer there driving the collection along, and actively shaping and changing it, it generally fades into non-existence. In many ways this makes the living collection more like a form of folk art than a traditional museum collection – the collector and the collection are inseparable.

Popular art collections

Someone who really understood the principle of collecting as an art form was the artist and writer Barbara Jones. Born in 1912, Barbara wrote and illustrated numerous books on folk art, including *The Unsophisticated Arts* (1951) and *Follies and Grottoes* (1953), painted many murals and illustrated a number of books for other writers, including *In Trust for the Nation* (1947) by Clough Williams-Ellis. Above all else, however, she was an impassioned collector, and in 1951 she put into practice for the first time her ability to curate and formulate objects into a story. As part of the Festival of Britain, she was asked to curate an exhibition on the folk arts of Britain, when fellow folk collectors Enid Marx and Margaret Lambert turned the job down. Barbara titled the exhibition 'Black Eyes and Lemonade' after a satirical line by the Irish poet Thomas Moore: 'A Persian's Heaven is easily made / Tis but – black eyes and lemonade.'[17] Barbara described the exhibition title as expressing 'the vigour, sparkle and colour of popular art rather

108

better than the words "popular art".[18] It also referred to two of the most infamous exhibits of the exhibition: a pair of illuminated glasses that had been part of an optician's sign, and a talking lemon from the Idris lemonade adverts. The exhibition ran from August to October at the Whitechapel Gallery in London and was an extraordinary success, with more than thirty thousand visitors.

Barbara, ever the innovator, was most insistent that it be titled 'popular art' rather than 'folk art', allowing her to celebrate all aspects of folk culture, both handmade and mass produced. You may wonder why she included mass-produced objects: surely these aren't folk objects, when the mark of the hand is deemed one of the defining features of folk? Barbara believed that some mass-produced objects did firmly sit in the category of folk. She asserts in the catalogue introduction that 'there is a dividing line between tool (allowed as hand) and machine, but it is very difficult to say exactly where, and so far, a human brain has always dictated just what the machine shall produce'.[19]

Her argument for their inclusion was unpopular – the exhibition sponsors, the Society for Education in Art and the Arts Council, were strongly against their inclusion due to the cheap production methods used and the generally crude or tawdry aesthetic of the objects. This is an argument that occurs frequently in relation to all folk objects. They are often made with cheap materials that are to hand, and without longevity in mind. They are, of course, also generally made to be used. Therefore they can sometimes look fairly weathered by the time they make it to the museum or exhibition space, rather throwing out of the window normal curatorial or preservation practice.

We often expect museum or exhibition objects to look perfectly preserved, but this is just not the case with many folk objects. They are generally fraying at the seams, faded and crumpled, and that in

THE LOST FOLK

many ways is part of their charm; they have had an active life and are imbued with all the stories and marks that come with that.

The catalogue for 'Black Eyes and Lemonade' makes it clear that Barbara also included many items that had not had an active life but would have an ephemeral one after the exhibition: cakes, biscuits and bread made up large swathes of the displays. There was a three-tiered wedding cake, a selection of harvest loaves in such shapes as a wheat-sheaf and a horn of plenty, and a variety of models made in royal icing in the shape of everything from St Paul's Cathedral to a stagecoach. The makers of these confections were all listed by name and often also by place. They were messy objects, and liable to collapse, melt or drip, but in Barbara's fizzing lemonade mind they were essential to a proper telling of popular art in Britain. In the Whitechapel Gallery archive there is an image of two children being handed pieces of one of the exhibits; the little boy licks icing from his fingers. This was truly living folk art.

Barbara, however, was not the first person to display food in this way. In 1928 the cook, writer and teacher Florence White began a group called the English Folk Cookery Association. It was set up with the aim of celebrating and teaching people traditional folk cookery methods, from how to make everything from Ripon spice bread* to frumenty.†

Florence was deeply influenced by an exhibition that took place in 1891, put together by the folklorist Alice Bertha Gomme: a selection of 'Feasten Cakes' for the International Folklore Congress held at Burlington House, London.[20] In an article titled 'Folk Cookery from the English Country-Side', Florence states, 'Lady Gomme's pioneering research work in English folk cookery must not be forgotten,

* Ripon spice bread is a yeasted cake from Ripon, North Yorkshire. The recipe was collected from Mr Herbert M. Bower.
† Frumenty is a spiced and sweetened porridge traditionally eaten with venison.

110

THE LOST COLLECTIONS

especially as her interest is still living and active,'[21] and in the entry for 'Fourses Cake' in *Good Things in England* she mentions Alice's involvement with the conference: 'This is a cake made of yeast bread, lard, currants, sugar, and spice, eaten by Suffolk harvesters at 4 o'clock. One was included in the collection of local and ceremonial cakes shown by Lady Gomme at a Conference of the Folk Lore Society held in London in 1892.'[22]

Like Florence, Alice had collected together cakes from across the British Isles, but her emphasis was very slightly different: she concentrated her efforts solely on cakes used in folk practice in some way or as part of folk customs that were just about still in use when she collected them, yet in danger of dying out. There were celebratory cakes such as Welsh Easter cakes and Cornish christening cakes, harvest cakes from Devonshire and soul cakes from Staffordshire, hollow biscuits from Norfolk and, interestingly, Turkish funerary biscuits made by a Miss Lucy Garnet. Each was labelled with its particular county. The locality was key to their importance. An article at the time, from the journal *Folklore*, suggests that collecting them together was not without its difficulties: 'A very large number of commemorative cakes have disappeared from local custom in England, but the entertainment committee have obtained as many as could be procured, in the hope that attention may be directed to these interesting relics of bygone custom.'[23]

The International Folklore Congress was the first meeting and exhibition of its kind to be held in Britain. It was hosted by the Folklore Society and brought together all the major folklorists working in the British Isles in the late nineteenth century. As chairman of the committee Alice's husband, the folklorist George Laurence Gomme, was instrumental in planning who spoke and what was chosen for the exhibitions, and so Alice was in charge of not only the feasten cakes but also, alongside Charlotte Burne, organising an evening of

THE LOST FOLK

demonstrations of traditional children's games and songs (in which she was an expert), folk songs and dances. The evening was entitled 'Conversazione' and was held at the Mercers' Hall in London. All the songs and dances chosen were still being performed at that time, which allowed them to be performed by children and adults who danced and sang them in daily life. It was not an exercise in re-enactment but instead an acknowledgement of contemporary folk practice and the need to collect the present. Alice's influence could be felt throughout the exhibition, and many of the more maverick aspects of the weekend seem to have her touch. A review of the congress in the *Journal of American Folklore* suggests, for instance, that the cakes were not only on display but also that 'a sufficient quantity of these had been provided for refreshment at afternoon tea during the congress'.[24] Not only could these cakes be admired and pontificated over, but they could also be consumed, and this is an important point: Alice came from a school of folklorists that believed in fully engaging themselves in order to understand the custom or tradition properly. Interestingly, Cecil Sharp often cited her as a major influence on his work, and indeed as the reason he started collecting folk songs and dances, but she was far more akin in her practice to Mary Neal or Dorothy Hartley. In many ways, Alice was before her time: she highlighted the folk practice of women and children when nobody had even considered things like skipping or counting games or folk cookery important to preserve.

In 1931, Alice Gomme became the president of the English Folk Cookery Association, and the next year, Florence's magnum opus, *Good Things in England*, was published, in which she dedicated a large section to the making of English cakes. Out of this research came her own fleeting exhibition inspired by Alice's: '100 English Cakes'. It has left almost no trace. The objects, of course, all being edible and therefore perishable, did not survive. I've not been able to

THE LOST COLLECTIONS

find any photographs of the exhibition, and there is barely any other evidence. There are several pamphlets that survive in Hampshire County Council's archive for Florence's English Folk Cookery School, which she began in 1936. This was based at 160 West Street in Fareham, Hampshire, and the pamphlets make reference to an 'exhibition window', so it could be presumed that this shop was the location for her exhibition of cakes but it was in fact, like 'Black Eyes and Lemonade', held in the heart of London at a lecture hall at 30 Kensington Church Street. The *Daily Telegraph* describes it as containing 'Burial Cakes, Yules Doos, Sedgemoor Easter Cakes and Checky Pigs'.[25] It is not known what was shown in the English Folk Cookery School 'exhibition window': perhaps more cakes made by her budding students, or perhaps other even less well-documented exhibitions of cakes.

Although the article only makes reference to a small amount of the confections on show, we can establish what the other cakes might have been thanks to *Good Things in England*, where there is mention of fried cakes, Shrewsbury cakes, revel buns, Lancashire parkin and Portland cake, among many others. What is trickier to guess at is the way in which Florence might have chosen to display them. Were they tiered? Or in lines? We may never know. It's also difficult to imagine what some of the cakes might have looked like: what, for instance, is a checky pig? Thankfully one other review in the *Daily Herald* makes mention of them as 'little pigs modelled out of dough and stuffed with mincemeat'.[26] Neither of the articles makes any reference to how long they were exhibited for, or whether they were consumed at the end. Florence's cakes have almost entirely vanished from memory.

Like Barbara, Florence stumbled on an aspect of folk which, until her exhibition, had almost been entirely ignored within collections. While Florence's interests were centred around food, Barbara introduced a vast quantity of items to the vernacular of folk that

113

THE LOST FOLK

had hitherto been entirely disregarded, including beer labels, pub signs, postcards and napkins. Unlike '100 English Cakes', 'Black Eyes and Lemonade' was widely reviewed; there were reviews in all the national newspapers and there are several photographs of the exhibition displays in situ.

As a result, we can form an exceptionally clear mental picture of the displays: a room filled with a giant beer bottle covered with beer labels, a fireplace in the shape of a terrier, trade union banners, Staffordshire spaniels and seven towering ship's figureheads. It was a feast for both the eyes and the mind, an extraordinary accomplishment in collecting, and one that Barbara mostly achieved through use of her own objects from home and 'a 1,500-mile trip around the British Isles in a second-hand taxi collecting exhibits'.[27] Barbara's effect on folk culture has been enormous: she is endlessly cited as an inspiration to artists and illustrators, and in 2013 an archive exhibition was mounted at the Whitechapel Gallery celebrating 'Black Eyes and Lemonade'. It comprised a number of original objects and ephemera relating to the planning of the exhibition.

Sadly, Barbara's collection for 'Black Eyes and Lemonade' did not stay intact. There are pieces scattered across Britain: the aforementioned terrier fireplace is in the Design Museum, the beer labels in the University of Brighton Design Archives and the pub mirrors came up for auction in 2011. It is very difficult to keep a collection together when the collector is no longer alive. Barbara is recorded as having discussed the possibility of donating the items from the exhibition to the Museum of English Rural Life in Reading. She also mentions at the end of her introduction to the catalogue that:

> The Victoria and Albert Museum has a wonderful collection of prints of fetes and pageant; could we not have a three-dimensional exhibit as well – a whole glittering roundabout? The ideal thing

would be . . . a large and comprehensive Museum of Popular Art, but this is a matter for the future. Meanwhile we present a sample of what its contents would be.[28]

Clearly she, like the Royal Anthropological Institute, believed in the need for a national museum that would house folk objects. Her vision for it was, however, very different from that of T. W. Bagshawe and his team. In her mind, it was to reach much further into the corners of what constituted folk. For Barbara, folk was not just agricultural tools and smocks; it was all the nebulous and ephemeral and strange things that sat in between and outside. More than anyone before her, Barbara managed to drag the conversation about what constitutes folk into the present.

Folk collections for the future

There is of course a danger that museums that conserve old methods and customs can also conserve a level of nostalgia and ancestor worship that doesn't allow for any progression or re-evaluation of history. We must never become stuck or fixed; preservation should not perpetuate bigotry. It is crucial that we continue to ask questions of how and what we are collecting. On a recent visit to St Fagans Museum in Wales it was refreshing to see how their approach to collecting had evolved to include artefacts from migrant communities that had made their home in Wales. In the main gallery was a huge effigy of the Hindu goddess Durga made by the Wales Puja Committee. In 1972, a group of Bengali students living in Cardiff began gathering together for *puja*, a form of private prayer. Initially this was conducted in their own homes, and used painted images and figures they had imported from India, but gradually it expanded to encompass a street festival as well as prayer at home, and by the

mid-1980s they had formed the committee. In 2002 they invited two craftsmen from Kolkata in India, Nimai Chandra Pal and Bishwajit Chakraborty, to Wales to make a series of Hindu effigies for the committee to use in their annual Hindu Durga Puja Festival at Caerphilly. Clay from the Ganges was mixed with clay from Wales to create five towering figures of gods and goddesses – Ganesha, Lakshmi, Saraswati, Kartikeya and Durga – a perfect fusion between two cultures, and a celebration of the community's place in India and Wales. These figures were actively used at the festival until they were donated to the museum in 2009, and the museum helped fund the making of replacements for the festival. All five of the figures now sit proudly in the archive among an array of objects from farm utensils and ceramics to quilts and love spoons, all of them together celebrating hundreds of years of Welsh folk history.

The picture St Fagans paints is one of an evolving folk history in which migrant communities are included and celebrated. There is a real danger that customs and objects can be lost in people's transit to new places; objects can get displaced and folk customs or rituals can be hard to maintain in a new home. Museums have a responsibility to seek out communities and record and preserve their folk histories. However, too frequently this does not happen. Fairly often, as exemplified by the beginnings of the Wales Puja Committee, migrant folk practice can be something that happens behind closed doors or tucked away in small unseen pockets of our towns, and it is not, as with the Wales Puja Committee, until a community is established that they are offered space to expand their folk practices.

In the same exhibition space, there is photograph of the Walker family in traditional Welsh hats taken in 1970. They had arrived in Port Talbot from Jamaica in 1961 with just one suitcase (which is also now in St Fagans' collection) and in this image they are immersed in the culture of Wales, complete with Welsh hats and lace collars: a

THE LOST COLLECTIONS

remarkable example of how folk culture can be used both to make arriving communities feel a sense of place and to share where they have come from. It is essential that as we move forward into the future we come together and create a communal history, one in which we all both listen and share.

The displays of St Fagans are alive and full of the fizz that Barbara Jones was so keen for museums to take on board. Through its collecting practice, the museum has found a way in which to navigate and tell a true people's history of Wales, largely due to a lasting interest in the history of migration of people to and from Wales. It has also made a very important decision in keeping the museum entirely free to visit, meaning that, for the people of Wales, their folk history is completely accessible and available to them to engage with.

In 2020, at the back of a shopping centre in Lewisham, a museum entirely dedicated to the history of migrancy was launched, called Migration Museum. It was established with the aim of collecting the stories, objects and images of migrant communities, and came out of many years of work by its founder Barbara Roche. Barbara grew up in a Jewish household in East London, and for a time was immigration minister. In 2013, she teamed up with Sophie Henderson, an immigration barrister and judge, to set up the museum. Their first ever exhibition, '100 Images of Migration', was put on at the Hackney Museum and explored the enormous depth of culture and experience of migrants in Britain, from an image of women in a sari shop in Leicester to an image of the annual La Salette* street party in Manningham in Bradford, featuring a steel band and people jubilantly dancing in the background. The exhibition brought together, in an entirely new and comprehensive way, the experience

* A Catholic feast day celebrated in Dominica in the Caribbean, which was a French colony until the eighteenth century.

of being displaced and having to make a home in a new place. The photographs were not taken by one photographer, but submitted in response to a callout in the *Guardian*; the resulting images are a wonderful array of both professional photographs and those taken from family archives or snapped by members of the public. They paint a vivid picture of what migrancy in Britain has looked like for the last hundred years, and what it looks like today. It is, you could say, a true folk archive created by and for the people. Migration Museum has subsequently put on many more exhibitions, both in person and online, all of which have continued to explore themes around loss, community, sense of place and identity from a historic perspective, but also crucially through a contemporary lens.

Between 1998 and 2005 the artists Jeremy Deller and Alan Kane assembled together a collection of folk art from across Britian. They called it 'Folk Archive'. It was perhaps the first time in the twenty-first century that anyone had come close to Barbara Jones and her methodology around collection practices, encompassing both the tasteful and the kitsch. Alongside more traditionally accepted folk customs like the Burryman and Mari Lwyd,* the artists shone a light on customs such as the World Gurning Championships at Egremont in Cumbria, church flower arrangements and the Clown Egg Register.† Crucially, like Barbara before them, Deller and Kane included what could be considered commercial signage, such as signs from burger vans, cafés and shops. There is also a section dedicated to food within the collection,

* Mari Lwyd is a form of Hobby Horse that appears across South Wales in the period leading up to Christmas. It consists of a horse's skull attached to a cloth which is placed over the wearer's head. Often they are decorated with ribbons.

† A collection of eggshells painted with each clown's individual make-up started in 1946 as a way of ensuring that no two clowns had the same make-up. For a time it was possible to view them at the Clowns' Gallery and Museum at Holy Trinity Church in Dalston, London; sadly at the time of writing the museum is closed and the eggs are in storage.

THE LOST COLLECTIONS

and, like Barbara and Florence's collections before, it includes ephemeral items such as wedding cakes shaped like brides, cakes from the Pudding Festival in Braithwaite, Cumbria, and vegetable animals from Lambeth Country Show. The images of the Pudding Festival have particular overlap with Florence White's '100 English Cakes' exhibition, with the festival collecting together exactly one hundred cakes, which were then auctioned off for charity. The festival doesn't appear to take place any longer. 'Folk Archive' consists of both images and objects. Sensibly, Jeremy and Alan ensured that the more ephemeral objects were represented in photographs, meaning that unlike 'Black Eyes and Lemonade', the collection remains intact. In 2007 the British Council acquired the entirety of 'Folk Archive', and it has subsequently travelled the world, popping up everywhere from Bideford in Devon to Rennes in France. It has become an encapsulation of folk culture and art at a particular moment in Britain, saved for the nation to learn from and enjoy for years to come.

Simon Costin, who worked on the curation for the Whitechapel archival exhibition of 'Black Eyes and Lemonade' in 2013, is also the founder of the Museum of British Folklore, a peripatetic folk museum that is very much inspired by the ethos of Barbara's work. Simon has mounted a number of exhibitions under the auspices of the museum since its founding in 2009, most notably the first ever exhibition in Britian to explore British folk costume. Curated with Mellany Robinson, project manager for the Museum of British Folklore, and the costume historian Amy de la Haye, 'Making Mischief' was held at Compton Verney in Warwickshire in the summer of 2023 and gathered together everything from sequinned children's horse costumes from South Ronaldsay in Orkney to an array of handmade hats from the Bridport hat festival held in Dorset every September. A follow-up exhibition, entitled 'Making More Mischief', was mounted at London College of Fashion in 2024. This iteration, alongside

the displays from the original exhibition, had a focus on London-based customs and costumes with a large section on pearly kings and queens, and a space called 'Somali Museum Atelier' exploring Somali customs in London curated by Kinsi Abdulleh, founder of Numbi Arts and the Somali Museum.*

The nomadic and moveable nature of the Museum of British Folklore, Migration Museum, 'Folk Archive' and the Somali Museum speaks to a new age of curation and collection, one in which a lack of a concrete, defined space creates an open-minded and expansive vision for how a collection can manifest and endure. While Simon and Mellany's goal for the Museum of British Folklore is a permanent home, they have not wasted time waiting around for this to become available to them, and have instead used what could have been seen as an obstruction as a powerful force for change, working with existing museums and collections to expand the public understanding of what folk means and how it can be celebrated and curated within a museum context. In a similar way, Migration Museum has looked to spaces outside the norm of curatorial practice, such as shopping centres, which are at the heart of everyday life for most people, ensuring that accessibility and approachability are at the core of the museum. Through their wandering exhibits, they have broken down boundaries and democratised the way in which culture is put on display. The moveability of these pop-up explorations feels much more in keeping with the spirit of folk, infused with a spontaneity and life force that is often absent from more traditional museum displays. Placing the displays in spaces that people actually use and interact with on a daily basis further enhances this.

* Although Kinsi's museum mostly exists in the virtual sphere, it has, like Simon's folk museum, popped up at a series of spaces across East London, and continues to give voice to the Somali community of Tower Hamlets.

THE LOST COLLECTIONS

At the village of St Columb Major in Cornwall, exactly this has been done, in the repurposing of a disused red telephone box into an exhibition space called the Smallseum. Panels of photographs detailing the town's history and folk customs line both the inside and outside of this box museum. Step inside and you'll find a map with important places dotted across it. The panels show everything from the annual Cornish hurling match that takes place in the town to images of costumes from the yearly carnival (including a very good one of a child with a huge papier-mâché head). When I first saw it, I made my partner stop the car so I could leap out and take a look. A time portal just sitting outside the pub, waiting to be discovered if you dare pause and enter, it is an extraordinarily simple and yet deeply effective use of what I imagine was previously a disintegrating structure. A plaque on one side tells me that it opened in May 2021 and is dedicated to Mrs Bill Glanville, a historian, archaeologist and, like Peggy Pollard, a bard of the Gorsedh Kernow, who was vital in the uncovering of many hidden aspects of the town's history. It seems a fitting tribute, and one I wish could be extended across Britain. Imagine tiny folk portals in all towns, the perfect way of displaying folk histories, in the places they are created, in the centre of where people live and work – free, and completely accessible.

This egalitarian vision is sadly not shared by many other museums, and I would hope that we as a nation can become better at telling our collective folk history as it is today rather than as it was in 1900. It would be encouraging to feel that we had more to show than just a collection of items that were once used to churn butter or card wool, and that they were housed in places that were fully accessible and welcoming. It's not to say that the butter churn or wool carder are without merit, or that the big institutions cannot be accessible – examples within this book have demonstrated that they absolutely

THE LOST FOLK

are – but it is to say we need to open our eyes to the present and the history that is being lost in front of us now, and to think about how we are including or talking about this history in our museums and exhibitions of the future. We owe it to Barbara Jones and her ilk to find the popular art of today.

3
★ THE LOST OBJECTS ★

Museums can easily become spaces of fossilisation, and perhaps this is why folk objects have had such an uneasy relationship with them. They are alive, vibrant and untameable objects that have been made with a purpose – to be used. They were not made with the intention of being placed behind glass or under domes or in drawers. Perhaps this why they are more often than not left to sit on shelves deep within archives, incorrectly labelled and very often forgotten. It is not to say that they are badly cared for: generally, these spaces are dry and ventilated, which is more than can be said of the sheds, barns, lofts or skips from which they have been plucked. However, they are not generally loved, and very often have no information attached to them. Out of sight and out of context, they become lost. They no longer have an active use and therefore are in many ways defunct. Without the knowledge of a place and its people, and all the love, care and life that comes with it, the objects lose much of their meaning. They have been stripped of their use and therefore of their worth. It is no wonder, then, that many folk objects sit within archives for years before being rediscovered and 'understood'.

There are also many objects that haven't made it into museum collections at all. Often these objects are still being actively used in folk customs or festivals, or they have slipped through the gaps and have found themselves locked in sheds or buried in attics. Objects yet to be recognised in terms of their cultural or monetary value are

THE LOST FOLK

often the ones that are most in danger of being permanently lost. They are frequently items that are still in active use and to some degree are so much part of the furniture of a place and period in time that they have become almost invisible. They often disappear almost overnight; it only takes a renovation or a clear-out to put them at risk of falling through the gap forever. Among these are folk objects we find everywhere: village signs, hurling flags, horse brasses and badges. We are surrounded by morsels of both our past and present whenever we wander a town or village, and yet it is very rare that we think to record or, indeed, consider these fragments in any detail. Hundreds of objects relating to our folk history are hidden in plain sight in museums, churches and pubs, among other places – some of which will be introduced to you in this chapter. It is impossible to be comprehensive – there are always new things that are being discovered – but I hope I can show you some of the objects that have gripped my fascination and encouraged me to seek out more, and that you will feel compelled to do the same.

Lost objects in plain sight

Churches are perhaps not the first place you would think to go in search of lost folk objects, and yet . . . they are full of folk treasures waiting to be discovered. There are quite often banners that relate to customs in the town or that have been made by organisations such as the Women's Institute. There are elaborate flower displays and garlands crafted by villagers for events in the seasonal calendar. There are bench ends and misericords* that have survived for hundreds of

* The underside panel of a wooden hinged choir seat in the choir stalls, usually found near the altar. They can feature all manner of scenes from witches to Green Men to mermaids. When the seat is occupied they are invisible, but when it is not in use and lifted up they are visible.

THE LOST OBJECTS

years and feature everything from morris dancers to mermaids. The inside of a church is a feast of folk objects and symbolism. However, many of these objects have seldom been considered as 'folk', partly due to the fact they *are* contained within the church, and so any Pagan or non-Christian associations must be downplayed, and partly due to the fact that they are still in active use and therefore blend into the backdrop of church life.

In almost every single church across Britain, there are small canvases of singular folk art that spend most of their time at our feet: church kneelers. They are hand-stitched, usually using cross or tent stitch, and they record everything from local societies and clubs to the solar eclipse in 1999. Their true purpose is, of course, to make kneeling for prayer more comfortable than it would be on stone or wooden flooring. However, they have a use far beyond this practical function; they are records of communities, and all the folklore and mythology that is attached to a particular place and its people. In St Clement's Church in Withiel, Cornwall, the kneelers are particularly notable for their representation of community. Through a series of stitched scenes, a whole calendar year is documented; among the many customs featured there are the harvest festival, Candlemas, St Clement's Day, Plough Sunday and the annual summer fete. It is, in a few short panels, the life of a small village on the outskirts of the moorland.

In places where there are folk customs, the church kneelers almost always record them; at Ipplepen Church in Devon there is a kneeler featuring a maypole and at Wimborne Minster in Dorset there is a kneeler documenting the annual folk festival, complete with morris dancers waving hankies and a merry band with accordions, recorders and drums. At St Nicholas' Church in Abbotsbury, Dorset, there is a kneeler telling the story of a custom lost to living memory. It features a garland from an event known as Garland Day,

127

THE LOST FOLK

where garlands made by children were blessed in the church and then strewn into the sea on 13 May. It no longer takes place as there are not many children in the village today, and the village school has closed as a consequence. Here the Garland Day kneeler acts as a reminder – a memory until there are enough local children for the day to be revived.

We have the tireless work of one woman to thank for the extraordinary community projects that church kneelers come out of – a woman who has almost been forgotten. Louisa Pesel was born in Manningham, Bradford, in 1870, and studied art and design at the Royal College of Art, specialising in embroidery. I first heard about her on a visit to the exhibition 'Unbound' at Two Temple Place in London, which celebrated the work of seven women who had led the way in deeming textiles a discipline worthy of study. Louisa immediately caught my eye for her work with recuperating soldiers during the First World War as part of the Bradford Khaki Handicrafts Club. As part of the programme of activities she taught stitch skills; an altar cloth made by the soldiers under her tuition still sits in Bradford Cathedral today. She was also a founding member of the Belgium Institute in Bradford, which helped refugees find skills while they were waiting to return home, including toy-making, shoemaking and embroidery. It was not, however, until I visited Winchester Cathedral that I discovered Louisa was also responsible for beginning a new wave of kneeler fever.

When she was fifty-two, she moved from Bradford to Twyford in Hampshire, where she carried on teaching, and began taking commissions. In 1931, the Bishop of Winchester got in touch with a request. He wanted some new cushions for his cathedral residence. She undertook the project and he was impressed. Soon, alongside the artist Sybil Blunt, she would embark on one of the largest embroidery projects of her life. In the space of six years, they presented

128

THE LOST OBJECTS

the cathedral with more than 365 kneelers and alms bags. It was a phenomenal achievement. Louisa and Sybil did not, of course, complete all the work themselves; they employed two hundred volunteers whom they taught to stitch, and formed what was to become the Broderers Guild of Winchester, a group that is still going today and works not only on the kneelers but on all other textiles associated with the cathedral, too. The huge project inspired similar schemes in the late 1930s, at Gloucester Cathedral (also supervised by Louisa) and at Southwell Minster. Soon guilds were popping up across the counties of Britain, and people were stepping forward to offer their help. Derby Guild was formed from the project at Southwell, and is, alongside Winchester, one of the oldest surviving embroidery guilds in the country.

At St Mary's Church in Nantwich, Cheshire, the Tapestry Group has been meeting since 1976 in one another's homes and stitching together to create kneelers for the pews of the church. Each pew's set of kneelers has a different theme, with inspiration taken from the history of Nantwich. There are kneelers that depict the remarkably well-preserved Tudor half-timbered buildings, kneelers that show the salt-making industry, kneelers that record the fire that took place in the town in 1583 and one that has panels of Nantwich in the past, present and future with an atomic bomb and a question mark at the centre. Altogether, they tell the story of hundreds of years of this small market town, and ask what will happen in the next century.

Church kneelers offer a brilliant opportunity to understand the folklore of a place. St Mary's Church in Painswick has more than three hundred kneelers, featuring a range of subjects from biblical scenes, including Jonah and the whale, to views of Gloucestershire. The most intriguing, though, are the kneelers that depict the ninety-nine yew trees that sit in St Mary's churchyard. They, more than anything, define Painswick both through their physical presence

THE LOST FOLK

and through the folklore attached to them. It is said that each tree is planted over a spring and that if a hundredth yew is planted, the Devil will appear. Every year, the yews are clipped and shaped into their distinctive cloud-like forms and peace reigns for another year.

Pagan interventions

The people of St Mary's are rightly proud of their kneelers. Sitting at the back of the church is a series of folders with newspaper clippings about the project and hundreds of tiny photographs with captions noting who stitched what. It is an incredibly important record of a place and a community coming together to record the stories and folklore of their village – a tiny archive housed in the back of a church waiting to be discovered. Painswick is a place steeped in myth, but it is almost entirely unknown outside the Cotswolds. Every year on 19 September (or the first Sunday afterward), the people of the village gather together for the Clypping Service – this is, it must be noted, different to the clipping of the yew trees. At the Clypping Service, the children of the village congregate to hug or 'clypp' the church and give thanks for its place in the community. This is not unique to Painswick. Similar services also take place in Shropshire, Derbyshire and West Yorkshire. Afterwards everyone attending was traditionally gifted a 'puppy dog pie'.* This has in more recent times been replaced with a small bun. As part of the service there is a procession through the churchyard. The congregation, headed up by the priest, weaves its way through the ninety-nine yews to the church before stopping in front of it for the service.

Two lost objects once joined this procession: a statue of the god Pan and a large, appliquéd banner on a pole. I first heard of the statue

* Puppy dog pie contains no puppy dogs but is in fact a beef pie which often contains a small ceramic puppy, much like the ceramic blackbirds used in pies elsewhere, to let the steam out.

130

THE LOST OBJECTS

on a trip to Painswick. I'd been staying nearby and was intrigued by the yew trees, so I stopped in to have a look at the church. Having wandered around, I paid a visit to the tiny tourist information office that looks over the graveyard. I chatted for a while to the volunteer about the history of the church and asked about the Clypping Service, which I had read about online. She told me of its importance to the community and of her involvement with it since childhood, and sang a small segment of the Clypping Hymn. The conversation then turned to the origins of the service and at some point, she mentioned a statue of Pan and how it was probably in the churchyard somewhere. She clearly did not want to divulge where it was, so I didn't press her further.

The statue of Pan is certainly mysterious. Its origins are nebulous and unclear. It is said to have once formed part of a processional ceremony that took place from the village to the hill that overlooks it. Pan was held aloft as the party of revellers processed up the hill and engaged in general merriment and frivolity. By the late nineteenth century, the ceremony was defunct and had become part of Painswick's folklore; the figure of Pan was placed in a folly in the gardens of Painswick House. In 1885, William Herbert Seddon arrived to take up his post as the new vicar of St Mary's. He was a classics scholar and deeply immersed in Greek mythology, so he was intrigued on hearing from villagers of Painswick's connection to Pan. He decided it was time to revive this lapsed and seemingly ancient custom – a surprisingly Pagan addition to the calendar by a vicar. William commissioned a local sculptor to make a replica of the statue of Pan that sat in the orangery of the Rococo Garden high above the church.

It is not known why he decided to do this, but at around the same time he also reinstated the Clypping Service, which had lapsed sometime in the early nineteenth century. The two events became

THE LOST FOLK

intertwined and Pan became an essential part of the Clypping procession. Held aloft by the priest, he led the way through the yews to the belltower steps, where William would take his place and lead the children in singing the Clypping Hymn. They would then process up to the woods and come to a stop outside Painswick House.

It is difficult to trace how and where William first discovered this association between Pan and Painswick and whether it truly had any ancient roots. The Cheltenham poet James Elroy Flecker writes in his poem 'Oak and Olive' of 1913, 'Have I not chased the fluting Pan, / Through Cranham's sober trees? / Have I not sat on Painswick Hill', suggesting that perhaps there was some earlier iteration of the procession. However, it seems that it was, in fact, a custom invented in the late eighteenth century by Benjamin Hyett, the then owner of Painswick House, who with a group of friends would process holding a sculpture of Pan made by Jan van Nost the Elder for his folly called Pan's Lodge. The procession died out around 1830, and it is likely that William heard snippets from villagers and elaborated on them to make the connection appear more ancient. In his book *Painswick Feast* he makes the statement 'Not everything Pagan is bad,' an intriguing phrase from a vicar and one that suggests that he had Pagan leanings alongside his Christian faith.[2]

In an issue of *Country Life* from 1996 there is an article entitled 'In the Realm of the Great God Pan', in which Timothy Mowl suggests that there was perhaps a wider cult of Pan that arose in the mid-eighteenth century in Painswick. He makes a connection between Benjamin's Pan sculpture and its processional route to Beacon House, which sits across the road from St Mary's churchyard and was once home to a dining room decorated with ornate plasterwork of acanthus leaves, owls, oaks, pipes and lutes.

I was told by a resident of the village that Pan had once been physically attached to the church, and there is to this day a faint outline

towards the left-hand side of the door. It has been suggested that this is a ghostly shadow of the once-resplendent figure. If you squint you can just about make out the form of Pan.

On the arrival of a new vicar in the 1950s, Pan was seen to be an inappropriate and, no doubt, too Pagan an addition to the service and was quickly disposed of. There are many rumours around what happened to the statue, the most romantic being that he was buried in an unmarked grave somewhere in the churchyard. Some say the figure was later exhumed and placed in the Rococo Garden, where the original statue once sat. However, this is probably incorrect given that there are generally considered to have been two figures, with one always being displayed at the Rococo Garden.*

The bow wow banner

William was also responsible for the commissioning of another lost object associated with the Clypping Service: the bow wow banner. This is a six-foot banner strung on a pole, with appliquéd symbols from Painswick's history: bells to symbolise the Ancient Society of Painswick Youths (the Painswick bell ringing society founded in 1686), a tankard of cider, the yew trees from the churchyard and two crossed pipes, which refer to the fact that Painswickians are known as Bow Wows.

The banner is thought to have been named after bow wow or wow wow sauce. Not dissimilar in taste to Worcester sauce, it was invented in Painswick and traditionally served with roast beef or game, and was so called for Painswick's archaic association with the sacrifice of dogs to ensure a good and productive year of shepherding.[3] Whether this story is true or not, it is interesting to note that William was married

* In recent years the Rococo Garden's Pan has been moved, he now resides in Painswick House.

to a member of the Perrins family, known for their famous sauce, and that a similar rumour prevails in Worcester about dogs being the secret ingredient in the sauce. Whether William had a hand in its invention or not, it is generally considered to be the origin of why and how the puppy dog pie became associated with the feast that takes place after the Clypping, and why the pie features on the banner. Alongside the 'ancient' Pan connection, this strange tale of animal sacrifice and an apparently medieval sauce would have appealed to William in the creation of a service steeped in antiquity, and therefore in authenticity. In order to weave the banner further into the make-up of the service and procession, he also wrote another Clypping Hymn, which is still sung today and makes mention of the banner in its chorus:

Brightly gleams our banner
Pointing to the sky,
Waving wand'rers onward
To their home on high.

The banner was lost at some point. It is not known where or even when it disappeared. There is only one known photograph of it and this, as well as the distant memories of older Painswickians, is the only lasting reminder of its existence; perhaps it disappeared at a similar point to Pan. Perhaps it is buried with him. We probably won't ever know, but in the early 2000s, Christine Sheldon made a replica of the bow wow banner, using the photograph for reference. It now once again joins the procession and is held by two attendants. The puppy dog pie also made a comeback when the feast was revived in 2014, and on the day of the Clypping, the pub across the road from the church does a roaring trade in them. On my visit I was happy to find they contained no puppy dogs, just steaming beef encased in pastry, a welcome delicacy after a cold morning watching the service.

Enid Baker dressed as the 'Merchant's Daughter' and Miss Small dressed as the 'Wealthy Merchant', as part of The Pageant of Ludlow, held July 1934, Ludlow Castle, Shropshire

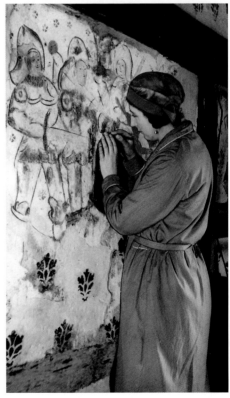

Top: An unknown group of people visit an unknown model village

Right: Elsie Matley Moore restores one of the murals at The Commandery, Worcester, Worcestershire, 1935

Top: Wattle & Daub Hut built by John Sebastian Marlowe Ward at The Abbey Folk Park, New Barnet, c.1930

Bottom: Ernie 'Oxo' Lesley Richardson's Wonders of the Deep cart, c.1930

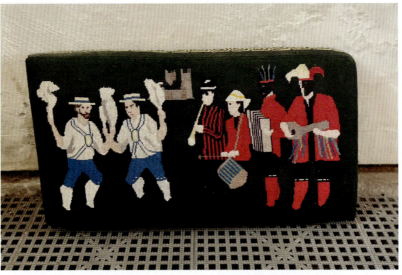

Top: 'The Garden of Eden' topiary garden created by David Davies, Glyn Aur, Abergwili, Wales, c.1932

Bottom: A church kneeler showing Morris Dancers at Wimborne Folk Festival, Wimborne Minster, Dorset, September 2023

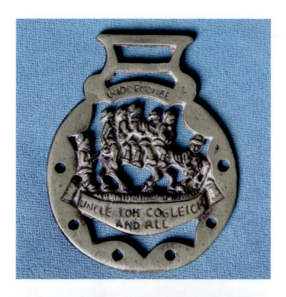

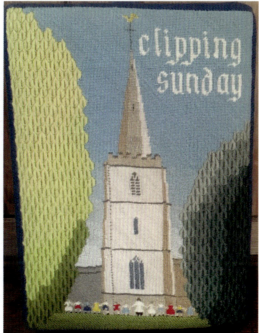

Top: Widecombe Fair Horse Brass, unknown date

Bottom: A church kneeler depicting Clypping Sunday, St Mary's Church, Painswick, Gloucestershire, September 2022

The Lion outside the Star Inn, Alfriston, East Sussex, May 2024

The bargeware painted bar, Snowdrop Inn, Lewes, East Sussex

Left: Ami the ship's figurehead before she was restored, Upton Slip, Falmouth, Cornwall, January 2024

Right: Souvenir replica of Ami the ship's figurehead, unknown date

Left: Plaster pigs that were once a butcher's sign, before their restoration in 2023, Folkestone, Kent

Bottom: 1st Sedgley Morris Men's badges, c.1980

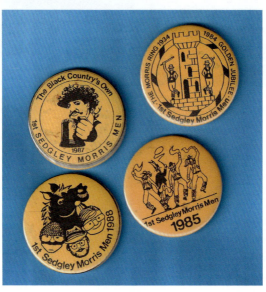

THE LOST OBJECTS

Maiden's garlands

A series of paper hands with tiny little cursive lines of pencil text inscribed onto their wrists hang from crowns set high in the eaves of St Mary the Virgin church in Abbotts Ann, Hampshire. They are curious things. The crowns are made of hoops of wood, obscured by fringed rosettes of black-and-white cut paper. At Holy Trinity Church in Minsterley, Shropshire, a similar paper crown decorated with folded paper rosettes hangs from a beam, and in St Giles Church in Matlock, Derbyshire, two paper crowns sit in a glass cabinet, both decorated with similar paper flourishes. The clue to all of their histories comes from a handwritten label in the cabinet next to the Matlock crowns. It reads 'The Crantses or Maiden's Garlands, between 150–200 years old'. When I read this, I was deeply intrigued firstly by the antiquated and strange word 'Crantses' and secondly by the term 'Maiden's Garland'. The images it conjured up were of some strange forgotten Pagan past; who were the maidens? Why had their garlands been kept for hundreds of years? The answer is rather sadder than I had first imagined, and also makes sense of why they hang in churches across the country. They are funerary mementoes, generally made in celebration of the life of a virgin or maiden. The crowns would have paper gloves, collars or handker-chiefs suspended from them and the names of the maidens would be written on these, alongside their date of death and sometimes a few lines of poetry. Occasionally they also had eggshells, ribbons or real flowers attached to them. Many of the women were very young, but there are also examples of women who died in later life being memorialised in this way. The garlands made up part of the funerary procession and were usually placed on the coffin, before being hung in the church afterwards. The use of flowers, paper and gloves seems to reiterate the message of purity and innocence that a maiden would have represented within the eyes of the Church. However, there is

THE LOST FOLK

certainly a sense that something more ancient is being preserved in these elaborately embellished paper creations.

The term 'Crantses' appears to derive from a Dutch word, *krans*, meaning 'wreath', and appears notably as a word for these particular type of garlands in *Hamlet*: 'Yet here she is allowed her virgin crants, / Her maiden strewments and the bringing home /Of bell and burial.'[4]

According to the folklorist Christina Hole, the oldest Crantses are at Alne in North Yorkshire, and date from 1709,[5] but it seems there is an even earlier example at St Mary's Church in Beverley, Yorkshire from 1680. All of them can still be visited today. The same cannot be said for the Eyam Garlands about which the Romantic poet Anna Seward wrote in her poem 'Eyam':

> *The gloves suspended by the garland's side,*
> *White as snowy flowers with ribbon tied,*
> *Dear village! long these wreaths funereal spread,*
> *Simple memorials of the early dead.*

These garlands have long since been destroyed. The illustrator and natural scientist Llewellynn Jewitt recorded in 1860 a letter he received from an Eyam-based historian, William Wood: 'No garlands now remain in Eyam Church, it was re-pewed some 30 years ago, and several faded garlands were taken down and destroyed then.'[6] A similar fate seemingly met the garlands in St Michael's church in Hathersage, Derbyshire. In 1818 it was recorded that they were 'covered with dust, and the hand of time had destroyed their freshness'.[7] I can only presume that they were also destroyed, given that they are no longer on display.

For the most part, the tradition has completely fallen away. There are remnants of it in Derbyshire, where at Holy Trinity Church in Ashford-in-the-Water a garland was made for Joy Suzanne Price, who

THE LOST OBJECTS

died at the age of seventy-two in 1995. At Abbotts Ann both modern and ancient gloves hang together. According to the parish website, in order to be remembered in this way you 'must have been born, baptised, confirmed and have died, unmarried, in the parish, and must have been of unblemished reputation.'[8] The last funerals to include garlands happened there in 1953 and 1973, and interestingly, although elsewhere in the country they are usually reserved for young women, at Abbotts Ann there are thirteen made for young men. This is not the only place where garlands were made for young men. In 1861 Hubert Smith records an example at Astley Abbotts, Shropshire: 'Upon a garland suspended from the sounding board hangs a pair of white kid gloves, and from an inscription we learn that Henry Phillips died in 1707, when presenting himself at the altar to be married. The lady to whom he was about to be united survived him but a short period.'[9]

'Famous' lost folk objects

Although most of the lost objects covered thus far have disappeared from public consciousness, there are instances in which lost folk objects can gain cult status. Further south, Dorset is home to one of the most recognisable symbols in the world of folklore, the Dorset Ooser, made famous for gracing the cover of the book *Reader's Digest: Folklore, Myths and Legends of Britain*. The cover is entirely black, with a line drawing in gold of this fearsome beast with large googly eyes, a menacing grimace and huge horns. He is certainly a sight to behold. But what was the Ooser?

The Ooser

Well, his story is a curious one, and has more than its fair share of overlap with the lost objects of Painswick. If you visit Cerne Abbas on 1 May at dawn, you will find the Wessex Morris Men dancing with

THE LOST FOLK

a giant robed figure sporting an Ooser head. It has a clapping jaw and sways gently alongside the morris men as they dance up the May Day sun. This is its only outing in the year: the rest of the time it lives in a display cabinet at Dorchester Museum next to an object that looks decidedly similar but much more frightening. Its companion is a smaller head made from clay with hair sprouting from its face, huge yellow eyes and a strange, mottled complexion. Both heads are replicas. The Wessex Morris Men's Ooser was made in the 1975 by John Byfleet, and the gruesome clay head was made in 1990 by the ceramist Guy Sydenham. They were both based on the only two existing photographs from the late nineteenth century of the Ooser head. Shortly after the photographs were taken by Yeovil-based photographer John W. Chaffin, the Ooser vanished. What happened to it is shrouded in mystery. Some have suggested it was sold by the Cave family, who had, until its disappearance, been the custodians of it for as long as anyone in the village of Melbury Osmond could remember. There are several contemporary recollections of it being stored away out of sight, with locations as various as the church vestry and the local malthouse being cited. It certainly hadn't seen the light of day in a great many years before John Chaffin snapped its portrait. Other stories allude to the head being stored in the murky recesses of an attic belonging to one of the Cave family's distant relatives in Crewkerne, left in the darkness to rot. By the time anyone realised that it might have been up there, it would have long since been munched by woodworm.

The truth is that no one truly knows what happened to the mysterious Ooser. Accounts from the late nineteenth century imply that it had not been in use for decades, and it is thought that, although it was in a bad state of repair by this point, with clumps of hair falling out, it's likely that it was sold, and that it further disintegrated before being turfed out with the rubbish. Its strange, otherworldly appearance, I cannot help but think, did not help secure its rescue.

THE LOST OBJECTS

Its original purpose has been forgotten, too. There is speculation that, like the celebrations in Painswick, it was part of a cult of Pan, or that it was used as part of a custom known as a skimmington, in which the people of a parish would parade through the streets making a huge racket with pots and pans, and other kitchen implements, while wielding a beast on a stick (and potentially creatures such as the Ooser). Skimmingtons were used as a way of ridiculing or jeering at people within the community who had committed adultery, husbands who were beating their wives, wives who were seen to be flirting outside of their marriage or those who had formed unions of which the community did not approve of. The form of music people played on their pots and pans was known as rough music, and it certainly caused a din. It was used as a way to drive the wronged from their homes, and humiliate them publicly. The practice was known in Somerset, Scotland, Lancashire and North Yorkshire as stang riding or riding the stang, in Warwickshire as lew-belling, in Cornwall as a shallal and in Wiltshire as wooset hunting. These were gruesome affairs, with members of the parade dressing up in costumes made to mock the offenders. There are accounts, too, of effigies being placed on wooden carts and paraded through the town before being ritually sent up in flames – a custom known as ran-tanning. The animal effigies that accompanied the proceedings were generally hideous: horned beasts, donkeys and strange beings that sat somewhere between human and animal.

It is not hard to imagine the Ooser forming part of such a riotous procession, his grimace looming out from above a rowdy crowd of people clattering their saucepans and sounding their horns. Thomas Hardy recorded such a racket in *The Mayor of Casterbridge* (1886), writing of a 'din of cleavers, kits, crouds, humstrums, serpents, ram's horns, and other historical kinds of music'.[10] Of course, it cannot be known with any certainty whether the Ooser was used as part of

139

such a proceeding, but it does seem likely given its truly terrifying expression. That he has been reinvented and is now being used in a celebratory way to bring up the sun is testament to how customs and their accompanying objects can evolve.

Widecombe Fair

In September 2024 I visited the village of Widecombe in the Moor on Dartmoor in Devon. I was there to visit Widecombe Fair, where, since the early nineteenth century, people have gathered together to trade cattle and sheep. Nowadays the fair is centred around a celebration of farming practices and rural life as opposed to any trading. You may have heard of the fair thanks to the well-known folk song of the same name, favoured in schools across Britian, which was written about a visit to the fair. In the song, a man called Tom Cobley borrows a horse from a man called Tom Pearce. He rides the horse to the fair and lets a number of his friends join him on its back. On the way back across the moor, the horse dies. It has been suggested that the song records an ancient, now lost, folk custom similar to the Mari Lwyd tradition in South Wales or the 'obby 'oss in Padstow. However, there is also said to be evidence that Tom Cobley did actually exist, and that his friends did too, in the form of what is thought to be his old carved wooden chair in the souvenir shop in the village. Whatever the truth, like the Ooser, the song has gained legendary status in folk terms, spurring on a whole trade of souvenirs and paraphernalia featuring the men named in its lyrics. It has also been illustrated by numerous people, including Pamela Colman Smith, who painted each scene of it to accompany a version published by the Devonshire folklorist Sabine Baring-Gould.

The object relating to the song that interests me most is one of more humble origins. In the late 1950s, Harry Price, a sailor from the

nearby village of Drewsteignton, took it upon himself to recreate the scene of Uncle Tom Cobley and all his friends sitting on Tom Pearce's horse on their way to the fair from scraps of wood. He set about carving each of the characters and made the scene fully mechanised, so that the horse galloped and a dog at the back of the model snapped at the horse's hooves. The model was shown to great acclaim at Widecombe Fair in 1959 and 1960. It then disappeared for some years. Given that Harry was reported as being eighty-two in 1960, I can only presume he died and it was packaged up into a box for safe-keeping for a few years. It transpired it had been sent by an unknown party to a craftsman in Launceston for repair. Alas the craftsman died before he was able to bring it back to its former splendour, so back into the box it went, and there it remained until the widow of the dead craftsman discovered it and sent it to Widecombe Fair Committee in 2008. At this point it was in pieces, and almost unrecognisable. The committee decided to embark on a full-scale restoration and employed the services of three members of Widecombe History Group: engineer Mike Wright, woodworker Sid Pontin and painter Aileen Carrett. The model was put back together and painstakingly brought back into being. It now has pride of place each year at the fair once again, and in the days in between it lives inside the parish church for all to visit.

Finding lost objects

Despite the cult status of the Ooser and of the Widecombe Fair song, objects associated with them have still been lost or destroyed. So what hope do folk objects with less status have for survival?

Call-outs for folk objects are incredibly useful ways of collecting items that would perhaps otherwise end up in skips or bins, or items that have been long lost. The Open Morris, the Morris Federation and the Morris Ring all now have active archives. They all regularly

put out calls for photographs, objects and related ephemera associated with their various morris sides.

In 2020 I received an email from a friend from the Open Morris, stating 'perhaps this is of interest'. I scrolled down to find a message from a man called Michael Sewell. He had been, for many years, part of a morris side in Lincolnshire called Allington Morris. Although he had hung up his bells and hankies many years before, he had kept one very important object from his years as a morris dancer. The object in question was a full-size pantomime donkey called Igor that Mike had lovingly built as the mascot for his morris side, and Igor's life was in jeopardy. Mike was having a clear-out and needed to find a new and loving home for his donkey. At the time no one had taken up his offer, perhaps due to Igor's enormous size. I wrote to Mike and explained that I'd like to help. I wasn't sure how; we were in the middle of a global pandemic and I was stuck in Cornwall, but I was determined. Some months passed with much conversation and planning, and eventually Igor was collected by Tatters, a morris side in Redruth in Cornwall. Igor has an active life once again and is not only part of Tatters but also has a role in the mumming play that they perform every Christmas.

Lost signs

When I was a child, my mum would frequently say to me when wandering through a new town or village, 'Look up.' It is an important lesson, in that so much of our lost folk history is contained in the remnants of old signs and shopfronts. What follows are just some examples of the folk signage disappearing from our streets.

Shop signs

On an unassuming street just up from the Old High Street in Folkestone, Kent, are two plaster pigs. They each sit above a

THE LOST OBJECTS

colonnade. They are bright pink with piercing blue eyes and snarling mouths. The building below is now a private residence but was once home to Thomas Taylor's pork butcher's shop. The butcher closed in November 1973, but the pigs remain: a fragment of a now-forgotten high street. I first spotted the pigs on a visit to Folkestone in 2022; they were looking rather the worse for wear, their trotters crumbling and their faces in need of a new slick of paint. I posted about them on Instagram, not mentioning that I thought they needed repairing but rather that I thought they were magnificent. A year later, they had been fully restored, and were looking resplendent. Whether or not this was due to my own celebration of them, it gave credence to the notion that talking about and highlighting objects can lead to their restoration and a renewed sense of interest and life force being injected into them.

If you look up, high above Nevill Street in Abergavenny, Monmouthshire, you'll see six plaster bull heads. They sit beneath the guttering of a building, gazing down at the street below. On the second-floor window frames there are also bull heads at each corner and a frieze featuring dragons, blue foliage, red and white roses and tiny faces. It would be easy to miss the entire scene if your gaze didn't rise above the café at street level. Why are the bulls there? The street was once known as Cow Street, as it was where cows were paraded before being taken to the slaughterhouse. The building was originally home to the Cow Inn, and the bulls marked the spot for a pint: a clue to the hidden history of this market town, the bulls' heads offering the last glimmer of insight to its former life.

Other signs have not fared so well: in Grimsby, Lincolnshire, on the corner of East St Mary's Gate and Victoria Street, there was once a pie shop called W. E. Fletcher's, and until it closed in the 1950s it had three icons carved from stone attached to its frontage – a monkey, a pig and a pie. The shop was famous for its pork pies and sausages but for many years was known as the Monkey Shop due to

THE LOST FOLK

its sign. The story as to why a monkey was affixed to the frontage of the shop is steeped in folklore, but what came first: the pig or the monkey? Some suggest that the disgruntled mason who was asked to carve the pig and pie was much affronted when the shopkeeper wouldn't allow him to go to the pub after finishing work, so in anger he set to work on carving a monkey rather than another pig.[11] Others talk of the monkey being made of iron and the pig and the pie of wood.[12] However, these stories are all disputed by Mary Thompson, the daughter of the last proprietor of the shop. In 1978 she told the *Grimsby Evening Telegraph* what she believed to be the real tale of the monkey. According to her account, in the first years of the shop being open, a sailor had run in and handed over the stone monkey to the shopkeeper, offering no explanation other than asking that the shopkeeper keep it safe. The sailor then ran out of the front door, never to be seen again. The shopkeeper held on to the monkey as asked and displayed it inside the shop, and then in the window, and then eventually outside, having a pig and pie carved to keep it company.[13] It's certainly a wonderful story, and whether it's true or not, the shop is still remembered in Grimsby today, even though it closed over fifty years ago and the signs are no longer present. The pig, the pie and the monkey were saved by the Fletchers when the shop was closed, and in the late 1970s they retired to a life in Mary's garden. They were photographed with Mary proudly holding the pie – and were all clearly made of stone. This is the last time they were mentioned and I can find no further record of them.

Pub signs

You don't have to look quite so hard to see another fast-fading but extremely vital part of Britain's folk history: pub signs. For hundreds of years, inns, taverns and pubs have made up a large part of any townscape – places for meeting, making merry and immersing yourself

THE LOST OBJECTS

in the distinctive culture of an area. The signs that accompany them are the signal to the outside world, to the traveller or lone visitor, to visiting families or locals: we sell good beer, we are warm, we are dry, we are a place of company and of conversation. They are often hand-painted by a signwriter or sculpted by a local craftsperson and usually, like church kneelers, record aspects of a place such as folk customs, Green Men and standing stones. They are firm markers of the ephemeral facets of a town, and are something we should revere and treasure. However, they are being quickly lost with the advent of chain breweries, and a generally more uniform approach to what a sign should look like. The idiosyncratic aspects are being done away with and replaced with generic, mostly 2-D images of wheatsheafs, swans and kings' heads.

Thankfully, there are a number of pubs that buck the trend; in Salisbury you will find the Wyndham Arms, with an ornate carved and painted Bacchus head above the doorway. It is dual-sided, with a face both front and back, sporting a wreath of grapes around its head. In Alfriston in East Sussex there is the lion that sits outside the Star pub, thick with red enamel paint from years of repair, and in Malvern in Worcestershire a unicorn sits atop the porch of the aptly named Unicorn Inn.

However, there are also almost entirely lost forms of signage called living signs. For many years this was a very popular way of luring people into a shop or pub, and Britain was home to a great many. Living signs were, as they their name suggests, signs that, unlike their 2-D counterparts, were imbued with life and movement – signs such as beehives that contained actual living bees or bells that rang when the wind blew them. It was seen as great novelty to have a living sign, an added enticement to passers-by and punters alike to part with their money in your establishment rather than in the pub across the street. However, they were also short lived. In his book *The History*

145

THE LOST FOLK

of Signboards (1866), Jacob Larwood describes how, as quickly as they were taken up, they were being replaced: 'No sooner were people seen swarming about this hive than the old signs suddenly disappeared, and Beehives, elegantly gilt, were substituted in their places.'[14] Jacob suggests this is because shopkeepers and landlords were copying one another and therefore the novelty was wearing off; I would suggest it probably also had to do with the upkeep, because a living sign is far more time-consuming and costly to maintain than a hand-painted one – it is a long-term investment.

Nevertheless, there are a few living signs that survived the change to 2-D signage. Perhaps the most famous one sits outside the Beehive pub in Grantham, Lincolnshire. First you will hear the buzzing, then if you look up you will find a beehive teeming with bees, and on looking to your left you will see a sign reading 'The Beehive Pub'. An ingenious method of beckoning people in from the street. There is a sign nearby that bears the famous rhyme: 'Stop Traveller! This wondrous sign explore. And say, when thou has viewed it o'er, Grantham, now two rarities are thine: a lofty steeple and a living sign.' A more common living sign, perhaps due to its lesser level of upkeep, is a bell: the Five Bells in Salisbury, Wiltshire has five that ring when the breeze blows, and the Bell at Tewkesbury in Gloucestershire has a single large bell high above its door. There are innumerable other bells that dangle from pubs across the United Kingdom, paying homage to the bell ringers that once graced their bars and seats.

The lost fragments of a street's or town's history are nowhere better depicted than in the names and signage of pubs. There are pubs that record great historical events – such as the Driftwood Spars in St Agnes, Cornwall, named after the spars* salvaged from a

* A pole used in the rigging of a ship, usually made of wood or metal; in this case they are made of wood.

wreck in the seventeenth century – and pubs that record the people who frequented them, from the ecclesiastical pub the Cardinal's Hat in Worcester to the Tinner's Arms in Zennor, Cornwall, where tin miners could once be found nursing a pint.

In Framwellgate Moor in Durham, there was a pub called the Thunderstorm, which recorded a particularly momentous storm in the seventeenth century. As memory of the storm faded, the pub was renamed and became the Traveller's Rest before closing in the early 1960s. This is a common theme – pub names that morph and move across time – so it is perhaps no wonder that again we are seeing a change in names and signage; in order to remain relevant, the pub must evolve. Many pub names and signs record pieces of history that are deeply problematic but nevertheless have found themselves deeply embedded in the towns of Britain.

Facing up to the past

In Killay in Wales, there is pub that until the 1970s had a sign featuring a young Black boy wearing a bejewelled turban; it is called the Black Boy. At some point, the sign was quietly repainted and changed to a young white boy with charcoal on his cheeks, as if he had come straight from the coal mine. It was subsequently repainted again and now features a young white boy who has his head turned, gazing into the distance, his face mostly obscured in shadow. This act of 'white-washing' is not a new phenomenon: in 1866 Jacob Larwood records that 'a woolpack, with a negro seated on it, was at one time very common' and that once these signs were considered unfashionable they were 'washed white, and thus became a naked boy, which in signboard phraseology, is equivalent to an angel'.[15] This act of obliter-ation, however well intentioned, prompts a difficult and conflictual conversation. Is it right that we literally paint over history, when it confronts us with problematic questions about our collective past?

The Swansea-born writer Darren Chetty points out that as a young half-Indian South African and half-Dutch boy, the sign of the Killay pub 'was the only black person I saw in Swansea'.[16] The Welsh artist Daniel Trivedy makes a similar point. He first visited the pub in 2012 and was confused by the mismatch between the name and the sign. He eventually tracked down the original sign in the Whitbread Breweries archive. He had it reprinted alongside the new sign, and displayed them in unison at his degree show exhibition in 2013. In an article published alongside the exhibition he stated that 'to ignore the black presence in our history (and pub signs) is to deny the roots and heritage of multi ethnic Britain'.[17]

There are many reasons given for the name. Some pubs suggest it is linked to the rumour that King Charles II was of mixed heritage, some suggest it represents an enslaved child, others that it is merely a reference to a chimney sweep and others that it represents coal dust. What is certain is that many of the images that found their way onto pub signs are deeply offensive in their depiction of Black people and Black culture. The Guyana-born artist Ingrid Pollard has collected references to Black Boy pubs and signs for over twenty years, and in 2019 pulled this research together in an exhibition entitled 'Seventeen of Sixty Eight',* for which she assembled banners, signs, photographs and ephemera. Nothing was labelled and the viewer was invited to find their own explanations. Ingrid makes the point that if landlords 'get frightened by media interest, then they'll just change the sign. When you do that you wipe out 500 years of history of that sign and its connection to the local community'.[18]

The problematic representation of people in signs and pub names is by no means confined to pubs called the Black Boy,

* 'Seventeen of Sixty Eight' was shown as part of the BALTIC Artists' Award exhibition from 15 February to 16 June 2019, and at Tate Liverpool as part of the 2022 Turner Prize exhibition.

either: there are many Turk's Head pubs across Britain, and there have been (although these have now been renamed) pubs called the Black's Head and the Black Bitch – a campaign in 2022 saw this particular pub in Linlithgow, Scotland, renamed the Willow Tree. Although the modern sign bore a picture of a black dog and the name is said to have derived from a popular thirteenth-century folk tale, campaigners suggested that it could have been perceived offensively. The community of Linlithgow maintains that the name is not racist in origin.

Folk objects from naval contexts can transport us into the murkiest parts of Britain's history. They can tell us stories of people who have been brushed under carpets, even maligned and abused. In Bristol, for many years, a salvage from the wreck of the ship *Demerara* hung above a mattress and bedding shop on Steep Street. Early Edwardian photographs show a towering figure wearing a tobacco-leaf head-dress and draped with swathes of fabric, with one hand holding a spear and the other hand a piece of fruit: a clue to Bristol's long involvement with the slave trade. Like the signs of Black Boy pubs, this figurehead is a reminder of the distressing colonial past associated with many of Bristol's streets and buildings. The figure was removed in 1931, not because its history was being reviewed but due to the building being demolished, and in 1932 it was presented to the Bristol Savages Art Society (renamed Bristol 1904 Arts in 2020) for safekeeping at its headquarters, the Red Lodge. At this point in its story, the figure 'was found to be so decayed from its long exposure to the weather that it could not be set up there as was intended'.[19] It's not known what happened in between, but at some point in the early 1940s, Mr Reginald Bussell bought the last remaining piece, the fruit from the figure's hand, and donated it to Bristol Museum and Art Gallery, where it is still housed today. This, however, is not the end of the story. The Drawbridge pub on St Augustine's Parade in

THE LOST FOLK

Bristol now rather oddly bears a replica of the *Demerara* figure. It was erected in 1969 on the front of the pub, and not unlike Black Boy pub signs, the replica figure has been painted white and given Westernised features; the problematic reason for its existence has been entirely erased. The question is: why did the pub decide to link itself with a deeply offensive representation of an African Caribbean man? Was it that the owners didn't know the history and simply saw the figurehead as an example of Bristol's naval heritage? It is hard to imagine not anticipating the racist connotations that the figurehead would evoke. The fact it was painted white suggests that there was an attempt to wash over the history.

It is true that erasing history is incredibly dangerous, and although there is no doubt that these signs should not be re-erected, there is room for a much broader and more involved discussion about how pubs might deal with their histories. To just rename them, wash over the sign with a willow tree or a white child and forget about the matter altogether is not an answer. We must engage with the fact that Britain has been, and often remains, a place of extreme racism. If we erase these images from our past, we work at erasing the crimes and acts that have been committed by and towards people, and we create a climate in which it becomes acceptable to brush over and forget when really we should be working towards cultivating a space in which we talk about the past.

There are ways of thoughtfully renaming and re-signing pubs; it doesn't have to be through erasure. Throughout history, landlords have also taken names from the past as a way of commemorating groups of people who have been forgotten in life. The Snowdrop Inn in Lewes, East Sussex, offers a brilliant illustration of this approach. On 27 December 1836 a huge avalanche fell from the downs above Lewes onto a row of cottages called Boulder Row. Numerous people died, although there is no definitive account of how many in total,

THE LOST OBJECTS

due to the cramped living conditions of the row of houses. These had been the homes of the poor, pushed to the very edges of the town, at the end of a long street with chalk cliffs towering above their tiny and packed cottages. In 1840, the building where the pub now stands was erected on South Street, just up from where the snow had fallen, and it was named in memory of the disaster by a landlord in the early twentieth century – a place for the nameless dead, who were overlooked in life, to be commemorated. Over time the pub became a place where local barge workers and boatsmen drank, due to the presence of the navigation pit behind the pub, where chalk from the cliffs was loaded onto barges, and the pub interior was evolved to celebrate this. A barge-ware painter was commissioned to paint the bar with traditional rose-and-castle designs; green, red and yellow enamel paint now adorns every surface, and the pub has become a folk object in itself. The sign still has an image of the snow tumbling down the cliff face and enveloping the homes below, a chilling reminder of the disaster it was named for.

Pubs are like patchwork quilts. They are encapsulations of people, of their lives, their work and their stories, which are often messy and complicated and hard to pin down to any form of linear history. They can offer up challenging narratives and test the ways in which we look at ourselves and our ancestors. However, the pub is a place where the lives of working people are told, and there are very few other tangible places where these stories are presented. Perhaps there is a way of retelling the history of pubs like the Black Boy that doesn't eradicate the bad aspects of their history, but instead uses pubs as places to discuss difficult histories, as places to investigate and explore our relationships and communities, and places where we can come together.

Ships' figureheads

The carvings featured at the front of ships crop up frequently in signage, saved from shipwrecks and re-utilised as eye-catching signs. The Ship Inn in Polperro, Cornwall, is home to a figure taken from the helm of a ship. She is dressed in blue and gazes into the distance. Likewise, the Red Lion in Martlesham, Suffolk, is home to a fearsome-looking red lion that protrudes from the exterior wall, and outside the Prince of Wales Tavern in North Shields, North Tyneside, is the Wooden Dolly, a huge figure of a woman with a red dress and black hair. She is thought to have once been a former figurehead placed there in the early nineteenth century, but is now said to be the sixth replica of the original due to the local custom of people carving a slice from her bottom for good luck.[20]

Sadly, vandalism is fairly common when it comes to figureheads. Down a narrow lane called Upton Slip in Falmouth, Cornwall, you can find Ami. She is a six-foot carved bust of a woman. Her hair is swept up into a bun; she has bright red lips and an expression somewhere between mournful and angered. Something of a local legend, Ami* has weathered all manner of cruelty in her life down the slip. She was originally placed there by a local chandlery as a sign for its premises after floating ashore from the wreckage of the British cargo ship the *Amazon* in 1852, and in the ten years I have known her she has encountered numerous attacks, from being peed on by drunks to a far more sinister episode when her face was slashed in 2019. She has been repainted numerous times and currently sports a blue dress; in the past it has been canary yellow and ruby red. Originally it was emerald green. I only know this because I stumbled upon a tiny replica of Ami in a junk shop several years ago which now has pride

* It's not known why she was given this name, but it is recorded in press cuttings from at least the 1960s.

THE LOST OBJECTS

of place on my mantelpiece.* Thankfully in 2024 Ami was once again restored, with her numerous slashes filled with wood filler and a fresh lick of paint applied to her face and dress. Both Ami's turbulent life and the tale of the Wooden Dolly tell us a lot about the way in which effigies of women in the public sphere are often treated. Senseless acts of brutality have been inflicted on them, and they are constantly in jeopardy of being so badly damaged that they have to be destroyed or replaced entirely.

Many figureheads have disappeared from the pubs or shops they were associated with. The Pandora Inn at Restronguet in Cornwall once had a figurehead, and the pub is in fact said to have been named after her, given that she once adorned the *Pandora*, a ship that sank on the Great Barrier Reef in 1791. She was sold at auction in 1963, and was at the time said to have been riddled with dry rot, so it's likely she has since disintegrated. At the Pilchard Inn on Burgh Island, South Devon, a figurehead greeted visitors before they were whisked inside to an interior that bore much resemblance to the Admiral Benbow. These days both the figurehead outside the pub and the packed interior have been done away with in favour of a more minimal aesthetic. It's not known what happened to the figureheads. At Deal in Kent a now-defunct pub, the Admiral Penn, had a figurehead of a woman with long blonde hair and a green dress, her eyes cast far into the distance. The pub closed in 2004 but the figurehead is still attached to the building, which was converted to a house. It is the only remnant of a pub that had welcomed punters through its doors since the early 1800s. This is by no means an unusual occurrence: there are examples of 'ghost' signs across Britain – that is, signs that once showed the way to a shop, pub or service. Quite often it is clear what they were for, which offers a clue to the history: a baker, a printer, a

* The Admiral Benbow also has a tiny replica of Ami on one of its shelves.

carpenter. Sometimes, as in the case of figureheads, their meaning is entirely lost. They are just a remnant of something that was once present but is now absent. Often their histories are obscure, and therefore they are perhaps even more in danger of being destroyed – without an institution or entity attached to them, they quite often disappear quietly, without anyone really noticing: removed, painted over or just left to slowly fall apart.

Mass-produced folk objects

One can meet resistance when attempting to discuss objects made with commerce in mind as folk. Usually not made by hand, products such as souvenirs do nevertheless record important aspects of a place and its people that would be forgotten or lost otherwise. Let's delve a little into the argument in favour of these being regarded as folk.

Souvenirs

Tea towels, T-shirts, badges and postcards are all miniature encapsulations of folk traditions and customs, and should, to my mind, actively be collected.

In Cardiff, there is a shop lined from floor to ceiling with tea towels adorned with recipes for Welsh cakes, the lore of love spoons (with intricate illustrations of the spoons themselves), traditional costumes and Welsh-to-English translations. They are cheap and plentiful, and this is a scene that is repeated in shops from Polperro to Edinburgh, the only difference being in the subjects they depict. I only recently came to appreciate the allure of the tea towel as a form of folk, and have begun to seek them out whenever I'm in a new place. I've recently acquired tea towels that memorialise Babbacombe Model Village and the Smallest House in Great Britain, located in Conwy, North Wales, as well as one that has diagrams on how to make a corn

THE LOST OBJECTS

dolly, and another that features a scene taken from a narrowboat, with swirling roses and a castle on a hill.

Badge souvenirs are another matter altogether: I have collected them for as long as I can remember. I am hard put to find a more maligned or ignored form of folk culture, and yet they are one of the most ubiquitous and universally accessible forms that folk can be presented in. They are bought in a feverish moment and discarded just as quickly, or pinned to a jumper and lost somewhere between the day out and the trip home. A badge is a fantastic example of a lost folk object in plain sight. There are badges made to record almost every folk festival, folk custom, historic property, church, town and pageant in Britain, and charity, junk and antique shops are stuffed full of them. Hunting for them requires just a little patience and time, and with that you will be rewarded with small snatches of a precise time and place. On a recent hunt in a well-known Brighton antique shop, I was pleased to stumble on three badges from a 1980s performance of *Jack and the Beanstalk* in Hastings. They feature full-colour illustrations of Jack climbing the beanstalk: a performance that would have ultimately been lost to time if not for these badges. Likewise, a series of badges I was sent by a friend records a morris side from the Black Country that I had never encountered before the badges: 1st Sedgley Morris Men. They are still dancing today, and after posting these badges on Instagram I received a series of messages from people sharing photographs and videos of their recent performances.

As well as recording folk customs and traditions, badges often have a central role in folk costume and folk dances. When watching a performance of morris dancing, you will regularly find the dancers and musicians utilising badges on their kit, be that through a badge-adorned hat or in the form of a waistcoat emblazoned with badges from other morris sides and folk-dance competitions. Badges

155

also crop up in the costumes of pearly kings and queens, the pearly button-clad fundraisers who wander the streets of London collecting for all manner of good causes. Their jackets, as well as making use of hundreds of buttons, often have an array of badges and pins from events they've taken part in and charities they support.

Pamphlets, flyers and programmes for folk events offer further opportunities to discover information about times and places past that would otherwise completely fade: souvenirs of a different sort. I have already spoken about the difficulty paper often faces when pitted against more shiny and tantalising objects, but the pamphlet box or shelf in a charity shop, book sale or library can offer up untold wonders in the pursuit of uncovering lost folk. Very often I will discover whole new facets of a community's folk practice through a pamphlet. I recently unearthed a programme for a Mullion village fete in 1960, a pamphlet on Ilfracombe's Pixie Day Parade and the original visitor's booklet for Cregneash Village Folk Museum on the Isle of Man, all of which sent me spiralling down rabbit holes of research.

The discovery of second-hand souvenirs in charity shops and car boot sales offers an opportunity to engage with folk customs and tiny museums that otherwise would be completely unknown to me – places that are far away from my home in Cornwall. They give the chance to travel both geographically and through time, to journey to May Day in Knutsford, Cheshire, in 1963 or Bonfire Night in Glasgow in 1984, and while you may know nothing else of that moment beyond the particular souvenir, they serve as a small reminder that it took place and that someone enjoyed it enough to buy a pamphlet, badge or tea towel to remember it by.

Horse brasses

Horse brasses can at first seem insignificant: they are now mass-produced pieces of metal often seen in piles in charity shops and

THE LOST OBJECTS

junk shops, rarely considered in any depth, and yet they are tiny snippets of folk magic. Originally used to adorn horses, they were considered to ward off the evil eye, protect the horse and bring good luck to the owner. These days they could be considered to perform the same function in many ways, but now in the environment of a pub or home, much the same as a witch mark on an old door or window frame might once have been used, or a horseshoe would have been hung outside a house. The brasses' decoration varies in theme. Many rely purely on symbols: suns, crescent moons, stars and hearts are popular motifs, and others depict animals such as cats or horses, or places such as Tintagel or Gretna Green. The latter tend to be newer examples, but they still have an essential place in folk history as souvenir objects that people have collected on their holidays and high days.

Alongside its nautical objects, the Admiral Benbow is home to hundreds of horse brasses nailed to its beams. Brasses were ubiquitous in traditional pub interiors for many years. Other great examples of these can be found at the Famous Barrel in Penryn, Cornwall, the George Inn in Shepton Mallet, Somerset, and the Ilchester Arms in Symondsbury, Dorset – all have brasses adorning every inch of their fireplaces. Sadly, these pubs are in a minority as there is increasingly a move towards a more minimalistic aesthetic inside pubs, one in which horse brasses and excessive paraphernalia are not welcomed.

The photographer and folklorist Homer Sykes recorded a number of pub interiors in the early 1990s. A photograph by him from 1991 shows the interior of the Royal Oak in Whatcote, Warwickshire, its fireplace completely festooned with horse brasses. If you visited today, you might think you had entered a different pub: it has been completely stripped of its horse brasses. In contrast, the Olde Gate Inn in Brassington, Derbyshire, appears much the same in Homer's photograph as it looks today; its beams and brasses are still firmly

in place. These photographs show the importance of recording pub interiors because they can disappear overnight with no remnants left of their former appearance.

Shop window displays

While investigating various customs across Britain I have become aware of another form of folk art that falls neatly into the space between folk, souvenir and commerce – the shop window. Although many folklorists and artists have explored the appeal of the shop sign, the shop window display has yet to be properly recognised as a legitimate form of folk art. On a visit to Helston in the first week of May leading up to the annual celebration of Flora Day, I find that each shop turns its attention to the transformation of its window space. Objects and flowers are collected and curated like compact exhibitions. There are souvenir mugs with 'Helston Flora Day' in curly script and tiny painted figures in top hats and tails, and fancy dresses; there are bunches of lily of the valley; mannequins dressed in ballgowns, long gloves and hats; and old programmes from decades past. One window of a disused shop is turned over to an exhibition of photographs from the last hundred years of Flora Day. As I peer at it, a man jabs his finger at a woman in a hat and proudly announces, 'That's my mum.' I am aware that if this was all I had seen of Flora Day I'd have a very good handle on the occasion without ever having been to the day itself.

A few weeks after visiting Helston, I found myself in Hastings. I had visited once before but only very briefly. On this particular occasion, I had more time to explore the town properly. The annual celebration of Jack in the Green had taken place the week before my visit and the streets still bore the remnants of this occasion, with bunches of leaves tied with brightly coloured ribbon hanging from above windows, gently wilting and disintegrating back into the earth. As I wandered through the lanes of the Old Town I found myself

THE LOST OBJECTS

peering into windows not dissimilar to those at Helston but with Green Men rather than behatted dancers. There were knitted Jacks and ivy cascading down shop poles, and in one window a huge display of photographs, programmes and badges from previous years. Unlike Flora Day, I have never been to Jack on the Green and so through these shop displays and images I had a window into what it might be like to experience the day: people covered in foliage and ribbons processing through the town joined by morris dancers, giants, milk-maids and choirs. A living, breathing celebration of spring.

Both Penzance's Montol and Padstow's May Day also see windows transformed into miniature folk exhibitions with mannequins dressed in long swathes of fabrics and masks and tiny 'obby 'osses dancing across windowsills, and Lewes's Garland Day sees the entire visitor centre window transformed into a celebration of the early May custom with garlanded mannequins dressed in the kit of the female morris side the Knots of May. In 1988 the photographer Brian Shuel took a series of images of the Denby Dale Bicentenary Pie celebrations. Among these are a selection of windows from the best-dressed window competition; in one a fabric doll in a red beanie hat sits slumped on a windowsill holding a sign saying 'Pie 88 I've got mine'; another shows Miss Muffet holding a pie, with a handwritten sign above her that reads 'Little Miss Muffet Sat on Her Tuffet, Eating Her Denby Dale Pie'.

Generally, none of the objects in these displays are for sale but are instead collected from or made by people in the town and displayed for the duration of the particular festival before being collected back up and squirrelled away for the next year. These are fleeting exhibi-tions of items generally so ephemeral that they get thrown in bins: programmes, posters, badges, set lists and posies, not to mention costumes which are carefully selected and then quickly reabsorbed back into wardrobes. Here in shop windows, they get a momentary elevation to objects worthy of keeping.

Folk costumes

I have spoken already about folk objects often being made quickly and with cheap materials, and this becomes especially apparent when considering why folk costumes have found themselves at the back of cupboards or in the furthest reaches of basements. They are not 'beautiful' in the traditional sense, so they are often considered as throwaway, easily displaced from any information relating to their provenance, losing any context beyond 'a smock' or 'a set of morris bells'. Who wore it? Where did it come from? Why was it made? Why was it donated? All of these questions and their answers offer very important context and meaning to what can often be a quite threadbare-looking object.

Mumming costumes and morris kit

Folk costumes regularly get passed from pillar to post, and it can sometimes be difficult to ascertain where they end up. Textiles have presented an especially arduous challenge to museums over the years, in that they are problematic to preserve and conserve; moths and damp are hard to keep at bay. The Museum of Nottingham Life houses a number of important folk costumes, including the Cropwell ploughboy costume, which we will discuss in more depth shortly, and many objects from a morris side called Forresters Morris and Sword Dancing Club. Looking through the list of catalogued objects, it is clear that some items have not fared so well; there is mention of an inflated pig bladder on a stick which would have been carried by the Fool – unfortunately it succumbed to a carpet beetle infestation in 2016. The use of natural materials and the fact that folk costumes and morris kit are generally acquired by archives or museums after they have been used, meaning they are complete with mud, sweat and tears, make it extraordinarily

THE LOST OBJECTS

difficult to keep infestations at bay. However, this is not the only problem folk costumes face. In the past, they have been less revered as objects; a silver cup versus a pair of clogs is no competition for most museums.

Some years ago, in the basement of a New York art gallery, a three-piece linen costume was found. It consists of a top, trousers and hat all covered in appliquéd black and red shapes; at the centre of the back of the top is a devil with a fork in its hands and at the end of the fork is a tiny impaled figure. There are also heads smoking pipes, a figure standing atop a horse waving two flags, ducks, hearts and stars. The costume is shrouded in mystery. It is thought to have originated in a tiny village called Bellerby in North Yorkshire, which was once home to a sword-dancing group that was also known for performing a seasonal folk play. Several photographs from the late nineteenth century document the group, and show a 'Fool' character who was part of their merry troupe, and who wore an appliquéd costume not dissimilar to the costume discovered in the basement. The costume has the date '1829' written on the hat, so it's entirely possible that it is an earlier example of the sword dancing Fool's garb. It is not known how the costume came to end up in an American basement, but it now resides in the rather more appropriate setting of the Philadelphia Museum of Art, alongside their collection of American mummers' costumes.

There is another largely forgotten costume that bears a more than passing resemblance to the Bellerby fool's outfit: the Cropwell ploughboy's costume. Thought to date from 1893, it features a similar colour palette of red and black appliquéd shapes on a white background. It has a more agricultural theme, with cows, chickens, pigs and ploughs gracing its surface, as well as the seemingly mysterious inclusion of the silhouette of a lady in fashionable dress. The creatures and machinery make reference to the fact that it was used as part

THE LOST FOLK

of a Plough Monday folk play* that took place at various locations in Nottinghamshire. The silhouette acknowledges the character of 'the Lady' within the play. Across the bottom is written 'In comes I', a line that is traditionally given to the character of Tom Fool in a mumming play. It is known that the costume was originally collected by T. F. Ordish, a folklorist who wrote frequently for the Folklore Society. Ordish originally donated it to the Cambridge and County Folk Museum, and following a number of moves – during which period it was lost for a short time – it now resides in Nottingham City Museums and Galleries. It is currently on permanent display in their galleries.

Smocks

The humble smock has suffered more than most when it comes to misattribution and lack of labelling, and yet smocks are deeply imbued with meaning: there in linen and embroidery is a whole life-time's story, waiting to be told in thread. At one point, smocks were worn by everyone from shepherds to blacksmiths, and the embroidery on their sleeves and collars hinted at the industries they were used in. There is much lost symbolism to discover within a smock's swirls and curls of embroidery. In her book *English Smocks* (1930), Alice Armes throws some light on what these symbols traditionally meant. Pinwheels suggest a wheelwright, beans climbing up stalks allude to a gardener and crooks refer to a shepherd. On first reading it I was most interested by her mention of motifs that suggest a milkmaid: hearts, churns and butter pats. Smocks are mostly considered,

* Plough Monday folk plays typically take place on or around 6 January, and are a celebration of continued good agriculture for the year ahead. Plough Monday plays generally take the form of a 'wooing play' in which a farm worker woos a lady but is rejected. There are various other archetypical characters, including the Fool, the Quack Doctor and the Baby (although these vary from village to village).

THE LOST OBJECTS

and often displayed, in a way that suggests that although they were made by women they were only worn by men – perhaps the opposite of what we might think today, given that they are nowadays mostly worn by women. Did Alice's mention of these symbols hint at another possible narrative, one of women wearing smocks as well as making them?

In her book *The Hidden History of the Smock Frock*, the dress historian Alison Toplis unravels the story, suggesting that in fact it wasn't until the smock entered the realm of fashion in the late nineteenth century that women began to wear them. Prior to this, women were only recorded as having worn them as methods of disguise: in June 1808 a young woman was found aboard a ship having disguised herself in a smock frock,[21] and in March 1842 the wife of Joseph Hoy was found guilty of stealing wood 'dressed as a man in a smock frock'.[22]

There are later instances of milkmaids wearing smocks. In December 1920 a young milkmaid named Beryl Seppings is recorded as having married her husband while wearing 'a smock coat, breeches and high rubber boots'.[23] It is described in another contemporary article as being 'regulation farm costume',[24] but it is unlikely that it would have been an embroidered example as referred to in Alice's book, as regulation milkmaids' smocks of the 1920s were plain mid-length coats with buttons up one side. There is also a beekeeper's smock which was once part of the Museum of English Rural Life collection.* The catalogue entry tells us that it was made and worn by Miss Milne of Holmewood, Surrey.[25] She is described as having been a beekeeper in the 1930s.

So to what was Alice referring? While there are photographs and

* It has subsequently been deaccessioned and removed to the Bee Research Association.

designs for all the other smocks mentioned in her list of symbols, there is no further mention of a milkmaid's smock in the book. There is an example in the Victoria and Albert Museum of a smock frock coat that features hearts and what look like milk pails, but there is no supporting information to indicate where it came from or who might have inhabited it. Other smocks in the museum's collection appear as illustrations in Alice's book; in fact, all of the images in the book are of smocks in the V&A collection, suggesting that for the most part this is where her research was conducted. What's more, an example of embroidery Alice describes as appearing on a smock from Essex appears on a smock labelled as being from Lincolnshire in the V&A archive. Clearly, some artistic and historical licence was being employed. The beekeeper smock does, however, suggest that other smocks worn by women potentially exist, although they are almost certainly later in date than the smocks Alice was referencing. While her facts might be a little hazy, her information on how to make a smock is exceptional, and it is a very useful resource for learning stitches.

Although we can establish that women did not wear embroidered smocks until around 1900, we can just as firmly establish that they were making them before this date. In Herefordshire Museum's collection there is a smock made by Mary Bufton, a young smock maker based in Hereford in the early nineteenth century who had a small shop for local tradesmen; likewise in Salisbury Museum there is a smock that belonged to the ox carter John King that is thought to have been made by his wife or daughter. At the Museum of English Rural Life there is a green linen smock listed simply as having been made by an 'Essex woman' sometime around 1900, and two other smocks in the museum's collection are described as having been made by 'the wife of a ferreter on Lord Hambledon's estate at Leigh in Kent' at the beginning of the twentieth century.

THE LOST OBJECTS

Information is generally scant. Smocks are notoriously difficult to date or attribute to specific wearers or makers. Often they have been donated after being discovered in attics or long-forgotten trunks. Quite often, long after their working life, they have been used for fancy-dress costumes or pageant outfits. This has historically led to a confusion in their labelling, with misinformation and indeed often no information at all making up their catalogue entries in museum collections. They have become merely mildly interesting, faintly anti-quated objects which finders quickly donate to the nearest museum. In Rutland County Museum there is a beautiful embroidered smock, with pinwheel motifs and ladders of zigzags. It has virtually no infor-mation attached to it: its owner and history are entirely lost. In this instance, Alice's book can be used as a tool for decoding the symbols; we can discover it would have belonged to a wheelwright. Similar unattributed smocks, with no provenance or record of their history, exist at the V&A, Brook Rural Museum, Wiltshire Museum and Hastings Museum & Art Gallery.

There have been attempts to rectify this void of knowledge. In March 1962, a weekend conference on costume was held by the Museums Association at Platt Hall in Manchester. At its centre was a discussion about smocks, and an accompanying exhibition of regional smocks from museums from across Britain. All the smocks displayed had companion labels with 'the approximate date of wearing; the place of wearing; the occupation of the wearer; the source of the garment'.[26] What was revealed by the exhibition and the resulting conversation was that very few smocks in museum col-lections had any accompanying information, and this led to a drive to collect any information that could be established. The information from the conference was amassed, and by the end of the weekend fifty-five of the smocks shown had at least partial labels explaining some of their history. In Warwickshire, the county council put a call

out in May 1962 to expand its collection of thirteen smocks, largely influenced by the Museums Association conference.[27] This seemingly sudden appreciation for the smock was hugely influenced by the curator of collections at Guildford Museum, Dr Edith Dance. In 1961, Edith had put together a campaign asking for donations of Surrey smocks for an exhibition of the same title. The museum was inundated, receiving almost two dozen in two weeks.[28] Among the smocks collected for the exhibition were four from the local church, donated by the vicar. These were reportedly worn by pall bearers at funerals.[29] Although Edith managed to expand the collection, she struggled to find information that backed up the authenticity of the smocks, and from this came a desire for a greater understanding of the provenance and history of smocks, which eventually led to the conference.

Edith was rather hard on herself, because although some of the smocks collected still have scant information, she did manage to amass, for Guildford Museum, one of the largest collections in the country of smocks specific to their county which can still be visited by appointment today. The only other collections of a similar size are held at Hereford Museum and Salisbury Museum.

The reintroduction of skills such as smocking can be a useful way of throwing a new focus on folk objects. Learning traditional skills is a brilliant way of meaningfully engaging with our folk history. In 2019, smocking was added to the Red List of Endangered Crafts, published every year by the Heritage Crafts Association. The list is made up of crafts that are in danger of dying out entirely unless they are taken up by more people. On reading this I remembered a garment I had hanging in my wardrobe: an English smock that my mum had made in the mid-1990s as part of a re-enactment project. She had followed a traditional pattern, and gone to Hereford Museum to view its collection of nineteenth-century smocks. She had taught herself

how to do the smocking and embroidery stitches required from a mixture of books and studying the smocks first hand. A kernel of a project was formed: we gathered together six other women, and we each embarked on making a traditional English smock. For five years our group has met every few months to stitch our smocks, with my mum guiding the way. We have now all finished our smocks and are beginning other smocking projects.

We are by no means the only group of women in history to embark on such a project. In the early twentieth century, a group was brought together in Bere Regis in Dorset. Its members called themselves the Bere Regis Arts & Crafts Association and it was started by the local vicar's wife, Sarah Lucy Bere. They gathered together in Sarah's home to embroider, smock and make raffia baskets and hats with the aim of highlighting and continuing these local and dying crafts. Like Frances and Barbara and the Irish Home Industries, Sarah was interested in promoting traditional folk crafts as a way for local people to make a living. In 1914, the Bere Regis ladies took their work to London and displayed their smocks as part of an exhibition that celebrated the arts and crafts revival across Britain,[30] and the Museum of English Rural Life houses seven of their smocks in its collection to this day. Their work is now firmly cemented in history as having helped revive these crafts.

Through the making of a garment or object, it is possible to learn details about its construction and materials that you simply can't gain from examining it. Through practical engagement with the process, a deeper level of understanding manifests. In the case of the smock, certain details become apparent very quickly. The shape allows it to be cut entirely from one piece of cloth, and there is almost no wastage: an important detail when thinking about the history of whom they were worn by, and the need to save every last piece when you had also possibly woven the cloth yourself. The practical reason for the smocked

THE LOST FOLK

panel at the front also becomes clear; it forms a natural elastic, meaning the smock moves and expands to fit the wearer. This has the benefit of allowing the person wearing the smock to be able to conduct their work without the garment getting in the way, and to grow over the years, meaning that the smock can be a lifetime investment or family heirloom, passing from one generation to the next.

These features may seem obvious, but it is only through the intense process of selecting the fabric, cutting the pattern and stitching my own smock that I began to fully understand the design of a smock. I imagine it was a similar experience for the Bere Regis women. What it taught me above all else, though, was the patience and time that are required in making one, and this is maybe why it found itself on the Red List. Smocks are time-consuming. They require months of work, and in a world geared towards speed this is seen as unfeasible for many people; this applies to many other folk objects and crafts, too. Even objects that are seemingly more thrown together have still required someone to have the idea, find the materials and assemble them. However, if the approach is taken of incrementally making an object, of taking time, of using it as a way of adding a moment of pause and reflection to the day, it can be an incredibly enriching experience. A folk object is a tangible and practical demonstration of a slower way of life.

In more recent years, smocking has been taken off the Red List. As in the early twentieth century, there has been a renewed wave of interest in the making of smocks. There is hope for the future of this skill that was nearly lost entirely. Through the revival of skills and through active collecting, we can ensure that other folk crafts and objects do not meet untimely ends; it is our collective duty to make sure that they don't. Learning a folk craft is one way in which to do this; understanding how something is constructed enables an understanding of why certain decisions were taken, and as my revelations

THE LOST OBJECTS

when making my smock demonstrate, seeing the process throws up questions and answers that otherwise might never have been considered about the clothes we wear.

Ephemeral folk objects

Food and flowers are used copiously in folk customs, but due to their intrinsically ephemeral nature they rarely get collected and preserved. Flowers are used in everything from May celebrations to harvest festivals, as a way of marking the season and giving thanks to the earth and its fruits. It is surprising, then, that there has not been more written about the use of flowers, plants and food in folk customs. They are an integral aspect and are more than worthy of some consideration. So why do they get forgotten? It is perhaps due to the fact that they fade so quickly. Their lifetime is just a few short hours. Transience is built into their very being, and although arrangements are put together with a great deal of care and thought, they are only really meant to last for the duration of the festival or duration of a custom. The ephemerality of a flower is essential to its meaning in relation to folk practice: time is cyclical, flowers bloom and wither, and another year passes.

At Helston Flora Day in Cornwall, each dancer wears a small sprig of lily in the valley; the Burryman Day in Queensferry makes ample use of seasonal summer flowers and of course burrs; and both oranges and spring flowers are used abundantly at Hocktide celebrations in Hungerford, as are rushes at the various rush-bearing ceremonies of Cumbria, Cheshire, Lancashire and Yorkshire. There is no doubt about it: food and flowers are deeply intertwined with folk, and both offer us an incredible insight into the ways in which folk traditions can seep into our daily lives.

THE LOST FOLK

Food

On a shelf in my grandmother's kitchen was a row of gingerbread men. They stood there with their chocolate-drop eyes and watched over everything that happened in her tiny kitchen for years and years. They should have been consumed, or perhaps thrown away, but instead they remained on the shelf until she died. No one ever really questioned why they lived there or where they had come from in the first place; they were just there, smiling down at us as we made cups of tea and cheese on toast, as we washed up or unloaded shopping. Every now and then my grandma would say 'hello' to them, a small reminder that we were being watched over by their benevolent presence. We became very superstitious about them, nodding to them as we passed through the kitchen and fiercely defending their spot on the shelf if it was ever questioned by visitors. When my grandma went into a care home, and the time came to clear the house, we wrapped each one carefully in a tissue-paper shroud before placing it in the bin: a funeral of sorts for these fossilised biscuits.

It is not that unusual for food items to be kept long beyond their sell-by dates. In fact, there are many very, very old biscuits, buns and cakes sitting deep within archives and buildings across Britain. In a small local museum in Devon, tucked away in a drawer, is a collection of slices of wedding cake. They are shrivelled and grey, and most certainly no longer edible. They do, however, give us a brilliant glimpse into what wedding cakes of the late nineteenth century looked like: the shapes, the textures, the decoration. Touchingly, each is labelled in copperplate calligraphy with the name of the couple who donated the slice, a tiny cakey record of their lives and love. Likewise, at the Willis Museum in Basingstoke you can find the world's oldest intact wedding cake. It is so delicate it looks as if it was iced only a few weeks ago, but in fact it was constructed in 1898 by C. H. Philpott,

THE LOST OBJECTS

a local Basingstoke family bakery. It was donated to the museum in 1995 by the original baker's daughter.

In a 1934 article from the *Peterborough Standard* on new acquisitions to the county museum at Huntingdon in Cambridgeshire, a small piece of antiquated cake is mentioned. It is described as a piece of burying cake, '6½in long, irregularly oval in outline; it appears to have currants in it, and a depressed line on the dorsal surface'.[31] Burying cake was traditionally given to mourners who were unable to attend the funeral service, as a recognition of their state of mourning and in remembrance of their departed loved one. Although the museum no longer exists in that form, I tracked down a similar-sounding cake in the Norris Museum, St Ives, Cambridgeshire. Its records describe it as: 'Dried burying cake: an irregular oval, pale brown, with an indented line on one side; appears to have dried fruit in it, probably currants. Length 170mm, max width 75mm.'[32] Thanks to an email exchange with the curator at the Norris Museum, I was able to discover that the cake is in fact the same burying cake; it was transferred to the Norris in the late 1950s when the Huntingdonshire Literary and Scientific Institution closed, and sadly the original accompanying label was lost in this transition. Luckily the *Peterborough Standard* article quotes the entire label, including who the cake memorialised: 'This was the Burying Cake of Mary Sayle, who died on Monday August 22nd 1791, aged 32.'

In a small tin box in the museum at Folkestone can be found a biscuit. It is over one hundred years old and yet it remains entirely intact. It is a Biddenden biscuit*, and it is not alone: the Pitt Rivers Museum in Oxford and Allen Gallery in Alton, Hampshire, are also home to Biddenden biscuits. These three biscuits are all printed with two figures and a label with the words 'Eliza and Mary Chulkhurst'

* Biddenden biscuits are sometimes referred to as Biddenden cakes.

THE LOST FOLK

above the image. The story attached to the biscuits suggests that the Biddenden twins were born into a wealthy family in the early part of the twelfth century, and were born joined at the hip and shoulder. On their death, they donated a portion of land to the people of Biddenden, and the profits from this patch of land were distributed among the poor of the parish each Easter. At some point over the hundreds of years during which this dole money was distributed, Biddenden biscuits were introduced, and at the same time the money was gifted, so too was a biscuit. Hard, white and seemingly rather unappetising, it is no surprise perhaps that many of these biscuits have survived.*

There is much dispute over whether the twins ever truly existed and, if they did, when they were born. It has been suggested that the image on the biscuit could represent an archetypical figure rather than any twins in particular. What is interesting is that the story of the Biddenden twins and their biscuits offers up one of the only examples of a disabled body within folk culture. It is scarce that anything other than an able body is represented in a folk custom.

The Pitt Rivers Museum doesn't just house a Biddenden biscuit; in fact, it has an entire drawer dedicated to biscuits. When I visited and pulled it out for the first time I exclaimed very loudly, 'It's the biscuits!' – to which a young student standing behind me replied, 'What are the biscuits?', so I took him on a tour of the biscuit drawer. They come from all over the world. There are Christmas biscuits from Sweden in the shape of St Lucia with her crown of candles and an iced biscuit from Vienna shaped like a priest, reportedly sold outside Viennese churches to pilgrims and tourists.

The drawer is labelled 'Ceremonial and Votive Cakes, Breads, Biscuits and Moulds', so it does actually contain a great number

* Biddenden biscuits crop up at auction from time to time.

172

THE LOST OBJECTS

of other items besides biscuits, and the most intriguing items are in fact not biscuits at all but two little doughy figures in the top left-hand corner, not dissimilar in size to gingerbread men. Their eyes are made with currants, although the left figure appears to have lost one. They have big round noses, and arms and legs pulled from the dough to make soft, pillowy bodies. These bread people are described as 'Popladirs' on the label, which also states they were made in St Albans on New Year's Day. It seems that, as with much folk history, 'popladir' is in fact either a misspelling or mishearing of 'pope lady', a form of bun that was widespread in St Albans. Although it was gifted on New Year's Day, its primary day of consumption was Lady Day on 25 March. It's not known exactly from where the lady bun takes its form, but there is speculation that it is supposed to represent Pope Joan.

The St Albans dough figures were gifted to the museum in 1913, and are described on the label, which was presumably written at around the same time, as being almost obsolete even at that point. There is certainly very little reference to them after the First World War, although confusingly there is another St Albans bun, the hot cross bun, which is said to have originated in St Albans Abbey in the fourteenth century. St Albans Museum is also home to a pope lady, but apart from these examples, dough ladies appear to have almost entirely vanished from history.

The bread people of St Albans bear resemblance to another bread figure made in England. In nineteenth-century Durham during the month of December you could find a 'Yule-doo'. These were yeasted currant cakes formed into the shape of a baby, traditionally considered to represent Jesus swaddled in his manager. They were originally made by mining communities, particularly by the wives of hewers* to gift to

* A hewer cut the coal from the mine.

173

THE LOST FOLK

the putters* with the hope that the gift would bring good fortune and luck for the ensuing year. It was considered unlucky to eat the Yule-doo during the lead-up to Christmas. Instead, it was kept in the house as a talismanic figure and only consumed after Yule (if at all). Although this custom has almost entirely died out, there are still a few people who make a Yule-doo each year, and it is still maintained by Beamish Living History Museum, where Yule-doos are made every December.

Further south there is a pub in the depths of East London called the Widow's Son. For over one hundred years, a net hung above the bar and in that net were hundreds of hot cross buns. Every year on Good Friday a sailor from the Royal Navy would place one freshly baked bun into the net. It is thought that both the tradition of the buns and the name of the pub came from a story of a widow who was awaiting the return of her only son from his life at sea. Each year she baked a fresh bun for him, but he never returned. When she died, a bun for every single year he had been missing was discovered hanging in her cottage. The pub was built in 1848 on the site where her cottage once stood, and the tradition of placing a bun in the net was taken on by the pub. Whether the story is true or not, the buns and accompanying custom crop up in newspapers from the late nineteenth century onwards, and it possibly plays on the myth that a bun baked on Good Friday never goes off. The buns have narrowly avoided a sticky end several times in recent history. In 1980 there was a fire in the pub and the net of buns was burnt to a crisp, however a new net was purchased and the tradition carried on. That is, until the pub closed its doors in 2015; the following year, it was held in a pub a short distance away. However, in 2017, the pub reopened its doors and the bun hanging returned. Its fate is nevertheless insecure: in 2023 the pub once again closed, and it is not known what will become of the net of buns.

* A putter took the full coal tubs up to the surface.

THE LOST OBJECTS

A similar custom can be found not too far away in Essex, where at the Bell Inn in Horndon on the Hill a hot cross bun is hung from a nail on an oak beam in the pub every Good Friday. The origins of this tradition are clearer than those of the Widow's Son's buns: in 1906, the then-landlord Jack Turnell wanted to mark the momentous occasion of collecting the keys to the pub on Good Friday. He opened the doors of the pub, and given that there were two other pubs in the village, he offered a free bun to all punters to entice them in. There was one left and it was decided that it would be nailed up. Each subsequent year, he invited the oldest villager present to hang the bun. In 1938, his father-in-law took over the lease and continued the ceremony. It continues to this day when at 1 p.m. every Good Friday the bun is raised. A collection of blackened buns now hangs from the ceiling above the bar, and since the mid-1980s they have been inscribed with the year in which they were hung. Like the buns in London, they have had some near misses – during the Second World War a bomb hit the Bell and five buns were lost – but for the most part they are all intact and available to gawp at over a pint or two.

A trip to the Tudor House and Garden in Southampton will also allow you to see an aged hot cross bun. It is pale brown, dried and cracked across its surface, barely recognisable as the steaming-hot treat we are accustomed to, and yet it is one of the museum's star exhibits. No one is sure quite how old it is, but it is much loved by visitors as a strange, but recognisable, oddity from the past.

Flowers

What about the flowers? Well, these are a bit harder to chart: they fade so fast that they rarely get saved in the same way that some of the food from folk practice has been, and yet they are enormously important. As well as having a vital role in folk festivals and customs, they also make up a principal part of folk funerary practice, and more than any other

THE LOST FOLK

item associated with folk ritual, they visually represent a calendrical year and the inevitable passing of life into death.

There is one certainty in life, and it is that death comes to us all; nevertheless, British people can struggle to talk about death customs. In her book *Design for Death* (1967), Barbara Jones recognises this difficulty we have in the acceptance of death, and in turn the acceptance of customs relating to death: 'No one really expects to die or to have to deal with death, but suddenly it happens, and then even the most rational of the living find that it has stirred up lost scraps of ritual in them, and fired a mindless chain of trimmings and doings that are easier to accept than to refuse.'[33] I find it interesting that Barbara's seminal text on death and its customs was only ever published by an American publisher, and is now entirely out of print. In order to explore how death customs and their associated objects have been recorded, we must mostly turn to people from other cultures.

Charlie Phillips moved to Britain from Kingston in Jamaica in 1955, and at the age of eleven he began taking photographs of the Jamaican community where he lived in Notting Hill, West London. He became interested in the costumes, sounds and colours of the near-daily funerary processions that would pass through his street, so he began documenting them and the associated customs and rites. Charlie's photographs are a fascinating document both of a community that was otherwise almost entirely ignored and left out of documentation of this period and of objects that have long since faded from memory and even existence. Among his record of West London African Caribbean funerals are hundreds of images of floral funerary tributes. There are floral Rizla packets rendered in tiny blue and gold flowers, 'father', 'brother' and 'sister' in red and white roses or carnations, and Jamaican flags in moss and yellow marigolds. Floral tributes seldom get remembered, let alone photographed. Generally they are left by the graveside and gradually disintegrate into the earth, leaving just the

THE LOST OBJECTS

foam base behind, so Charlie's archive offers not only a trace of their presence but also an invaluable insight into a Jamaican community and its rituals. We would all do well to take a moment to reflect on the photographs from Charlie's collection. They are poignant and beautiful encapsulations of death customs.

Polly Weston's BBC Radio 4 programme *The Patch* explores a different postcode in the UK each episode: in 2024, the show came to one of the largest settled Romany communities in Britain at BR5 3, otherwise known as St Mary Cray, near Orpington in Kent. Within this postcode is a cemetery that is often referred to locally as 'the traveller's resting place', a safe haven in death for an often-maligned community. Polly goes to meet Terry, the warden of St Mary's, the nearest church to the cemetery. Terry is keen to emphasise how private the community are, despite the fact that the graves and funerals might suggest otherwise: 'Thousands and thousands and thousands of pounds' worth of flowers ... there's so many wagons absolutely full of flowers but you can't stand there and look because they're very, very private.'[34]

Polly goes on to describe the way in which the graves are kept, immaculately clean, always with fresh flowers and generally with other adornments hinting at the life of the person being memorialised. In Southampton a similar scene is repeated in a large collection of Irish Traveller and Italian graves that sit on the outskirts of Hollybrook cemetery. Each grave is cared for with love and the utmost respect. Wreaths of flowers and 'papa', 'sister' and 'son' floral tributes line the edges of each plot, carefully tended and kept looking their best at all times. Often the gravestone itself has an inlaid photograph of the occupant. When I took a walk around Hollybrook, I was struck by the tenderness, the softness and at times the humour. One grave had a pint glass, half full, the accompanying bottle of Guinness set by its side. A drink for life and for death. Polly describes a similarly emotive scene at St Mary Cray: 'The graves were immaculate, covered in

THE LOST FOLK

flowers, even for people long deceased. You could see the personality of each individual represented on incredibly elaborate stones and you could instantly see those who had recently had birthdays: cards, cakes and banners laid out all around these graves.[35]

Corn dollies

In death, of course, there is also life. In many ways, death customs are a useful reminder that we are living. Although beginnings form the basis for many folk customs, so too do endings: the end of the harvest is one of the best celebrations of life and death. Corn dollies offer a particularly brilliant illustration of how plants can be used in folk practice as a way of celebrating life. Traditionally considered to represent fertility, they act as a symbol of the spirit of the land and of the corn, made after the harvest and displayed to bring fecundity and luck to the next year's harvest. Historically they were hung on walls, and sometimes they were used as adornments for the top of ricks* or thatched cottages. There are many examples in collections around Britain, and some of the most extraordinary sit in the collection at the Museum of English Rural Life. These were made by Fred Mizen, a thatcher by trade who resided in Great Bardfield, Essex. The examples at the museum include a full-size hay rake, a barley fork and a straw crown, both made for the Country Pavilion at the Festival of Britain in 1951.

Fred is perhaps most famous for having made a full-size lion and unicorn from corn for the Festival of Britain pavilion of the same name. The figures were a towering seven and ten feet high, respectively. Sadly, there is almost no trace left of them, barring some photographs taken by John Tarlton of Fred proudly making and posing with the resulting forms in his garden in Essex, as well

* A stack of hay, corn or straw which has been built into a shape and thatched.

178

as a number of press photographs of the creatures installed in the pavilion. The only other remnant of their existence is in the form of a commemorative tea towel now in the collection at the Museum of English Rural Life. It features both the lion and the unicorn among bundles of straw and corn dolly plaits, and was designed in 1989 by Neil Thwaites (president of the Guild of Straw Craftsmen until his death in 1999) and Rosemary J. D. Meakins for a weekend in Great Bardfield called 'Heritage of Straw', which explored Essex's long and rich history of straw work.

So, what happened to them? It would be difficult to lose two enormous mythical beasts, right? Well, yes and no. After their stint at the festival, they were sold to Selfridges and initially displayed in the shop windows before going into storage in the basement, where they were munched by mice. The remnants were transferred to Reading Museum but have subsequently been discarded.

Their fate raises an interesting question about the way objects of folk are treated in a commercial setting. The Festival of Britain, like the Great Exhibition before it, created a revival of interest in folk crafts and thus Fred and his contemporaries were suddenly in great demand, making objects for everything from breweries to high-street shops. In 1959, Fred was commissioned by the Institute of Brewing to make two large-scale barley figures of a harvest queen and a malting maid. These were to be shown in an exhibition called 'Barley Mow' which brought together corn crafts from across Britain as way of encouraging farmers to grow barley for the brewery industry. Most of these items, including the two harvest figures, are now completely untraceable. They were made, bought and cast off when they no longer were of interest. Unlike more traditionally accepted forms of craftmanship such as carpentry, marquetry or silverwork, straw craft has an ephemeral aspect because it is by nature short-lived; when it becomes dusty, or the

THE LOST FOLK

mice get in, it is easy to justify it going in the bin. It is also true that folk objects fall in and out of fashion. 'Promotional' exhibitions and displays are made up of intrinsically evanescent objects made from materials that are natural and therefore fleeting: made for the present moment, and then rejected in favour of the next object or idea that can be used to sell or put forward a particular scheme (as in the case of the 'Barley Mow' exhibition).

Every October at All Saints Church in Siddington, Cheshire, for over fifty years, a local figure known as the Corn Dolly Man mounted a display of thousands of corn dollies. The black-and-white timber beams of the church were layered with corn in all shapes and sizes, plaited and twisted into incredible formations. So, who was the Corn Dolly Man? His name was Raymond Rush and he had originally trained as an engineer but worked for most of his life as a dairy farmer. However, he was also the author of several books on country life, a lay preacher at All Saints Church and something of an amateur historian, amassing over his lifetime a huge collection of antique agricultural tools as well as smocks, signs and folk art. He first became interested in corn dollies after he saw a local farmer making one in 1950. He was fascinated by its intricacy and so he taught himself to make one and quickly became an expert, probably helped in some part by his background in engineering. Most counties have designs and names associated with them. There's 'the Welsh Border Fan, the Suffolk Bell, the Norfolk Lantern, St Bridgid's Cross and the Medallion Cross; Lancashire even has a corn dolly which is in the shape of a chandelier',[36] but Cheshire is the heartland of the British dairy industry and traditionally had not been known for corn craft, so Raymond had to invent his own shapes. These included angels, stars and elaborately plaited crosses. He made each one of his corn creations at his home, Golden Cross Farm, which sits next door to the church, and from

THE LOST OBJECTS

his workshop he also sold examples to passers-by. Sadly, Raymond died in September 2021, meaning that although his collection of corn dollies is still displayed each October, the tradition of corn dolly making in this small village has now disappeared after sixty-seven years and there are no new yearly additions to the display.

A similar display of corn dollies was put on at churches in Culbone, Oare and Porlock in Somerset, where for four years in the mid-1960s, a Mr M. M. Priscott was engaged in making the creations for the harvest festival.[37] Similarly, a Mrs Sterndale-Hurst in Huddersfield was still making corn dollies in the mid-1970s, having been taught by her grandfather as a child. She recalled to the *Huddersfield Daily Examiner*, 'He used to make corn dollies for all the churches especially at harvest festival time, and I used to spend my weekends and holidays helping him.'[38] In later years, Mrs Sterndale-Hurst went on to teach others the craft as a way of ensuring it didn't die out. In Herefordshire the artist, writer and corn dolly expert Lettice Sandford turned over an entire room of her home to displaying corn dollies, inviting people to workshops to learn the craft, and in Leicestershire, a Petronilla Jones was decorating her local church and teaching the craft as of 1975. Like Raymond Rush, she mostly had to invent the symbols owing to the fact that Leicestershire, like Cheshire, didn't have a tradition of corn dollies, so she 'adapted the Suffolk horseshoe and a corn dolly in the shape of a whip to symbolise her native county'.[39]

Although nowadays it is much harder to find people actively making corn dollies, there are still places where they are made and sold. On the Isle of Wight, in the small village of Whiteley Bank, there is a woman carrying on the tradition. She has a nickname akin to Raymond's, being known locally as the Corn Dolly Lady. Her real name is Pat Burgess and she has been making corn dollies since she was a child. Each Christmas she opens a shop from her

THE LOST FOLK

garage where she sells her corn dollies to the community. Likewise, in Essex, Janine Connor makes corn crafts in both traditional and contemporary styles, and is a member of the Guild of Straw Craftsmen, a group dedicated to the active promotion and reintroduction of straw skills and craftsmanship, and training a new generation of corn dolly makers.

Ryedale Folk Museum is home to an intricately woven crown, a series of cornucopias, a steam train, a bell, an umbrella and a hay cart, among many other items, all made from corn. They are the work of Emma Beeforth and her husband Sid, who for more than fifty years lived at Ivy Holme in Westerdale, North Yorkshire, and dedicated themselves to spreading the craft of corn dolly making around the region, having taught themselves the craft from books. They gave demonstrations at the Ryedale Folk Museum and, like Raymond, decorated the village hall during the harvest season with a plethora of corn ornaments. On Emma's death in 2017, they bequeathed their entire archive of corn dollies to Ryedale Folk Museum, and so these are preserved for everyone to appreciate.

Flowerbeds

The planting of municipal flowerbeds each spring and summer for the people of a particular town or city to enjoy is a custom that began to take form in the 1890s. At the height of their popularity, thousands of people would have visited their town's flowerbeds during the summer months: floral clocks, butterflies and crowns all provided joy and amusement to communities.

The first ever floral clock was unveiled in Paris in 1892. Floral clocks were generally made up of a variety of flowers in the form of a clock with hands that mechanically moved to tell the time. They quickly became a popular way for councils to create a free and engaging form of entertainment for visitors to public parks. Edinburgh has one of

the first and most well-known contributions to this form of folk art: a floral clock that was envisioned by the superintendent of the parks, John McHattie. In 1903, it was unveiled to great acclaim in the garden at West Princes Street, and soon many other park keepers were following suit. In 1907 Royal Prince's Parade in Bridlington opened a floral clock, and by the 1930s, Victoria Park in Swansea, Hesketh Park in Southport and Clarence Park in Weston-super-Mare had all also installed working clocks. People would flock to see the clocks tick, a folk custom for a new age of leisure and pleasure gardens.

So what became of these strange ticking attractions? Many were quietly abandoned. With expensive upkeep and hundreds of bedding plants being required each season, councils no longer see it as a necessity to provide free entertainment for the people of the town. In 2003 Swansea's clock was redeveloped; luckily the horologist for Swansea at the time, David Mitchell, managed to save the enormous mechanism and hands that had kept the clock ticking. He's kept them in his garage ever since, hopeful that one day the clock will be reinstated. In 2024 it was reported that concrete had been poured over the hundred-year-old Weston-super-Mare display by its current leaseholders. The intention had been to maintain it through painting rather than planting, which was deemed more cost-effective, but the people were not impressed and it was quickly removed.

Floral clocks are not the only example of this form of municipal folk art. There are flowerbeds planted to flower in such a way that a picture or phrase is revealed, such as 'Welcome to Christchurch'. In a particularly spectacular example planted in Bournemouth in the summer of 1966, a series of flowerbeds displayed Snow White and the Seven Dwarfs, complete with seven bushes cut into figures that held real pickaxes over their leafy shoulders.

Wibsey Park in Bradford was once famous across West Yorkshire for its exceptional flowerbeds. During the summer of 1930, the park

THE LOST FOLK

keeper, James Walton, created a functioning living room from bedding plants. All remaining pictures of the scene are in black and white so it's difficult to ascertain what the planting scheme would have been, but in the grainy images you can pick out two floral armchairs framed by three topiary walls, a floral mantelpiece with an electric fire and the crowning glory, a floral gramophone that played classical music to the people wandering the pathways of the park. People were able to walk into the display, and if they wished to, they could sit on an armchair and listen to the warbling sounds of the functional record player. To make this scene, James had, in fact, refashioned a display from the year before of a towering floral organ complete with pipes and a stool to sit at, reforming the organ into the basis of the fireplace. Another of his triumphs was a floral grand piano with the words 'City of Bradford' emblazoned above the keys. Little is known of him beyond his name,* and he is seldom acknowledged as the maker of these magnificent attractions, but he was clearly trying to put Bradford on the map with his elaborate and sculptural displays.

In a rare instance of a flowerbed being recorded for posterity, there is tucked away in a cabinet at the Museum of Barnstaple and North Devon a wonderful reminder of a flowerbed of past times. In 1995, Margaret Curtis of the North Devon Sugarcraft Guild created a replica in sugar flowers of one of the flowerbeds submitted as Barnstaple's entry to Britain in Bloom that same year. The model is made up of hundreds of minute pink, cream and white flowers that spell out the words 'Barnstaple in Bloom' with two castles either side. A second replica flowerbed sits above it, featuring rows of orange flowers, and a border of tiny pink and white blooms. It is incredible in its level of detail; at first glance you would not know that it is made entirely from

* In the writing of this book the great grand daughter of James contacted me and sent a number of photographs and press clippings of him at work. It is clear his work was well loved – the clippings even include two fan letters from America!

184

THE LOST OBJECTS

sugar. Unbelievably, this is one of very few examples in a museum collection of preservation in any form, be that model or photographic, of a municipal flower display. Council record offices offer some examples of flower displays, notably Bath's Record Office, which holds photographs of several beds from the 1960s including an image of Humpty Dumpty, sat on a wall, in a round bed surrounded by the words 'Humpty Dumpty sat on the wall', all rendered in flowers. Morrab Library in Penzance holds a photograph of a flowerbed in Morrab Gardens from the summer of 1965. It depicts two children looking at a magnificent butterfly, its wings sitting proud from a flat flower bed.

Flowerbeds last a season, and are then reimagined for the next: this, and the fact that they are often viewed as a council-planned operation, is probably why they have rarely been given much consideration. I would argue, however, that although a degree of planning goes into them, the orchestration is generally down to one individual or a handful of people working for a council, who very often add their own flair and imagination to the displays. Their work is entirely anonymous, generally just coming under the heading of simply 'created by the Parks Department'; these are true pieces of folk art for the people of a place, made without ego or any sense of wanting acclaim or applause. With increasing cuts to council budgets, there has been a major decline in the money, and therefore the creativity, afforded to parks teams to create flower displays. They are a dying art form.*

Hare's tails

While hunting for examples of flowers and foliage in museum collections, I came across a series of mysterious postcards in my favourite second-hand bookshop. I had been about to leave when a

* Interestingly, the COVID lockdowns of 2020–1 saw an upsurge in people taking council planning into their own hands and planting up disused plots or dead spaces on street corners and around council-planted trees.

box of cards by the till caught my eye. I picked out four, each with a selection of images in panels featuring flamingos, wild buffalo, sheep and all manner of other creatures. All larger than life. All with the text 'Battle of the Flowers Museum' in sans-serif text, and all made from marram and hare's tail grass. I had many questions. What was the Battle of the Flowers? And what was the museum named after it?

The Battle of the Flowers, it transpires, is a celebration that has been taking place at St Ouen on the island of Jersey since 1902, when it began as part of the events to mark Edward VII's coronation. Originally, large floats were covered in flowers and after a parade they were taken apart and the flowers used in a mock battle. Although the parade continues today, the mock battle has long since ceased.

The museum was started by Florence Bechelet on 16 June 1971. Florence had first seen the Battle of the Flowers as a child while picking winkles on the beach, and she made her first entry into the battle in 1934 dressed as 'a walking watering can'.[40] As time went on her entries became more elaborate and soon she was entering full scenes mounted onto carnival-style floats. She gradually expanded her creative activity and made several static exhibits for exhibitions and fetes, and made a special display of more than forty flower flamingos for the visit of Queen Elizabeth II to the island in 1978. Florence opened the museum as a way of preserving and showing off her floats from previous years. On its opening, it had sixteen displays, and by the late 1980s there were twenty, including one with 101 dalmatian dogs, an Arctic scene featuring an igloo and polar bears, two horses pulling a carriage, a leopard and a ski slope, all contained within the four outbuildings Florence had turned over to the museum.

Florence's museum became one of the must-see sites on any tourist's trip to the island, advertised in national newspapers and with its own brown sign from the local authority. Florence continued to make an exhibit for the parade each year until her death in 2012, and

after the parade of each of her creations was placed on display in the museum. In its latter years, the museum suffered from dwindling visitor numbers, and without its creator's presence and protection, it was dismantled and closed. There is no record of the dismantling of the displays, but there are several photographs of the interior of the museum now held in the Jersey Heritage Archive. Although Florence's vision was to preserve her floats to inspire future generations, the ephemerality of enormous artworks rendered in soft grass meant their upkeep largely relied on her making sure they were not being nibbled by mice, as in the case of Fred Mizen's corn sculptures, or that damp did not get in. When she died, no one stepped forward to take over their care, and they disappeared, lost forever.

It is hard to feel I have even touched the surface of the great breadth of folk objects that inhabit Britain. They are everywhere, and I am constantly finding new things that fall into the category of the folk object. Folk is an expansive term, and ultimately one that is difficult to compact into a box. There are a multitude of newer folk items to which I have given no space, but that could, and should, be considered modern folk objects in need of collection: knitted postbox lids, nail art designs, tattoo flash sheets, embroidered or painted denim, airbrush T-shirts and painted mirrors, to name but a very few. Hopefully it is clear from this very small selection of examples, however, how important it is to look, to appreciate and to care for these objects. We must all take responsibility for recording them, for making sure their stories don't become detached from them and for singing their histories because, without us, their fate is uncertain.

4
★ THE LOST CUSTOMS ★

Across Britain there are hundreds, if not thousands, of folk customs. They range from dancing around maypoles in the springtime to the celebration of apple trees through wassailing in the wintertime. There are wells dressed with flowers across Derbyshire, bonfires lit in Lewes and Hastings, and 'obby 'osses acting out seemingly ancient dances in Padstow and Minehead. There are also hundreds of folk customs that have disappeared or that have been almost entirely lost from public consciousness, from grotto day in the streets of London, when children would construct makeshift shelters from oyster and mussel shells,[1] to elaborate historical pageants that involved the entire community of a town coming together to build sets, stitch costumes and perform.

There are also more folk customs than it would ever be possible to cover in this book, so instead I have focused on a selection of customs that I feel offer a picture of Britain's vast folk calendar, and have woven together a story of what folk customs mean to us and why we find ourselves doing seemingly perplexing things, like rolling cheeses or dressing up in Easter bonnets. There are hundreds more that I would have liked to have included, and there are, I imagine, a great number more that I am yet to even discover. This is the power of folk. Just as you think you have captured it, it presents something new and unexpected.

Although hundreds of traditional folk traditions have survived in the UK, the First and Second World Wars put an end to many

observances due to the many, many deaths and the generally subdued mood after years of hardship. Morris sides disbanded, mumming plays ended and lots of localised customs such as rushcart ceremonies and garland days ebbed almost into non-existence. However, remnants of many of these practices are still laced into the British folk calendar – snippets that hint at the more widespread celebrations that once happened across counties and seasons.

The world turned upside down: inversion customs

Inversion or misrule customs have in the past been hugely important in the folk calendar, offering a chance for the common man, woman or child to have their voice for a day, to experience power, even just for a few moments. Characters such as the Lord of Misrule or the Abbot of Unreason crop up in numerous folk customs, with the ability to cause mischief and unrest for a matter of hours before disappearing into the dark for another year.

Mock mayors

Nowhere is the idea of unruliness better represented than in mock mayoral customs, which, at one point, were countrywide. Mock mayors were elected from the townspeople and sent forth to rule their town for a day. Sometimes the real mayor was even locked up in the town's jail. Generally, as with mumming or guising traditions (see below), these were processional customs, moving through the streets, with the new mock mayor making ample use of the town's drinking establishments; proceedings gradually became more raucous and debauched as the day continued. The most famous mock mayoral inauguration happens in Abingdon in Oxfordshire, where the election of the mayor of Ock Street takes place on the nearest Saturday to the summer solstice. The ceremony is conducted by the Abingdon Traditional Morris Dancers,

THE LOST CUSTOMS

with only residents of Ock Street itself allowed to vote. In the past, it was a position that could be held for a number of years, with Thomas Hemmings reigning for nearly twenty-five years after his election in 1840.[2] His sons, William, James and Henry Hemmings, also held the post for thirty-four years between them. The elections continue today, and each year the new mayor is processed through the town on a litter decorated with flowers. More recently the mayoral position has fluctuated, with a different mayor taking the reins each year.*

In Penryn, Polperro and Penzance in Cornwall and Barton in Gloucestershire, the election of a mock mayor has been revived based on accounts of much older traditions. Penryn's mayoral ceremony historically took place during the hazelnut harvest in September and was known locally as Nutting Day. It was performed by the tailors of the town, with the merry crowd setting off for the neighbouring village of Mylor and choosing a mayor, who they carried back to Penryn. Nuts were thrown liberally by the revellers at passers-by. These have, in the revival, been replaced with Brussels sprouts.

In 2018, I had my own brush with misrule when I was elected as the second mock mayor of the Penryn revival. For one day, I set about the town making merry and guiding my band of revellers in mischief. I was bestowed with a mayoral chain made by Robert Padfield, a Newlyn-based copper worker, and robes and a litter made by Suki Haughton. My merry band and I went from pub to pub, dancing and singing as we went, and making proclamations such as 'give us free chips', which the chip shop thankfully did. It was an occasion of much joy, and gave me a sense of the authority and influence this custom must have bestowed on people in feudal times: for one day in the calendar, they were removed from the constraints of work and oppression and could rule the roost.

* Apart from the reign of Harry Knight, who held the post from 2017 to 2022.

For several hundred years, on the annual election day for a new mayor of Newcastle-under-Lyme in Staffordshire, a mock mayor was also chosen, who was 'decked in a calfskin tunic, a Staffordshire bull's hide for a gown, and a sheepskin wig' and would take to the town with his mace-bearers, holding cabbages on sticks and making proclamations.[3] These statements generally encouraged stealing, or at least begging, from the rich to give to the poor.

From the early nineteenth century until the 1920s, a mock mayoral election also took place on 7 November at Bishops Nympton in Devon, which was later revived after the Second World War though has subsequently lapsed. In a similar vein to Penryn and Newcastle-under-Lyme, a series of complaints was issued by the faux mayor. These generally centred around the lobbying of makers of products such as bread, beer or sugar to stop them being adulterated with lesser or substitute ingredients. One such proclamation was made after the ceremony in 1925, with the new mock mayor stating that 'any grocer or provision dealer known to mix sand with sugar, water with vinegar, or brick dust with pepper, if found guilty will have to send the mayor 13 slices of ham every morning for breakfast for one month'.[4] Although these proclamations are, of course, meant to be humorous, they did also open up serious comment on the conditions that working people endured, and the terrible living conditions that were present for many on a daily basis. Some mock mayoral customs saw the real mayor of a town locked up for the day while the mock counterpart took to the streets. It is interesting to ponder whether this role reversal had any effect on the mayor of a town, and whether their policymaking was changed as a result.

Mischief night

A similar idea to the election of a mock mayor and the upsetting of societal order exists in the ancient custom of mischief night, which

THE LOST CUSTOMS

was particularly common in the period around Halloween, taking place on the evening of 30 or 31 October. Residents of a town, generally children, would take to the streets and enact mischief. This would mostly involve the moving or displacing of important objects such as farm tools, the blocking up of chimneys and doors or the throwing of flour or other items of food. It was a chance for children to cause havoc. There were many regional variations of the name; in Wales it was known as Noson Ddrygioni ('Night of Evil') and in Scotland as Oidhche nan Cleas ('Night of Tricks').

The custom has almost entirely been replaced these days by the American custom of trick or treating. However, in Liverpool there are remnants of the practice: the evening is still referred to as Mizzy Night, and sees many people take to the street to cause mischief. It has in recent years become more sinister, with people letting off fireworks in the street and pelting buildings with bricks. In 2019 it was reported that thirty-four deliberate fires had been started across the city, and as a result the evening now has a heavy police presence.[5]

In the early 1930s folk collector Margaret Fay Shaw, whom we met in the first chapter, recorded a series of black-and-white photographs of Oidhche nan Cleas taking place on the moorlands of the Hebridean island of South Uist. In the images children look directly at the camera but their faces are obscured with masks made from animals' skins, sacks, paper bags and paint. Over their clothes they wear cloaks made of shaggy sheepskins or old pieces of fabric with ropes tied around their waists. They look truly haunting. As if they could have stepped from a folk horror film . . . but this is Scotland in 1932. They were known locally as gìsears, and as in the English mumming tradition (which we will come to later), they would go from door to door singing in exchange for a bannock (a flatbread). If the treat of the bannock was refused, they would engage in mischievous acts. Even rarer than the photographs is Margaret's footage

195

of the children in their costumes, a unique piece of film that captures the custom in action, the children moving about and looking deeply menacing. Margaret was clearly chilled by the custom, writing: 'On the evening of the last day of October, I was sitting by the fire reading when I heard a knock at the door and looked up to see a horrible face. Mary [Mairi McRae] laughed at me and I remembered it was Hallowe'en.'[6] The custom has, like the other mischief nights around Britian, been largely usurped by Halloween, which retains some of the traditions (in trick or treating) but has done away with the more demonic costumes featuring sheepskins and paper bags in favour of more jokily 'spooky' renditions of ghosts and popular characters from television.

Folk sports

Shrovetide or Lenten customs that occur in the month of February have also often leant towards this theme of societal unrest, a remaking of how and who is in charge. Folk sports offer a particularly good example of how people can use physical strength to exert a sense of power – but what exactly is a folk sport? It is difficult to define them as they vary enormously, but generally they take place in streets, they are usually processional in some capacity (in that they move with speed through a place), and they generally involve a handmade ball or device that is kicked, hit or thrown from point to point. The rules are usually very clear, but they are almost always governed by the people of a place rather than any outside force such as a council or committee.

In Lanark in Scotland, an event called Whuppity Scoorie takes place on 1 March. This was traditionally the first day the church bell would ring again after being silent for the winter. It was historically a symbol that spring was on its way. The first chime of the bell is still the signal for the children of the village to take a race around the church. They make three laps of the building, whirling paper balls

THE LOST CUSTOMS

attached to string around their heads as they go. In the past, rather than swinging the paper balls, the children would pelt the church with stones as they ran. This practice, as you might imagine, has been discouraged. The event used to be competitive, with the child who won the race being awarded a prize. These days, with the aim of making it inclusive to children of all abilities, a prize is awarded for the best-decorated paper ball.

Further south, at Purbeck in Dorset, the Shrove Tuesday Football Ceremony of the Purbeck Marblers takes place. Here the Company of Marblers and Stonecutters of Purbeck meets at the Fox Inn in Corfe Castle, and waits for the town clock to strike twelve. Gathered around tables of the pub you will find both the freemen of the Ancient Guild of Purbeck Marblers and their hopeful apprentices. On the chime of the clock, the freemen process to the town hall – the smallest in the country – where they await the apprentices, who, on being called to the town hall, bring with them a tankard of beer and a penny loaf in the hope of exchanging them for admittance to the guild. The honour of becoming a freeman of the guild allows each stonemason to take marble or stone from anywhere on the Isle of Purbeck: a right that is passed down the generations.

After the election of the new freemen has taken place, the guild takes to the street and plays a game of football which is akin to a beating of the bounds (in which the boundaries of a town are beaten with sticks). At Corfe Castle they kick the ball in a field near the town hall, and a separate football is also sent to Ower Quay with a pound of pepper. The latter ceremony is enacted to reaffirm the quarrymen's rights of way, as Ower Quay is where the quarried stone was originally shipped out from. Although the tradition continues, as families move away it becomes a smaller and smaller affair each year.

Similar Lenten games of football also take place at Ashbourne in Derbyshire, at Alnwick Castle in Northumberland, at Atherstone

197

in Warwickshire and at Sedgefield in County Durham. In Scotland, a game takes place on Shrove Tuesday at Jedburgh, known as the Jethart hand-ba': here the ball is tied with ribbons and thrown into the air, after which the men of the town work to win the ball back. It is said that the game was originally played using an Englishman's head, and that the ribbons represent his hair. Shrovetide games used to be played at Chester-le-Street in County Durham until 1932, when they were deemed unsafe by the local constabulary due to their boisterous nature, which often led to people being injured, and at Nuneaton in Warwickshire until 1902, when they too were quashed by the police for fear of the number of people taking part.

In Cornwall, hurling takes the place of Shrovetide football, and games can still be witnessed today at St Columb Major and St Ives.* A silver ball is thrown into the streets and it is chased to a designated endpoint, where a winner is declared. It is a fast, furious and at times terrifying game that favours those who are fearless and literally throw themselves into the proceedings. Likewise in Haxey, north Lincolnshire, a raucous game called the Haxey Hood takes place in January, featuring a leather tube known as the sway hood that is launched into the air and which men of the town sway (or scrum) to get. The game has strict rules and has a series of characters called boggins, who are essentially folk's answer to health-and-safety stewards, ensuring that the rules are followed and that property and people don't get *too* damaged in the process. The self-governing aspect of all these folk sports is an important feature. Those that have continued into the twenty-first century almost always have this as part of the game's focus – a sense that if it gets too violent and wild, the community will rein it in and prevent anyone getting gravely injured.

* Like the Whuppity Scoorie the St Ives Hurling game is performed by children.

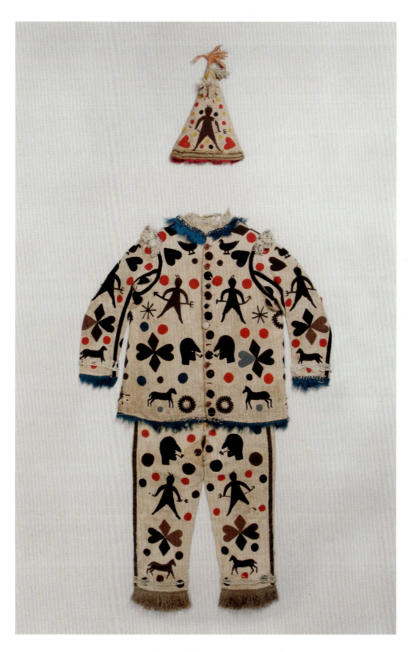

Mummer's Costume made up of an appliqued jacket, trousers and hat, dated 1829. Held in the collection at Philadelphia Museum of Art

Left: Traditional English Smock made by Penny MacBeth, 1996

Bottom: The Floral Clock, Weston-Super-Mare, 1936

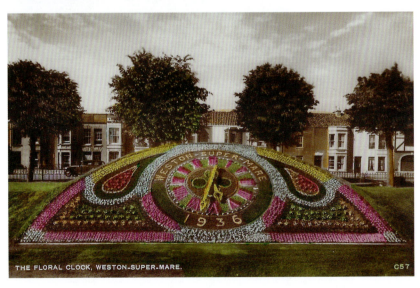

Right: Jubilee Bonfire held at Wolfstones Heights Trig Point (also known as Jubilee Seat), Netherthong, West Yorkshire, 1935

Bottom: Community centre Christmas lights, Angarrack, Hayle, Cornwall, December 2024

Top: Stan's Country Christmas light display, Perranzabuloe, Cornwall, c.1999

Bottom: John Brown, a local farm worker, dressed as Uncle Tom Cobbley at Widecombe Fair, Widecombe in the Moor, Devon, September 1956

Top: 'Whither I Go Ye Know', a Well Dressing at Coffin Well, Tissington, Derbyshire, 1904

Bottom: Ilford Park Polish Camp folk dance performance, date unknown

Badges from three, now defunct, Model Villages: Skegness Model Village, Tucktonia and Little Town Minehead

The Castle at Fairytale Land, Margam Park, Glamorgan, Wales

Above: Mrs E. Head stands in the Model Village at The Woodcarver's Cottage, Woolmer Green, Hertfordshire, c.1972

Right: The Shell Village, Southampton, Hampshire

Top: The remnants of the mural outside Bramwell's Meadery (now a hotel), Penzance, Cornwall, January 2024

Bottom: Excalibur's Meadery carnival float made by Terry English for Hayle Carnival, c.1980

THE LOST CUSTOMS

The burning pyre: fire customs

Bonfires could fall into many categories of folk practice, given that they celebrate seasonal points in the year such as midsummer or Halloween. However, they do also often work to even the balance of society and show the powers that be who is really in charge. What better method than a burning pyre? The idea of unrest through fire is nowhere better represented than in the customs surrounding Guy Fawkes Night on 5 November, commemorating the plot to blow up the Houses of Parliament. The evening is of course still widely celebrated across Britain, with notable celebrations across East and West Sussex where a great number of bonfires are organised by the numerous bonfire societies.

Coronation and jubilee bonfires

Fire as a means of keeping outside forces at bay forms the basis of coronation and jubilee bonfires: towering piles of offcuts of wood and vegetation, layer upon layer, soaring into the sky, crowned with a flag flapping in the wind. Photographs of Edwardian coronation fires generally show a large group of bonfire builders standing proudly in front. Sometimes there is a ladder propped against the unlit pyre, as if to accentuate the magnificent height. Occasionally the initials of the monarch being crowned or celebrated are emblazoned on the front, made from twigs or flowers. Altogether, they present images both of extreme national pride and of menace. Standing in front of these immense fires constructed like the tiers of a wedding cake, the tradespeople who have built them give off the air of a placated mob, celebrating until they are not. There is something almost *Wicker Man*-esque in the presentation – 'we gift you this but be careful, otherwise you might end up on top of it'.

On the eve of Edward VII's planned coronation date of 23 June 1902, celebrations were called off due to the ill-health of the king-to-be.

199

THE LOST FOLK

In Dunstable, Kent, this was met with great upset: windows were smashed, tables were toppled and the mayor (who had called off the celebratory events) had his house stoned. The people were not happy. The food was ruined and was going to go to waste. In an age of food poverty, this was a cause for revolution. A large bonfire had been built on the downlands above the town. The rioters marched to it and set it alight. They would not be stopped from making merry. The events in Dunstable provide an excellent example of what can happen when a community's carefully planned custom is cancelled, prompting the question, in the instance of coronation events, is it about the coronation of a new monarch or, as with other folk customs, about the gathering together of a community and a much-needed letting off of steam? It is interesting to note the date of St John's Eve: a traditional point in the calendar for the lighting of bonfires, with or without the crowning of a new king.

Ysbrydnos: fires to keep the spirits away

Wales was once home to a widespread custom of bonfires to keep away malevolent spirits who were thought to roam the villages and towns at particular points in the year. Across Wales, protective bonfires would be lit on three nights known as *ysbrydnos*, meaning spirit nights. These nights were said to be when the veil between the living and the dead was at its thinnest point, and spirits and ghosts could walk between worlds. In order to protect the towns from these wandering spirits and bring good luck for the ensuing season, people would collect wood to build huge bonfires known as *coelcerth*. The burning furnaces would be kept going all night with people leaping over them and scattering herbs deemed to have protective properties over the flames. The three spirit nights were May Eve, known as Nos Galan Haf, St John's Eve, known as Nos Gwyl Ifan, and Halloween, known as Nos Galan Gaeaf. It was common for the ashes to be saved

THE LOST CUSTOMS

at the end of the fires as a further protection from evil forces such as witches and ghostly entities. A similar practice of seasonal fires was at one time found in Cornwall in the celebration of Nos Kalan Gwav (or Allantide) at Halloween and Golowan on St John's Eve, where bonfires were lit, known as tindle fires, and at Halloween on the Isle of Man, where the celebrations were known as Hollantide.

As part of the network of Welsh fires there was also a practice, in North Wales and Anglesey, around Nos Galan Haf of *gware gŵr gwellt*, meaning to play a straw man. This involved young men who had lost their loves to other suitors making straw effigies to win them back. The straw man, or *gŵr gwellt*, was left for either the potential love interest or the love rival to find. The following day of May Day generally resulted in a fight between the two men.

Straw customs are often intertwined with fire. In the village of Whalton in Northumberland, until just before the First World War there was a custom for making a large figure called a kern baby, which was burnt on a bonfire known as the Baal fire at the end of the harvest celebration. The custom was recorded by the photographer and politician Sir Benjamin Stone in the early twentieth century. One of his images shows a life-size corn figure in a white dress; her head is made from a spray of ears of corn. Other photographs show children hand in hand, gathered around a pile of vegetation waiting for it to be lit. The photograph is curiously labelled 'Baal Fire, St John's Eve', although the date beneath in the same cursive text is '4th July 1903'. You may be thinking, 'but midsummer is in June!' – well in Whalton they still celebrated the old date for midsummer before the Gregorian calendar was adopted, a truly ancient survival.

In Monkwearmouth in Sunderland, a similar figure was erected, known as a mell baby, which was dressed in old clothes and decorated with coloured ribbons. Mell is thought to be a derivation of the French word *mesler*, meaning to mix. A clue to its name comes in its

201

THE LOST FOLK

usage in the context of the harvest home supper, which was known in this area of England as the mell supper. These feasts would have traditionally seen a greater level of social integration than usual, with master and servant sitting at the same table to eat, drink and celebrate a successful harvest. The custom died out much earlier than the Northumbrian kern baby, but it crops up frequently in nineteenth-century newspaper cuttings.* The practice of making straw effigies and burning them upon a raging fire was a means of invoking protective spirits, much like the Welsh *coelcerth*. It was a way of using the harvest or the fruits of the land to protect the village and its people from otherworldly, ghostly entities.

In Scotland, great protective fires known as Halloween bleeze were also lit on 31 October. This night was similar to the Welsh *ysbrydnos*, and was used to banish the that were believed to wander when the veil was at its thinnest in the space between Tìr na mBeó (the Land of the Living) and Tír na Marbh (the Land of the Dead). Alongside these fires, a number other traditions took place, including dookin' for apples, tumshie (turnip) carving and throwing nuts into the fire to see who would be wed first – it would be whoever had the nut that cracked and jumped out of the fire first. Nuts were also thrown into the fires that took place in Cornwall at Nos Kalan Gwav, but here the cracking and jumping was said to foretell the fidelity of a partner.

* It is widely reported that the kern baby custom fell away in the early twentieth century, but there are records of something called a kirk baba being made in Whalton until the early 1960s by Bella Harvey, a resident of the village. Although much smaller than the effigy that Benjamin Stone photographed, it was fashioned at the end of each harvest and kept in the church until the following year. Likewise, at St Mary's Church in Dymock, Gloucestershire, until the early 1970s two corn effigies, part figure, part cross, were nailed to the church door each harvest. A kirk baba made by Bella, and a corn cross from Dymock, both featured in the 'Barley Mow' exhibition mentioned previously.

THE LOST CUSTOMS

The burning of Old Bartle

Although fires are often built to protect, they can also be built to harm. Folk sport and fire meet in the custom of the burning of Old Bartle, which still takes place in the village of West Witton near Wensleydale in North Yorkshire. The event occurs over the course of a day in late August, generally the Sunday closest to St Bartholomew's Day. In the daytime, a gala takes place, with stalls, a barbecue and bouncy castles. Then there is a fell race, which involves villagers running from the village to the top of nearby Pen Hill and back. In the evening, an effigy called Owd (or Old) Bartle is brought out, generally made from straw stuffed into old clothes with a cloth head. He is carried through the village while onlookers chant the following rhyme:

> *At Penhill crags he tore his rags*
> *At Hunter's thorn he blew his horn*
> *At Capplebank Stee he brok his knee*
> *At Grassgill Beck, he brok his neck*
> *At Waddam's End he couldn't fend*
> *At Grassgill End we'll make his end*
> *Shout lads shout!*

Old Bartle is then ceremoniously thrown onto a burning pyre, and burnt to a crisp while the people of West Witton make merry, dance and sing. It is believed that the name of the effigy comes from the day being associated with St Bartholomew, and there is some suggestion that the effigy originally represented the saint himself. However, it is not known why the villagers began the practice of burning it. The rhyme that is chanted does suggest they believe Old Bartle, whoever he is meant to represent, to be bad, and it could be that he, like the

203

THE LOST FOLK

character of John Barleycorn,* represents a general, undefined evil spirit who must get his comeuppance. In broader terms, Old Bartle is the representation of the harvest, and the gradual ebbing of the summer into autumn.

The burning of Old Bartle, and the burning of the kern baby, once again show how villages and towns across Britain have throughout history taken into their own hands the practice of protecting themselves from what they believe to be wicked forces – be that more esoteric presences or, in the case of coronation bonfires, groups of people perceived to be in charge such as the monarchy or councils. Fire in folk practice is a way of forming a defence against the world.

'In comes I': folk on the move

Movement in folk customs is hugely important. Folk is full to the brim with people hopping, skipping, walking and leaping through Britain. Not only is there of course a plethora of folk dance from morris dancing to clog dancing but there are also processions, parades and carnivals, all of which incorporate movement alongside spectacular costumes, decorated floats and music. Folk dance is a huge and varied part of the folk landscape of Britain, and although a full discussion would need more space than I have here, I would like to make mention of a particularly interesting group I recently unearthed.

For many years, Leonard Cheshire, a charity that once provided homes for people with complex needs, illnesses and impairments, produced an in-house magazine called *Cheshire Smile*. In an issue from 1977, I discovered an article about chair dancing written by George

* 'John Barleycorn' is a popular folk song that appears in England and Scotland in which the character of John Barleycorn suffers multiple attacks before dying. It is often believed to be a representation of the process of the harvest from sowing to reaping.

204

W. J. Hart, the treasurer for the Wheelchair Dance Association. In it, George talks about a project put together by the charity now known as Scope, in collaboration with a dance teacher called Sally Murphy who was based in Falmouth, Cornwall. Sally adapted folk and country dances so they could be taught to and performed by wheelchair users. George states: 'Disabled folk from all over Britain, including Scotland, were now going on journeys and meeting other dancers – things beyond their wildest dreams.'[7] It grew massively in popularity and by 1976 there were at least three national festivals celebrating chair dancing, with a particular emphasis on folk dances. From St Bernard's waltz to the Virginia reel, the dances had been fully adapted to make them enjoyable and accessible. In the same article, George also mentions that Sally put together a book of these dances, and gained the support of the English Folk Dance and Song Society. Sadly, despite searching for this book, I haven't been able to find it. It's likely that it was a very small pressing, and that the copies were distributed only within the Leonard Cheshire Homes network.

Mumming, guising and folk plays

One of the oldest forms of folk on the move is the custom of mumming and the associated folk plays, which happened across Britian in the lead-up to Christmas, around Plough Monday and at Easter. As part of the celebrations in the lead-up to Christmas, groups of performers known as 'mummers' used to make their way around towns across Britain performing folk plays, clad in paper costumes or clothing made from old rags, ringing their bells and jangling their money pots in the hope of some pennies to buy beer and plum pudding.

The mumming play is a form of folk custom that has existed for hundreds of years in England and Ireland. They generally feature archetypal figures such as St George and his dragon, or Father Christmas and Old Beelzebub (aka Satan). Traditionally they take

THE LOST FOLK

place on Boxing Day, Plough Monday, Easter and May Day, and they almost always feature homemade costumes. Paper costumes are the most common: tall fringed hats made from newspaper, and jackets with paper rags and rosettes adorning them.

While the streets and pubs of Britain were once awash with mummers, there is now only a small contingent that continue the tradition. Some of the most well known are the Marshfield Mummers (also known as the Old Time Paper Boys) from Gloucestershire. Their play was revived in 1930 and, according to their website, is one of the only plays of its type to conform to the tradition of being learnt entirely orally, i.e. passed from mummer to mummer. The folklorist Violet Alford was instrumental in the revival of this custom.[8] Her brother was the reverend of the parish, C. S. L. Alford, who told her of a strange and antiquated form of language being used by his gardener. On visiting she was able to ascertain that the line he was singing – 'In comes I' – was from an old mumming play that in years past had been performed in the town, and working with the gardener's recollections she was able to reassemble a script. The Marshfield Mummers still perform their play using Violet's script on Boxing Day in the market square of Marshfield.

There are other plays which were once as well embedded in their towns as the Marshfield Mummers but that have now entirely disappeared. One such in Penryn, Cornwall, is said to have taken place each Christmas in the square (which was later bombed and destroyed) and is described in an article from the *Cornishman* in 1879:

> A kind of Christmas Plays are still continued at Penryn ... their representation is confined to a few children, or very young persons who appear fantastically dressed, decorated with ribbons and painted paper ... They entertain their auditors with a barbarous jargon ... which has been handed down from father to son from time out of mind.[9]

206

THE LOST CUSTOMS

There are no other remnants of this play, and it is not recorded in *English Ritual Drama*, the Folklore Society's seminal 1967 study of English folk plays, but mumming and mummers are known to have been widespread in Cornwall in the nineteenth century. There are records of Christmas plays having taken place at Polperro, St Austell, Liskeard and Mylor, among a great many other places. Often the mummers in Cornwall are referred to as 'guise dancers' or 'geese-dancers'. This is in fact a slightly different tradition, and one that has been even more forgotten, in which people, generally children and young adults, would don old clothes and take to the streets to make mischief – not dissimilar to the customs around mischief night. Fragments of the guise dancers' history can be pieced together from the numerous Victorian antiquarians who wrote about them. In the late nineteenth century, the writer and historian Fannie Goddard wrote of the continuation of the Christmas guise tradition in Cornwall, making reference to them as Goosey dancers:

> The Old Christmas Mumming Play is still in great force in various part of Cornwall during the festive season . . . The 'goosey dancers', or guised dancers, still play their merry prank, and, on Christmas-eve, make a raid on their parents' wardrobes, and . . . disguise themselves . . . and dance and sing for money.[10]

There is no doubt that, as a folk custom, guise dancing was deeply rooted in the Cornish region, paralleled only in parts of the Outer Hebrides, Shetland and Staffordshire, where there were similar customs of guising. In Staffordshire, the custom was also knitted into the winter calendar. Until 2003, the Uttoxeter Guisers graced the pubs of Uttoxeter in East Staffordshire each Christmas, dressed in jackets covered in coloured ribbons and hats decorated with tinsel. They danced, sang and, in a merging of guising and mumming plays,

THE LOST FOLK

performed their play St George and the Dragon* while going from hostelry to hostelry and home to home. The tradition was virtually unbroken for over a hundred years and was recorded in 1906 as having been performed by 'mostly people of gipsy origin settled here',[11] suggesting that it was linked to a long-standing tradition of wandering. The custom was certainly maintained and passed down by particular Uttoxeter families, as is often the case with mumming plays. The guising custom at Uttoxeter, unlike many others of its kind, survived through both the First and Second World Wars; in 1938 it was recorded by the BBC, and the play was recorded again in 1946 and aired to the nation as part of the Midlands regional broadcast. The group continued to perform into the early 2000s – with only one break in 1964 due to a bereavement – until so few of the original families still lived in the area it was deemed impossible to continue.

Before the redrawing of county boundary lines in 1974, Uttoxeter was in Derbyshire, and it seems that the Uttoxeter Guisers were the last remnants of a long-standing tradition of guising in the county. There are records from the early twentieth century of guisers in Matlock, Weston-on-Trent and Draycott,[12] but it seems the practice was once even more widespread than this: there is a mention of a play at Ashbourne that had already faded into history by 1906, and guisers at Alvaston in 1867, though the custom seems to have lapsed there soon afterwards.[13]

The fact that both Cornwall and Derbyshire had such ingrained and sustained guising traditions is interesting. Both seem to have continued in spite of a rise of the Methodist Church in both regions. Although Methodists are often discussed in relation to the suppression of customs, many of the nineteenth-century accounts I

* The story of St George and the Dragon is generally more associated with springtime mumming plays.

THE LOST CUSTOMS

have found make reference to a Methodist chapel or Sunday school having started a more sanitised version of the guising tradition, with processional carollers going from door to door. It seems that when Methodism arrived in both Cornwall and Derbyshire, it was easier for the clergy to go with rather than against the people, and they seemingly decided to adopt the ancient tradition, or at least a version of it. Mumming is now very much intertwined with drinking and pub culture, but in mid-Victorian Britain, it appears to have been co-opted as a way of keeping people in check, and allowing them just enough supposed rowdiness under the strict conditions of chapel. The consequence of this was that in Derbyshire and Cornwall, an ancient custom was largely sanitised and softened to correspond with Victorian ideals. Occasionally both official Christian and folk practices occurred at the same time – this was certainly the case in the small village of Duffield, where guisers, a Methodist service and morris dancers all appeared over the period of Christmas.

On the Shetland Islands the guisers were known as skeklers, and similarly would go from house to house in exchange for gifts of food or money. Their costumes differed from their English counterparts: the skeklers made costumes from straw that bear more resemblance to the straw boy mumming costumes worn at Christmas and on St Stephen's Day across Northern Ireland than anything worn by English mummers. The skeklers' heads were entirely obscured by conical straw hats, the tops of which were decorated with rags of fabric. The people at each house would have to guess their identity before they removed their disguises. The Shetland tradition had died out before the end of the nineteenth century, but an original skekler costume is held by Shetland Museum & Archives, and in 2013 the artist Gemma Ovens visited the island of Fetlar and recreated a number of costumes and made a film exploring the tradition and its history. Other than these remnants, it is all but lost to history.

209

THE LOST FOLK

Guising and mumming are customs that tend to be associated with rural towns and villages. This is probably in no small part due to the fact that in 1405 an Act was passed in London banning mumming throughout the city, with bans coming a few years later in both Bristol and Chester.[14] There was a sense that mumming was used as way of committing sinful acts and, as Ronald Hutton states in his book *Stations of the Sun* (2001), a Scottish man was hanged in 1508 for stealing while in his mumming guise.[15] The authorities were keen to suppress the custom, given their feeling that it was leading to bad behaviour, and this tended to happen in cities more so than rural towns due to the population size. In smaller places it simply did not make such a difference whether mumming happened or not.

These days a mumming play does once again take place in the capital: outside the Globe Theatre on Bankside in London, mummers perform a play on Twelfth Night before eating Twelfth Night cake and processing to the George Inn. In modern Britain, mumming customs have in many ways evolved into the pantomime tradition that takes place across the period of Christmas and New Year. Panto preserves many of the tropes that mumming once used – archetypical characters, repetitive lines, topical local references and slapstick comedy, and there is, of course, the panto horse, which could have its origins in the form of the hobby horse or 'obby 'oss.

The art of guising has, in more recent years, been revived in Cornwall at the Penzance midwinter festival of Montol, for which historical accounts have been used to build an entirely new event. People gather on the streets dressed in masks, there is a huge bonfire and Pen Hood, the Montol 'oss, parades through the shops and bars. Montol is essentially an inversion custom: for one evening all the rules and hierarchies are turned on their head. The authorities must give way to the people, who take to the streets, wreaking havoc and merriment, before dawn strikes and the world reverts once more to

the established order. It is the embodiment of dark turning to light, the darkest moment in the year being lit by fire and joy.

Processions and parades

Processional customs happen across the folk calendar from midsummer to the winter solstice. There are processions as part of the Wakes Weeks, which involve residents of a town taking part in events known 'Walking Days'. Wakes Weeks are week-long holidays that take place across the North-West of England.* The tradition was originally a celebration of the saint's day associated with each particular local church. Gradually the custom became secular and moved to be associated with a week's holiday given by the mills and factories when they closed for repairs in the summer. Each town would take the week's holiday at a different week to promote tourism to other towns. Around these weeks, various customs and traditions began, including processions. These are particularly prevalent in Cheshire, where walks take place at Macclesfield and Warrington. Around the rest of Britain there are a whole host of other processions that take place including at Allendale in Northumberland where men carry flaming barrels through the streets on New Year's Eve, at Leicester where the Sikh population of the city walk through the streets for the traditional festival of Nagar Kirtan in November and the Whit Walks that take place across the North West on the Friday after Whitsun.

At Musselburgh in East Lothian, Scotland, there exists a fragment of a mostly forgotten walking custom. September used to see the fisherman's walk take place, an event that brought together the fishing community in a procession to give thanks for the sea and its bounty, and importantly to distribute the funds that had been collected by the Musselburgh Fisherman's Walk Society, a friendly society begun in

* In Scotland they are two-week breaks and are known as 'Trades Fortnight'.

1790, ensuring that all members of the community were provided with help during times of need, as well as a pension. All fishermen paid into the fund throughout the year, and each September it was opened and divvied out to those in need. The event gradually expanded, spreading into multiple streets, the community decorating their houses with creatures from the deep and small replica sailing boats. Banners featuring emblems of the society were carried by members of the procession, and at the end of the walk there was a series of races and reels. One of the most intriguing of the races was known as the 'race for a shawl', in which the wives of the fishermen raced each other to win a new shawl. It was generally considered to be a highlight of the day, with the women jostling and pushing to get to the desired reward. There are few remaining remnants of the shawl race, and only one black-and-white photograph of the women running, from the early 1930s, now held by East Lothian Archive Service. It offers us a rare glimpse into a female folk sport: here the women are barefoot, their expressions both joyful and fierce, eyes on the prize. A crowd of revellers looks on, shouting words of encouragement.

The tradition seems to have lapsed shortly after the photograph was taken, evolving into the slightly less rowdy fishwife parade, which happened on the same day and saw the women of the community don the traditional local fishwife costume (a kirkin' shawl, a striped skirt and an apron) and walk alongside the fishermen. Many of them carried poles with dolls dressed in miniature versions of the costumes: 'A doll carried by the Misses Langlands has been in the possession of the Langlands family for over fifty years. Beautifully coloured shawls, many of them priceless family heirlooms handed down from generation to generation, were also worn by the women to the admiration of onlookers.'[16]

The Langlands' doll was called Betty, and was originally carried by Leebie and Mary Langland; it has been suggested that it represents a

THE LOST CUSTOMS

dead third Langland sister.[17] In general, these dolls seem to have served as talismans, connecting the women to their long lineage of female ancestors. They had been made by their mothers, aunts and sisters and were paraded by the living through the streets with deep pride.

The walk was long and tumultuous and in 1912, due to the decline of the fishing industry and a rise in larger boats that could no longer fit into the harbour, the society folded and the procession fell into non-existence. However, in 1930, local fishermen Robert Fairnie, Alex Craig and Robert Brown decided to revive the procession. It lasted for several years before ceasing just prior to the Second World War. The next decades saw the occasion re-emerge then fold repeatedly until 1989, when it finished for good. There is now a small nod to the original event incorporated into the annual Musselburgh Festival held in July, where the last remaining fishing boat of the Fisherrow fleet, *Fairnies*, sails out to sea with the newly sashed honest lass and honest lad, who were introduced when the town's festival was instigated in 1936, alongside the procession.* Once the boat comes back into harbour, a reel is performed and a mussel feast is eaten.

The ancestral dolls, or at least some of them, can be found resting in the archives of National Museums Scotland and the Scottish Fisheries Museum, alongside several of the traditional gala outfits worn by the women of Musselburgh for generations, keeping alive the memory of the powerful Musselburgh women.

Carnivals

Carnivals as we know them today have existed in Britain since the late nineteenth century, although the term is a much earlier one. It was originally used in relation to Lenten customs happening in

* The honest lass and lad are chosen from the community by the Musselburgh Festival Committee, and are seen to be upstanding members of the town. They are each given a ribbon sash by a figure known as the 'sasher'.

213

THE LOST FOLK

the lead-up to Easter, which often involved processional elements, such as football games or roving performances. By the late nineteenth century, however, carnivals had evolved to look much more like what we know today, with people in fancy dress taking part in what are mostly walking processions. Floats began to make an appearance in the early twentieth century, the early iterations generally completely encased in flowers, using bicycles or carts as the structures beneath.

In the archive of family photographs I found in my grandfather's shed, alongside the pageant photographs, I discovered a series of photos from a very early carnival in Ludlow. The images are in black and white, very faded, but among them is one of a float covered in flowers. It is a strange, wobbly structure, and behind it there appear to be many others. They are all clearly pictured while in motion, seemingly going around a field. Many carnivals began in this way, as largely static displays on recreational land on the outskirts of a town. In some ways they were more akin to a modern-day fete or country show. However, as they grew in popularity, they expanded out into the streets, and the whole town became focused on making costumes and floats, as well as choreography and music. As technology improved, so did the floats: cars and motorbikes were utilised and electric lights were used to illuminate the various vehicles. In many ways these glowing vehicles replaced the earlier widespread custom of using light to celebrate points in the year through bonfires. In the early to mid-twentieth century these fires (although later revived in some places) had for the most part disappeared and in their place emerged electric-lit floats in all shapes and sizes, offering a modern way of bringing the warmth and brightness of a fiery flame into towns. There are a great number of carnivals that focus entirely on illumination through brightly lit floats, which take place across Somerset from August to October.

THE LOST CUSTOMS

Carnivals are intrinsically accessible events, as they comprise a mixture of floats, walking parties, cars and other forms of transport. They offer a range of spaces, within which anyone and everyone can get involved; there is room for all.

In particular they can offer one of very few spaces within folk customs where disabled bodies are represented. Societies, charities and trusts have often used carnivals as a vehicle for raising money for their particular causes; the 1964 Nuneaton Carnival raised money for a bus for the disabled, Portland Carnival in 1966 raised money for the Guild for the Disabled and the Dagenham Town Show Carnival in 1972 included a float from Dagenham Mental Health Association of a huge papier-mâché dinosaur and a sign beneath that read in block capitals, 'IN ANCIENT BRITAIN DID DINOSAURS HAVE BREAKDOWNS? IN MODERN BRITAIN 190000 PEOPLE DO EVERY YEAR'. A photograph from 1960 of Worcester Carnival shows a float for the Muscular Dystrophy Society with a papier-mâché model of a child in a wheelchair, a photograph from the 1969 Northampton Carnival shows a group of people in wheelchairs all dressed in carnival costumes and an image from the 1988 Elland Carnival shows a child in a wheelchair dressed as a Pierrot. Although many of these examples are through the very particular lens of charitable organisations, they do all open up a par- ticularly inclusive space in encompassing a range of mobility.

Hackney Street Carnival was established in 1973 by Centerprise, an African and Caribbean community centre, and today it bears witness to this inclusive spirit with the inclusion of Paracarnival. Led by Bettina Fernandez and Richard Sleeman, Paracarnival encourages people with a range of disabilities, from deaf people to people with Down's syndrome, to take part in the wider carnival by holding workshops in the lead-up to carnival including wheelchair dancing and head-dress making. All the workshops are prepared for groups

THE LOST FOLK

with mixed abilities, with provision made for a wide scope of accessibility needs, the emphasis being on having fun and being present. Through their work with Paracarnival, Bettina and Richard have created an environment in which disabled people can be actively involved in a celebratory and joyous way in this form of folk custom. The focus is on having fun, not on their condition or being used as a way to raise money for charity. As well as taking part in Hackney Carnival, Paracarnival now also has a presence at Bristol Carnival, and a number of smaller events across London.

Carnivals have evolved to encompass a mixture of walking and dancing parties, alongside traditional floats. In the 1950s these processional town carnivals saw a wave of new energy: the arrival of HMT *Empire Windrush* had seen communities from Trinidad and Tobago, St Kitts and Nevis, and Jamaica, among other Caribbean islands, relocate to Britain, bringing with them steel bands, calypso music and an injection of fresh energy. The first ever Caribbean carnival celebration in Britain took place on 30 January 1959 in St Pancras Town Hall, organised by Claudia Jones in response to the horrific attacks on the Caribbean community during the Notting Hill race riots of 1958. The carnival was a chance for the community to come together, and to be present and heard within the city. Later on, in September 1966, Rhaune Laslett organised the Notting Hill Fayre and Pageant, including in the event a steel band and a walking parade. The combination of these two events was instrumental in the formation of the Notting Hill Carnival we know today. Although this is now the best-known Caribbean festival in Britain, it was started amid a great number of other, similar celebrations, which have subsequently faded from history.

Leeds is often considered to be home to the first Caribbean carnival organised outside London by the Caribbean community. It emerged in 1967, although it had been proposed by Arthur

THE LOST CUSTOMS

France the previous year and rejected by the United Caribbean Association, the committee that was set up to represent the voices of the Caribbean population of Leeds.[18] Although I can find no reason given for this rebuff, there is no doubt that in the late 1960s there was a gradual sea change towards these expressions of culture, and so it is not surprising that the Notting Hill Carnival, having been put on for the first time in 1966, would have encouraged the Leeds community to put on their own event.

There were even earlier Caribbean festivities, though, than those in Leeds. In Birmingham in 1966, the West Indian Students' Association started up the West Indian Festival, a celebration of Caribbean dance, music and food that was held across two days at Aston University. In an article of the time, nursing student Monica James stated, 'We are trying to show the English people how we enjoy ourselves,' and she went on to say, 'The only thing missing is the sun but it's still great.'[19] A further cementing of Caribbean culture into the make-up of Birmingham came in May 1969, when the city's first ever solely designated Caribbean carnival took place. It was held at Farm Park in Sparkbrook, and included floats, steel bands, a calypso band and a carnival queen.

Both the West Indian Festival and the carnival were introduced as ways of integrating the Caribbean community into Birmingham, with the Birmingham carnival organiser Gus Williams stating that it was instigated as 'a celebration of friendship and unity within the communities and has brought people of all colours together'.[20] This inclusive approach was by no means confined to Birmingham. A Caribbean carnival was organised in Reading for the 1977 Silver Jubilee. It played host not only to a number of Caribbean groups but also to the Chinese Association, and was generally considered to be a successful step in the direction of celebrating all the communities living in the city. The third carnival in 1979 saw a change of name

THE LOST FOLK

to just 'Reading Carnival', with the organising committee suggesting that 'it was an occasion for everyone, no matter what their race, creed or colour.'[21]

In 1997 when Gus Williams, the then-chair of the Birmingham Carnival, was interviewed by the *Birmingham Post* he stated: 'You need a comforting thought when you are living in a society that treats you less favourably, that one day you can escape from it all.'[22] He makes an important point. Carnivals, or the idea of them, have served a purpose in place of the longed-for return to the perceived 'homeland'. They have offered migrant communities a safe space to express their culture – to feel a sense of home, and a sense of belonging.

In Trinidadian culture there is a word that loosely translates as a sadness or depression at the end of carnival – 'tabanca', a longing for the party to go on, and a feeling of pathos at having to return to the humdrum of normal life. The video artist and writer Akinola Davies Jr explores the meaning of the emotion connected with carnival in his 2023 film of the same name. In it he unpacks the multitude of narratives that unfurl during the two days of Notting Hill Carnival, from extreme joy, to fear that it'll be shut down, to unbridled hedonism, and the resulting sadness at its passing for another year. In an accompanying text to the film, the writer Bianca Manu says, 'Carnival is a portal that transports the local community back to Caribbean islands abstracted through time.'[23] For the communities involved, carnival is escapism; carnival is freedom; carnival is belonging.

The uprise in specifically Caribbean carnivals has not been without difficulties: Notting Hill Carnival has seen a gradual decline in the space afforded to it. In its early days, it ran for twenty-four hours a day and was filled with music, dancing and celebration. In the film *Tabanca* one carnival reveller says, 'It used to be twenty-four hours, then it stopped at midnight, then ten, then eight and now seven, it's closing earlier and earlier.' Year on year, the festivities have decreased, to the

THE LOST CUSTOMS

point that it now has a very defined slot ending at 7 p.m. on the dot on both the Sunday and the Bank Holiday Monday that it takes place. This is not the decision of the community, but rather due to authorities attempting to make sure the celebrations are contained within their carefully defined parameters, within their control: it must not spill out. St Paul's Carnival in Bristol, which was established in 1968, was cancelled between 2015 and 2017 due to disagreements between the organisers and Bristol City Council, after a series of stabbings at the 2014 carnival. Serious incidents had also taken place in 2011, leading to a suspension of the event in 2012. Although the carnival now once again takes place, it is on a biannual basis, with the organising committee stating that in order for it to safely take place each year, they need more funding and support from the council. The violence is not from within the African Caribbean community, they say, but from a small group of outsiders infiltrating the event to cause problems.

While it is of course of vital importance that events such as carnival can ensure revellers' safety, there is a legitimate point to be made around the policing of white versus Black customs. Typically, there is a more lenient attitude to white folk customs. Although many white folk customs command smaller audiences and fewer participants than many Caribbean carnivals, they do often pose dangerous risks; Ottery St Mary sees adults and children running through the streets of the town with burning barrels of tar carried on their backs, for example, and at the cheese rolling in Gloucestershire people throw themselves down a hill in great numbers, often sustaining life-changing injuries in the process. The general sense is that if the authorities tried to clamp down and impose health and safety rules on these white folk customs, they would have no chance against the people of the town, who will work against all odds to protect their right to perform the custom. The policing policy seems to be: why bother? Just let them get on with it. This same laissez-faire attitude

219

THE LOST FOLK

is rarely applied to Caribbean carnivals, where there need only be a sniff of unrest or violence and the event is cancelled.

There is also almost a separation between Caribbean carnivals and main town carnivals. Although traditionally they have both taken place in August, they have generally been held in different parts of a town. Caribbean carnivals in their early iterations in Britain tended to be static, happening in a field or park, and it wasn't until the 1970s that they began to become peripatetic in a similar fashion to town carnivals. Historically, this pushed the celebrations to the periphery of a town. In effect it is like saying 'We will allow this to happen, but not in the heart of the town because that is for *our* carnival.'

In recent years there has been a move towards removing the culturally appropriative and racist elements from town carnivals, and a move towards better inclusion within main town carnivals of aspects from Caribbean carnivals. In his interview with the *Birmingham Post*, Gus Williams goes on to say, 'I want the Birmingham carnival to be a carnival that reflects the whole city, a celebration of many cultures coming together.'[24] Although Gus and other Caribbean carnival organisers were keen to emphasise the inclusivity of their carnivals, there is no doubt that non-Caribbean carnivals have historically been spaces that have prompted deep levels of entrenched racism, from floats with women dressed as 'hula girls' to white men with their faces painted black riding atop papier-mâché elephants. Councils have allowed xenophobic and racist tropes to be traipsed out year after year, creating, despite the aforementioned inclusivity of non-disabled and disabled people, a climate of exclusion for people of other cultures. In order for a carnival to be truly inclusive, it must be for everybody. This should be encouraged: the carnival naturally provides a space in which all aspects of a place and its people can be celebrated, and they have the potential to be some of the most radical, funny and open-minded folk customs of the modern world.

THE LOST CUSTOMS

'We want buns!': food customs

Food, as established in the previous chapter, exists as the focus of a number of folk customs and is present in folk practice in a variety of forms. There are numerous regional cakes and associated customs about when and how they get eaten. There are well-known customs surrounding the making of, for instance, Christmas cakes – the ingredients are mixed on 'Stir-Up Sunday', the last Sunday before Advent, which typically falls in November – and the making of Lammas* loaves at harvest time. Other food-related traditions can take a more raucous form . . .

Scrambles

An ancient game of bottle kicking takes place at Hallaton in Leicestershire on Easter Monday. The day begins with a hare pie being processed through the town. It is blessed by the vicar, cut and thrown to the crowd, who scramble for slivers. After this, a further scramble takes place at Hare Pie Bank for the remaining pieces of the pie. This is then followed by the game of bottle kicking, which is played between two teams, one from Hallaton and one from the neighbouring village of Medbourne. The village of Cranoe also takes part but does not choose sides and instead plays with the side that is losing. The game is fiercely fought. In 1957, it was reported that there was 'only one chipped rib and one cut head'.[25] The game is played with three 'bottles': one is a large bottle carved from oak and painted white and red, and the other two are barrels of beer that become the prizes.

The act of scrambling or clamouring for a 'prize' crops up often: by far the most popular is the 'penny scramble', which takes place

* Lammas is a medieval Christian festival that took over from the much earlier Pagan festival of Lughnasadh. It takes place on 1 August and is a celebration of the harvest.

221

THE LOST FOLK

in Driffield in East Yorkshire, at Rye in East Sussex and at Reach in Cambridgeshire, among many other locations. It is also a popular tradition at Scottish weddings, where coins are thrown for children to catch. There are various thoughts on the origins of 'penny scrambles'. At Rye it is suggested that it was instigated in the eighteenth century when 'The town ran out of pennies on Mayor's Day, and a boy sent to fetch new ones from the mint brought them back so fast that they were still hot,'[26] and at Reach its origins are considered to be even older: it is suggested that it began when the town's royal charter was given in the thirteenth century. Cheese forms the basis of other popular scrambles, such as the cheese rolling that happens in late May on Cooper's Hill in Gloucestershire, where participants throw themselves down the grassy bank in a race to win the wheel of cheese, often sustaining injuries in the process. A slightly less gruelling ceremony takes place at St Briavels (also in Gloucestershire), where bread and cheese are thrown from the Pound Wall outside the church to parishioners below.

Hurling, throwing and rolling

Abingdon, as well as holding the mayor of Ock Street elections, is also famous for its enthusiastic bun throwing, which takes place any time there is a major royal celebration such as a coronation or a wedding. The mayor and councillors stand in full regalia at the top of the County Hall and hurl buns to the crowd below, who try desperately to catch the soft currant-filled buns. The tops of the buns are marked with a symbol of the event that is being celebrated (e.g. a large white '60' for Queen Elizabeth's Diamond Jubilee), and the quantity of buns thrown varies depending on the occasion. These days it tends to be several thousand. In May 1880, a bun throwing also took place in Lancaster on the occasion of the New Market Hall being opened. The buns were pelted at the crowd as a gift to the population of the city from the mayor. All these customs offer up a comment on the

THE LOST CUSTOMS

historically feudal and often difficult relationship that has existed between the councils of a town and their constituents. Pelting them with free buns (or pennies) was a way to placate them and keep them under the illusion that they were being gifted something – even if it was just a penny or a slightly stale bun. Abingdon is nowadays only joined in the pelting of its constituents with spiced buns by Harwich in Essex, where each May on Mayor's Day the newly elected mayor throws buns from the window of the Guildhall to the clamouring mass of people below. The buns at Harwich are known as kitchels, sometimes spelt ketchels. It is not entirely known where this strange antiquated term comes from; there is a suggestion that it is a derivation of 'catch-all'.

At Ramsbottom in Lancashire there exists another form of throwing: black pudding hurling. Here, outside the Royal Oak pub on the second Sunday of September, you can find hordes of people slinging black puddings at a tower of Yorkshire puddings, attempting to topple them over. Whoever knocks over the greatest quantity of Yorkshire puddings wins. Although the championship has only been running officially since 1984, it is said to have taken the place of an older custom begun by the pub landlord in 1839, and some say it dates back even further, although there seems to be little concrete evidence of this.

As well as throwing, the rolling of food also crops up frequently in folk customs. For over two hundred years, the people of Draycott in the Moors in Staffordshire made fig pies each Mothering Sunday for their Fig Pie Wake. The tradition of making fig pies was once common throughout the region, extending up into Lancashire, and was almost always associated with the period around Lent and Mothering Sunday. It had largely disappeared by the 1890s, with only Wybunbury in Cheshire continuing the tradition today. Further afield, the custom of eating figs and making fig pies was also

recorded in Bedfordshire, Buckinghamshire, Dorset, Wiltshire and Northamptonshire, where Palm Sunday was known colloquially as Fig Sunday. The writer Walter Johnson describes the custom of fig eating atop Silbury Hill: 'The villagers of Avebury, Wiltshire, who mounted the famous Silbury Hill, there to eat fig cakes and drink sugar and water. The water was procured from the spring below, known as the Swallow Head.'[27]

At the Fig Pie Wakes in Wybunbury, fig pie rolling also takes place. The annual pie race now occurs each June, with pies baked by residents of the village, made to a traditional recipe handed down by the late Dorothy Wharton. When the Fig Pie Wakes were revived in 1995, Dorothy, then in her late eighties, was the only resident of the village to remember the original custom before it died out in 1920. The original Fig Pie Wakes had been stopped because, like the Shrovetide football games, they were deemed too hazardous. Originally, alongside the pie rolling, pies were also hurled down from the church tower onto the audience below for people to catch, and there was generally much merriment and many drunken brawls: by all accounts it was a rowdy affair.

When the custom was revived, a decision was made to cut out the hurling of the pies and the focus on drinking that had led to its initial demise and instead to place greater emphasis on the family-friendly nature of the day. Forsbrook in Staffordshire was also once home to a fig pie rolling contest, and an attempt was made to revive it in the 1970s, which was unsuccessful due to a lack of figs – and interest. A number of other Wakes Week celebrations across the North-West and North-East of England also include food as a central aspect of their revelries, with brandy snaps being one of the most popular delicacies consumed, as at Blackburn in Lancashire and Sandbach in Cheshire. In the past, Wakes cakes, a type of all-butter biscuit with raisins, also formed a popular addition to many Wakes Weeks festivals.

THE LOST CUSTOMS

A very different fruit was rolled around Eastertide: the orange. Children and adults gathered for over two hundred years on Dunstable Downs in Bedfordshire to roll their oranges down the hill and hopefully retrieve them in good enough order that they could munch them afterwards. The custom was active until the Second World War, when rationing meant that oranges were in short supply. After rationing ceased, the practice was revived, until in 1968 the decision was made to cancel it due to dwindling numbers of participants. At Sharp Hill Woods in Ruddington, Nottinghamshire, children would similarly gather in great crowds on Shrove Tuesday to roll their oranges before gorging themselves on the remains. The custom here ceased in the late 1930s, and seems to have completely disappeared with no attempt at a revival as yet. However, after over fifty years, the sight of oranges cascading down the grassy hillside of Dunstable Downs can once again be witnessed, having been revived in 2023 by the National Trust, which now manages the site.

Generally, the rolling of eggs has become the more popular and recognised tradition at Eastertide these days, but at Preston in Lancashire, both eggs *and* oranges were once rolled down the slope at Avenham Park on Easter Monday. A news report from 1887 states that 'there was not a square yard of splendid green visible: egg and orange rolling and eating were going on.'[28] It must have been quite the sight: a sea of oranges and eggs – dyed with crimson and purple pigments with accents of gold leaf – spinning down the hill, before being picked up and rolled again, the aim being to roll them until they cracked or, in the case of the oranges, were bruised, the contents then enjoyed by many greedy hands and mouths. Nowadays, only eggs are rolled in Preston.

The element of peril associated with hurling, rolling, throwing and scrambling customs has become hugely unfashionable over time, with councils and committees seeking to downplay the dangerous

THE LOST FOLK

aspects and sanitise the customs. These days we seem to want folk customs to be palatable and without menace, and yet chaos is an integral element of the folk year. Shrovetide football, scrambles, bottle kicking and hurling all provide an important function for communities, being traditional ways in which to let off steam and settle disputes that have arisen in the year in a healthy and focused way. They offer a space in which people can come together with a common goal. In the same way that mock mayoral elections provided independence, and inversion customs offered a chance to turn the world and authority on its head, these self-governed games of folk sports allow people to make the rules for a day.

Festive food

The other period of the year in which food customs crop up frequently is the period around Christmas, which, with its related festivities, is the most well-established and best-observed custom in Britain, and as Lilla Fox suggests in her book *Costumes and Customs of the British Isles*, it is certainly the festival which the most people engage with, regardless of religious or cultural background.[29] From the beginning of December, Christmas trees and decorations make their way into homes, shops and businesses across the country, and there is a general sense that it is a season for celebration and for maintaining 'tradition'. In years past, items such as the kissing bough were made and hung from ceilings, and oranges were studded with cloves and ribbons and turned into Christingles. For the most part, these have fallen by the wayside as decorative and symbolic customs and been replaced with more modern and easily achievable iterations, such as sprigs of mistletoe in place of kissing boughs, and chocolate advent calendars in place of Christingles.

In South-East Wales, a custom that is now very rare, but has much overlap with the more currently popular Christingle, is the practice of

THE LOST CUSTOMS

making and giving a Calennig. This is a Welsh word meaning New Year celebration or gift, giving a clue to the custom. On New Year's Day, children took apples and decorated them with hazelnuts or cloves, and pierced the base with three twigs. Sometimes, as the historian Ronald Hutton writes in his book *Stations of the Sun*, the apples would be smeared with a flour paste and then decorated with the nuts.[30] A sprig of a herb, such as thyme or rosemary, would be poked into the top, and then the children would walk from house to house with the gifts, singing a rhyme as they went. They would ask for a gift in return for the Calennig, which would usually be either bread and cheese or a penny.

The period around Halloween also sees food enter the folk calendar. In Scotland, a particularly interesting intermingling of food and folk practice occurs during this season. It was believed across regions of Britain that at this moment in the year, when the veil between the living and dead was thin, it was a good moment to engage in the practice of divining the future. Divination often took the form of searching for something in food. In Scotland this was done through the making of fuarag, a mixture of toasted oats and whipped cream into which a coin, a ring, a button, a thimble, a wishbone and sometimes a horseshoe were stirred. Each object was believed to foretell the finder's future: a coin suggested good fortune, a ring that you would marry, a button that you would remain a bachelor, a thimble that you would die a spinster, a wishbone that you would get your heart's desire and a horseshoe that good luck would be bestowed on you. Each guest was given a spoon and instructed to dive into the creamy mass; the object they retrieved would tell their future for the year ahead. The Scottish folklorist Florence Marian McNeill wrote of the custom for these hidden charms in the third part of her four-volume book *Silver Bough* (1961), calling the dish 'cream-crowdie' and mentioning that 'nowadays a potful of "champit tatties" (mashed potatoes) is used instead.'[31] Presumably the 'nowadays' Florence refers to is the early 1960s; the practice seems to

227

have mostly lapsed in 2025. Florence also makes reference to another divinatory practice of a slightly less appetising nature in which a salt herring was eaten on Halloween night in three bites just before going to bed; it was said your future husband or wife would then appear in your dreams. A similar custom existed at Allantide (31 October) in Cornwall of putting an apple beneath a pillow; again, the future spouse was said to appear when you fell asleep. All these practices have died out, although Halloween is still widely considered a good time of year for engaging in magical practices such as reading the future through Tarot cards or tea leaves.

'What 'av 'ee, what 'av 'ee, what 'av 'ee': religious folk customs

Ellen Ettlinger, whose unique contribution to the study of folklore I explored in the first chapter, is one of the earliest folklorists to have used and explored the term 'religious folklore', meaning objects or customs that are associated in some way with religion or religious buildings. Her own fascination was with recording the many customs of the Catholic churches of England and the Celtic customs of, in particular, Ireland. She travelled extensively, collecting images, and her index-card catalogue includes numerous entries on everything from well dressings to bread customs in churches.

The Church has customs across its calendar that could be considered as 'folk' with many practices that, as in the case of the Pan statue at Painswick (pp. 130–34), possibly record much older Anglo-Saxon customs that pre-date Christianity. Many of these customs were Christianised to remove any sniff of worship of nature or Pagan leanings. But sometimes this Christianisation is a very thin veneer, and when the surface is brushed away, beneath it is an almost intact ancient folk custom.

Harvest festival

Perhaps the largest survival of a folk custom inside the setting of a church is the harvest festival, and although this festival often gets touted as having 'ancient' roots it is, in fact, the invention – or reinvention – of a Victorian vicar, Robert Hawker. Robert was a poet and antiquarian and totally obsessed with finding titbits from history and reinventing them for his own purpose. In 1834 he became the vicar of the church at Morwenstow in Cornwall, and it was here that he had some of his best ideas.

Having read up about the medieval festival of Lammas (sometimes referred to as Loaf-mas), in which thanks were given for an abundant harvest through baking bread, feasting and singing, he decided to reinvent it. In order to create a sufficient distinction from its more dubious (in the eyes of the Church) and possibly Anglo-Saxon beginnings, he moved it from August to October. Robert's first festival took place on 1 October 1843, and was met with much excitement. He placed a sign on the door inviting people to 'gather together in the chancel of our church, and there receive, in the bread of the new corn, that blessed sacrament which was ordained to strengthen and refresh our souls.'[32]

Fruits, vegetables and flowers were gathered and displayed in the church, and Hawker gave a sermon filled with congregational singing. Word travelled fast and in the following years, many other churches around Britain also decided to take up the custom. During the month of October, churches were suddenly filled with all the bounty of the harvest: tables groaning with bread, arrangements of flowers decorating the altar and huge bundles of wheat at the doorways.

Archdeacon Dennison of East Brent in Somerset and Reverend William Beal of Brooke in Norfolk expanded further on Hawker's custom and took to holding a harvest home during the festival, a feast that had traditionally taken place at the end of the harvest. They

reintroduced this in part to stop the perceived raucous behaviour and drinking that were being exhibited at the end of the harvest in the wheatfields. Like the Methodists co-opting the customs of the mummers, they spotted an opportunity to influence and change the actions of the rowdy harvesters. The reintroduction of the harvest home in turn spread back to Cornwall, along with the reintroduction of the custom of crying the neck at the end of the harvest, where the last handful of wheat is held aloft and the words 'I 'ave 'un! I 'ave 'un! I 'ave 'un!' are shouted by the person holding the wheat, to which the onlookers reply, 'What 'av 'ee, what 'av 'ee, what 'av 'ee,' and the words 'A nek, a nek, a nek' are bellowed back. The custom had entirely died out in Cornwall by the 1810s and was first revived by the Madron Old Cornwall Society in 1924 at Boswarthen Farm.

Soon a whole season of harvest events was embedded across England, Scotland, Wales and Northern Ireland, and they continue to this day to in schools, churches and village halls across Britain.

In the book *Ask the Fellows Who Cut the Hay*, George Ewart Evans writes about similar harvest customs in Suffolk and Norfolk known as crying (or hollering) the largesse, after which a harvest home or largesse supper would take place. The custom is slightly different from crying the neck in that everyone involved in the reaping joins hands and the master of the proceedings calls 'Holla lar! Holla lar! Holla Larjess!', to which the reapers would reply 'O, o, o, o, o.' A similar custom was performed in Hampshire until the late eighteenth century, where harvesters would process through their towns hollering the largesse after the harvest had finished. At the time George was writing, in the 1950s, the custom was still within living memory.

Both the crying of the neck and crying/hollering the largesse overlap with the making of corn dollies, which I explore in the previous chapter. Very often the last bunch of hay was used to make a corn dolly, which was then taken into the farmhouse and hung up

THE LOST CUSTOMS

until the harvest the following year. Regionally, there have been a great number of variations in the ways that the harvest has been celebrated but the making of some form of effigy with the last handful was widespread.

Hawker's reinvention of the harvest as a festival was an excellent piece of mythmaking. He had a vision, which he orchestrated: he got everyone in the community involved and in the blink of an eye it was so ingrained that it is now often considered to be something that we have always done in a continuous way. Harvest has always marked a natural point of a celebration in the calendrical year, but the very particular ways in which we observe it can be attributed to Hawker and his wild imagination: gathering food in for the poor, decorating the church with vegetation, baking plaited loaves and singing. Hawker 'rediscovered' harvest, and his discovery meant that we were able to preserve aspects of a custom that would probably have entirely disappeared otherwise, and reinvent elements of it for a rapidly changing world in which agriculture is no longer the driving reason for giving thanks.

Rush bearing and rushcarts

There are also customs that can be classed as 'religious folklore' but that sit outside the Church; customs that began inside the Church and gradually moved outside. The rushcart ceremonies of Lancashire offer an excellent example of this, having their roots in the rushes that used to be laid on the floors of churches. Before flagstones, church floors were made of earth and spread with rushes to help to keep the ground warm and dry. The distribution of new rushes on the floor each year was a chance to tidy up the church and make sure everything was in good order for the coming year. Originally, parishioners carried in the new rushes by the armful and placed them on the floor; later people built carts to pile them into, making the job much easier

THE LOST FOLK

(although some places have retained the practice of carrying them in, mainly in Cumbria). These carts became more and more decorative, with the rushes stacked beautifully and adorned with floral garlands. They were dragged by members of the congregation to the church and unloaded, along with their floral decorations, which were used to embellish the altars and rood screens. Slowly, a celebratory aspect began to take over. The rushcart became the central focus, and a whole day of festivity developed around the pulling of the cart, with morris dancers and musicians following alongside. The rush bearing and elaborate rushcart ceremonies always took place in the particular town's Wakes Week.

Rushcart ceremonies survive at Saddleworth, Sowerby Bridge, Littleborough and Whitworth, all with associated processional morris sides, but there are many more that no longer take place. These days the carts are all made and pulled by men, but there are various historical accounts that make reference to both women and men collecting rushes and pulling the carts. The earliest mention of women being involved in rush bearing is in King James I's *Book of Sports* from 1618, where he states: 'Women shall have leave to carry rushes to the church for the decoring of it, according to their olde custome.'[33] In a poem called 'The Village Festival', from 1802, the Lancashire poet Elijah Ridings wrote: 'Behold the rush-cart and the throng / Of lads and lassies pass along!'[34]

As late as 1859, women are described as pulling a rushcart at Rochdale – 'on Tuesday the Smallbridge cart was partly *manned by women and girls*, 42 bedecked females helping to drag the cart on that day.'[35] One can't help feeling, however, that already, given the use of italics, this is being suggested as an unusual practice, deemed amusing to the men, and that women would usually be observing rather than participating. A custom associated with the rushcart was that of the skedlock cart, a smaller contraption that was generally

pulled by children, and young girls were recorded as pulling this late into the nineteenth century: 'The girls drawing the cart had adorned their hats with flowers, whilst boys improvised music out of tin whistles and old cans.'[36] It is a common feature of folk customs historically that as women age they get written out, suddenly deemed too dainty for or incapable of such tasks as pulling a rushcart. This argument was made in the morris world for many years as a justification for single-sex morris dancing, but has been remedied in recent years.*

Easter bonnet parades

Another religious folk custom that can be found beyond church walls is the Easter bonnet parade, a once fairly ubiquitous event held on Easter Sunday or Monday, with parades taking place across Britain with notable instances at Morecambe in Lancashire and Coleshill in Warwickshire. Easter is traditionally regarded as a time of renewal, of new hope and fresh outlooks, and in the folk calendar it has often been associated with customs that incorporate new clothes. The Easter bonnet parade largely came out of the ancient tradition of putting on fresh clothes and parading out to show them off. This originally happened in the setting of the church at Palm Sunday and Easter Sunday services. As bonnets became fashionable in the mid-nineteenth century they were incorporated, with people either buying a new one or adorning their old one with a fancy new piece of trimming. The trimmings became a way to give the sense of a 'new look' without the expensive price tag. Gradually the trimmings took over. More and more accoutrements were added, and so the Easter bonnet as we know it today was born. The height of Easter bonnet fever in the 1950s saw literally hundreds of parades and competitions

* In 2022 Saddleworth changed their rules to invite women's and mixed morris sides to join all-male sides in pulling the rushcart. In 2024 both Saddleworth Women's Morris and Clog and the Belles of London City joined the procession.

happening across the breadth of Britain. Year on year they became more and more intricate and considered, with people trying to outdo their entry from the previous year.

Easter bonnet parades of the period between 1950 and 1980 were quite a sight: hundreds of homemade hats were sported, all adorned with Easter scenes made from felt, paper flowers, pipe cleaners, and cardboard, all sitting precariously atop heads. And then there was the prize-giving: there were prizes for the most original, the funniest, the largest and for the best bonnet made by somebody else. One such example can be seen in a short film from the South West Film and Television Archive, which shows a sea of hats walking along the creek at Restronguet in Cornwall in 1966, offering us a glimpse of an Easter bonnet parade in motion. The Restronguet parade was conceived in 1964 by Ernest and Ken Gray, who ran the Pandora Inn in the 1960s. It ran until the early 1970s, and was briefly revived in the 1980s before falling away altogether. The film opens with a man standing outside the Pandora Inn, wearing what looks like a knitted tea cosy pulled over a bowl. He has added leaves at the ears. From there it gets more surreal: a person wearing a chamber pot covered in cabbage leaves, someone sporting a towering windmill made from card and a man showing off a newspaper top hat with bottle tops hanging from its rim. It is a wonderful portrayal of the humour and ingenuity that taking part in an Easter bonnet parade can instigate – a chance to get really creative, to use up materials that are lying around the house and make a (hopefully) prize-winning bonnet.

Although the bonnets at Restronguet were eccentric, in Lancashire the people of Morecambe pushed it even further for their annual parade, which usually happened on Palm Sunday. The parade of 1959 saw a woman called Christine Hodgson walk out with two cardboard egg-packing cases strapped to her head. They were tied on with a length of red ribbon and filled with dozens of eggs. Christine

THE LOST CUSTOMS

won first prize for her elaborate contraption. At the 1960 parade, competitors upped the ante even further. Grace Downham, a local hairdresser, scooped second prize for a hat that engulfed her head – a square straw basket laden with eggs and tiny chickens – and Eleanor Elvey wore a hat that towered above the others, covered in dolls, eggs, chickens and all manner of other knick-knacks that she had collected in the weeks leading up to the parade. It is reported to have weighed sixteen pounds. Competition was heated in Easter parades of this period, with people entering year after year, and travelling from afar to take part. They drew huge audiences: Morecambe's 1960 parade had an audience of well over four thousand people, who came to watch the strange hats wobble along. Although Morecambe has a number of Easter bonnet competitions held in schools, there is no longer a public parade.

Apart from their homemade charm, Easter bonnets have another defining feature: they are one of the only truly intergenerational customs for people to engage with. Unlike customs such as hurling or fire parades, which can be dangerous or require lots of energy to keep up with, the Easter bonnet parade has offered an opportunity for both the very young and the very old to engage. Children as young as two and adults as old as ninety are able to make a hat and have the chance of winning first prize. Other folk celebrations that allow for intergenerational mixing include the rubber duck race (the slowest of all races), the carnival, egg-decorating competitions (at schools across Britian), skipping competitions (such as that at Scarborough in North Yorkshire) and scarecrow festivals (such as at Penrith in Cumbria and Copford in Essex). However, what sets Easter bonnets apart from these other customs is that the bonnets can be made in the lead-up to the big day, and because categories such as 'a hat made by somebody else' exist, the parades allow for varying levels of engagement – that is, you do not have to be physically present to take part.

235

THE LOST FOLK

Today, Easter bonnet competitions or parades are increasingly rare outside schools or care homes, both of which do thankfully keep the tradition alive. There is still a large parade held at Lyme Regis in Dorset, which encompasses all ages, and one at Lowther Gardens in Lytham, Lancashire. It is difficult to find many others, however, and it generally seems that they are considered these days to be the preserve of either children or the elderly, not both at once, and certainly not for *all* ages. It is a pity we have moved away from multiple generations coming together to participate in the comedy and silliness of wearing strange hats that have been laboured over for weeks in people's homes.

Although the Easter bonnet parade began in the Church, it became something much more expansive, encompassing entire communities regardless of religious affiliation, cultural background or age. The abundant creativity allowed in Easter bonnet competitions meant that everybody could express themselves freely – be that with a novelty hat or with a pretty concoction of flowers and birds. They were transportive events, allowing people to dress up and play for an hour or two.

'The glove is up!': municipal folklore

There are numerous customs that fall into the category of municipal folklore, by which I mean practices largely organised by town councils with the aim to engage the community of a town in a collective activity, be that to instil a sense of civic pride or to celebrate a day of perceived historical importance. They can be events associated with notable dates in the formation of a town or city's history such as a charter or founding day, or they can be activities such processions or parades. Other customs to fall under the category of municipal folklore include mayoral processions, some carnivals and Christmas

light displays (if organised by councils), the Lord Mayor's Parade in London, and often beating the bounds, where the boundaries of a town are hit with sticks or bumped with constituents' heads to reinstate rights of way each year. Some mock mayoral customs could also be considered to be municipal folklore, when the real mayor takes on the role of one of their constituents for the day – at Penryn the mayor is dressed in a jailer's outfit while the mock mayor takes the reins, for example. There are also a number of objects or additions to buildings that can be considered in this light, such as micro-mosaics in town centres, community murals and in some cases topiary and window displays.

They almost always involve organisation on a large scale and much bigger sums of money than more organic or homespun folk customs. However, many customs that have been begun by councils morph into practices which the people of a place harness for themselves, and from these, new customs and traditions emerge. Council involvement can be extremely beneficial in getting customs off the ground and is nearly always useful in ensuring a custom continues – even if a council is not involved in organisation, it is often instrumental in providing space or funding.

Fairs and charter days

Freedom, or at least a perceived sense of freedom, was at the heart of the many medieval fairs of Britain. They were once widespread happenings from Kilmarnock to Chichester, and they took place across the year. There were fairs that celebrated particular harvests such as the cherry fairs at Newbury in Berkshire and at Bath. There were mop or hiring fairs that were used as events for employers to meet would-be employees. There were goose fairs held around Michaelmas Day in September where geese would be bought and sold. There were also of course pleasure fairs, of the type we might

see today. These centred almost entirely around entertainment, and were largely organised by councils.

Deep in the archives of the London Museum Docklands is a small parcel wrapped in layers of lilac tissue. Inside is a piece of gingerbread: it is a rich shade of brown, the top is marked with lines from the rack it was cooled on and it has a warm, spicy aroma. You could almost take a bite, until you read the lines of frilly letters that adorn the tissue it's wrapped in: 'This piece of Gingerbread was bought by my father . . . at Frost Fair on the Thames in January 1814.'[37] The frost fairs once took place on the Thames in the depths of winter when the river froze over. They became occasions to meet, to play games and to feast: they were focused on pleasure and indulgence; a chance to let loose and enjoy life. Huge numbers of people would collect to view the sights of the fair and visit the stalls that would be set up on the ice, selling everything from souvenirs to roasted meats to hot apples. Although the Thames was to freeze over several more times in both the nineteenth and twentieth centuries, 1814 marked the last ever frost fair, and this piece of gingerbread is one of the few remaining markers of over a century of celebration each January and February.

I was given a clue to another custom connected with Britain's many ancient fairs when on a rainy afternoon several summers ago I stopped off at the town of Honiton in Devon. I stepped into the museum to take shelter and when gazing at the many objects on display in the cabinets I was mesmerised by an enormous golden hand attached to a garlanded pole. What was this gigantic disembodied limb? Perhaps a sign from an old shop or pub? Or some sort of trophy? Well, I discovered that, in a way, it is both. The golden hand is in fact a huge ceremonial glove that is used each year on 23 July when Honiton's hot pennies ceremony takes place. This is also, crucially, the first day of the town's fair. The glove is raised in the air by the town crier at the

THE LOST CUSTOMS

beginning of the proceedings and the following words are bellowed: 'Oyez! Oyez! Oyez! The fair's begun, the glove is up. No man can be arrested till the glove is taken down.'[38] After the glove has been raised, a hot penny scramble takes place and pennies are scattered from the window of the pub for people below to catch. They used literally to be hot, having been heated in an oven to make it harder to pick them up, but this practice has ended and nowadays they are lukewarm at best. The golden glove is then processed with much ceremony through the town until it meets its final resting place, where it stays for the duration of the fair week.

The notion that 'while the glove is up no one can be arrested' comes from the fact that traditionally, medieval fairs were travelling fairs, with people going from place to place to sell their wares and provide entertainment. Often within their midst would be people on the periphery of society – those who had not paid their rents, had skipped their taxes or had committed petty crimes. A glove was raised to show the people selling and frequenting the stalls that for the duration of the fair they were welcome, could roam and trade freely without condemnation or judgement, and would not be arrested either going to or returning from the fair. The rules varied slightly from fair to fair, but it was commonly considered to be a symbol of peace and goodwill to all.

The raising of a large glove still takes place at Kingsbridge Fair in Devon, again on a garlanded pole. Here the glove is hung outside in a ceremony conducted by the mayor where the town's charter is also read. It is accompanied by a floral dance that happens through the town, which bears some resemblance to the well-known Helston Flora Dance in Cornwall. Glove-raising ceremonies are likewise still held at Axminster in June for the Cherry Fayre, at Chulmleigh's Old Fair in July, at Exeter for the Lammas Fair in August and at Barnstaple Fair in September.

THE LOST FOLK

On a trip to the Tudor House Museum and Gardens in South-ampton, I discovered at the back of a cabinet a magnificent stuffed black silk glove. I was immediately reminded of the golden hand at Allhallows Museum in Honiton, and discovered that until the late nineteenth century, Southampton was also home to a fair that com-menced with a glove-raising ritual. It was called the Trinity Fair due to its proximity to Trinity Sunday (it was generally held in late May or early June), and the glove was, like in the other fairs mentioned, raised to signal the beginning of the merriment. It was, most years, hung outside the town gaol in what was known as the 'hoisting of the glove'. Once it had been raised, the senior bailiff took charge of the fair, and for the length of it held a Piepowder Court, a form of special tribunal which was reserved only for fair days. It essentially allowed for informal trials to sort out any ruckus that ensued during the trading and buying of goods at the fair (crimes committed outside the period of the fair were not considered). The glove was last raised in 1873, and entered the Tudor House collection sometime later, when William Spranger bought the building to convert it into a museum. After the Trinity Fair was discontinued, although the city saw other fairs in different areas, the hoisting of the glove never returned and the black silk glove in the glass cabinet is the only tangible remnant of this fair that happened for hundreds of years.

In the North-West of England, until the late eighteenth century, Chester also held three annual fairs where the Chester Hand was hung initially outside the courts, and then from the battlements of St Peter's Church.[39] They happened in July, October and February. The Chester Hand varies from the other hands I have discussed so far in that it was carved from oak and was, over its years of service, painted many different colours including red, white and black, and it hung from a metal hook screwed into its wrist. It was acquired by a jeweller and founder of the Meyer Museum in Liverpool, Joseph

240

THE LOST CUSTOMS

Meyer, 'for two pints of ale at the Sign of the Boot in the City of Chester on 27th Dec., 1836',[40] and in 1867 Joseph passed his collections to the Liverpool Museum. I have, beyond several articles in the 1920s about its possible repatriation to Chester, failed to track down its whereabouts; my hope is that it is safe somewhere, wrapped in acid-free tissue paper.

The fair as a custom has evolved, and although there is the hangover of some of the odder customs associated with it, and indeed many of the names still bear witness to their more ancient roots (see Tewkesbury Mop Fair, Ashby-de-la-Zouch Statutes Fair, Nottingham Goose Fair and the Black Cherry Fair at Chertsey), they all represent the associated history only in name. All of them now could be considered pleasure fairs, with fairground rides, stalls, musical entertainment and food to enjoy. The many fairs of Britain may exemplify better than anything else the ways in which folk customs can and do evolve over time. Mop fairs, where employers went to trade and buy new employees, might seem hugely outdated in an age of employment rights and the ability to choose where and how we work, but the enjoyable aspects of the fair – the gathering, the conversation, the frivolity – have been retained. The glove is still raised at many fairs, perhaps because it gives them a sense of being genuinely old, and therefore allows people to relax because, well, we have always done it on that particular date, in that particular place. Keeping these slightly antiquated and faraway names, such as a mop or goose fair, attaches the events to the past, to our ancestors and to a sense of a wider and long-lasting community.

Pageants

At the beginning of the twentieth century a wave of activity swept Britain; in towns, villages and cities, people began planning elaborate performances known as pageants. So what was a pageant? Well, it

THE LOST FOLK

generally involved the whole community coming together to build a form of play which recorded the history of a town. There would be a number of scenes within the play, sometimes starting as far back as prehistory and often stretching far into the imagined future of the town. Everything was created by the townspeople, from the costumes, props and scenery to the writing of the script and the scoring of the music. Although pageants have been widely written about, they have seldom been considered under the banner of folk or of municipality, when in fact they encompass both.

On looking at the shelves of a charity shop one idle afternoon, I discovered a pamphlet about Southampton's charter day. As part of the celebrations a fair took place and a pageant, in several acts, detailing the history of the city. In this moment it dawned on me that although pageants can be, and often have been, organised by individuals in a community, more often than not they involve the council in some capacity, either in the telling of a particular story or in the use of a particular space; without the financial backing of councils these events have rarely got off the ground.

Southampton's pageant took place in 1947 at the Guildhall and had an organising committee chaired by the mayor and councillors of the city. Likewise, Bradford's pageant of 1931 had a similar make-up for its organising committee, and Birmingham's mammoth pageant of 1938 saw councillors and aldermen take positions in its organisation. The pageant was effectively used as a way, in the inter-war period, of bringing the people of a city or town together, instilling a sense of community and national pride. It was a celebration of history both ancient and modern, and a way of making everyone feel they had a place in telling the story of their home.

The Birmingham pageant was one of the most ambitious ever planned. Held as part of the centenary celebrations of the signing of Birmingham's civic charter in 1838, it involved eight 'episodes',

242

or scenes, and thousands of performers from across the city. The pageant master was Gwen Lally, an actor turned pageant producer. Thwarting traditional gender roles, Gwen was resolutely known as a pageant master, never as a pageant mistress, and was generally seen wearing an impeccable suit and bow tie while directing. Gwen had originally found her way into pageantry via designing pageants for the National Federation of Women's Institutes, and had been in charge of the pageant of Battle Abbey held in 1932 and the pageant of Runnymede in 1934. By the time Birmingham was considering producing a pageant, Gwen was much in demand, and her talents were called in by the council to make this the most ambitious and showstopping pageant ever staged. Gwen did not disappoint, but perhaps not entirely for the right reasons. Her plan was to stage the entire history of Birmingham across the eight episodes. It would take in everything from prehistory right up to the present day. It was hugely ambitious.

As part of Gwen's plans, she had many extraordinarily sophisti-cated and extravagantly expensive props made, the largest of which was Egbert – a sixty-foot, roaring papier-mâché dinosaur on wheels who was to appear in the first episode. Egbert stole the show. With yellow smoke streaming from his enormous nostrils and a magnificent rumble emanating from deep within his fanged jaw, he was a sight to behold. He was flanked by two smaller dinosaur friends: Ogbert and Sidney. As a trio they were fearsome and made for a fairly entrancing beginning to the pageant, appearing as they did in the first episode. The next seven scenes are widely reported to have been dull in comparison, such was the audience's fondness for Edgbert, Ogbert and Sidney.

Generally, councils used the pageants as ways of raising money for charity, not dissimilar to town carnivals. Gwen's pageants, however, were often bottomless money pits. Her vision was all-encompassing and no expense was spared on costumes or props. Egham Museum in

THE LOST FOLK

Surrey now holds three costumes from the pageant of Runnymede. They are all hand-stitched and made of very fine silk. They are all hand-stitched and made of very fine silk, showing that Gwen strove always for the very best in craftmanship and historical detail.

Although pageants were generally richly documented in photographs, postcards and programmes, actual artefacts such as costumes and props have mostly disappeared. It is exceptionally rare to find pageant costumes in collections, as they were generally amassed in dressing up boxes, attics or am-dram costume departments. However, there are some exceptions. St Albans Museum in Hertfordshire holds several pageant costumes, and in 2023 a display was mounted in Ludlow Museum in Shropshire featuring costumes from the town's spectacular 1934 pageant. The costumes on show are in fact the tip of the iceberg – Shropshire Museums Trust holds numerous other items pertaining to the pageant, including handmade wigs, jewelled hats and tunics with fluted sleeves. It is a remarkable and very unusual collection. As I have discussed in previous chapters, costumes often get broken up after performances or events, so the fact that these were all kept suggests a great level of pride in the pageant. Seemingly it achieved what many other councils aimed to accomplish: a unifying of community spirit.

Unlike the costumes, Egbert, Ogbert and Sidney did not have such a happy ending. As the Birmingham pageant was drawing to a close, the *Evening Dispatch* put out a call for someone to give the three large dinosaurs a home. Bernard, the property master of the pageant, is quoted as saying 'Maybe I could auction them . . . if anyone wanted them, I could guarantee to deliver them at his door on any day he names.'[41] There is no record of what happened to them, but it seems probable that they were quietly destroyed once the pageant closed.

The guild day

Egbert and his friends are not the only scaly creatures to fall under the banner of municipal folklore. For centuries in Norwich there was a feast day and accompanying procession on St George's Day held by the Guild of St George, a charitable organisation in the city. The history is long and convoluted, with many iterations of the event, and in the sixteenth century the decision was made to reform the day and combine it with the election of the new mayor. At this point, the council (or assembly) took over the proceedings and gave it a new date of 23 June. This spectacular feast day included a much-expanded series of events, such as a newly elaborate parade featuring a character who was revived from a much earlier procession. Enter the Norwich snapdragon, affectionately referred to by the people of Norwich as Snap, a large dragon in the style of a hobby horse construction.

According to contemporary accounts, in his earliest sixteenth-century form, Snap had a snapping jaw and large erect ears, and was a dark shade of green with yellow spines painted upon his back. He is said to have looked almost gargoyle-like, with his body laid flat behind him. He was always accompanied in the procession by two attendants known as whifflers, and another character known as Dick Fool. They were largely there to guide Snap, who, beneath his fearsome exterior, contained a person I'd imagine had very limited visibility due to their costume. The attendants also provided, in their own right, a suitable level of gravitas to this important procession in their satin breeches and waistcoats.

The guild day, as it became known, was enormously popular with hundreds of people watching the procession and enjoying the feast afterwards, and it spawned a number of mock guilds across Norwich, with accompanying mock mayoral ceremonies and mock snap dragons, all happening in the period before and after guild day. Civil ceremony and municipal pomp become entwined with folk culture

THE LOST FOLK

to the point that I imagine it was difficult to recognise which was the official ceremony and which was the mock – indeed the Costessey Guild is said to have used a very old snap from the civic procession as its mock snap. Over time, the distinction became much more apparent as the mock elections became more boisterous, debauched affairs. Although the official procession and feast day ceased in the early nineteenth century, Snap and his companions continued to be brought out from time to time for other civic events. Likewise, one of the many mock guilds that had popped up continued to hold mock elections until as late as 1895, although much of the pomp and ceremony had been phased out.[42]

Three entirely intact snapdragons survive in the archives of the Norfolk Collections Centre, two of which are known to have come from mock guilds. The snap head of the Costessey Guild snapdragon is held at the Museum of Norwich. What is clear from studying the Norwich snapdragon and its associated mock guilds is that civic ceremony seems to inspire a counter-response from local communities, in a play-act against authority. Mocking is a way for the people to assert power and to subvert societal order.

'New' customs

There are many more recent customs that are not yet properly recognised as folk traditions – ones that perhaps don't have the historical roots of older customs or celebrations because they belong to immigrant communities, or have been more recently instigated. They are often events that have merged or woven together different elements and created new customs in the place of older, seemingly outdated ones. Out of these amalgamations of customs come fresh ones that make sense for our current times and communities: customs that mean something to people of the twenty-first century.

THE LOST CUSTOMS

Lunar New Year

In a 1974 edition of the journal *Folklore*, there is an article that explores what was then a very recently arrived custom on the streets of London: the Lunar New Year celebrations of London's Chinese community. This typically happened between late January and mid-February, depending on the calendar year. The authors of the article, A. Roy Vickery and Monica E. Vickery, describe seeing the custom for the first time in 1971, and how it had grown by 1973: 'What had been a purely domestic Chinese event in 1971 had become a London festival attended not only by a vast number of Chinese but also by an approximately equal number of non-Chinese.'[43] Lunar New Year had actually first been celebrated in this way in London in 1963, and seemingly the crowds had grown year on year, with visitors flocking to see the dragon and lion dances that tended to be performed. It had initially just been celebrated on Gerrard Street in London's West End, but gradually expanded out across the streets of Soho. In the Vickerys' article, they are unsure whether the custom will manage to take hold: 'Whether it becomes an annual event or not remains to be seen.'[44] It seems that the Vickerys needn't have worried, because by the late 1970s, Chinese Lunar New Year celebrations were well established not only in London, but across Britain, with Chinese immigrants beginning committees and starting up their own celebrations.

One of the earliest customs from this festival to be widely adopted was feasting. Typically, a New Year feast in China can last for ten days, and many restaurants in the burgeoning Chinatowns of Britain began to advertise all-you-can-eat feasts and banquets from the last years of the 1960s, with the dishes being served varying according to the region the chefs had originated from.

Having begun in restaurants and homes, it wasn't long before activities stretched out onto the streets. Liverpool was, alongside London,

one of the first to begin dragon and lion dances. Birmingham quickly followed suit, and all three cities still have festivities today. In 1989 Venetia Newell interviewed Tony Man of the London Chinatown Chinese Association about the other traditions surrounding the festival, including the hanging of green vegetables such as cabbages and spring onions above the doors of homes and businesses, because green symbolises new growth and fresh approaches for the ensuing year.[45] The use of lucky red envelopes filled with money as gifts for friends and relatives around the time of the celebration was also referred to by Tony. He goes on to say that 'almost all the things Chinese people do at New Year are private', and suggests that, by the 1980s, the evolution of Lunar New Year celebrations in Britain had become more outward- and public-facing than would have been the case in China – although it had retained some traditional aspects of the festival. He emphasises that although these new celebrations in Britain were perhaps not entirely authentic, they had retained the original spirit, and that it was essentially a positive move for Chinese communities in Britain in terms of integration and spreading an understanding of Chinese folk culture. However, not everyone agreed with Tony's optimistic attitude. In the same article, Venetia Newell quotes a young Chinese worker, Weibi Zhong, as saying 'the celebrations are only a show . . . artificial picture-postcard, souvenir culture . . . just to attract tourists'.

Discussion about the artificiality of folk customs and culture is a theme that presents itself time and time again; it is easy when looking at customs that are not of this time or of our own personal culture to think they look 'authentic'. Through the lens of the past, or of perceived otherness, folk customs can take on a halcyon, nostalgic appearance, which makes them seem entirely genuine and deeply appealing. This is not to say that, for instance, the Lunar New Year celebrations as they exist today do not contain traditional aspects, but they have most certainly evolved, and the introduction of public spectacle will have

THE LOST CUSTOMS

for some entirely changed the meaning of the celebration. Many of the private aspects of the celebration are harder for people to maintain, in particular the length of the festival, due to working hours and living arrangements. Perhaps it is inevitable that customs have to evolve when communities are established in new places, and as Tony Man asserts, this is generally a positive thing if it strengthens a better sense of inclusion and acceptance of newly arrived communities.

Spalding Flower Parade

A wonderful example of a community making a new home and new traditions exists in Lincolnshire. At the beginning of the twentieth century there was a large population of tulip growers in the town of Spalding, who had migrated there from the Netherlands. This migration began in the late nineteenth century, but had been precipitated much earlier, when the Dutchman Sir Cornelius Vermuyden had come to the Fenlands in the seventeenth century and instigated a drainage system that would later prove to be instrumental in establishing good growing conditions.[46] Initially the nineteenth-century Dutch settlers brought with them skills in land management and drainage, and then expertise in the rearing of tulip bulbs. Lincolnshire's flat arable land and silt soil echoed the Dutch landscape and offered perfect conditions to enable the beginning of a new age of bulb growing. At its height, the bulbs from Spalding's tulip industry were being shipped all over the world, and Spalding and the surrounding area became known as Little Holland.

In order to concentrate the energy of the plant into forming a healthy bulb, the heads were clipped off; this helped the bulbs grow large but also 'reduced fungal disease, such as "tulip fire".[47] As the industry rapidly grew, there became an urgent need for a practical way in which to use the flowerheads; literally thousands of flowers were being thrown away and were rotting in great heaps in the

surrounding fields. Initially, in the 1920s, these were used to create huge ornamental flower mosaics in the town centre; hundreds of flowers were arranged onto boards in geometric patterns for people to enjoy while shopping and carrying out errands. Then a festival called Tulip Time was begun in 1950, and visitors from elsewhere were encouraged to come and enjoy the fields of flowers on the outskirts of the town before they were clipped, as well as the floral mosaics and flower baskets in the town centre after they had been beheaded. In early May, a trailer decorated with tulips drove around the streets of Spalding and a tulip queen was crowned. The industry grew even larger, and a further step of forming the Spalding Tulip Time Committee was taken. The committee took on the dual responsibility of finding more places for the floral by-products to be used and of expanding the promotion of Spalding's tulip industry. The idea was to focus on the disparate activities of the Tulip Time festival and create an event that would unite the growers, townsfolk and visitors from outside Lincolnshire.

In 1959, it was decided that a parade was the perfect means for achieving the committee's purposes, and on 9 May, the first ever Spalding Flower Parade took place. The Spalding Farmers' Union joined forces with the committee and the artist Adrianus van Driel was brought over from Holland to help design and organise the floats. He was famous for his involvement in similar flower parades in the Netherlands, and alongside his son, Kees, he would go on to heavily influence the aesthetic of the Spalding floats.

Constructed by hand in the months before, using metal armatures made by local blacksmiths, the frames were initially covered in straw matting, a material that was also in ready supply in Lincolnshire, before thousands of tulip heads were pinned onto them. The completed scenes were then attached to tractors loaned by local farmers. It was a true community effort.

THE LOST CUSTOMS

The tulip queen was reinstituted, now as 'Miss Tulipland', and local businesses all took the opportunity to have their name attached to a float. For the next fifty-five years the parade would see floats featuring everything from clowns to butterflies to hot air balloons, all decorated with a technicolour array of tulip petals. Each year after the parade, the floats would be driven onto Sir Halley Stewart Field and left for a week for visitors to come and view them.[48]

In 2013 the last ever parade took place. A lack of funds was cited as the main reason for its demise, but the previous year had also seen the worst tulip harvest in many years.* The increasingly cold temperatures and wet weather in springtime meant growing conditions were no longer favourable to the industry: there were barely any bulbs for sale, let alone any wastage available for decorating floats. The festival's end raises an important point about the use of cut flowers for folk traditions in an era of decreasing crops. Depleted soils and dwindling insects mean that we should be looking to more sympathetic ways of incorporating plant life into our folk customs. Particular kinds of flowers have been used in the past because they were in season and therefore abundant, but when there is a scarcity due to changing climates or difficulty in sourcing, surely it is important to evolve the tradition?

In 2023, the growers of Spalding made the decision to revive the parade, and instead of using mostly real flowers, they decided that the majority of the floats would be decorated with artificial blooms, with just a few genuine flowerheads mixed in. Spalding Flower Parade was a custom that originally appeared out of necessity: an enterprising and appealing solution was found to the problem of what to do with excess produce. Although the use of fake flowers

* The Spalding Flower Parade website states that in 2013 '200 bags of heads were picked instead of the 1,200 required'.

251

THE LOST FOLK

retains the visual appeal of the custom and serves to feed the nostalgia of those who remember it from years past, it has led to the parade losing its agrarian link. Its original function has been lost; it is no longer connected to the soil of Lincolnshire.

Might it be better to ask what the by-products of growing in Lincolnshire are today? Indeed, if in our age of greater scarcity there aren't any gluts, then perhaps an event that draws attention to the changing climate and difficulties of farming in the current period would be more sustainable. This is not to say that it is wrong for communities to revive lost traditions, but it is important that when reinstating them, we consider whether they still hold meaning. Should they be revived in their past form or evolved into something that pays homage to past traditions but has a fresh and modern approach, which is relevant to the period we inhabit now?

A similar problem has faced the Battle of the Flowers parade on Jersey, where hare's tail grass has been traditionally used to cover floats in a technique known on the island as harestailing. However, as Lucy Wright establishes in her essay 'Chasing the Harestail',[49] it was a species introduced to the island in the mid-Victorian period, which is now considered an invasive plant – and additionally it largely grows in areas of the island that are designated as areas of special environmental interest. The grass occupies tricky territory for the islanders, who are faced with a difficult decision of whether to continue decorating the floats for the parade with it. In recent years the parade has seen a downturn in participation due to materials having to be brought in from elsewhere, and this inevitably drives costs up, again raising questions around the sustainability of a custom that no longer uses local materials.

Christmas lights

A new custom that has taken a particular hold in Britain since the mid-1980s is the tradition of Christmas lights: for the month of December, small towns across Britain festoon their pubs, houses and shops with strips of lights curled into shapes as varied as stars and swans, and hundreds of local people flock to see them. Whole communities come together in order to put on these displays; there are months of planning, fundraisers and then the all-important switch-on. They are, without exception, free events: the only expectation is that visitors might voluntarily put some money into a bucket or box to ensure that the light displays can continue into the future. In this sense they are truly made by the folk, for the folk, for pure enjoyment and pleasure.

Each Christmas I, alongside hundreds of others, visit Angarrack, a small village outside Hayle in Cornwall which has a series of lights that celebrate images from the song 'The Twelve Days of Christmas': there are two turtle doves with a glowing love heart above them, there are five gold rings with a flashing diamond, and there are seven swans swimming on the river that flows through the town. There are also a number of other lights such as stars, snowmen and reindeer, and in 2021, there was the addition of a light that reads 'Angarrack Thanks Keyworkers' lit up in rainbow colours. In mid-Cornwall, Redruth's light switch-on sees a brilliant merger of the old and new with the revived Redruth wassail happening on the same day. People gather in the main high street where the wassail bowl, made by local musician and craftsman Pol Jenkin, is ceremonially handed over by the mayor to the wassailers. The lights are turned on, and the wassailers then make their way around the town singing and dancing as they go. Interestingly, in a parallel to the guising tradition, the Red River Choir join the merry makers with renditions of Thomas Merritt's carols, a series of nineteenth-century Methodist carols written in

THE LOST FOLK

Illogan near Redruth by the tin miner Thomas Merritt. The whole event celebrates both the past and the present, bringing together historical details and modern entertainment.

A little while ago, a friend told me about a curious collection of lights in Cornwall. At the point she described them to me they had long since vanished from the Christmas calendar, but they had left a strong impression. She told me that each year she would make a pilgrimage to see Stan's Country Christmas lights. Later the same week she sent me a folder of images she had collected over her many years of visiting. I opened them and found little green aliens, turquoise tinsel penguins and silver cowboys. So who was Stan? A small clue is offered in one of the photographs. Beneath the aliens are the words 'Stan Penrose' in red and green backlit lettering. It took me a long time to track down any more information about him. The internet turned up no mention, and the lights themselves had disappeared some years ago, according to my friend. Finally, I discovered an article in the local newspaper from December 1994. In it the mysterious Stan appears, and at the point of the article he had been making and mounting the lights each December since 1989 in the hamlet of Penstruthal. Stan was a retired county highways worker, and had worked for the council for twenty-seven years. Alongside his other jobs for them, each year he was responsible for putting up the hundreds of strings of bulbs used to decorate the surrounding towns during the Christmas season. The article also mentions another notable display in the vicinity, one by Jimmy Jones in Lanner, who had worked alongside Stan at the council. Why did Stan and Jimmy feel compelled to continue their lifetime's work into retirement? 'Seeing the pleasure on the faces of people who stop to look at them.'[50] The final question I pondered was: why was it known as Stan's Country Christmas? The question seems to have a simple answer. Stan and his wife, Inez, were big fans of country music, and

254

THE LOST CUSTOMS

would take off to a country and western week held in Weston-super-Mare for their annual holiday each year.[51] The only tangible remains of Stan and Jimmy's lights are my friend's photographs and the one newspaper clipping mentioned. There will no doubt, however, be many people in Lanner and the surrounding towns and villages that remember the yearly illuminations.

Stan's Country Christmas and the Angarrack Christmas Lights are both ultra-localised events: happenings that you can only know about if you either live in a place or happen to be in the right spot at the right time. This is something that is repeated across Britain. If you happen to find yourself in a village on the right day in the lead-up to Christmas, you too may stumble on a magnificent display of kaleidoscopic coloured lights. It is so important to support the communities that put them on, because as we see in the case of Stan's Country Christmas, in an age of increased costs, they are a dying form of folk art.

Festive swims

Another new custom has been bubbling up across the shorelines of Britain since the mid-1980s: people taking to the sea for a cold-water dip en masse. The activity is most popular on Boxing Day or on New Year's Day but sometimes happens on Christmas Day itself.

In Scotland on the shorelines of Portobello and South Queensferry, residents not only take to the water but do so in fancy dress. Costumes are varied, with people wearing everything from rugby shirts to mermaid tails for the collective swim known as the Loony Dook.* The first ever event took place on 1 January 1987 and was instigated by two local residents from South Queensferry, Andy Kerr and Jim Kilcullen, who were keen to find a cure for their New

* In Scots, 'dook' means to immerse yourself in water.

255

Year's Day hangovers. Their solution was to dunk themselves in the icy waters of the River Forth wearing a funny outfit – the perfect way to start the year!

The dook has been happening ever since, and now involves a parade to the beach with spectators gathering to watch the wild and wonderful array of outfits. The swimmers are then given a bowl of porridge before plunging into the frozen depths of the river while being cheered on by an audience. A similar festive swim takes place at Porthcawl in South Wales on Christmas Day, where again swimmers dress up in elaborate costumes – recent years have seen people dressed as presents and Christmas elves. Tenby, also in South Wales, likewise has people run to the water on Boxing Day. There, hundreds of Santas, reindeer and other characters dive into the sea before returning to the beach for a bonfire and a bowl of hot soup.

These collective dips are an excellent way for communities to join together at the darkest point of the year. As with the more ancient mumming customs or Christmas folk plays, they are a way of bringing joy and humour to what can be a difficult point in the year. Many of the dips, dunks and swims now raise money for local charities ranging from those that support mental health to organisations that promote clean water.

Ivan Kupala Night

While Christmas light displays and New Year swims are beginning to become traditions, there are even newer customs that are emerging. In 2023, a friend of mine decided to rent her spare room out, and welcomed into her home a lodger who had recently arrived from Ukraine. During her first weekend living in the house it was, she revealed, Ivan Kupala Night, a very important evening in the Ukrainian folk calendar. The celebration has its roots in a much older pagan fire custom and in Ukraine is now celebrated on the evening

THE LOST CUSTOMS

of 6 July, although it used to be, as it is still in many other Slavic countries, celebrated on St John's Eve in June. As dusk falls, people gather together near a water source to dance and sing. Single women collect together herbs and flowers which they use to make garlands that are strewn into rivers and streams in a ritual that helps foretell their future relationships, and men and women jump over flaming bonfires, casting off their sins as they reach the other side. My friend was keen that her lodger would be able to continue this important custom, so they gathered together the elements needed and spent Ivan Kupala Night by the water enacting the tradition.

When I heard the description of the activities of this evening, I was immediately struck by the parallels in the celebration of St John's Eve customs in Cornwall, where bonfires have held a central role for hundreds of years, with herbs being cast into the fire including St John's wort, vervain, mugwort, foxglove and mallow, and where people jumped over the flames in much the same way as in Ukraine. Although the custom has been revived by the Old Cornwall Society with its annual beacon fires, it is nowhere near as widespread as it once was in Cornwall. Perhaps, having been born on St John's Eve, I look on this with more interest than many customs, but isn't it wonderful to think that someone arriving from another culture might have customs to offer our folk landscape that are not only new to us but also enrich and revive ancient customs that have been forgotten?

While reading about Ivan Kupala Night, I also discovered that there is a tradition revolving around fern flowers. It is thought that on this evening, when the veil thins and magic is alive, the fern plants flower for one night only. As the bonfires dim and people wander home, they search for the fern flowers, for it is believed they will bring good luck for the year ahead to whoever chances on one. These curly fronded plants litter the hedgerows and roadsides of Cornwall. The writer

THE LOST FOLK

Ithell Colquhoun described Cornwall as 'the fern loved gully', and they truly do pop up wherever a crack in masonry or pavement allows them to. Here in Cornwall, in this place that is seemingly very distant from Ukraine, is the potential for a cross-pollination of folk tradition: bonfires, herbs and ferns. It is exactly how we should be approaching inclusion in modern folk practice: as a conversation. We should be listening to and experiencing the traditions of other communities, and sharing our own.

Changing times and the evolution of folk customs

There are customs that, as I have already explored in relation to the Britannia Bacup Coconut Dancers, are deeply problematic, and there is an argument that these should be lost or at the very least evolved to not be offensive.

As a teenager I lived in North Cornwall, and one Boxing Day we decided to take a walk through Padstow. As we stepped out of the car into the car park we were confronted by a crowd of people with blackened faces. It was a very strange moment. We asked one of the onlookers what was happening, and they replied, 'Don't you know? It's D****e Day.'

In recent years D****e Day has hit the national press for obvious reasons, and in 2006 the decision was made to rename it Mummers Day in an attempt to update the custom. Mumming is a custom, as explored earlier, that is also still practised in Cornwall. This has led to a confusion in narrative around the gathering that takes to the streets on Boxing Day and New Year's Day in Padstow.

In 2016 the Bristol-based filmmaker Michael Jenkins made a documentary for BBC Radio 4 on the subject of this custom, having visited Padstow in 2014, where he overheard people singing the line 'They gone where the good n*****s go.' The line comes from the 1848

THE LOST CUSTOMS

minstrel song 'Old Uncle Ned'. He was rightly disturbed by this seemingly unashamedly racist song being sung by people dressed in costumes that looked as if they had taken inspiration from black-and-white minstrel shows, with women in large gold hoops and brightly coloured turbans in 'Mammy'-style caricatures. On returning to record and film the event, he was met with a generally antagonistic and defensive attitude towards his questioning of the history behind the custom. The message was clear: it was certainly not drawn from the minstrel tradition, the songs sung were not racist, it was in no way meant to cause offence and they definitely did not want to talk about it.

The narrative that has arisen around the day is varied. Stories range from it being started by African slaves who were celebrating their emancipation on the quayside after disembarking from a ship, to it being a day that developed around the slaves' only holiday in the year, to it being a Pagan celebration of the light returning after the darkness of winter. What is without doubt true is that the narrative of where the custom originated is inconsistent, and so it can feel difficult to make sense of the firm assertion by the participants that it is definitely not racist; how can we know something 'definitely isn't racist' if we can't even agree on its origins?

The justification for the continued usage of songs during the procession that include racist slurs is problematic, to say the least: there is no doubt that the songs derive from murky origins. 'Old Uncle Ned' can certainly be traced back to minstrelsy and very obviously contains a racist slur, but what about the other songs that are described as 'not racist'? 'Polly Wolly Doodle' is mentioned as having been sung during the procession, and is known to have been sung by the black-and-white minstrel group the Virginia Minstrels, and 'Miss Lucy Had a Baby', a popular American skipping rhyme, was adapted into 'Miss Lucy Long', a song that appeared frequently

THE LOST FOLK

in Victorian minstrel shows. The use of minstrel songs as part of the custom seems to have arisen in the late 1920s when a (white) group called the Padstow Missouri Minstrels was formed. The group performed across North Cornwall, including in Padstow itself, presenting audiences with their repertoire of songs, jokes and skits, all done with blackened faces. In 1930 at a performance in Newquay, among the minstrel songs they also included a rendition of the Padstow May Song, which was described as giving 'much satisfaction and causing a good deal of laughter. The players were rewarded with a loud "Wee 'Oss" from a Padstonian in the audience.'[52] The Padstow May Song is generally only performed as part of the town's May Day custom, so the fact it was sung as part of the seemingly unrelated performance by the Padstow Missouri Minstrels suggests that members of the minstrel group were also involved in the May Day custom* and that there was, historically, crossover between the two events. This is corroborated by the fact that in the May Day display at Padstow Museum there is a set of bones laid at the base of the 'obby 'oss – an instrument that was often played by minstrel groups (the Padstow Missouri Minstrels are known to have played them) and that is considered to be one of the many racist tropes used by the minstrel tradition.

It seems that popular Victorian black-and-white minstrel songs and costuming combined with an earlier guising or mumming tradition in the town to make the custom that takes place today: at the same time Padstow Missouri Minstrels were doing the circuit there are also records of a travelling Padstow mumming play – the May Day song being sung further confused the links between the seasonal customs of the town and the minstrel tradition. Somewhere

* The Padstow May Song is also audible at the end of a film called *D****e Day*, made by students of Roehampton University in 2005, exploring the origins of the custom.

THE LOST CUSTOMS

along the road the two, seasonal custom and racist troupe, became entwined and extremely difficult to unpick.

The general consensus that the origins of the day are somewhat hazy is not, I think, a mistruth from the people of Padstow: there is a genuine belief that the custom has arisen from some ancient and forgotten practice, lost in the wilds of time and memory, and this is a crucial factor in relation to the particular community of Padstow, who have been pushed to the edges of their own town by property developers and tourism and are struggling to retain a sense of identity as a community. They argue that their folk customs have become the only lasting way they collect together as a community both in an abstract sense and in a physical way – this, however, does not absolve them of their use of racist stereotypes and songs.

Some understanding of why these practices have continued can perhaps be found in looking at the economic climate of the town. Padstow itself is now largely made up of shops selling linen dresses, oysters and wildly expensive coffees, all destined for the population of second homers who use the town over the spring and summer season. There is very little left for the few remaining locals who live in the town or on its outskirts. The sense of any physical community within the town has fallen away: it is now an intangible idea related to surnames, accents and birthrights. The people who have grown up in this climate of 'us and them' in relation to tourists and second homers versus locals have clung tightly to traditions that should have been left behind through a feeling, due to the perceived ancient origins of the custom as a mumming tradition, that what they are enacting connects them to both their ancestors and their home place. As the folklorist Helen Cornish writes, 'supporters seek to justify their practices through the legitimising power of heritage and community'.[53] The question is: does the community make the custom, or does the custom make the community? At Padstow it certainly seems closer

THE LOST FOLK

to the latter: their displacement means that the only way in which they *feel* they can still act as a community or entity is through engaging in customs which have 'always taken place'.

Since the change of name in 2006, the event has garnered a heavy police presence, and there is a general feeling among the partakers that they are being carefully watched. They were asked to stop singing 'Old Uncle Ned'* and wearing aspects of the costume, and for the most part proceeded to do so; however, some participants continue to wear blackface, with one attendee stating that 'as long as there are Padstow people in Padstow there will be D****e Day'.[54] The custom certainly still makes use of racist tropes imported from the American black-and-white minstrel tradition and bears little relation to any of the remnants of guising that exist elsewhere in Cornwall. As the folklorist Simon Reed states, the people of Padstow would do better to 'return to their true Cornish roots, and adopt the tunes and disguise practices of the guisers as their forefathers would have done',[55] rather than borrowing the tunes and guising practice associated with a deeply outdated and extremely racist form of entertainment.

Evolving customs

Entrenchment does not have to be the answer to evolving customs, however: there can also be an approach that focuses on inclusivity and celebrating the diversity of Britain; a way in which communities can raise their discontent around issues in their locality or on a wider, national scale. Across Derbyshire, between May and September, you will find brightly decorated panels with images as varied as Paddington Bear with his marmalade sandwiches and

* It is also important to note that when the filmmaker Michael Jenkins visited in 2014, they were still singing the song.

THE LOST CUSTOMS

people building a dry-stone wall. Each panel is constructed from thousands of individually coloured flower petals pressed into clay, and arranged in symmetrical patterns that make these magnificent images. Nuts, seeds and shells are often used to fill in gaps and add borders to the images, creating a marvellous variety of textures. Each of the panels sits above a well, and they last for around a week before fading and gradually disintegrating, ready for the panels to be taken down, stored and redecorated the next year. The custom has existed, in its current form, since at least 1850 but has much earlier origins. It is known as well dressing or tap dressing, and the suggestion is that it began as a way of venerating the many freshwater sources across the county after the plague, but it has even earlier, pre-Christian roots. Well dressing is, in fact, an act of worship found the world over. In times when clean water was hard to come by, a fresh spring was deserving of reverence, and what better way than to decorate its bubbling source with floral tributes.

Originally the images chosen in the Derbyshire dressings were popular scenes from the Bible, and religious phrases or proverbs such as 'as cold water to a thirsty soul, so is good news from a far country', as at Buxton in 1902, or 'Whither I go ye know', as at Tissington in 1904. There were periods when certain villages, such as Belper, banned the practice entirely: much like Lenten football games and Fig Pie Wakes, raucous behaviour and vandalism caused councils to suppress the custom, believing that it was, despite the God-fearing messages of many of the well decorations, inciting people to revolt.

The 1940s, however, saw a new wave of interest in dressings, and with it an evolution of the themes encompassed, so although religious themes prevailed, charitable causes and events in the royal calendar became more common as inspiration for the imagery. Festivals arose around the practice, with flower queens being crowned, and people travelling between villages to visit the trail of dressed wells.

THE LOST FOLK

Over time they have become a way of communities exercising their voice and raising contemporary issues. They can even be a place for radical discussion. In 2004, the village of Etwall decorated its well with a panel that bore the words 'save rural post offices', and two red letterboxes and a thatched building with a post office sign: a symbol of solidarity in a period of rapid closures of post offices in villages. Likewise, in 2023, the village of Eyam dressed its Townhead Well with a display that took in the joint seventy-fifth anniversary of the arrival of *Windrush* and the founding of the NHS, an example of how these richly decorated floral panels can also celebrate the achievements of our country.

The success of the Caribbean carnival offers perhaps the most obvious example of migrants bringing a custom to Britain and enacting it on a large scale, and well dressing presents an example of how ancient customs can work to become more inclusive. But what of other, smaller migrant communities and their customs and how these can affect a place? Cultural exchange is an important part of how folk culture can and does move on. In London the Scandinavian and Italian communities give carol concerts and hold fetes around Christmastime to which everyone is invited. Likewise in Edinburgh during the Hindu festival of Diwali the whole of the city takes to the streets in a mass celebration of light, which welcomes anyone who wants to join in. This open and inclusive spirit, of sharing and learning from one another, is how folk should be. There are many more examples of this cross-cultural exchange, and it would be impossible to cover the full breadth of the many migrant communities and their individual customs given the enormous richness and range that exist, but I wanted to offer up an example that shows just how wonderfully a community can adapt and evolve its traditions when faced with new surroundings, and influence the traditions of its new home in turn.

THE LOST CUSTOMS

Newton Abbot is home to a seemingly unlikely community. On the outskirts of this small Devon market town there has been, since 1949, a development known as Little Poland. It was first opened, after the Second World War, as part of a nationwide scheme to house displaced Polish communities and offer them a place of refuge and of peace. Accommodation was provided, along with a chapel for mass to be said by a Polish priest each day, and a Polish shop selling everything from sausages and sauerkraut to chocolate-covered plums. There was a commitment that staff would be bilingual – allowing for residents to continue speaking their native tongue if they wished. At its instigation it provided homes for more than a thousand residents. There were evenings of Polish dance where people would don their regional costume and dance the folk dances of their long-lost, but never forgotten, villages. Intricate embroidered waistcoats and swirling striped skirts, whirling around a community hall in Devon. People from the town were invited to visit and participate, and the Polish families would venture into Newton Abbot on market day: a cultural exchange of sorts, and a vital one, as many customs that these displaced Polish citizens were preserving had been suppressed during the war and as a result were entirely dying out in Poland. These sanctuaries in small towns across Britain allowed Polish people to preserve their culture and remember their much longed-for homeland.

It is hard to believe, due to the ephemeral nature of its postwar inception and construction, but Little Poland is still in existence today. A new building was completed in 1994, and the residents were moved from a series of crumbling post-war blocks to a modern, purpose-built unit. Although many of the residents are now in their late eighties, a photographic project by Karolina Jonderko explored how in 2022 the customs of the community were very much still being kept alive. The walls of the building are covered in *wycinanki*

THE LOST FOLK

(vibrant Polish paper cuts), bunches of dried herbs and embroideries and paintings of Polish folk costumes. There is a sense from Karolina's images that while the folk dance evenings can no longer happen because of the community's decreased mobility, the focus has shifted to ways of preserving their customs that are manageable and still create a feeling of their native Poland in this small enclave of Newton Abbot. Many of the people living in the community had children who have moved out into the surrounding towns and villages, and they now relate back to Little Poland as their homeland. Often, as with Caribbean communities, there is a hope or desire to return 'home' among older members of the community, although the idea of 'home' of course becomes more convoluted and confused as time goes on and people grow more rooted in the place where they have resettled. There is often a resistance to thinking of the new place as home, and a sense that the place from which they have arrived is more authentically home – home is, after all, where the heart is. In this sense the folk customs and folk culture provide the sense of home.

There were, until the late 1960s, hundreds of these communities, and there are many records of dances being given in community and village halls. In 1948 a demonstration of Polish folk songs and dances was given at St Columb Major church hall by members of the Polish hostel based at St Mawgan, indicating that the communities did not exist in a vacuum and that they were keen to share their customs with the people and places among which they had found themselves living.

Newton Abbot and Penrhos in Wales were the last two remaining Polish resettlement camps in Britain, until 2020, when it was announced that the Penrhos development was to be demolished and the Polish Housing Company, which had run it, was merging into ClwydAlyn, a social-housing body in Wales. While this will mean more sustainable, warmer and more comfortable housing in the future, it does also mean

THE LOST CUSTOMS

that the Polish community is being dispersed, and its customs of over fifty years have been halted. The proposed plan for the new homes is for singular units, which do not see people eating communally or engaging with one another in the same way that these communities had previously encouraged. The sharing of food, the sharing of traditions, has been written out. The new homes are energy efficient, but are they community enhancing?

The sad truth is that driving customs back behind closed doors means that culture is suppressed. Penrhos was once home to a wayside shrine, typical of the type found by the roadside in rural parts of Poland: an image of a Madonna behind glass in a wooden frame. It was unique within Wales; this will be demolished alongside the homes. Christmas and Easter customs were celebrated in a traditional Polish way, with displays of *szopka*, nativity scenes, being mounted in the community hall during December, and *pisanki*, painted eggs, being made in the spring, and the language being kept alive with residents conversing mostly, as in Newton Abbot, in their native tongue. The communities that existed in these camps were bonded by their shared heritage but also by the atrocities that they had lived through, and this made their drive to keep their traditions active incredibly determined. In spite of sometimes extreme sadness and homesickness, people rallied together to perform the customs that made a place feel like home: to create a sense of community, and of hope.

This is what, at best, folk customs can offer us all. Hope. The hope of returning home, even if that place is no longer accessible. The hope of another year having turned, another season having arrived, and a comfort in once again rolling the eggs down the hill or gathering the twigs to make the bonfire. In the case of migrant communities across Britain, folk customs also offer a way of a community finding a new home and feeling settled – a way of laying down new roots.

THE LOST FOLK

Folk customs are, as I keep reiterating, always in motion: they morph, changing and evolving with time. They are affected by people arriving and leaving. There are, of course, overlapping eternal themes that run through them, a sense of seasonality and the calendrical year being the most obvious, but for the most part their one unifying factor is that they are in a constant state of flow. The idea that tradition must be preserved is often important to communities enacting the custom, but even in the more rigidly observed customs there is always change.

At Minehead, in the far reaches of Somerset, a May hobby horse custom is practised, involving a series of hobby horses decorated with strips of multi-coloured fabrics, which dance across the town for the week around May Day. For the last decade, the events have evolved to encompass a pink, white and blue horse called Sailette, who appears alongside a series of other hobby horses including the Original Sailor's Hobby Horse, the Traditional Sailor's Hobby Horse, Baby Quay and Black Devil, on Alcombe Night, which falls on 2 May. Sailette is described by Jodie Thresher Walton, who looks after the Original Sailor's Hobby Horse, as being 'built for ladies'.[56] Although I have no evidence to concretely suggest that Sailette is inclusive of trans women, it is interesting that the hobby horse is rendered in blue, pink and white, the colours of the trans flag.

We can so often think that just because something is 'old' or has 'always been done a certain way' it must remain the same for ever, suspended in aspic and preserved for eternity. But customs often change, and usually without clamour. In 2024, it was reported that the annual beating of the bounds in Helston would clash with the town's yearly festival, Flora Day. Flora Day is usually held on 8 May (unless that date falls on a Sunday or Monday, in which case it is moved to the closest Saturday), while the beating of the bounds is always held on Ascension Eve (the thirty-ninth day of Easter). Due to a very early

THE LOST CUSTOMS

Easter in 2024, it was scheduled to take place on the eve of Flora Day – an evening that is dedicated to decorating the town, and having a pint of the infamous Spingo in the Blue Anchor Inn. It is not the time to be walking miles around the boundary of the town and bumping people on stones (as is the custom for the overlapping ritual). There was much discussion about whether the event should be moved, and if so, to what day. Finally, after much conferring and several articles in the local paper recording the disagreements, it was decided for the first time ever to move the beating of the bounds to the following week.*

Further back in history, the Festival of Britain saw a number of regional customs move their practices, albeit briefly, to London for the first time ever for a celebration of folk performance at the Royal Albert Hall on 21 June 1951. Notably the Old 'Obby 'Oss from Padstow travelled the long road to the city with its teaser to show off their dance: 'From Cornwall will come the man dressed as a dying hobby horse, who will be led by a "Mayer" in the May Day Hobby Horse dance. Led on by a teaser he will continually die and resurrect himself.'[57] There are only two other occasions when the Old 'Oss has left Padstow, and 1951 is the only time it has ever crossed the border out of Cornwall.† In the documentary *King for a Day* (2022), made by Barbara Santi, there is a scene in which the teaser of the Old 'Oss Party shows an old teasing stick used to cajole the 'obby 'oss. He explains the symbolism of the various motifs, including what he describes as 'the ghost fisherman'. When I first saw it, I was intrigued. It is, without a shadow of a doubt, the Festival

* There have subsequently been a number of disagreements around suggested changes to the practice itself, with the council wanting to evolve the custom to bump the stones with sticks, as in some other beating of the bounds across the country, rather than with people's heads, as is current method, in an attempt to make the custom safer.
† The Peace 'Oss left Padstow for London in 1927 for that year's Folk Dance Festival at the Albert Hall.

THE LOST FOLK

of Britain logo of Britannia's head in her crested helmet: a painted date of 1951 sits in the star that encases her. At the point I watched the documentary first, I didn't know the 'obby 'oss had ever made its way to London, and I had no idea about its involvement in the 'Folk Dance of the British Isles' event, but I was later able to connect the dots when I stumbled on a paper programme produced for the day. Later on in the film, the teaser shows the new teasing stick which he is about to finish painting ready for that year's May Day. The ghost fisherman is painted on it, but the date is left off. It is now cemented into the tradition as an archaic symbol: the 'obby 'oss's trip to London has left a ghostly impression, which has fixed itself into this folk tradition for another generation. In the even more distant past, continued rationing at the end of the Second World War saw a wooden replica replace the cheese that is rolled down Cooper's Hill in Gloucestershire, although, so as not to break the custom, a small fragment of actual cheese was encased in its centre. For one year in 2013, the actual cheese was once again replaced with a foam replica, not for rationing reasons but due to health and safety concerns. The decision was not popular, and people now once again throw themselves down the hill in pursuit of a real wheel of double Gloucester.

These perhaps do not, in the grand scheme of things, seem very notable events, and yet they are representative of what can and does often happen: for very logical reasons, customs evolve. Dates clash, bad weather stops play, sometimes lack of funds or dwindling numbers of participants dilute a custom, or it can be that messages or symbols simply get lost in time: all these things can, and have, affected whether customs have continued, or evolved in a different way to their original instigation. It remains to be seen in coming years if the beating of the bounds will return to its traditional date. I suspect it will, but equally I would not be surprised to read in years to come that it 'has always happened on 17 May'. This is not to say that people

THE LOST CUSTOMS

are forgetful or do not take an interest in the history of their customs, but rather that, as exemplified by Robert Hawker's mythmaking or the ghost fisherman, customs can change very quickly into events that have supposedly *always* happened at a particular place and time, and within a generation it can become very hard to establish what is fact and what is fiction. The question is: does it even matter? Surely half the fun is that it is often impossible to know when, where, how or who started a particular folk custom. Folk is about the past, but it is also about the present. It is about who is enacting the customs now, and if they want to hold their ceremony on that day rather than this, or wear this costume because it's more comfortable than that old scratchy one that needs to be dry cleaned, or hold the festival outside rather inside, or vice versa, then that is perfectly legitimate. They *are* the people carrying on the tradition. They are the folk now.

Folk tourism

The current folk revival has seen a previously unprecedented level of fame come to folklorists, folk dancers, folk musicians and participants in folk customs. The rise of folk tourism via platforms such as Instagram and TikTok has played a major part in this, and while this has been positive in some ways – such as the elevation of previously lost voices or discussion around inclusivity in folk practice – it has also meant that communities have struggled to maintain the same sense of identity in relation to their customs. Additionally, an element of vanity or even ego has been injected into folk culture that was previously absent, and the focus has moved away from actual enactment or engagement in folk towards merely the *appearance* of those things, often for the benefit for social media.

Folk tourism, which comes off the back of posts on social media, has increasingly become a difficulty for larger and more popular events, with hundreds, if not thousands, of people flocking to see

certain customs. Towards the tip of Cornwall is Mousehole, where the famous Christmas light display now commands so many visitors that people have to be bussed in from neighbouring towns to ease traffic. In the neighbouring fishing port of Newlyn, Santa arrives at the beginning of December each year by a raft into the harbour to switch on the lights, followed by a firework display on the water. Both events have become busier year on year, and while this can be useful for fundraising, and therefore being able to continue the custom, it does also mean that small towns can struggle with the logistics of running a larger-scale event. Just this happened at Spalding in Lincolnshire during the Tulip Time festival in the 1950s, when traffic became such a big problem due to the hordes of people flocking to see the magnificent displays that it was felt that the activities needed to be concentrated into a more condensed timeframe. Out of necessity, to minimise the impact on Spalding and its people, came the decision to start a one-day parade.

May Day at Padstow in Cornwall is an event that has also swelled in size, with the 'obby 'osses now commanding an audience of more than thirty thousand people. Likewise, the Burryman Day in South Queensferry in Scotland was once a small affair with only people from the town paying their respects each August. It now attracts crowds of people who travel from all over Britain to catch a glimpse of the Burryman and its companions. In January 2024, the *Telegraph* published an article on the top wassails to visit and a friend in Dorset had to stop replying to messages on social media, so inundated was she with requests to come to her town's wassail. Similarly, Boss Morris's annual Finger in the Spring ceremony, invented by them as something fun to do in the lead-up to their summer season of dancing out, now commands a large audience. Although it is not surprising that people want to travel from far and wide to watch these festivities – they are certainly all spectacles – I would urge people to seek out

THE LOST CUSTOMS

and discover their own local customs, and if there isn't one, or one has lapsed, to revive it! Folk is about place, and experiences within a community. These things will always be absent from the experience of a custom if you are not rooted in your town.

Folk must make sense for the times we live in, for the current communities of Britain. In order to move folk into the future, we must ask: what are the things that make us feel alive today? What are customs that should be left behind? What are the days of the year that we want to celebrate? It is vital that we continue to ask ourselves these questions, and always keep a keen eye on the evolution of folk customs.

A revived interest in people travelling to folk customs and engaging with 'folk' via social media has, both inevitably and rightly, brought a focus to customs that are problematic. Throughout this chapter we have seen that folk can be beautiful – full to the brim with community spirit and a drive to work together – but it can also be horrifying. It can bring out and encourage some of the worst aspects of humanity, in particular responses to the perceived 'other' from racism to homophobia. Although the hype of folk on social media and folk tourism can pose organisational difficulties, they do also mean that more people see problematic practices that had in the past been confined to one town or region. This quite rightly leads to conversation, and hopefully ends in the evolution of folk practice towards customs that are inclusive and open.

It is so important that as modern collectors of folk we search for the hidden meanings behind customs, that we interrogate them and, if necessary, help them evolve to be more inclusive and more meaningful for today. Folk practice must not become fossilised. If it does, it is in danger of becoming something prosaic and disconnected from the very meaning of the word 'folk', because while folk customs can be inspired by the past, they must work for the present and for the future; they must represent the people of today.

273

5
⋆ **THE LOST WORLDS** ⋆

Folk customs are what we often consider to be the centre of folk culture in Britain, but there are also buildings that offer us a magnificent picture of folk culture today: buildings that people have crafted for the pure joy of it, buildings that are based on folk stories and mythic worlds, and buildings where people gather to form folk memories. These are not buildings in the traditional sense of the word, but folk art worlds that encompass everything from model villages to shell gardens to fairytale kingdoms; realms where myth and truth are intertwined and woven into the fabric of place. The buildings we will journey to in this chapter are all places that might not conventionally have been considered 'folk', but they are places that exhibit characteristics of folk in that they are handmade (all the buildings we are going to travel to have been brought together by impassioned architects, engineers, builders or craftspeople), they bring people together as communities or they transport the people who visit them to the realms of the mythic – the places of folk tales.

Many of the places we will visit together have long since been destroyed, leaving only the smallest fragments of their existence. Quite often they are recorded only in the memories of those who visited them, entirely lost to history but for people's recollections. What unifies all these spaces and buildings is the deep-seated nostalgia they provoke in people who remember them and their use of myth and legend – the stuff of childhood and memory. Memories are what 'folk' as a concept is built on. A large selection of the buildings

THE LOST FOLK

use fragmentary building practices in their very make-up – shards of ceramics in mosaics, or buildings, as in the case of the model village, from many eras. Snippets of memory are transformed into buildings and gardens – worlds for people to lose themselves in.

Model villages and fairytale worlds

Model villages have rarely been considered in the context of 'folk', and yet for me they are true folk art worlds: they are made by people using cheap materials they have to hand, they are egalitarian in that they have generally in the past been free or very cheap to visit, with the proceeds often (though not always) going to charity,* and they often record, at least in part, real places and buildings (sometimes they are entirely set in the realm of the mythic or imaginary, but this is rare). They also very often record, as we will see later, buildings or crafts that have fallen out of use – thatching, for instance, is a very popular way of roofing a tiny shop or home. They are encapsulations of folk crafts. Model villages generally take a rather whimsical approach to town planning. Often there will be a handful of buildings from the locality but they will be from a certain time period (e.g. pre-war or late Victorian), without modern additions to the townscape. Sometimes the planners of these miniature worlds do away with reality altogether and create something entirely fictionalised.

The world of the mythic reigns in the model village. Generally they are built in 1:24 scale, so children are rendered giants in these miniature lands. Adults tower, having to bend and contort themselves to peer into the windows, doors and alleyways. There is a sense of the mythological in this rendering of humans into giants and giantesses.

* This has changed in recent years, due to increased costs of upkeep.

THE LOST WORLDS

When else does one have the opportunity to experience our world on such an uncanny scale?

The first ever iteration of a model village can be dated to 1908, when the former architect and obsessive collector Charles Paget Wade, whom we met earlier (see p. 90), began work on what is generally considered to be the world's first model village. Using all the skills he had acquired as an architect at Unwin and Sons in Hampstead, he conjured the fictional village of Fladbury. Built in 1:24 scale in the back garden of his rented home in Hampstead, it was intended as entertainment for the daughter of a friend.

In 1920, Charles relocated to Snowshill Manor in Gloucestershire and moved the entire village of Fladbury to the garden there. He renamed it 'Wolf's Cove' and set to work remodelling it into a Cornish fishing village. This new iteration became more elaborate: there was a miniature pub, a working harbour complete with water, a canal and a fully working railway network that Charles had purchased from the model train-set makers Bassett-Lowke. He opened it to visitors in the early 1920s, receiving well over five hundred people a year including some illustrious guests, such as Virginia Woolf and Clough Williams-Ellis (of Portmeirion). J. B. Priestley visited in the early 1930s, and wrote evocatively of it: 'This miniature seaport . . . has a proper harbour in one of the ponds of the garden. It has its quay, its fleet of ships, its lighthouse, its railway system with station, sidings and all, its inn, main street and side streets, thatched cottages and actual living woods.'[1]

In 1931 John Betjeman also visited Wolf's Cove and wrote it up for *Architectural Review*, where he described it as if it was a full-size village, detailing the characters and lives of the village folk: 'The first building of note is the old sixteenth-century Manor House, inhabited by an eccentric gentleman, Mr P. Morton Shand, who is rarely seen outside his grounds . . . Mr Frederick Etchell's, the wheelwright,

who lives in the large, red brick, seventeenth-century cottage on the right, farther up the hill.'[2]

Betjeman leaves it until the final line to reveal that this picturesque village is, in fact, entirely rendered in miniature. The English pastoral landscape is nowhere better explored than in the imagination: there we can imagine the most elaborate views of an idealised English past – rural idylls filled with the bounty of the land. Fladbury and Wolf's Cove both encapsulate a collective imaginative world. They allowed Charles to explore architecture, form and function in a playful and irreverent way, chopping and changing parts of the village as he pleased but always adhering to a romantic, folk vision of England.

In the 1920s, he made detailed architectural drawings for a full-size Folk Hall, which included a hall for folk dancing, a library, a café and space for communal events. Although his Folk Hall designs were partially realised, the intended usage was never fully implemented and the building that became the Folk Hall was more of a village hall than a fully operational centre for folk culture (and was subsequently bombed and destroyed in 1945). Arguably, however, Charles's vision for a celebration of British folk culture was realised in Fladbury. In 1951 Charles handed Snowshill over to the National Trust, and for many years the model village disappeared entirely from display. However, in the last few years, National Trust volunteers have restored the village's houses using archival images and have recently reinstated parts of Fladbury into Snowshill's gardens.

Around twenty years after Charles first conceived Fladbury, Roland R. Callingham began work on Bekonscot Model Village. Perhaps the most famous model village in the world, it was opened to the public on 4 August 1929. Roland was a model railway enthusiast, and had built a model railway inside his home. However, his wife was not such an enthusiast and gave him an ultimatum: 'It's me or the railway.' Thus, the railway was moved to the garden and

work on the village of Bekonscot began. It included traditional buildings inspired by those around Buckinghamshire, a castle, a coal mine and several lakes. Much like Charles's village, it was not initially conceived as a visitor attraction, but rather for the amusement and joy of Roland and his friends and family. In time, though, word got out about Roland's tiny world and he decided to open the doors to the public, using the money raised from tickets to donate to various charitable causes. By the 1930s visitor figures had reached an all-time high, due, in part, to a number of films made about Roland's miniature railway, including one by British Pathé. Its fame gathered steam and by the 1940s it had inspired Enid Blyton's story *The Enchanted Village*, as well as a number of other model villages across the country, including the now defunct Tucktonia in Dorset, and Babbacombe in Devon.

Although Bekonscot continues to welcome visitors through its gates, many other model villages have not had such kind fates. Merrivale Model Village (sometimes known as Land of the Little People) was opened in Southport on 17 April 1959. It was the dream of Thomas Francis Dobbins, who, alongside his brothers Harry and Bill, set out to create a model village to rival all others. The three brothers were all engineers, so were aptly placed to achieve their vision. Thomas (who led the project) left his job at Brockhouse Engineering and began work on landscaping the site, building a pump to feed the river 'Merry' and laying a path made from slabs of serpentine, from which visitors could view the buildings. What is perhaps most remarkable about all this work is that the site Merrivale was erected on was as far from the nostalgic vision it became as possible: it was a former petroleum depot, which required extensive works to remodel and to make it safe for people to visit.

In 1964, Tom relocated to Torquay, where he began work on Babbacombe Model Village, and left Harry running Merrivale. Bill

opened his own Merrivale at Great Yarmouth. The original Merrivale trundled on until the 1970s, when a downturn in ticket sales meant Harry sold the land. It remained open to the public until 1987, when it was demolished: the handmade buildings were crushed, the landscaping was flattened and the trees were uprooted. The site that was once its home is now a supermarket car park. A full circle – petrol station, to miniature world, to car park.

There is something of the eighteenth-century folly about model villages: huge endeavours purely for entertainment. They are faintly ridiculous in the degree of effort required for the end result. However, where they fundamentally differ from the folly, which was traditionally something only to be enjoyed by aristocrats wandering their extensive estates, is that they are for the viewing public. The model village is for everyone: pay your entrance fee and you are permitted into an entire world in miniature. It is classless and utopian. Here, among the rose beds and Lilliputian clipped trees, are castles, village shops, post offices, pubs, palaces and churches collaged together for everyone to enjoy.

They are both egalitarian and wondrous in the way in which they blur the lines between reality and fiction: at Babbacombe Model Village, Stonehenge stands proudly by the Shard; at Legoland in Windsor, Stonehenge merges with Glastonbury Tor; and at St Agnes Model Village, the brutalist Truro County Council office sat next to a miniature Truro Cathedral, a masterpiece of late neo-Gothic architecture built by local builder John Foot, who dreamt up St Agnes Model Village with his wife Vicki. In these spaces fact and fiction are of no consequence: the craftsman rules.

At this point I must admit that, although I've long been intrigued by model villages, I hadn't until very recently ever visited one – surprising perhaps, given that Cornwall, where I live, was home to a small army of them when I was growing up. Perhaps the time was

THE LOST WORLDS

not right and I had to wait until I was older to enjoy the true wonder of a visit to a miniature land. In reality, the reason is more practical: I don't drive and am often reliant on public transport or lifts, which can be hard to come by when the words 'model' and 'village' are mentioned together.

I did actually try to visit a model village earlier this year, only to find it very much 'shut for winter'. As I stared out of the café window hopefully, I heard a woman behind me explain to another visitor that 'the buildings have to be mended – it takes a lot of work to get them ready for the summer season, you know'. I continued staring out of the window hoping to see someone busily re-tiling a roof or mending a door, but it was entirely devoid of any life. Nevertheless, I vowed I would return when the summer came round.

Cut to five months later, and I am standing in the middle of Corfe Castle Model Village. It is smaller and more exciting than I ever could have imagined. The thatched roofs are made from what look like cut-up old doormats. The tiled roofs are made from individual tiny pieces of slate. There's a fully working water mill and a small plastic ghost in the manor house courtyard. It is truly marvellous. As I wander, I consider the hours of labour that have gone into these near-exact replicas of Corfe Castle. It is remarkable and obsessional. There is a human-sized potting shed with some information. The village was opened in 1967 and was the brainchild of a local shop-keeper in the village, Eddie Holland. Although Eddie came up with the idea and paid for the village, he did not make the models himself, but instead employed a local builder called Jack Phillips to construct the houses and shops of Corfe (this is actually quite unusual for a model village; generally, the instigator is also the builder).

My fellow visitors are particularly interesting to me: a smartly dressed man with an earl grey teabag wrapper placed in his hatband (is he saving it for later?), a couple who don't speak a word to one

THE LOST FOLK

another but offer to take my picture by the replica castle, and a man in a luminous red T-shirt, who loudly declares the models 'very accurate'. They all look and sound like they could have stepped straight from the miniature scenes I am examining.

What I learn quickly is that if you are not willing or able to bend, you will miss most of the joy of a model village. So much of the detail is contained within the windows and gardens that are only visible when you are stooped. At points I find myself sitting on the floor (I'm not sure if this is good model village etiquette but no one complains) to really get in on the action. Look! Some people are getting married at the church! A family is having lunch in the garden! A farmer is tending his cattle! It is staggering how the mundane becomes remarkable when translated into miniature.

The next day, buoyed up by how exciting I found Corfe Castle, I make my way to Wimborne Model Town. I've read about it online, and it looks bigger and even more comprehensive than Corfe – which makes sense, given that Wimborne itself is a much bigger town. The admission fee is slightly more, at £10 a ticket, but it is certainly worth it. The woman on the reception desk informs us it is valid for an entire year. Bargain! Corfe was only valid for a week. On entering, we hear a ringing sound. I look down at my feet to find a tiny telephone box ringing. I am giddy with joy. Some time later the miniature bells of the replica Wimborne Minster ring. On the outskirts of the village is a woman on a mobility scooter who, while unable to access some of the narrower streets at the village's centre, is able to look at many of the buildings given their slightly larger height than the average model village. There is a general sense that everyone is welcome in this model town.

There are streets and streets of tiny buildings, each containing shops or homes. As I peer at the handwritten signs and windows filled with wares as varied as country wines and jewellery, I am aware

THE LOST WORLDS

that here is an incredible record of lost crafts and businesses. From an ironmongery to a poulterer, here is a series of long-forgotten ways of making a living. What also strikes me is the level of craftmanship in the rendering of these buildings. It is much less crude than Corfe (although for me there is a charm in Corfe's basic construction). Here the signs have obviously been hand-painted, the bricks have been properly laid and each window has individual, albeit plastic, panes of glass. There is even ivy growing up the side of one of the (on my count) five pubs.

Best of all is the model of the model. There was also one at Corfe and it seems it's a bit of a feature of all model villages: a little maker's joke, if you will, like the modern version of a medieval stonemason's graffiti on the tower. Wimborne has, in fact, got a model of the model of the model of the model (phew!), rendered so small it becomes almost impossible to see.

Re-entering the real world feels strange. I can now entirely map Wimborne (despite having never previously visited) exactly as it was in 1950. I spend the rest of the afternoon unpacking the strangeness of being giant in a seemingly normal town; stomping through the streets like some sort of human Godzilla is an odd feeling but it is also intensely magical. When else do we get to experience seeing an entire town or village from above or below (depending on whether you tower or crouch)? I feel evangelical about model villages. I want everyone to get a chance to spend an hour or so as a giant. These little worlds are unique, and odd, and filled to the brim with humour, and they should be cherished and adored. In a mad moment on returning home, it occurs to me that they should also be listed . . . imagine that! Hundreds of miniature grade 1 and 2 listed buildings. It is a silly thought (probably), but at their heart, model villages encourage silliness – which is something we could all do with more of.

285

THE LOST FOLK

The listing of tiny houses does not seem so silly when you read about model villages that have been completely lost. In September 1948, the *West Briton* newspaper reported that five Cornish schoolboys had spent their summer holidays building a village. Alan Johns, Kingsley Morris, Michael Edwards and Stewart and John Nicholls had turned Alan's father's garden in Germoe into a realm of fantasy, constructing a church, a quarry, a school and a bus station, among a number of small houses. It had fully lit streets and a drainage system to stop flooding. Printed in the *Cornishman* on the same day was a small, grainy sepia photograph of the boys crouched over their creation. A few years earlier in 1945, in Crest Grove in Erdington, just outside Birmingham, fifteen-year-old Peter Walker set to work drawing up plans for a fictitious place called 'Littleton'. Using cardboard, straw board and anything else he could get his hands on from around the house, he built a village: there was a tramline, a church with cellophane stained-glass windows and tiny bushy trees lining the streets. Both villages have long since disappeared; they are remembered only in the newspaper clippings that record their brief existence.

Part of the difficulty in preserving model villages is the materials they are made from. Peter was clearly using recycled materials scavenged from around the household. In Wicken in Cambridgeshire, a couple, retired seamstress Pat Bullman and retired digger driver Oliver Bullman, spent over fifty years building a miniature world in the front garden of their home. It was constructed entirely using found materials: pieces of plywood made up the walls of the shops and homes of the town, and windows were painted with acrylic paint. For the most part, the materials used were not intended to weather the elements, and as Pat and Oliver grew older the village gradually started to fall into disrepair. Photographs from 2014 show weeds growing up between the buildings, and the paint on them cracked and peeling. After Oliver's death, Pat engaged the help of

THE LOST WORLDS

two volunteers to bring the village back to its former splendour: a number of buildings were reconstructed, and it was all given a fresh lick of paint. There is little to be found about the village and its fate after 2016, but a remote trip on Google Maps took me to a satellite view of their garden, where I found the village fully intact and looking resplendent as of March 2023.

The question is: what happens when there is no longer anyone to take care of the guttering, re-roofing or repointing of the buildings? Generally, as we have seen, they become shabbier and shabbier before they are demolished or thrown away. However, there is one particularly heartening example of this trend being bucked. At Coniston in Cumbria is the Ruskin Museum, and within its grounds is a miniature village made up of slate-and-brick buildings. There's a chemist, a baker and a draper, as well as replicas of a number of important buildings and bridges in the Lake District. The buildings are all the work of John Usher, who spent a lifetime perfecting his village, Riverdale. On his death in 1993, his house was sold, and the question arose of what to do with the model village. The community of Coniston came together to find a solution. People wanted the village to be preserved in memory of John but also so generations more children and adults could enjoy his work. In 1995 it was decided that the museum would take on the maintenance with a view to opening it to the public in the future. It was moved to the museum grounds and unveiled to the public in 1999. It turns out the upkeep of a model village takes a whole village of helping hands.

In the gardens surrounding Margam Abbey in Port Talbot is a place called 'Fairytale Land', in which lies a collection of perfect child-sized houses. Unlike the houses in most model villages, these buildings are large enough to explore but just small enough that adults have to crouch. There is a castle with battlements, a half-timber Tudor manor house (complete with a garden), Snow White's cottage,

THE LOST FOLK

a gingerbread house and a huge Humpty-Dumpty that greets you on entry. At one point there was also an enormous shoe, inspired by the rhyme 'There was an old woman who lived in a shoe'.* Adults were in the past banned from exploring this miniature landscape,† which was originally called 'Children's World'. The pint-sized buildings were all built to exacting standards, calling to mind St Fagans Folk Museum and its open-air collection of historical Welsh buildings. Fairytale Land really encapsulates the meeting of the rural idyll with the mythical landscape of Britain.

Fairytale Land is by no means alone in this exploration of the mythic landscape brought to life. On the Isle of Wight is a place that lays claim to being Britain's first ever theme park: Blackgang Chine. Built in 1843, it has been home to all manner of differing worlds, rides and exhibitions in its lifetime. Across its history it has seen everything from a series of scenes featuring garden gnomes to a wishing well to a hall of mirrors and a maze, all melding into a strange and very surreal place ripe for discovery and encounters with the illusionary. Here, within the amusement park, sometime in the late 1970s, a world entitled 'Nurseryland' was brought into being. Like Fairyland, it is home to an enormous Humpty-Dumpty (this one rocks gently back and forth). There are giant toadstools with doorways and tiny pixies sitting atop them. There is also a large boot or shoe, very similar in shape and style to the one that graced Fairytale Land, complete with an entrance and windows for children to peer down at their relatives from.‡

Elsewhere on the Isle of Wight is another giant shoe, this one abandoned, buried deep in the woodland of Undercliff. With tendrils of ivy

* It was quietly removed at some point in the 1990s after being deemed unsafe.
† A more lenient attitude is taken to their presence these days.
‡ Again, like the shoe at Fairytale Land, the shoe at Blackgang Chine was inspired by the nursery rhyme 'There was an old woman who lived in a shoe'.

THE LOST WORLDS

curling through its windows and festooned with ants and woodlice, this shoe had been entirely forgotten until it was posted on a series of abandoned building forums online, and subsequently in a variety of tabloid papers. Why is there an abandoned shoe in the woods? The answers are seemingly endless and generally inconclusive. There's speculation that it was once part of a holiday park – a few people have suggested it was the Blackgang Chine shoe (which it definitely is not), and some have mused that it was part of another now-defunct and nameless theme park. Scattered in the land around it is a series of concrete mushrooms, and higher up lies the remains of a turreted castle. So perhaps it is, indeed, the remains of a long-forgotten theme park.

There are few examples that manage to weave the miniature and the mythic quite so well as St Agnes Model Village. It holds somewhat legendary status in the minds of adults who grew up in Cornwall from the late 1960s onwards. Housed on land just outside the quintessentially beautiful village of St Agnes on the north coast of Cornwall, it was home to a series of worlds, from Cornwall rendered in miniature to yet another iteration of Fairyland. Here the fictitious and factual sat side by side, including Noah's Ark and Jack and Jill's well, alongside a Cornish engine house and a petrol station. It also played with scale – there was a full-size Gulliver with tiny Lilliputians surrounding him, a miniature fairytale castle set on a mountain overlooking a pond and, as at Fairytale Land, a human-sized gingerbread house for visitors to explore. It was a truly utopian vision of what Cornwall, and indeed the world, could look like if myth and legend were allowed to take hold. Why shouldn't there be a windmill next to a house shaped like a toadstool?

Sadly, St Agnes Model Village was gradually dismantled after the original owners sold it in 1988. It is not known what happened to the buildings, but a quick Google search will send the curious researcher into a rabbit warren of theories as to where they ended up.

THE LOST FOLK

The village of Woolmer Green in Hertfordshire was also once home to a model village which, like St Agnes, now only lives on in people's memories and a few remaining objects. Harry MacDonald was a carpenter, making garden and household furniture in the garage at his house on New Road. In an inspired move to attract attention to his business he set to work on carving a full-size wooden policeman, his hand outstretched to the cars passing on the road, beckoning them to come and purchase a hand-carved table or chair. Over time this sign did have an effect, but perhaps not the one Harry had initially desired. He began to get commissions for signs, for figures and for carvings but not for tables or chairs.

Harry took it in his stride. He began carving animals and people, flowers and symbols and attaching them to the side of his house. Gradually this became a local talking point, a place for people to stop and look up at his creations. It became known as the Woodcarver's Cottage. Not satisfied with this alone, Harry went on to cover his entire house, and then the garden beckoned. He began work on a model village, making all the buildings from timber in his workshop and creating elaborate settings for them to sit in – waterfalls and streams wound around the buildings. There was a bell that rang as people entered and a slot to put the 20p entrance fee into.

Harry's world was one of magic, one of folklore and storytelling but also one of necessity. In order to make a living, he created a place people could escape to and spend a few moments removed from the cars whizzing by on the road beside it, with the added benefit that it could act as a showroom for his wares – of course at the end of a visit to Harry's there was always the opportunity to purchase a carved creature. In 1971 Harry died, and the house was sold to a local entrepreneur. Initially it seemed that perhaps the space would be turned into a tourist destination, but this was not to be, and in a few short years it had been sold again and demolished, replaced with new housing. Thankfully

many of the villagers of Woolmer Green managed to save pieces of Harry's carvings, and some now reside in Stevenage Museum, which has a carved self-portrait and a Santa Claus, and in 2023 St Michael's church in Woolmer Green held a small exhibition of his carvings alongside recollections about Harry and his woodcarver's cottage. In 2010, a blue plaque was erected on the former site of his home, and so, piece by piece, his history can be placed together, and the wonderful world he created can be remembered.

Model villages so often remain, long after their demise or destruction, in the memories of the many children and adults that have visited them – they become fairytale worlds. On my first ever visit to Bekonscot Model Village, I spoke beforehand to a friend who had grown up nearby. He recounted how he had visited repeatedly as a child and could list many of the tiny buildings. Likewise, when I quizzed a friend about her experiences of St Agnes Model Village, she could remember the many worlds and buildings that it was made up of. Sometimes the memory is so distant that it has become almost entirely detached from the place, and is instead a recollection of parts of the day out, but not a specific location, just a small fragment disconnected from time or place. This multitude of memories, both the hyper-focused and the slightly fuzzy, is a good representation for how folk memory works. It is the collective building of an idea. Sometimes that involves fact, quite often it involves fiction, and mostly it involves a fusion of the two.

Model villages of course also represent folk in a more concrete way, in that they are made literally brick by brick and tile by tile by the hands of a few dedicated craftspeople. Those people get to choose exactly how they want their village or town to run; as with the inversion customs I explored in the last chapter, they can play at being king. They also get to choose what gets put in or left out of their village – at Wimborne Model Town there is an interesting

example of this: a chapel that is a replica of a chapel that existed in the full-size Wimborne at the time the model town was built, though the full-size chapel has subsequently been demolished, meaning the miniature one is now the only reminder of its place in the town. Model villages are very often maintained by a band of committed volunteers and this collaborative effort is perhaps above all else why model villages for me are folk: they represent in a very small 1:24 scale the ability of a community to come together over a collective goal and fight against the odds to preserve it.

Shell houses and gardens

Taking folk building even further away from the utopian into the fantastical or mythological is the shell garden. For a time, towns across Britain were awash with these mollusc-encrusted paradises. Shell and mosaic gardens and houses first erupted as a pastime in the mid-nineteenth century as a way of using up or saving shards of ceramics and souvenirs collected from travels. They quickly became popular both for the makers and as attractions for the visitors. Often the pursuit of the retiree, they were mostly run on a donation basis, and, as with model villages, they generally raised money for local groups engaged in charitable activities. The act of making a world from scratch from shells, shards of ceramics and other seemingly 'scrap' materials is entirely in keeping with the folk ethos that I have discussed elsewhere in the book, of using what you have to make something for the wider community: a way in which people can express themselves creatively, a way of bringing joy and colour to daily life.

'We'll build a world of our own'

One of the first recorded shell houses open to the public was created by Frederick Attrill at East Cowes on the Isle of Wight. It is said that

THE LOST WORLDS

he started the garden after an incident when he was a child. In the summer of 1852, he was gathering shellfish on the beach when another child came and kicked his bucket from his hand. Frederick thumped the child, only to discover that he was in fact Queen Victoria's son – Albert Edward. Frederick was summoned to Osborne House, where the queen proceeded to congratulate him on his fortitude of spirit and some say she gave him several guineas as a reward for his feistiness. Although Frederick died in 1926, the garden that he supposedly created to commemorate the episode remained open until well into the 1970s but was subsequently bought and dismantled. Only a very small remnant of its past life remains in a small commemorative plaque and one panel of the original shell work. Luckily another shell house exists on the island that is still intact – this one is located in St Helen's and celebrates the island's history in shells. It was created in the 1970s by Bobby Allen, who employed the skills of his friend William Wright to design a series of panels which Bobby then realised in shell work. He coloured the cement in between the shells in green, blue, orange and yellow, creating the effect of a mural. The panels featured St Catherine's Lighthouse, Carisbrooke Castle, yacht racing at St Mildred's Church, among other buildings and activities of island life, and they were placed in between more graphic patterns. The resulting garden was extremely memorable and left a deep impression on the many people who visited. Bobby opened the garden to the public until the 1990s, and although it is now closed, the present owners have kept much of Bobby's shell work on the end wall of their house, which is visible from the pavement.

Across the sea, back on the mainland there used to be one of the best-documented shell gardens on the outskirts of Bournemouth in Southbourne, in the garden of Heathercliffe Hotel. Created in 1948 by George Howard, a Jack of all trades (he was described as a retired coal miner in a 1965 British Pathé film and in various other sources

THE LOST FOLK

as having been a hotelier, soldier, sailor and policeman, as well as working at Bournemouth's ice rink). Raymond Howard, George's son, is reported to have said that his father began the garden as memorial to his son (and Raymond's brother) who died in the 1940s from meningitis. George described shells as being 'the only things in this world that grow more beautiful after death'. Over the years, George added sculptures, mosaics and other strange and wonderful trinkets to the garden, including a number of William de Morgan tiles, picked up from car boot sales. The garden was completely free to visit, but George came up with numerous ways to get people to donate money, including a wishing well constructed in 1957. All the money collected was given to various local charities.

Sadly, in the 1980s, George, and then subsequently his wife Sarah, died and the garden fell into disrepair. Many of the shells and sculptures were stolen, including two rare giant clam shells reportedly worth £1,000 each. Then in 2001 neighbours awoke to the sound of bulldozers. The contractors stated that 'We were asked to clear it by the owner and that's what we're doing. I'm aware it might not be a very popular move but a job's a job.'[3] The local community were shocked by such a senseless and aggressive action – and many neighbours saved bits of the smashed garden as mementoes. Indeed, even this comment on an article about the garden in the *Bournemouth Echo* shows that the contractors knew they were in the wrong: 'The "developer" did not need planning permission to demolish the Shell Garden and knowing this they moved in unannounced and got the job done before anyone had a chance to complain or start a petition to save it.'[4]

Carrying on up the coast to Portsmouth in Hampshire, there is a shell house with a more cheering fate than Southbourne's shell garden. The house was decorated by Mr R. Scott, once the landlord of the Eastney Tavern. In the 1930s, he began decorating in idle moments,

294

THE LOST WORLDS

collecting shells from Southsea beach, which quickly covered the entire building. On its entrance, above the door, he spelled out in enormous shell letters, 'Come Stranger and Friend': an appropriate message for a publican in a seafaring town. At first, I worried that Mr Scott's work had met a similar end to Frederick and George's, but on a visit to Portsmouth I was happy to find that the beer garden of the pub is still overlooked by this marvellous expression of creativity. Nearby in Southsea, Richard Cole spent the early part of the Second World War constructing an ingenious shell garden over the entrance to his air raid shelter. It's unknown why he began the project, but in this dark period of history it is not hard to imagine needing to find some cheer. An image from the *Portsmouth Evening News* in July 1943 shows Richard proudly standing by it. It is an incredible piece of folk art. There are pointed and domed turrets, all of which, including the original shelter structure, are of course covered with shells. All the materials to make the shelter cover were collected from the beach, or from his garden, which had recently been bombed. Richard collected the shards together to make something new out of the destruction. Despite exhaustive searching, I haven't been able to find out what happened to Richard, or to his magnificent garden.

Since the 1950s, the children and adults alike of Swaythling in Southampton have been delighted by a collection of very small houses known as the Fairy Village on Burgess Road. These were made from poured concrete and decorated with shells. Inside are small panels of mirror that gently glow in the streetlight when night falls. The village includes a replica of Bargate, the medieval gate in the centre of the city, and was originally made by local resident Harold Butler in the 1940s. On moving to a house a few streets away, like Charles Paget Wade he picked up the entirety of his village and carried it with him to his new front garden, where he reinstalled it. The village still sits there, waiting for people to discover it.

295

THE LOST FOLK

While in Southampton I decided to walk and find it. I only had one slightly pixelated video from a Facebook group to help me in my search. In this video, there are some huge, golden arches of a well-known restaurant chain, which was how I managed to work out where the village might lie. I tapped the road name into my phone and began. Eventually, after several miles of walking, and just as I was starting to lose hope, I saw some tiny shell-encrusted turrets ahead of me, and there it was: a village of buildings straight out of a fairy tale, clad in periwinkle and limpet shells, with fragments of glass and mirror twinkling in the light. Some of the buildings, including the replica of Bargate, looked as if they might soon topple, their foundations crumbling into the grassy verge. Somewhere online, I had heard a rumour that there was once a windmill, but any vestige of that had completely disappeared, and there were ghostly holes that looked like they once held fairy homes within their foundations. One building had recently been smashed and was now made up of a pile of shards of mirror and concrete, the walls entirely caved in and its former shape unrecognisable. Harold died many years ago, and so in some ways it is surprising that any of the village is intact at all, given the fate of many folk art worlds when their creators die. When I visited there was a 'To Let' sign outside, and a small army of bins in front of the houses, but I remain hopeful that the village will be left alone for the fairies to dance in, among the tiny shiny houses.

On the outskirts of Leven in Scotland is a garden which, until the mid-1970s, was home to a series of buildings and walls, all encrusted with shells. It was the work of a coal miner, William Bisset, known to everyone as Wull. He began the project in 1920, and gradually added to it over the years, not only with shells but also with a variety of animals both imaginary and real* and other odd trinkets that he

* The garden was also home to a menagerie filled with parrots, canaries, golden pheasants and monkeys.

THE LOST WORLDS

sourced from skips and junk shops. He opened the attraction in 1927. In 1930 he acquired a decommissioned public bus that had once ferried people to and from Arbroath. Wull gave the bus a new lease of life, entirely covering it in a mosaic of shells and oddments: it became a huge attraction, and soon townsfolk and holidaymakers alike were flocking to the gardens to see it. By the mid-1930s, the gardens would typically see around thirty thousand visitors in a season. Wull never charged an admission fee for entry to his gardens; instead there was an honesty bucket he encouraged visitors to drop small change into, and the donations all went back into the upkeep of the garden and to local charities. The house and gardens became known colloquially as the Buckie Hoose, 'Buckie' being a Scots word for a whelk or shell.

It is clear from almost all the descriptions of Wull's work that he was considered an artist both locally and further afield. After a visit to the gardens in 1931, a reporter in the *Dundee Courier and Advertiser* said simply: 'Others may etch and draw, or paint in oils or water colours, but this genial coal trimmer has a different medium. He decorates in shells.'[5] The reporter goes on to mention Wull's expressive use of colour, and his use of sea glass between the creamy white shells, truly bringing the decoration alive.

Wull died in 1964, and his son James took the reins of the shell house and garden. However, when he too died, in 1978, it was sold and broken up. The bus and house were destroyed and replaced with a bungalow, and the only remnants of Wull's work are the walls around the garden, which still bear witness to his lifelong project. The remaining pieces give some sense of his style of decoration – lots of shells, of course, scallop and conch, as well as limpet and whelk, but there is also half a buoy, clearly rescued from the nearby beach, and several cracked plates. What is evident is that Wull was using materials close to hand, and making his environment from recycled items. Nothing, in Wull's world, was wasted. Cracked a cup? Never

THE LOST FOLK

mind, stick it on the wall! Smashed a priceless figurine? That arm or leg will do nicely among the shells. The Buckie Hoose was an early experiment in what it is to recycle human detritus into something beautiful and meaningful.

In the small fishing village of Polperro in Cornwall sits another shell house, created by Mr Samuel Puckey, who began work on its exterior in 1937 and had completely encrusted it by 1942. The shell work is similar in style to Frederick Attrill's in that it records nautical themes, including sailboats and seagulls, but the largest image of all is that of Eddystone lighthouse, which sits on the Rame Peninsula nearby. Unlike Mr Attrill's house, much of the Polperro shell house survives. Although there are a few missing shells, the main images of the boats and lighthouses are intact, and you can still enjoy a view of it today from the street.

Shell houses and gardens are by no means confined to the seaside. Sidney Dowdeswell, who began creating his mosaic and shell garden, Harveydene Gardens, in Hindlip near Worcester in 1921, spent over forty years perfecting the walkways, ponds, fountains and sculptures that made up this extensive garden. He used a combination of broken rejects from the nearby Worcester porcelain works and gifts from friends' seaside holidays; in his own words, 'I'm not above looking for old bottles and crockery in dustbins.'[6] It was clearly an enthralling environment, backed up by the recollections of one visitor writing on a blog about her visit forty years prior:

> Peacocks, butterflies, birds of every colour all illustrated using tinted broken glass from bottles. Thousands upon thousands of sea shells, broken tile and household ceramic. This mosaic of material all set into a bed of mortar to form a forever work of art . . . Arches and walkways, all splendidly patterned and illustrated beyond imagination.[7]

THE LOST WORLDS

This nameless visitor's description, alongside a short film clip by British Pathé from 1962, and an even shorter clip from a 1957 documentary on Worcestershire, offer the only remnants of Sidney's magical environment. He died in 1979 and not long afterwards, the plot was purchased and redeveloped.

In Lancashire, John Thomas Halstead covered his semi-detached house in Rochdale with shells, mosaic shards and oddities he collected from junk shops and skips. The house was called Ebenezer Cottage, but to many it was known as 'the Shell House', and was, like Sidney's garden, destroyed following John's death in 1940. He had previously worked as a newspaper seller and later as a mule overlooker* in a local mill, and on retiring he took to writing poetry and pouring his efforts into decorating the exterior of his home. There is very little remaining evidence of the cottage's existence: a British Pathé film from 1937 and two newspaper clippings, one from the Manchester *Examiner*, dated 30 December 1936, and the other from the *Liverpool Daily Examiner*, dated 27 October 1936, both with an extremely grainy photograph showing the front of John's home. Until recently, I thought these three very short references (the film is just forty-six seconds long) were the only footnote left in a history that rejected John and his extraordinary cottage.

However, there turns out to be a longer article from the *Reynold's Newspaper*, for which a reporter actually visited John at his home and was clearly enthralled: 'Picture it decorated from the ground level to chimney tops with the most amazing collection of objects, ranging from broken pots and plates, teapots, jugs and ornaments, to oyster shells, photo-frames, cows' horns, empty bottles, and a host of other odd knick-knacks, so that not a square inch of the original fabric is

* A mule overlooker was someone who oversaw the spinning mule, a machine used for the spinning of cotton and other fibres.

299

visible.[8] He goes on to mention entering the cottage, which seemingly also housed a wonderful and strange arrangement of objects, a dreamlike world.

Similarly in Ardrossan in Scotland, Netta Holmes, Elizabeth Clark and Rae Harvey set out to create their own shell-decorated home. Netta and Elizabeth, both widows, lived next door to Rae and together they collaborated on turning the outside of their tenement flats into a paradise of shells in elaborate patterns. Having seen Wull's shell garden at Leven, they began transforming their small outdoor space into a haven, with flowers made from mussel shells and swans made from limpet shells, swimming along the steps. They told the local newspaper, 'We'll build a world of our own,' and they certainly achieved just that: it was a feast for the eyes and the imagination.[9] However, in the same way that Mr Halstead's cottage has left almost no trace in the world, the shell-encrusted sanctuary of the three ladies of Ardrossan has disappeared entirely.

This story of the loss and destruction of buildings and folk art worlds is repeated across the country. It is easy to believe that in twenty-first-century Britain buildings are safe from such sorry endings, with a greater level of focus on heritage and the saving of buildings and a wider interest than ever before in folk art, but even in the last five years, model villages in Skegness and Lakeland have closed, and countless others have been vandalised.

Meaderies

An excellent example how to build a folk world is presented in the shape of the Cornish meadery – a form of restaurant experience that is almost unique to Cornwall. They are perhaps not everybody's idea of what constitutes folk, but I place the making of them, and the experience of visiting them, firmly in that category. In the simplest

sense, they are medieval-themed restaurants selling mead, but they are much more than this: deeply nostalgic, they are the preserve of birthday and Christmas parties, anniversary dinners. They are the home of the 'big occasion' and all the memories that sit with that; you would be hard pushed to find someone in Cornwall who has not spent at least one significant occasion in a meadery. Added to this important function of bringing people together, they also offer up a curious mythic backdrop that has usually been entirely 'homemade', with appliquéd banners and hand-painted crests, and fairly often they are in buildings that look like nineteenth-century follies. Generally, meaderies make use of existing spaces and are crafted and decorated to fit the medieval theme rather than being built from scratch, as in the case of a model village. They do, however, share characteristics in their use of cheap and easy to acquire materials, and an ethos of 'make do and mend' in the building style. Nothing is bought especially but rather things are found and utilised to create the desired effect. The meadery also employs a mythical take on history similar to that of the model village – fusing together eras and blurring the edges of reality to create environments that are definitely based more in folk tale than fact. In this fuzzy world of invented history, people, again as in model villages, make memories which become essential parts of their folk histories.

The Cornish Mead Company began in 1960, brewing up batches of mead in a Cornish kitchen. Initially it was marketed as a gift for tourists, playing on Cornwall's rich Neolithic past and mead being the drink of the 'ancients', but its appeal grew widely. In 1964, a local businessman bought up the disused Gaiety Cinema in Newlyn and converted it into a medieval-themed restaurant. Visitors would walk across a drawbridge and enter the restaurant via an arched doorway. Once inside, they would eat with their hands, and slurp Cornish mead to their hearts' content. This was the origin of a cultural experience

THE LOST FOLK

now so ingrained into the history and culture of Cornwall it is hard to believe that there was a time before its existence.

Meaderies spread from Penzance and Hayle right up the coast to Newquay. They have become a vital part of Cornwall's folk history. They are bathed in a warm red glow of light, somewhere between Lady Macbeth's castle and a school disco. There are soft drapes of fabric and banners swinging over your head as you tuck into 'chicken in the rough', a popular dish of fried chicken, and a glass of elderberry- or blackberry-flavoured mead. A soundtrack of eighties and nineties pop serves to further enhance the experience.

The meadery calls to mind medieval pageantry. It tries incredibly hard to impart a sense of history, but the devil is in the detail. As with all revivals, the meadery sits in a place all of its own: part folk culture, part revivalist, part surreal art experiment. Meaderies are a place of memory and folklore. This is the very distant past, made imaginary; the fabric drapes, banners and painted shields and murals have more to do with a 1970s portrayal of the 'medieval' than any genuine, historically accurate depiction of what medieval Britain looked like. Gone are any of the gritty or grim bits of history; they are instead replaced with a romanticised image of some unknown idyllic past in which we all ate with our hands in enormous banqueting halls, drank delicious mead and laughed with our friends.

Here, under the gentle red glow, with Britney blaring from the speakers, as you get back up from your chair to visit the salad bar one last time, here is where true folk culture lies. It is here that memories and traditions have been forged, where place and people are inextricably connected, imbuing each other with meaning. Nostalgia within nostalgia. This is memory as revival, and revival as memory: what is more folk than that?

Much like the souvenir as an object of folk, meaderies are a place that lies between folk and commerce. They were invented to sell

THE LOST WORLDS

mead and draw attention to it as an export of Cornwall. However, they are also great vessels of folk craft, and like model villages, they are gradually being dismantled and bought up by developers to turn into homes or hotels. As a consequence they are fading fast from the folk landscape of Cornwall. There are only very few left in existence and they are constantly under threat. As I write, it has been announced that the Waterside Meadery in Penzance will close due to redevelopment of the harbour it sits on.

Opposite the train station in Penzance are the remnants of a mural that once graced the entrance to Bramwell's Meadery. Once a technicolour scene featuring pirates and portraits of families happily enjoying chicken in the rough, it is now cracked and peeling. The colours have faded and you can just about make out a few eyepatches and mugs of mead. It sits on the entrance to a budget hotel from a well-known brand. In many ways, it's extraordinary that there is any remnant of the building's former life at all. It certainly feels like an accidental rather than a conscious decision to preserve it. St Agnes Meadery, which closed in 2016, was entirely stripped out after closing, and sometime in late 2023 four of the heraldic shields that once graced its bar came up for sale online. Like the Newlyn Meadery it had a long life prior to its days of mead quaffing. Initially built as an Oddfellows Hall,* it became a cinema before being given its medieval makeover. The building in St Agnes is now a wine bar, and most traces of its former life have been erased.†

* The Oddfellows are a friendly society founded in 1730. Their motto is 'making friends, helping people'. Most of their work centres around raising money for charitable causes.

† As of 2024 the wine bar has closed and the former meadery building is once again closed. A very small fragment of its former life can be seen in a window which still has a jester painted on it.

THE LOST FOLK

Although the experience of visiting Excalibur's Meadery in Hayle can no longer be enjoyed due to its closure in 1996, the Hayle Heritage Centre, which opened in 2013 in the former building of the meadery, is now home to a scale model of Excalibur's Meadery: a perfect replica in miniature made by its founder, Terry English. Inside the model, the walls are papered to look like brickwork; there is a knight in armour, shields, and little benches and tables lying in wait for eager punters. The entrance has a minuscule shield with the opening hours on it, and a sign reading 'Excalibur's Meadery', adorned with a sword. It gives a perfect sense, in all its wonkiness, of what it might have been like to step through the arched doors, take a seat and get stuck into an evening of merriment and mead. The model was made by Terry when he was applying for planning permission to open the restaurant with Stephen Elliot in 1988, which was granted that same year. Terry had worked as an armourer and prop maker on a variety of Hollywood blockbusters, and he put his skills to good use creating a mass of medieval props to decorate the interior. It was perhaps the most elaborate design of any meadery in Cornwall, full of theatrics and drama, but also, given its central position on the square, a meeting place for the people of the town. Both Excalibur's Meadery and Terry are deeply ingrained in the memories of the community in Hayle. Each year Terry entered Hayle Carnival, often winning a prize for the best float, and in 1996 he designed and made a full suit of armour for his friend, Colleen Williams, to wear further up the county at Lanner Carnival.[10]

Terry has left his thumbprint on other buildings in the area, too. At the Bird in Hand, a pub just outside of Hayle, is a huge 3-D mural of an industrial mining scene. It is breathtaking in its complexity. There are sections that are lit from behind that convey a feeling that it could come to life at any moment. I first encountered it several years ago, when I 'danced out' with a morris side for the first time. I was

304

very nervous, and don't remember much about the afternoon: I was mainly worrying about trying not to knock any other dancers out with my enthusiastic stick wielding (dyspraxia and morris dancing aren't always a natural combination). However, I do remember being mesmerised by the mural. I later discovered when researching Terry that he was, in fact, solely responsible for it: it reportedly took over a hundred hours to complete and was unveiled in 1992; it has remained there ever since.[11]

In 2023, Hayle Heritage Centre mounted an exhibition with props, photographs and original menus from Excalibur's Meadery, so its memory lives on – not just in the minds of the hundreds of people who frequented it, but physically, too, in the archive.

Although meaderies are unique to Cornwall, there have been similar experiments in incorporating mythology into shopping and dining experiences elsewhere in the West Country. On the edge of Dartmoor lies the small village of Sourton. It is an unassuming place, except for the presence of the Highwayman Inn: a coaching inn with a difference. The back of the inn is shaped like a huge black boot, which has a doorway into the pub. The front door of the pub is made from an old coach and in the car park is a Wendy house, with lattice windows and doors made from enormous barrels. Across the road is a house that looks like it was taken straight from a fairy tale, with an undulating, deliberately wonky roof and ornate white ironwork gates. I felt sure on walking past it that it must be related in some way to the fantastical inn opposite. And indeed, it turns out both were the work of entrepreneur and athlete John Edward Jones, known as 'Buster', who moved to the village in 1959 with his wife Rita. They were both fascinated by the ghost tales of headless horsemen and roundheads and cavaliers that teemed from the surrounding moorlands. On receiving the keys to the inn they began to convert it into a suitably themed space, weaving local stories and hauntings into the fabric of

THE LOST FOLK

the building. Over the years came the addition of the Wendy house for children to play in while their parents sipped pints, and in 1978, the couple purchased the old village hall across the road, which they gradually converted into the fantastical Cobweb Hall – the house that I had spotted and wondered about. Nikolaus Pevsner even mentions it in his entry on Sourton in his guide to Devon, describing it as 'a Disneyland cottage ornée'.[12] With local stone, moorland bog oak and pieces of shipwrecks, Buster and Rita crafted a world in which illusion and fantasy reigned. Guests were invited to step into this wonderous place and revel in tales of hauntings and spectral beings, while enjoying fare not dissimilar to that of a meadery. Thankfully both the pub and Cobweb Hall are still open to visitors today and are now run by Buster and Rita's daughter Sally and her husband Bruce, who have retained Buster and Rita's sense of magic and wonder; on a misty day, if you squint, I'm fairly sure you may still encounter an entity from the other side.

Urban folk worlds

It would be easy to think, given the exploration of the pastoral idyll in many folk art worlds, that experiments in folk building existed only in rural landscapes, and only represented the bucolic. But they are also found widely in city spaces. In fact, urban environments, for me, offer up some of the most exciting explorations of folk building that I have discovered: people really fighting against the grain and working to create something extraordinary in contexts that are not always supportive of maverick working or living interventions. Urban folk worlds are, however, in constant danger of being dismantled. In a world where commerce is king, they must prove their worth against new housing developments and councils who don't necessarily always see the value in something that exists just for the pure joy

306

THE LOST WORLDS

of it. Thankfully people often, rightly, feel very strongly about urban folk worlds, and there are many examples of people banding together to save places from destruction.

Folk is often found in unexpected places. On the back streets of the city of Plymouth is a fantastical world: Southside Street is home to 'the House that Jack Built', a shopping arcade-cum-portal to another realm. Walk through the arch and you will find yourself surrounded by gnomes atop toadstools, plastic vines trailing around pillars and water cascading down fibreglass stones. It is a kingdom of myth and legend in the middle of an arcade in a city that is largely devoted to shopping malls and commerce. This mythical world of gnomes and dragons was conceived and made by Jack Nash, whose family had run a fruit and vegetable business in the same building since 1905. Jack spent many holidays in Cornwall and was deeply inspired by the architecture and quirkiness of the land, in particular the Sloop Arcade in St Ives, so he decided to set to work on his own arcade in Plymouth. He wanted to take visitors on a journey far, far away from the streets outside, to somewhere strange and magical. Jack opened the finished arcade in 1982, and it has been thrilling visitors who take a trip through it ever since. The arcade shops, with their bay windows and white plastered walls, look like they have been plucked straight from the narrow alleyways of St Ives or Polperro, and the brightly coloured scenes featuring mythic creatures feel as if they have been pulled from some long-lost Arthurian tale. It is a transportive space; the visitor enters via one arch on an unassuming street, passes through a magical landscape and then exits onto the Barbican, which overlooks the water.

There is more hope elsewhere for these folk lands of modern mythos set in urban landscapes. Ron's Place, a remarkable terraced house in Birkenhead, is the work of musician and folk artist Ron Gittins. At first glance Ron's home looks like nothing more than an

ordinary house, but on stepping through its door a mythical world unveils itself. Ron worked mostly in secret, painting the entirety of his rented flat with large-scale figurative murals. He built a fireplace in the shape of a lion's jaw and made numerous sculptures that sat on chairs and shelves. This was a utopian environment like no other: Ron made himself an alternative world to live in, filled with Roman goddesses, temples and mythological creatures. On his death in 2019, his family opened the door to discover this classically inspired paradise and felt it needed to be preserved, but struggled to find the money to keep it. The house was put up for sale by the landlord in 2023 and Ron's creation was very nearly lost. A huge campaign to 'Save Ron's Place' was launched by Jan Williams (Ron's niece) and Chris Teasdale of the Caravan Gallery, and thankfully it was saved at the very last minute. An advisory board, Wirral Arts and Culture Community Land Trust, was formed solely to look after Ron's Place, and the interior will now be restored to inspire generations to come.

Another unlikely location for a fictional folkloric land lies along the canalside in North London, in a garden filled with concrete sculptures of historical figures from Oliver Cromwell to Anne Boleyn. There are hundreds of them: hundreds of beady eyes staring out at people cycling, boating and walking along the towpath. There are jewels set into their concrete clothes, and the walls behind are mosaiced with tiles and oddments. Each figure has gloopy paint washed onto its eyes, mouth and hair, and its name scratched into the base. They are the work of Gerard Dalton, known to everyone as Gerry, an Irishman who settled in London in the 1970s. He spent decades turning his council flat, its garden and a derelict piece of land by the canal into a memorial to every person and building he felt needed recording. It was described by a former director of the Royal Academy of Arts as 'a folk version of the National Portrait Gallery'.[13]

THE LOST WORLDS

'They'll be astonished by what they find in my garden in years to come. It'll be like Pompeii or something, Gerry's Pompeii.'[14] Gerry knew that he had created something important, and he was rightly incredibly proud of his world. There is no doubt that the environment he crafted is a miraculous one, a pocket of wonder in an otherwise fairly grey housing estate. It added colour to the everyday, making people stop to look as they walked their dogs or trundled to work. Little did they know the interior was also a vehicle for Gerry's creativity, filled with his replicas of well-known buildings such as Buckingham Palace, Hampton Court Palace and St Paul's Cathedral, made in the colder winter months when he couldn't be outside mixing cement and painting.

In 2019, Gerry sadly passed away, and like Ron's Place, Gerry's Pompeii for a time faced an uncertain future. The sculptures were at risk of being moved, the garden dismantled and the interior destroyed. Thankfully, the world had taken note of Gerry's work. A campaign was forged, and people from far and wide came out in support. Jarvis Cocker and Stephen Fry voiced their love for the garden and stressed the importance of keeping Gerry's world alive. Thousands of pounds were donated and an organisation was set up: Gerry's Pompeii CIO,* with the aim of preserving his works in situ, and creating public access to the garden in years to come.

Another example of an urban folk art building sits on the corner of a street in Brockley, South-East London. It is a Victorian semi-detached house. The external walls, once brightly painted in elaborate patterns, are peeling, flaking and faded; the garden, previously a sea of hollyhocks, geraniums, roses and red valerian, is now bare, and the formerly cherry-red steps leading up to the front door have discoloured to pink. In 2017, its owner and creator Brenton Samuel Pink,

* Charitable incorporated organisation.

309

THE LOST FOLK

known as Mr Pink, died, and it has subsequently become a glimmer of its former self. If you had visited just a few years prior to this, you would have found a world of colour and vibrancy that would have made even the most distracted passer-by stop and look. Brenton created a life-filled fortress, a world in which he was able to express himself fully within the confines of the monotone city.

Brenton was born in Jamaica in 1925, and came to England as part of the Windrush generation in 1957. He worked for Lewisham Council as a street cleaner, and in his spare time set about turning his home into a small piece of Jamaica in England: 'My additions make a difference, brighten it up. I've created a part of Jamaica here. Some like this house and some may not like it, I don't know. But I know a lot of people like it and I like it myself.'[15]

Using cans of household paint and ready-mix plaster, Brenton painted the exterior and interior of his home in vibrant reds, pinks, mustard yellows and blues. He painted stripes on the walls, and further enhanced these with 3-D decorative lattice patterns using plaster and white paint. Here was something simultaneously both intensely Jamaican and intensely English. Bouquets of dried flowers were hung from the ceiling alongside bursts of dazzling pink and silver Christmas tinsel. His mantelpiece was filled with candles, ornaments and photographs of family in Jamaica. In this space, memories from two homes were combined: Jamaica and England.

In 1996, the filmmaker Helena Appio made an extraordinary fifteen-minute film about Brenton entitled *A Portrait of Mr Pink*. It is extraordinary in the sense that, like the British Pathé film about Sidney Dowdeswell, it is one of the last remaining pieces of evidence we have showing Brenton's life and home in its original state. In the film, Helena records Brenton sitting in an English garden, wearing a wide-brimmed hat he has adorned with flowers and foliage. Behind him are blue-and-red-striped columns. Brenton's hat looks

310

reminiscent of a morris dancer's May morning kit. This could be Jamaica or England. There are the roses and delphiniums of an English garden, and there is the adornment and use of colour of the houses he remembered in Jamaica. 'I love plants and since I also cultivate in Jamaica, when I come here, I couldn't get to plant what I used to there: coffee and chocolate. So, these flowers remind me of the plantation we do in Jamaica.'[16]

It is without doubt a tragedy that Brenton Pink's once-vivid home has been left to crumble. However, thankfully a different story can be told of 575 Wandsworth Road, which is less than an hour's walk west from Brockley. Behind the doors of this unassuming Victorian town-house lies a work of masterful craftsmanship now under the careful custodianship of the National Trust. For twenty-five years, from 1981 to 2006, Khadambi Asalache, a Kenyan poet and civil servant, decorated the walls of his home with intricately cut fretwork; using old pallets and doors, he created something more akin to the interior of a temple or place of worship than a home.

> Khadambi . . . first started to carve pine fretwork in order to mask the 'dreadful damp problem', as [his partner Susie] Thomson puts it, in his own south London house. 'He found floorboards to use as panelling, but they looked heavy. So he did a bit of fretwork and placed it on top of the boards,' Thomson says.[17]

What is perhaps most remarkable is that Khadambi only used a Stanley knife to cut his delicate and complex patterns. Not only did he decorate the walls with his wooden fretwork, but he also painted the wooden floorboards with shapes taken straight from tiles and rugs, and the ceilings became canvases for his trelliswork, too.

It could perhaps be argued that because Khadambi studied architecture he was not truly a folk artist in the same way as Brenton Pink

THE LOST FOLK

or Sidney Dowdeswell, but I would argue that, like Charles Paget Wade, he was creating a world to inhabit, a place and space far and away from his daily reality as a civil servant in the Treasury. Here, behind the front door of 575 Wandsworth Road, he created a paradise that transported anyone inside this otherwise ordinary building on an ordinary city road to the interior of the Alhambra in Granada or the Hagia Sophia in Istanbul. Like Brenton Pink, Khadambi played with what home meant. Combining references to his motherland, Kenya, with a very British taste for lustreware jugs and mugs that line the mantelpieces of country cottages across England and Wales, he made something that transcends borders and boundaries; it is a place of cultural exchange.

Urban folk worlds so often rely, like model villages, on their creators to keep them afloat. But unlike the other forms of municipal folklore that I've covered here, councils are rarely engaged in keeping them going, and in fact have often been at pains to discourage the creation of urban folk. There are, however, other forms of folk intervention in the urban built environment that are encouraged, and at times instigated by councils. The community mosaic or mural might not be the first place your mind goes to when thinking about built environments or folk. However, in my mind these are a form of municipal folk art in relation to buildings. They perform, in a similar way to graffiti, a function in allowing people a voice in their towns. Although they are certainly less anti-authoritarian and definitely more planned than graffiti, they do create space in which to celebrate the special aspects of a place, the intangible essence of a community and what matters to it. In Bampton, Oxfordshire, there is a mosaic designed in 2000 by Rosalind Wates and Alec Peeve featuring two morris dancers from Bampton Morris, a horse to represent the (now defunct) Bampton Horse Fair and two trees, recognising the derivation of the town's name from *beam*, the Saxon word for tree. As with many community

THE LOST WORLDS

mosaics, Rosalind and Alec worked with local schoolchildren to bring together the design, and to find the elements that intrinsically made Bampton Bampton. A similar project in Marske-by-the-Sea begun by Helen Jane Gaunt and Derek Mosey brought together, in a series of mosaiced scenes, buildings from the town with a maypole, a scarecrow and Winkies Castle Folk Museum. Again, the local schools were involved in developing the images, and in drawing out the details that were inherently connected to the town. Since the millennium there have been hundreds of other mosaics created in towns across Britain, each featuring unique aspects of a place's history and population, and each celebrating what local people think makes it feel like home: there are morris dancers in Liverpool outside the football stadium, a maypole in Longford Park in Manchester, May dancers in Skelton in North Yorkshire and a bonfire in Salisbury in Wiltshire.

In South Queensferry, Scotland, a mosaic unveiled in 2019 shows the Burryman processing through the town, and in the background there is the gala queen sitting on her throne surrounded by an archway of flowers, a handbell ringer and a man playing the bagpipes. It was made by the hands of more than seventy volunteers from the town, and in a few panels, it encompasses the history and folk culture of South Queensferry in an easily readable and colourful way, which for visitors and residents is much more inspiring and durable than some panels of text that gradually weather over time and become unreadable. Offering an injection of colour into the parks and forgotten alleyways of Britain, community mosaics could, and I hope will, come to be considered as pieces of folk art in years to come. They are made by communities for communities – true expressions of people and place. If we look to ancient Rome, many of the finer or more nuanced details of Roman culture that we now know of come from the incredibly well-preserved mosaics that have been uncovered.

THE LOST FOLK

There is a long-lasting quality to mosaics that means that, unlike many folk art buildings, they will outlive us. Through the community mosaic we are making something that will endure and speak our voice for generations to come, and ensure that our folk customs are in some way preserved.

Ephemeral buildings

The ephemerality of all the spaces I've written about in this chapter is perhaps one of their most defining features. They are labours of love for their creators, and when the creator dies or moves away, they usually face redevelopment or destruction. But what of those buildings or spaces that are made with impermanence at their core? A prime example of this, a blink-and-you'll-miss-it piece of folk art, is the sandcastle.

Building a sandcastle has long been a beloved activity of children across the world when visiting the seaside. From great turreted towers to sandy drawbridges and windows made from scavenged pebbles, the features of the sandcastle offer up endless opportunities for anyone with an imagination: some sand, water and a few minutes to create a mythical world. They are folk art on the most ephemeral scale; within a few short hours, they are washed into the sea and forgotten forever.

On Weymouth beach in Dorset, self-proclaimed sand architect Jack 'Skivvy' Hayward took building with sand to new heights. He became famous in the 1940s and 1950s for his enormous renditions of English cathedrals, all made from just sand and water. He left a pot by the base to collect money; he was a 'professional' sandcastle builder. Even more remarkable was that Jack was partially sighted and created his architectural wonders using a kitchen knife. In just a few short days he would bring to life Salisbury Cathedral

314

THE LOST WORLDS

or Westminster Abbey, slicing and cutting the sand into elaborate architectural forms.

Jack was by no means the only person carving sand; for many summers, Weymouth beach was also home to the work of one Fred Darrington, another full-time sandcastle builder. Although Fred did dabble in sand buildings, his most famous work was a rendition of Leonardo da Vinci's *The Last Supper* in sand. In the summer of 1975, Fred worked on a series of sand scenes inspired by nursey rhymes. During this season, he created his interpretation of the rhyme 'There was an old woman who lived in a shoe', sculpting a large boot with an old woman poking her head out of a sand window. He also made a sandy Humpty-Dumpty and Jack and Jill tumbling down a sand hill. In an episode of the BBC news show *Nationwide* from August 1975, Fred is interviewed while working on a scene. The interviewer asks how long he has been at it, to which Fred replies, 'At the moment this is about the eighth day... It's a long time, eight days. Especially when you're down on your knees all that time.'[18]

There is something truly astonishing about spending several days on a project that will soon either dissolve into the ocean or disintegrate in the rain. Although Fred died in 2002, his grandson Mark Anderson continues the tradition on the same patch where Fred spent nearly eight decades making his fleeting sand tableaux – representing a time-honoured tradition of folk crafts being passed from generation to generation within a family.

The sandcastle fades quickly, washed away in a few quick licks of the ocean, meaning that like model villages and shell gardens it generally lives on only in people's memories of a fun day out. As with other folk buildings such as the meadery, the sandcastle becomes a marker of human experience – a symbol of folk memory.

Although the sandcastle might seem like the most ephemeral building process in Britain, in Wales there exists an even more

315

THE LOST FOLK

temporary form of folk building; the tradition of building a one-night house or *tŷ unnos*. The tradition evolved around the enclosure of previously open plots of land in the seventeenth century. This, combined with land taxes and rising levels of poverty among the working classes, meant previously itinerant workers were looking for a means of continuing their previous way of life. In response a folk belief rose up that if a person could erect a house with a roof in a night on a piece of common land and be living in it by the next morning then it became their own: a dusk-to-dawn building project. Although there is little legal basis for this belief, the practice continued well into the nineteenth century and was seldom disputed. The buildings were generally made from materials that were to hand, such as hedgerow stones and turf, and they were built so quickly that little thought was given to normal principles of construction – they were thrown up as quickly as possible in the darkness of night so no one would notice. Sometimes they would have roughly thatched roofs, but for the most part very little is known about what they looked like.

In the depths of Snowdonia just outside the village of Betws-y-Coed is Tŷ Hyll, or the Ugly House. It is often considered to be the last remaining example of an intact *tŷ unnos* in Wales: there are tales of it being constructed by 'two bandit brothers in 1475'.[19] In fact, it is more likely a romanticised Victorian reconstruction of what an overnight house might have looked like. It is marked on the first Ordnance Survey map for Bangor and Holyhead, published in 1841, but there are very few earlier accounts of it. Its four walls are constructed from enormous slabs of stone placed in a higgledy-piggledy fashion, which suggests a quick, haphazard build but in fact probably took much deliberation to create the effect of 'randomness'. What is certain is that it has become a major attraction for people passing along the road beside it. Nowadays it serves as a tearoom where you

THE LOST WORLDS

can pause for a few moments and admire the picturesque landscape over a slice of cake and a cup of tea.

Other instances of *tŷ unnos*, be they romantic reconstructions or the real deal, are incredibly rare. There are a few ruined cottages dotted about Wales that are believed to be genuine overnight houses, and in the 1970s a woman called Ivy Rees constructed a minature version for her two daughters in her garden at Portskewett. She was inspired by a trip to North Wales and the Ugly House, and on returning home decided to construct her own simply because, in her own words, 'she loves making things'.[20] Although Ivy's project is again an example of a romantic notion of a *tŷ unnos*, it shows that this folk belief has long captured people's imagination in Wales; as a way of creating a home in a short space of time from materials that are of the landscape, perhaps it offers people a sense of an old way of life without the complications of modernity. Although the actual structures were fleeting, the idea of the *tŷ unnos* is what has captured people more than anything. Like the model village or meadery, they conjure a world in which things were simpler and people lived on the land. It doesn't matter that, for the most part, they can't be visited, because as a principle this type of house has entered the folk memory of Wales. The transient building. The notion that if you needed to, you could build yourself a home. A cheering thought in a turbulent world.

Perhaps, then, evanescence is the magic of all these buildings and experiences. Perhaps without the sense of transience they would lose their sense of wonder or become in some way mundane. Their liminality is their power. These are not spaces to live in, these are the spaces of fantasy.

These lost worlds are deserving of being saved, not only for the craftmanship they display, but also for the vitally important place they hold in our discussions and interpretations of history and how we teach it. Myth, legend, folklore and the ordinary coalesce in these

THE LOST FOLK

environments: an essential principle in any exploration of history. History is not, and never should be, considered linear, and these small worlds allow non-linear time to be explored in a practical way. Scale, time and reality are dissolved into worlds in which division and history are softened. Through these worlds, engineers, accountants, policemen and hoteliers have created extraordinary spaces that allow people to explore the lines between myth and reality, re-creating the Arthurian myths and the castles of Britain and placing them in conjunction with greengrocers and libraries, and palaces next to cottages. And this a true folk landscape – one in which both the commonplace and the remarkable can exist in unison. Through their experiments in creating folk worlds, people have made buildings accessible to all and in doing so have created spaces in which we can dream and in which we can expand what history means and whom it is for.

The buildings and environments I've explored all de-emphasise the ego or self, and therefore can all be considered genuinely folk environments. They are places that were created to bring something joyous to the everyday, whether to their creator or, as in the case of model villages, to people on a day out. In my eyes this is above all else what makes these buildings, worlds, environments and gardens truly folk. They are all small pockets of wonder in an often grey and unforgiving world, and they are all deserving of our attention. As Brenton Pink eloquently expresses it in Helen Appio's film: 'Myself, the house here, my voice and everything is a rainbow.'[21] A rainbow for everyone to enjoy.

★ Conclusion: ★
From Lost to Found Folk

The social historian and illustrator Dorothy Hartley once said, 'If everything I possessed, vanished, suddenly, I'd be sorry. But I value things unpossessed. The wind, and trees, and sky and kind thoughts, much more.'[1] I could not agree more; this quote has become something of a personal mantra. In our current age of material possession and ego, we are all too keen to want to lock objects or ideas down – to make them belong to someone or something. Quite often, with folk objects, customs or stories, this is simply not possible. Their very nature is to be inexplicable, something that *just is*, made or created by someone who is often known only to the people of their village or town. If I have learnt anything from researching and writing *The Lost Folk*, it is that folk as an entity is unknowable: it is unpossessable, nebulous and constantly evolving.

The evolution of folk means that there are constantly new practices or objects that fall under its banner. Humans are extraordinary in their ability to be creative and invent new traditions, new ways of coping in times of unrest or turbulence. In this sense, folk customs and practices become even more important. Folk gives people a voice within society and for positive change. Engaging with folk could potentially feel difficult if you are living in an urban space, given that there has, in the past, been a tendency to think of folk as something that exists only in the countryside. However, you do not need to be living in a rural idyll to find folk. Cities and urban landscapes are brimming with it: examples of municipal folklore

THE LOST FOLK

and experiments in urban folk appear in everything from flowerbed displays to pageants, and more recently in community mosaics and murals. Collectively they all give a sense that folk is everywhere and can be found even in the most unlikely of locations – be that at a railway station or at your local park.

The perception that folk practice can only be found or performed in rural spaces is incorrect. It is not always easy to find and it sometimes requires further research to properly understand and engage with it – as was the case with Gerry's Pompeii or Brenton Pink's house – but it is there; you just have to go in search of it. It might be something you pass every day without questioning its presence – perhaps it's the house that you see on the way to work that is painted a different colour from the others in the street, or that pub sign that you look at each time you walk to the train station. Folk truly is everywhere; you just have to recognise it as being folk.

How, then, do you do this? Well, hopefully the pages of *The Lost Folk* have offered you some scope for discovering the folk practices in your own town, village or city. The key really is to be open and awake to the world. Get out into the air. Talk to people, but most importantly listen, because probably the most important lesson I can impart as a collector of folk is that listening is the key. In the past folk collectors have tended to swoop in, get their material and leave. This is not folk collection of today but a practice that is outdated and colonial in its approach. In order to understand what folk means, you must engage with a place and its people; you must take an interest beyond, as I discussed earlier, 'folk tourism', and properly get to the heart of a community.

Place is so often the reason something becomes considered as 'folk'. Think of a custom you remember from childhood . . . I imagine that it happened in either your hometown or a village local to where you grew up. It happened at 'home', and herein you have a large part

CONCLUSION

of what makes folk folk. It is something that connects us to a sense of our ancestors – whether those related to us by blood or more of an instinctual feeling of the people who came before. What, though, makes a place feel like home, and therefore something 'folk'? It is a tricky question to answer, and it is very often contained in aspects that are hard to define or put into words. They can be small and seemingly insignificant details, as Dorothy suggests, like wind, or trees – a sense or a feeling of something being home or belonging somewhere. It can be in the scarecrow that you see on the brow of the hill each time you pass a certain field, or the spire of the church that greets you as you cross the road, or in the jangle of the bells of the morris side that dances outside the pub each May Day. Perhaps it is the smell of the hay being cut, the call of 'the glove is up' or the sound of a thousand pennies being scattered across the tarmac ready for hundreds of hands to pick up.

It is different for every town, for every person, and it moves across time. Sometimes a custom from a hundred years ago can be more of a place than a building erected twenty years ago, and yet for someone else, that custom could mean nothing because they have just arrived and their sense of home or place is entirely different. There are plenty of customs that have been introduced in very recent times that are full of meaning and sense of place for the people who enact them. This is why community-led projects such as mosaics or murals are so important in capturing the elements of a particular place. Like oral histories, they offer a way of people sharing what is important to them, why they choose to live in a place and what parts they'd like to preserve for future generations to admire. Yet the folk world has been slow to consider these projects as a form of folk collection, and although they now decorate towns across Britain, they have not yet been recorded in any proper form.

THE LOST FOLK

A similar problem faced the church kneeler until I began the Church Kneeler Archive in 2022. Prior to this, church kneelers had only been recorded in a very localised way by the communities who had made them, largely in pamphlets or booklets sold in churches. Although it is a near-impossible task to record them all alone, given the many hundreds that are dotted around Britain, my hope was that other people would become inspired to go out and record them, and gradually through a collective effort the archive would expand – and it has. People from across Britain now send me their photographs of kneelers, and the archive is constantly growing. I have also heard from people who have begun making their own kneelers, contributing to community projects at churches and village halls. This is the power of shining a light on folk objects: not only is the history recorded but the tradition also continues. This is why it is important for us all to take up the baton of collecting. Textiles have often, as in the example of church kneelers, not been met with the same level of interest as other folk objects. Often, when I visit a church to record the kneelers, I get the feeling that I have arrived just in time, as I pick up a kneeler from the ground and several moths fly out from inside its stuffing, leaving a patchwork of holes behind. Sometimes I have found them covered in snail slime trails, or festooned with cobwebs. Sometimes there are piles of them soaking up water from leaking roofs, a deep, dank smell emanating from around them. The truth is that there is still a hierarchy within folk collection of what does and doesn't matter, of who and where should be remembered, and textiles have, until relatively recently, fallen firmly into the category of 'stuff to put in the corner and forget about' – quite literally, in the case of kneelers, their only saving grace being that they are spongey enough to be utilised in the mopping up of drips and damp. We must all work to address this, to open our eyes to what is folk, and to where we might find it – because it is not always where we might expect.

322

CONCLUSION

When we speak the word 'folk', it is likely we have a particular idea in our minds of what this means. Perhaps it is something old, something slightly faded, something 'traditional'. The lens of time is a great softener and older objects or customs generally enter the canon just by virtue of looking 'old' or feeling as if they have 'always happened'. As I discussed in the chapter on Lost People, judgement can often come into folk collection: there is a perceived sense of 'I know what folk looks like', or indeed 'That isn't folk enough'. Without meaning to, we can have preconceived notions of the validity of certain folk practices or objects – for instance, certain objects can be considered too modern or not blessed with the mark of the hand (i.e. they've been made by a machine), and certain customs can be ignored because they don't conform to certain archetypes that we feel offer legitimacy to true folk customs – age being the predominant marker for authenticity, alongside provenance and whether something has been passed down via a certain family lineage, the aesthetics of said custom and whether it conforms to what we consider it should look like, and the community it has come out of and whether they are seen as suitable for consideration as part of 'British folk culture'. As time passes, folk becomes more ancient, by which I mean that as a custom becomes more ingrained in the make-up of a place, it becomes harder to say definitively when or why it began. Its history becomes more fluid and so in the eyes of a community it becomes more authentic because its origins are forgotten. It doesn't matter that this might have happened in just a few short generations.

This has typically presented a problem for communities that have arrived from overseas and begun folk customs in Britain, as exemplified in the ways in which Lunar New Year and Caribbean carnival customs have struggled to be included in conversations about British folk practice. Although these communities have been

323

THE LOST FOLK

'allowed' by councils to engage in their customs, they have generally sat outside the traditional British folk year of May Day and bonfires, and have been pushed physically to the periphery, often taking place in car parks and out-of-town recreational fields. Hopefully the tides are starting to turn, meaning that the inclusion of perceived 'outside' communities and people in customs within the approved canon of British folk has slowly begun, with well dressing ceremonies celebrating the arrival of the Windrush generation, and the Morris Ring electing to allow women to dance within mixed sides.

We must all work towards picturing what a folk map of Britain in the twenty-first century could and should look like, and put this into action, remembering that any perceived authenticity in folk is generally a fabrication, and that while this in and of itself is fine, it should not be used as a device of one-upmanship against more newly arrived communities and customs.

It is important to consider why customs from some communities have not been recorded. There are folk practices that are quiet, private ceremonies, traditions that do not need many eyes or ears to acknowledge them, and in the age of spectacle we must remember this. Just because somebody's folk practice does not involve them taking to the streets does not mean it is not of value, but it *does* mean that it is potentially more difficult to record. I am thinking of ceremonies such as the Serbian Orthodox celebration of *Slava*, where annual thanks are given to a family's particular patron saint, and a feast is prepared, including elaborately decorated breads and a priest who blesses the home with holy water. The event is quiet and without any need of a crowd. There is much work still to be done on the recording of customs that happen within the home or behind closed doors, and in speaking to communities who potentially have barriers in enacting their customs – be this because of language, the unavailability of space, economic reasons or indeed privacy being

324

CONCLUSION

at the heart of a custom's meaning.* Although, as I have described, ego has entered the folk world in recent years through the use of social media, there is still space for folk practice that is not driven in this way, and I would argue that this is the more authentic version. Folk should not be about how many 'likes' something has gained on social media or about how many people flock to watch the custom. It should be about the community and the coming together of people.

We must work collectively to gather up the fragments to find the folk traditions that are slipping through the gaps, and the customs and objects that accompany them. We must search out the photographs, track down the signs, record the sounds and immerse ourselves in the folk of Britain, because without us all to care for it and care which bits make it through into the history books, it will become homogeneous and without any real meaning of what it means to live in Britain today. We must discard notions of what we think folk is and get out there and discover what it *actually* is. We must look to everyone who lives across Britain and discover what 'folk' means to them. We must find the communities of today and ask, 'What is it that makes you feel alive?', because folk at its heart is a celebration of all that encompasses life – from birth to death.

My hope for the coming years is that we can find a way to evolve the traditions of towns and villages across Britain to encompass everyone. That we can build a world of folk that is not exclusionary – where we hear and see everybody, one in which folk is not just the preserve of one community in a particular town. In a truly inclusive,

* In October 2024 it was announced that UKRI Arts & Humanities Research Council would fund The National Folklore Survey, a new project led by Dr David Clarke and Dr Diane Rodgers from the Centre for Contemporary Legend at Sheffield Hallam University, and Dr Ceri Houlbrook and Professor Owen Davies founders of the MA Folklore Studies at the University of Hertfordshire, with the aim of capturing a multicultural picture of folklore in England.

THE LOST FOLK

modern Britain we will work together to make sure all folk are heard, all folk are included and all folk are able to perform their customs in a way that does not make anyone feel in the minority but rather that their customs are performed in the celebratory and joyous way that they should be – whether in public or in private.

We must not forget that in the capturing of folk, the harnessing of the unpossessable, there will always be an inherent problem of the intrinsic magic being partially lost. In nailing it down and boxing it up, some of the effervescence and the spontaneity will dissipate, and that is why beyond anything else I implore you to search out your own local customs and get involved in them. Learn to morris dance, take part in a carnival or join a kneeler stitching group. Engaging in folk practice, be that through wassailing or joining bonfire societies, is the only way to truly understand its essential meaning, the sparkle and pure joy it can produce and the sense of being part of a collective history that such a ritual confers.

I have frequently been asked during this current revival in folk whether I think the enthusiasm of people for folk will wane. Will people not grow tired and move onto the next thing? My answer is always that people will only grow tired of folk when they grow tired of being alive. Customs, traditions and all the bits in between are part of being human. The ways in which they are made manifest can be different: sometimes it's through a shell garden, other times it's in a parade through the streets and often it's in the annual fair day that takes over a town. At the centre of it all, though, is a desire to make a mark and be heard: a chance to sing, to dance and to make merry. To celebrate a wassail, or make a mosaic, or learn a clog dance or see in May is to be alive. It is a point of connection to our ancestors, but it is also a chance to connect to the future, and to be hopeful about that future. Celebrating the coming of spring, or the ebbing of winter, is a way in which we can say, 'It's OK, another season will come, and

CONCLUSION

another, and another,' and what is more hopeful than that? Folk allows us to put the colour into the grey days, and makes us feel that brighter moments are coming.

As long as we inhabit the Earth, humanity will find some sort of way of marking our days, our seasons and our holidays, because it is the way in which we mark time, the way in which we collect together and the way in which we express ourselves. In unsettled times, this becomes more essential than ever. Hence rather than people's interest waning, I think it will increase, because to be interested in and engaged in a folk practice is to find belonging, and this is paramount in a world where we face a changing climate, ecological unrest, and many of us experience political division and economic deprivation.

In an unsettled world, to engage in folk customs is a radical act. It is a message that we have not given up, that we will continue to dream, and that we believe there is something better ahead, something worthy of celebration. To continue to don a costume, to dance, to plait a corn dolly and collect together is to believe that the world is alive. It is a recognition that through coming together we are a force for change, we are the folk and we will not be lost, because wherever there are people there is community, and wherever there is community there is folk.

✶ Acknowledgements ✶

Thanks to Matthew Shaw, the love of my life and my constant champion, my remarkable and multi-talented mum Penny MacBeth, my brother George MacBeth, my editor Hannah Knowles and everyone at Faber for believing in me and my ability to write a book (as a dyslexic this means more than anything), and my agent Becky Thomas. Thanks also to Jane Thorniley-Walker, Sue Hill, Corella Hughes, Marcus Williamson, Diva Harris, Bill Drummond, Jeff Barrett, Feargal Lynn, Zippy Kearney, Desdemona McCannon and all the Ashridgians, Marion Elliott, the WAD, Alex Merry, Angeline Morrison, Lucy Wright, Anna F. C. Smith, Daisy Culmer at Hayle Heritage Centre, Judith Edgar at Nottingham City Museums and Galleries, Churches in Churches, Lesley Akeroyd at the Norris Museum, Chris at the Admiral Benbow, Simon Costin, Scott Johnson, Liam Hoskins, Mark Norman, Ruth Guilding, Grace Redpath, Simon Reed, Rupert White, Ian Kerr, Nona at the Fishermen's Museum, everyone who follows the Folk Archive and has me sent me invaluable contributions along the way, and to the cafés and waiting rooms of Bournemouth Hospital and to all the nurses of Ward F11 at Southampton University Hospital where I wrote an extraordinary amount of *The Lost Folk*, and to all the staff at Situ Cafe, my favourite neighbourhood haunt.

Thank you most of all, though, to all the Lost Folk who I have included in the pages of this book, without whom the world would be a far less fascinating, fun and exciting place.

✴ **Notes** ✴

Introduction

1 C. Sharp, *English Folk Songs, Some Conclusions* (London, 1907), p. 3.
2 C. Wade Paget (1883–1956), *Coat of Arms*, oil on wood, Snowshill Manor and Garden, Gloucestershire, NT 1336237.
3 I. F. Grant, *The Making of Am Fasgadh: An Account of the Origins of the Highland Folk Museum by Its Founder* (Edinburgh, 2007).
4 https://historicalpageants.ac.uk/pageants/1194 [accessed 10.1.2023].
5 E. Lloyd, 'How the County Celebrated the 300th [*sic*] Centenary of Comus', *Shropshire Magazine*, June 1984, p. 19.

1. The Lost People

1 Cecil Sharp, note to Ralph Vaughan Williams, before June 1924, British Library, Letter No. VWL790. https://vaughanwilliamsfoundation.org/letter/note-from-cecil-sharp-to-ralph-vaughan-williams [accessed 19.8.2024].
2 Cecil Sharp to Mary Neal, 14 March 1909, Sharp Correspondence, Box 5, Folder A, Vaughan Williams Memorial Library.
3 Espérance programme, 5 January 1909, Carey Collection, Vaughan Williams Memorial Library.
4 R. Rosewell, 'In Praise of . . . Florence Elsie (Matley) Moore, FSA (1900–1985)', *Vidimus*, no. 72 (September 2013). https://www.vidimus.org/issues/issue-72/feature [accessed 10.8.2023].
5 Quoted ibid.
6 Her correspondence with Walter Godfrey suggests she was unimpressed by the idea of photographs being used instead of drawings, and that people should be paid to illustrate alongside photographers: 'Why will you pay for photographs and not drawings?' See ibid.
7 Unfortunately, this is perhaps a case of wrong time and place, because in 1939 Kenneth Clark came up with a scheme for a series of artists, including Barbara Jones, to record places in Britain that were considered to be of national importance. It was funded by the Pilgrim Trust, and published as a series of

volumes titled *Recording Britain*; in 1941 a further photographic project entitled the National Building Record was funded by the Pilgrim Trust.

8 K. Lee, 'I've got two special photos of Elsie', *Worcester Evening News*, 25 November 2010, https://www.worcesternews.co.uk/news/letters/read/8688593. ive-got-two-special-photos-of-elsie [accessed 10.8.2023].

9 W. Chappell, *Popular Music of the Olden Time* (London, 1859), p. 446.

10 D. Hartley, *Made in England* (London, 1939), p. ix.

11 M. F. Shaw, *From the Alleghenies to the Hebrides: An Autobiography* (Edinburgh, 1993), pp. 85–6.

12 Ibid., p. 86.

13 T. Brown, 'Obituary: Ruth Lyndon Tongue (1898–1981)', *Folklore*, vol. 94, issue 1 (1983), pp. 118–19.

14 Ibid.

15 R. L. Tongue, *The Chime Child, or Somerset Singers* (London, 1968), p. 3.

16 Ibid., p. 2.

17 A. Ransome, *Bohemia in London* (New York, 1907), p. 57.

18 Ibid., pp. 64–5.

19 E. Tregarthen, *The Pisky Purse: Legends and Tales of North Cornwall* (London, 1905).

20 E. Yates, 'Enys Tregarthen 1851–1923', *Horn Book Magazine*, vol. 25, no. 3 (May 1949), pp. 231–8.

21 H. S. Wright, 'A Visit with Enys Tregarthen', in E. S. Norton (ed.), *Folk Literature of the British Isles* (London, 1978).

22 Ibid.

23 E. Yates, 'Enys Tregarthen 1851–1923'.

24 E. Yates, foreword to E. Tregarthen, *Piskey Folk: A Book of Cornish Legends* (New York, 1940).

25 Yates, 'Enys Tregarthen 1851–1923'.

26 C. Burne, 'Short Notices', *Folklore*, vol. 19, no. 4 (30 December 1908), pp. 505–10.

27 '"Nellie Cornwall" Passes Away at Padstow', *Newquay Guardian and Cornwall Chronicle*, 26 October 1923, p. 2.

28 'Old Pubs, Barrow Races and Pure Soap', *Cambridge Evening News*, 26 February 1998, p. 24.

29 Ferguson's Gang, 'The Boo' (minute book), 1932–5. Chippenham, Wiltshire and Swindon History Centre, N-750-1, p. 2.

30 'Women's Institutes', *West Briton*, 14 July 1937, p. 2.

31 'Truro Women Learn of a Vanishing England', *West Briton*, 31 May 1937, p. 2.

32 The money on this occasion was delivered on 31 December as 'a small parcel wrapped in Christmas paper and tied with tinsel, with the message "Highly perishable, deliver at once"'. '"Ferguson's Gang" to Rescue in West Country', *Western Daily Press and Bristol Mirror*, 31 December 1937, p. 8.

33 Rescarow (1938). 'Cornish Gorsedd Meets at Stone-Age "Shrine" on Bodmin Moors', *Newquay Guardian and Cornwall Country Chronicle*, 25 August, p. 4.

34 V. Newall, 'Black Britain', *Folklore*, vol. 86, no. 1 (1975), p. 30.

NOTES

35 V. Newall, 'Folklore and Male Homosexuality', *Folklore*, vol. 97, no. 2 (1986), p. 124.

36 D. Rollison, 'Property, Ideology and Popular Culture in a Gloucestershire Village 1660–1740', *Past & Present*, no. 93 (November 1981), pp. 70–97.

37 'Calling Time on Blackface' (2020), https://www.morrisfed.org.uk/2020/07/03/calling-time-on-full-face-black-makeup [accessed 15.4.2024].

38 T. J. Buckland, 'The Tunstead Mill Nutters of Rossendale, Lancashire', *Folk Music Journal*, vol. 5, no. 2 (1986), pp. 132–49.

39 E. C. Cawte, 'The Morris Dance in Herefordshire, Shropshire and Worcestershire', *Journal of the English Folk Dance and Song Society*, vol. 9, no. 4 (1963), pp. 197–212.

40 David Harewood on blackface, BBC 2, 27 July 2023, 13.39.

41 T. J. Buckland, 'Black Faces, Garlands, and Coconuts: Exotic Dances on Street and Stage', *Dance Research Journal*, vol. 22, no. 2 (1990), pp. 1–12, at p. 9.

42 J. Goodwin, 'Gosling Takes a Gander', *Manchester Evening News*, 2 July 1984, p. 7.

43 English Folk Dance and Song Society Festival programme, Royal Albert Hall, 11/12 January 1963.

44 L. Wright, 'Folk Is a Feminist Issue' (2021), https://www.folkisfeminist.com/manifesta [accessed 5.9.2023].

2. The Lost Collections

1 M. M. Banks, 'Folk Museums and Collections in England', *Folklore*, vol. 56, no. 1 (March 1945), pp. 218–22.

2 T. W. Bagshawe, 'A Scheme for the Development of a Museum of English Life and Traditions', *Folklore*, vol. 60, no. 2 (June 1949), pp. 296–300.

3 'A Romany museum in Marden', *BBC Local, Kent* (24 September 2014). https://www.bbc.co.uk/kent/voices/museum.shtml [accessed 24.3.2024]

4 A. Sampson, 'The Decline and Fall of Romany', *Observer*, 17 January 1993, p. 9.

5 S. Lonsdale, 'Law Reforms Condemned as Ethnic Cleansing', *Observer*, 17 January 1993, p. 9.

6 'Romany Museum Would Be out of Character with Green Belt', *Hoddesdon and Broxbourne Mercury*, 11 August 1989, p. 6.

7 'Auction Champion Bids for £2½m Gipsy Dream', *Manchester Evening News*, 10 October 1988, p. 10.

8 M. Williams, *Curious Cornwall* (St Teath, 1992), p. 22.

9 L. Taylor and D. Crowley, *The Lost Arts of Europe: The Haslemere Museum Collection of European Peasant Art* (Haslemere, 2000), p. 3.

10 G. S. Davies, *The Peasant Arts Museum at Haslemere* (London, 1910).

11 'Peasant Arts Museum', *West Sussex Gazette*, 1 April 1926, p. 5.

12 E. Pinto, *The Pinto Collection of Wooden Bygones* (Northwood, 1960).

13 P. Cox, 'Permanent Home for the Pinto', *Birmingham Evening Mail*, 25 April 1969, p. 12.

THE LOST FOLK

14 M. S. J. Ward, 'First Folk Park in Britain', *Sunday Observer*, 20 December 1934, p. 10.

15 *Collecting Now*, BBC 2, Wednesday, 16 February 1983, 18.45.

16 G. Evans, 'History on Your Doorstep', *Western Mail and South Wales News*, 20 January 1956, p. 7.

17 Thomas Moore, quoted in B. Jones, *Black Eyes & Lemonade* (London, 1951).

18 Ibid., p. 5.

19 Ibid., p. 6.

20 *Papers and Transactions of International Folklore Congress* (London, 1892).

21 F. White, 'Folk Cookery From the English Country-Side', *Daily Express*, 15 September 1928.

22 F. White, *Good Things in England* (London, 1932), p. 350.

23 'The International Folk-Lore Congress', *Folklore*, vol. 2, no. 3 (September 1891), pp. 373–80.

24 'The Second International Folk-Lore Congress', *Journal of American Folklore* (October–December 1891), pp. 342–5.

25 'English Folk Cookery', *Daily Telegraph*, 16 January 1931, p. 7.

26 'Checky Pigs and Haver Bread', *Daily Herald*, 17 January 1931, p. 2.

27 'The Road to Art', *Huddersfield Daily Examiner*, 4 August 1951, p. 2.

28 B. Jones, *Black Eyes & Lemonade*, p. 7.

3. The Lost Objects

1 J. E. Flecker, *Collected Poems*, ed. J. C. Squire (New York, 1916), pp. 176–8.

2 Quoted in T. Mowl, 'In the Realm of the Great God Pan', *Country Life*, 17 October 1996, p. 58.

3 W. Black, *The Land that Thyme Forgot*, (London, 2006), p. 385.

4 W. Shakespeare, *Hamlet*, Act 5, scene 1, lines 255–7.

5 C. Hole, *English Custom and Usage* (London, 1941), p. 110.

6 L. Jewitt, 'Funeral Garlands', *Reliquary*, vol. 1 (July 1860), p. 7.

7 Ibid., p. 8.

8 T. Tayler, 'The Virgins' Crowns', https://www.abbottsann.com/amenitiesservices/church/the-virgins-crowns [accessed 22.1.2024].

9 H. Smith, 'Funeral Garlands at Astley Abbotts, Shropshire', *Reliquary*, 1861, p. 289.

10 T. Hardy, *The Mayor of Casterbridge: The Life and Death of a Man of Character* (London, 1886), p. 220.

11 'Odd Man Out', *Grimsby Evening News*, 23 January 1978, p. 6.

12 'The Charles Ekberg Column', *Grimsby Target*, 9 September 1993, p. 10.

13 'Odd Man Out'.

14 J. Larwood and J. Camden Hotton, *The History of Signboards* (London, 1866), p. 31.

15 Ibid., p. 272.

16 D. Chetty, 'Whatever Happened to the Black Boy of Killay', *Wales Art Review* (September 2018).

NOTES

17 D. Trivedy, 'The Black Boy', *South Wales Evening Post*, 18 February 2013, http://www.danieltrivedy.com/the-black-boy.html [accessed 6.12.2023].

18 E. Fullerton, 'Turner Prize Finalist Ingrid Pollard Explores Why So Many British Pubs Have the Same Racist Name', *Art News*, 7 February 2023, https://www.artnews.com/art-in-america/interviews/turner-prize-ingrid-pollard-explores-british-pubs-racist-name-1234654950 [accessed 6.12.2023].

19 'The Red Lodge', *Western Daily Press*, 8 February 1932, p. 7.

20 D. Morton, 'Remember When: North Shields Wooden Doll – Then and Now', *Chronicle Live*, 29 July 2014 https://www.chroniclelive.co.uk/lifestyle/nostalgia/remember-when-north-shields-wooden-7528155 [accessed 5.1.2024].

21 'London June 20th', *Salisbury and Winchester Journal*, 20 June 1808, p. 3.

22 'Wood Stealing Felony', *Essex Standard*, 18 March 1842, p. 2.

23 '"Mail" Mustard & Cress', *Hull Daily Mail*, 24 December 1920, p. 1.

24 'Milkmaid Wedded', *Midland Maid*, 31 December 1920, p. 6.

25 T. Oliver, 'Smocks: A Guide to the Collections', University of Reading, 2000.

26 A. Buck, 'The Countryman's Smock', *Folk Life*, no. 1 (1963), p. 16.

27 'Priceless Gifts to the University to Create a Galsworthy Room', *Birmingham Post*, 15 May 1962, p. 6.

28 'Surrey Smocks for Museum', *Surrey Advertiser*, 16 September 1961, p. 11.

29 'Genuine Surrey Smocks Are Hard to Find', *Surrey Advertiser*, 5 August 1961, p. 8.

30 'Revival of English Arts and Crafts', *Guardian*, 21 May 1914, p. 5.

31 'Hunts Historical Treasures: Helpston Man and a "Burying Cake"', *Peterborough Standard*, 30 November 1934, p. 21.

32 Dried Burying Cake, X.2375, https://www.norrismuseum.org.uk/discover/museum-collection/post-mediaeval-collection [accessed 5.3.2024].

33 B. Jones, *Design for Death* (Indianapolis, 1967), p. 10.

34 *The Patch*, BBC Radio 4, 8 April 2024.

35 Ibid.

36 R. E. Heaton, 'Corn Dollies in Cheshire', *Evergreen*, autumn 1988, p. 102.

37 'Corn Dolly Decorations at Churches', *Evening Post*, 8 October 1964, p. 4.

38 B. Flemming, 'She'll Revive the Art of Corn-Dolly Making', *Huddersfield Daily Examiner*, 18 September 1974, p. 6.

39 H. McLean, 'Keeping the Dolly Image Alive', *Leicester Chronicle*, 31 January 1975, p. 5.

40 E. Owen, 'First Lady of the Flowers', *Daily Telegraph*, 29 July 1972, p. 9.

4. The Lost Customs

1 S. Roud, *The English Year* (London, 2006), p. 350.

2 'Abingdon', *Jackson's Oxford Journal*, 20 June 1885, p. 6.

3 'The Mock Mayor of Newcastle', *Manchester Weekly Times and Examiner*, 17 September 1851, p. 5.

THE LOST FOLK

4 'Mock Mayors of Devon: An Old Time Custom', *Crediton Chronicle*, 25 April 1925, p. 4.

5 'Mischief Night Vandals Cause Chaos across Merseyside', BBC News, 31 October 2019, https://www.bbc.co.uk/news/uk-england-merseyside-50248809 [accessed 2.9.2024].

6 F. J. McKenzie, 'Oidhche Shamhna – a South Uist Halloween', https://www.nts.org.uk/stories/oidhche-shamhna-a-south-uist-halloween [accessed 12.9.2024].

7 J. W. G. Hart, 'Chair Dancing', *Cheshire Smile*, winter 1977, pp. 26–7.

8 'When Folklore and the Motor Age Are Face to Face', *Evening Post*, 24 December 1966, p. 4.

9 'Shreds and Patches', *Cornishman*, 2 January 1879, p. 5.

10 F. Goddard, 'Cornish Customs of To-Day', *West Briton*, 27 September 1888, p. 2.

11 'Town and County Gossip', *Derby Evening Telegraph*, 24 December 1906, p. 2.

12 Ibid.

13 'Alvaston', *Derby Mercury*, 2 January 1867, p. 3.

14 R. Hutton, *Stations of the Sun* (Oxford, 1996), p. 12.

15 Ibid.

16 'The Fisherman's Walk', *Musselburgh News*, 14 September 1934, p. 2.

17 https://photosearch.scotfishmuseum.org/view-item?i=2594&WINID= 1742654663503 [accessed 18.11.2024].

18 M. Farrar, 'A Short History of the Leeds West Indian Carnival 1967–2000', p. 3, https://www.leedsbeckett.ac.uk/-/media/files/schools/csh/caribbean-carnival-cultures/mf-carnivalhistorywyas.pdf [accessed 3.5.2024].

19 'Touch of Caribbean in Festival', *Birmingham Evening Mail*, 24 August 1968, p. 20.

20 Gus Williams, quoted in N. Western, 'Handsworth Carnival Magic', *Birmingham Post*, 14 September 1992, p. 16.

21 'Can't Stop the Carnival – Even for a Downpour', *Reading Evening Post*, 29 May 1979, p. 9.

22 'The Man Who Got the Second City Dancing', *Birmingham Post*, 9 August 1997, p. 47.

23 B. Manu, 'Tabanca' (2023), https://harlesdenhighstreet.com/Tabanca [accessed 21.5.2024].

24 'The Man Who Got the Second City Dancing'.

25 'Hallaton Can't Regain Bottle-Kicking Glory', *Leicester Mercury*, 23 April 1957, p. 5.

26 J. Simpson, *The Folklore of Sussex* (London, 1973), p. 9.

27 W. Johnson, *Byways in British Archaeology* (Cambridge, 1912), p. 194.

28 'Eastertide in Preston', *Preston Chronicle and Lancashire Advertiser*, 16 April 1887, p. 6.

29 L. M. Fox, *Costumes and Customs of the British Isles* (Boston, 1974), p. 21.

30 R. Hutton, *Stations of the Sun*, p. 67.

31 F. M. McNeill, *Silver Bough: Calendar of Scottish National Festivals*, vol. 3 (Glasgow, 1961), p. 34.

32 'Perranuthnoe', *The Cornishman*, 22 October 1924, p. 3.

NOTES

33 L. A. Govett, *The King's Book of Sports: A History of the Declarations of King James I and King Charles I, as to the Use of Lawful Sports on Sundays* (London, 1890), p. 39.

34 E. Ridings, *The Village Muse* (Macclesfield, 1854), p. 25.

35 'Rushbearing', *Rochdale Observer*, 27 August 1859, p. 3.

36 A. Burton, *Rush-Bearing* (Manchester, 1891), p. 55.

37 Museum of London Collection, inv. no. 63.77/2.

38 R. Stewart-Brown, 'The Chester Hand or Glove', *Chester Archaeological Society Journal*, vol. 20 (1850), p. 146.

39 Ibid., p. 124.

40 Ibid., p. 134.

41 'Who Wants Egbert, Obert and Sidney?', *Evening Dispatch*, 22 July 1938, p. 9.

42 F. W. Cheetham, 'Norfolk Museums Service Information Sheet: The Norwich Snapdragon' (Norwich, 1984).

43 A. R. Vickery and M. E. Vickery, 'Chinese New Year Celebrations in London 1971–1973', *Folklore*, vol. 85, no. 1 (1974), pp. 43–5.

44 Ibid.

45 V. Newell, 'A Note on the Chinese New Year Celebration in London and Its Socio-Economic Background', *Western Folklore*, vol. 48, no. 1 (1989), pp. 61–6.

46 B. Simpson, *Spalding in Springtime* (Spalding, 1966).

47 D. Braybrooks, *Spalding Flower Parade: The Golden Years* (Spalding, 2007), p. 17.

48 'Spalding Says It with Tulips', *Guardian*, 11 May 1973, p. 5.

49 L. Wright, 'Chasing the Harestail' (2019), https://axisweb.org/artwork/chasing-the-harestail [accessed 1.6.2024].

50 'Commercial Displays Are Not the Only Bright Lights', *West Briton*, 22 December 1994, p. 88.

51 'Mrs I. Penrose Penstruthal Obituary', *West Briton*, 5 February 1998, p. 43.

52 'Padstow Minstrels', *Cornish Guardian*, 1 May 1930, p. 4.

53 H. Cornish, 'Not All Singing and Dancing: Padstow, Folk Festivals and Belonging' (2015), https://www.tandfonline.com/doi/full/10.1080/00141844.2014.989871 [accessed 1.5.2024].

54 *D****e Day* (2005), dir. Dewi Konuah-Bruce, Roehampton University: 8:45.

55 S. Reed, *The Cornish Traditional Year* (Penzance, 2009), p. 64.

56 A. Cowan, 'The May Tradition of the Minehead Hobby Horse', *Somerset Life*, https://www.greatbritishlife.co.uk/magazines/somerset/24266882.may-day-tradition-minehead-hobby-horse [accessed 13.5.2024].

57 'Blue-Eyed Stranger Will Lead Dance', *Reveille*, 15 June 1951, p. 3.

5. The Lost Worlds

1 J. B. Priestley, *English Journey* (London, 1934), p. 62.

2 J. Betjeman, 'Wolf's Cove, Thirlwall Mere and District', *Architectural Review*, vol. 71 (January 1932), pp. 8–11.

3 'Pictures of Shell House in Bournemouth', *Bournemouth Echo*, 2018, https://www.bournemouthecho.co.uk/news/16955678.pictures-shell-house-southbourne [accessed 25.7.2022].

4 'Pictures of the Shell House Garden Being Demolished', *Bournemouth Echo*, 9 January 2021, https://www.bournemouthecho.co.uk/news/18993092.pictures-shell-house-demolished [accessed 25.7.2022].

5 'Leven's Artist in Shells', *Dundee Courier and Advertiser*, 6 June 1931, p. 10.

6 'Shell Garden' (1962), British Pathé, https://www.britishpathe.com/asset/36889 [accessed 1.6.2022].

7 A comment taken from a post on: https://outsider-environments.blogspot.com/2011/09/sidney-dowdeswell-mosaic-and-shell.html [accessed 21.11.2024].

8 'Fairytale Cottage of Oyster Shells and Jugs', *Reynold's Newspaper*, 18 October 1936, p. 7.

9 'Fantasy World up the Close', *Irvine Herald*, 4 November 1977, p. 13.

10 'Villagers Turn Out in Aid of Band', *West Briton*, 10 July 1996, p. 29.

11 'Hayle's History Goes on the Wall', *West Briton*, 3 September 1992, p. 51.

12 N. Pevsner and B. Cheery, *The Buildings of Devon* (London, 1991), p. 745.

13 Charles Saumarez Smith quoted in A. Fowler, 'Hidden Treasures: A Statue-Filled Canal Garden', *Guardian*, 26 October 2019, https://www.theguardian.com/lifeandstyle/2019/oct/26/hidden-treasures-a-statue-filled-canal-garden [accessed 6.3.2024].

14 Gerry Dalton quoted at https://www.gerryspompeii.com/home [accessed 6.3.2024].

15 *A Portrait of Mr Pink* (1996), dir. Helena Appio, https://www.youtube.com/watch?v=YXh_sho2NGw [accessed 1.7.2023].

16 Ibid.

17 A. Freyberg, 'Interiors: A House Filled with Fairytale Fretwork', *Daily Telegraph*, 19 March 2009, https://www.telegraph.co.uk/lifestyle/interiors/5007218/Interiors-A-house-filled-with-fairytale-fretwork.html [accessed 24.7.2023].

18 *Nationwide*, BBC 1, 26 August 1975.

19 'Ugly-House is a Money-Spinner', *Daily Post*, 14 January 1984, p. 22.

20 L. Hutton, 'Mum Builds Tiny Fairytale Cottage for Girls', *South Wales Argus*, 14 June 1973, p. 10.

21 *A Portrait of Mr Pink* (1996), dir. Helena Appio.

Conclusion. From Lost to Found Folk

1 D. Hartley, *Lost World* (Totnes, 2012), p. 32.

⋆ Image credits ⋆

Plate One

Enid Baker dressed as the 'Merchant's Daughter' and Miss Small dressed as the 'Wealthy Merchant', as part of The Pageant of Ludlow, held July 1934, Ludlow Castle, Shropshire. Part of The Folk Archive collection.

An unknown group of people visit an unknown model village. Part of The Folk Archive collection.

Elsie Matley Moore restores one of the murals at The Commandery, Worcester, Worcestershire, 1935. Part of The Folk Archive collection.

Wattle & Daub Hut built by John Sebastian Marlowe Ward at The Abbey Folk Park, New Barnet, c.1930. Part of The Folk Archive collection. Unable to trace rightsholder.

Ernie 'Oxo' Lesley Richardson's Wonders of the Deep cart, c.1930. Held in the collection at Hastings Fishermen's Museum, © Hastings Fishermen's Museum.

'The Garden of Eden' topiary garden created by David Davies, Glyn Aur, Abergwili, Wales, c.1932. Part of The Folk Archive collection. Unable to trace rightsholder.

A church kneeler showing Morris Dancers at Wimborne Folk Festival, Wimborne Minster, Dorset, September 2023. Taken by the author in September 2023

Widecombe Fair Horse Brass, unknown date. Part of The Folk Archive collection

A church kneeler depicting Clypping Sunday, St Mary's Church, Painswick, Gloucestershire, September 2022. Taken by the author in September 2022

The Lion outside the Star Inn, Alfriston, East Sussex, May 2024. Taken by Matthew Shaw in May 2024

The bargeware painted bar, Snowdrop Inn, Lewes, East Sussex. Taken by the author in August 2023

Ami the ship's figurehead before she was restored, Upton Slip, Falmouth, Cornwall, January 2024. Taken by the author in January 2024

Souvenir replica of Ami the ship's figurehead, unknown date. Part of The Folk Archive collection

Plaster pigs that were once a butcher's sign, before their restoration in 2023, Folkestone, Kent. Taken by the author in October 2022

1st Sedgley Morris Men's badges, c.1980. Part of The Folk Archive collection, gifted by Ian Kerr

THE LOST FOLK

Plate Two

Mummer's Costume made up of an appliqued jacket, trousers and hat, dated 1829. Held in the collection at Philadelphia Museum of Art. Purchased with funds contributed by various donors in memory of Anne d'Harnoncourt, 2009-106-1a–c

Traditional English smock made by Penny MacBeth, 1996. Part of The Folk Archive collection.

The Floral Clock, Weston-Super-Mare, 1936. Part of The Folk Archive collection. Unable to trace rightsholder.

Jubilee Bonfire held at Wolfstones Heights Trig Point (also known as Jubilee Seat), Netherthong, West Yorkshire, 1935. Part of The Folk Archive collection.

Community centre Christmas lights, Angarrack, Hayle, Cornwall, December 2024. Taken by the author in December 2024.

Stan's Country Christmas light display, Perranzabuloe, Cornwall, c.1999. Taken by Sue Hill c.1999

John Brown, a local farm worker, dressed as Uncle Tom Cobbley at Widecombe Fair, Widecombe in the Moor, Devon, September 1956. Part of The Folk Archive collection.

'Whither I Go Ye Know', a Well Dressing at Coffin Well, Tissington, Derbyshire, 1904. Part of The Folk Archive collection.

Ilford Park Polish Camp folk dance performance, date unknown. Held in the collection at Newton Abbot Museum, © Newton Abbot Museum.

Badges from three, now defunct, Model Villages: Skegness Model Village, Tucktonia and Little Town Minehead. Part of The Folk Archive collection.

The Castle at Fairytale Land, Margam Park, Glamorgan, Wales. Taken by the author in January 2023.

Mrs E. Head stands in the Model Village at The Woodcarver's Cottage, Woolmer Green, Hertfordshire, c.1972. Part of The Folk Archive collection.

The Shell Village, Southampton, Hampshire. Taken by the author in March 2024

The remnants of the mural outside Bramwell's Meadery (now a hotel), Penzance, Cornwall, January 2024. Taken by the author.

Excalibur's Meadery carnival float made by Terry English for Hayle Carnival, c.1980. Held in the collection at Hayle Heritage Centre, © Hayle Heritage Centre.